THE ART OF

PYROGRAPHY

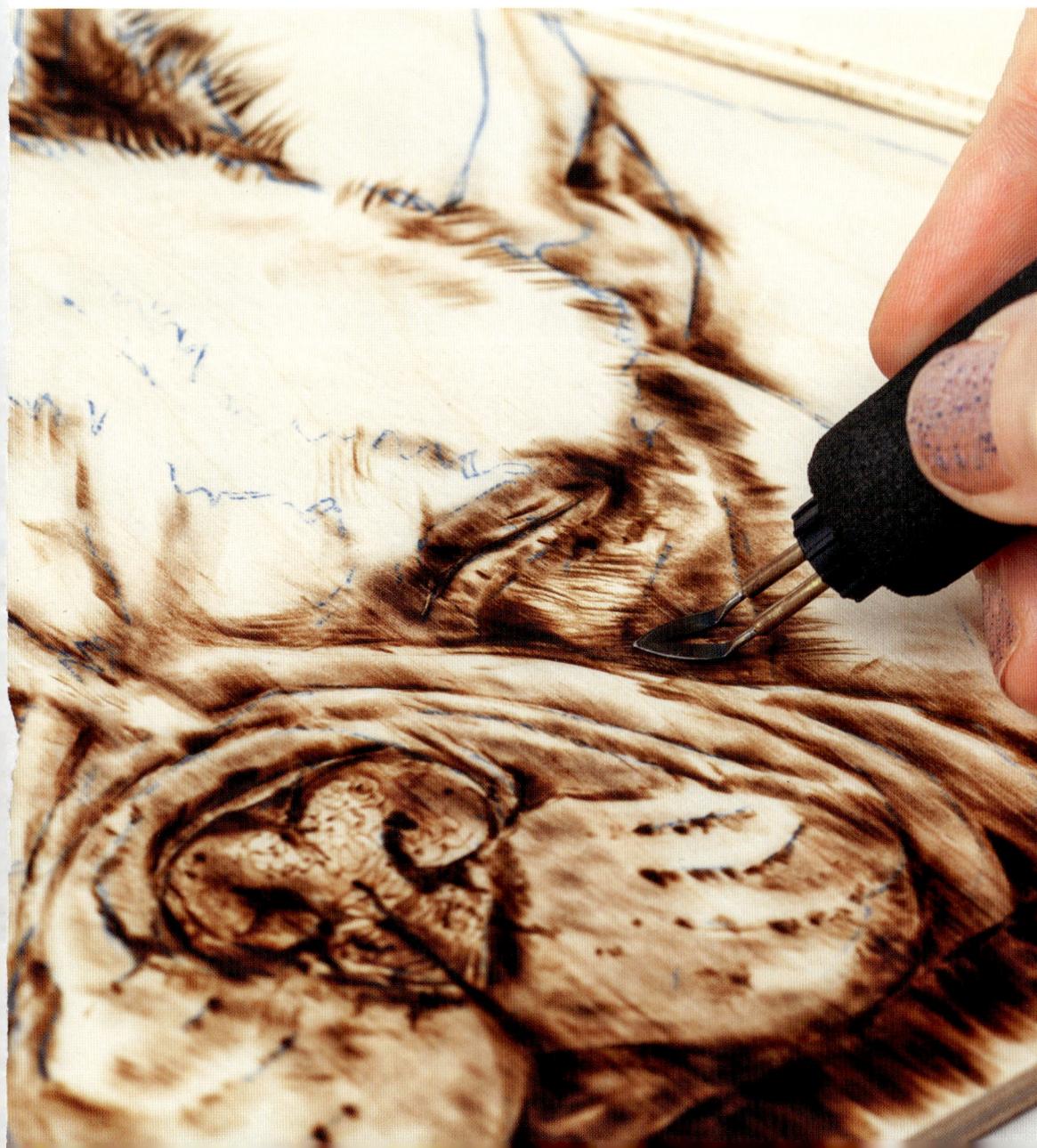

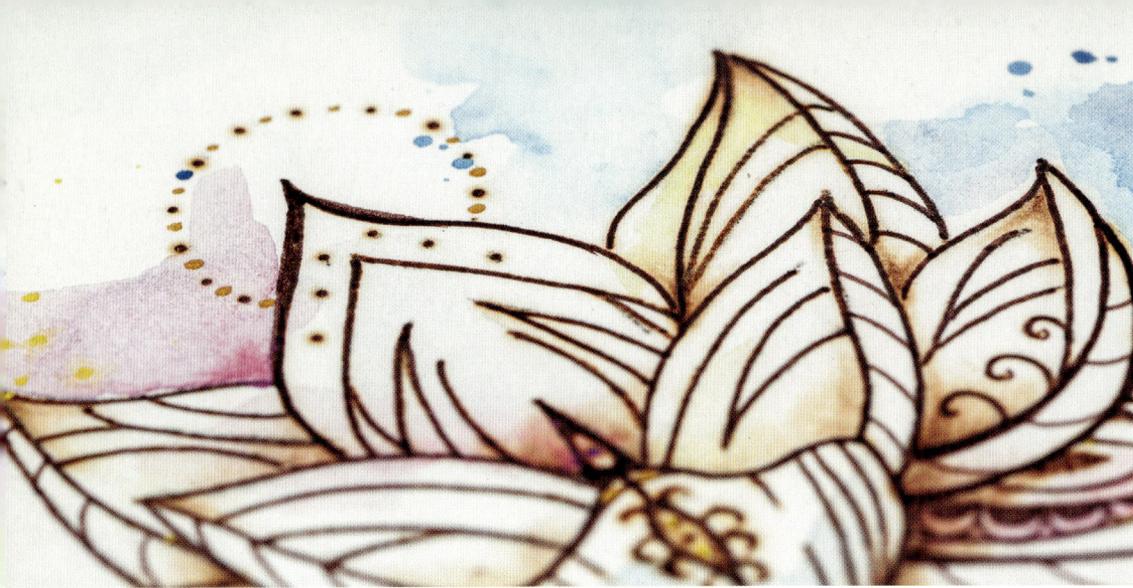

Dedication

For Mr J – my forever after; and for Mum, who never
got the chance to turn the pages of this book.

First published in 2023
Search Press Limited
Wellwood, North Farm Road,
Tunbridge Wells, Kent TN2 3DR

Text copyright © Cherry Ferris 2023

Photographs by Mark Davison at Search Press Studios, and author's own.

Photographs and design copyright © Search Press Ltd. 2023

ISBN: 978-1-78221-938-5
ebook ISBN: 978-1-78126-932-9

The Publishers and author can accept no responsibility for any consequences arising from the
information, advice or instructions given in this publication.

Readers are permitted to reproduce any of the artwork in this book for their personal use, or
for the purpose of selling for charity, free of charge and without the prior permission of the
Publishers. Any use of the artwork for commercial purposes is not permitted without the prior
permission of the Publishers.

Suppliers
If you have difficulty in obtaining any of the materials and equipment mentioned in this book,
please visit the Search Press website for details of suppliers: www.searchpress.com

You are invited to visit the author's website at: www.fairiewoodart.com

Publishers' note
All the step-by-step photographs in this book feature the author, Cherry Ferris, demonstrating
her pyrography techniques. No models have been used.

THE ART OF
PYROGRAPHY

Drawing with fire

Cherry Ferris

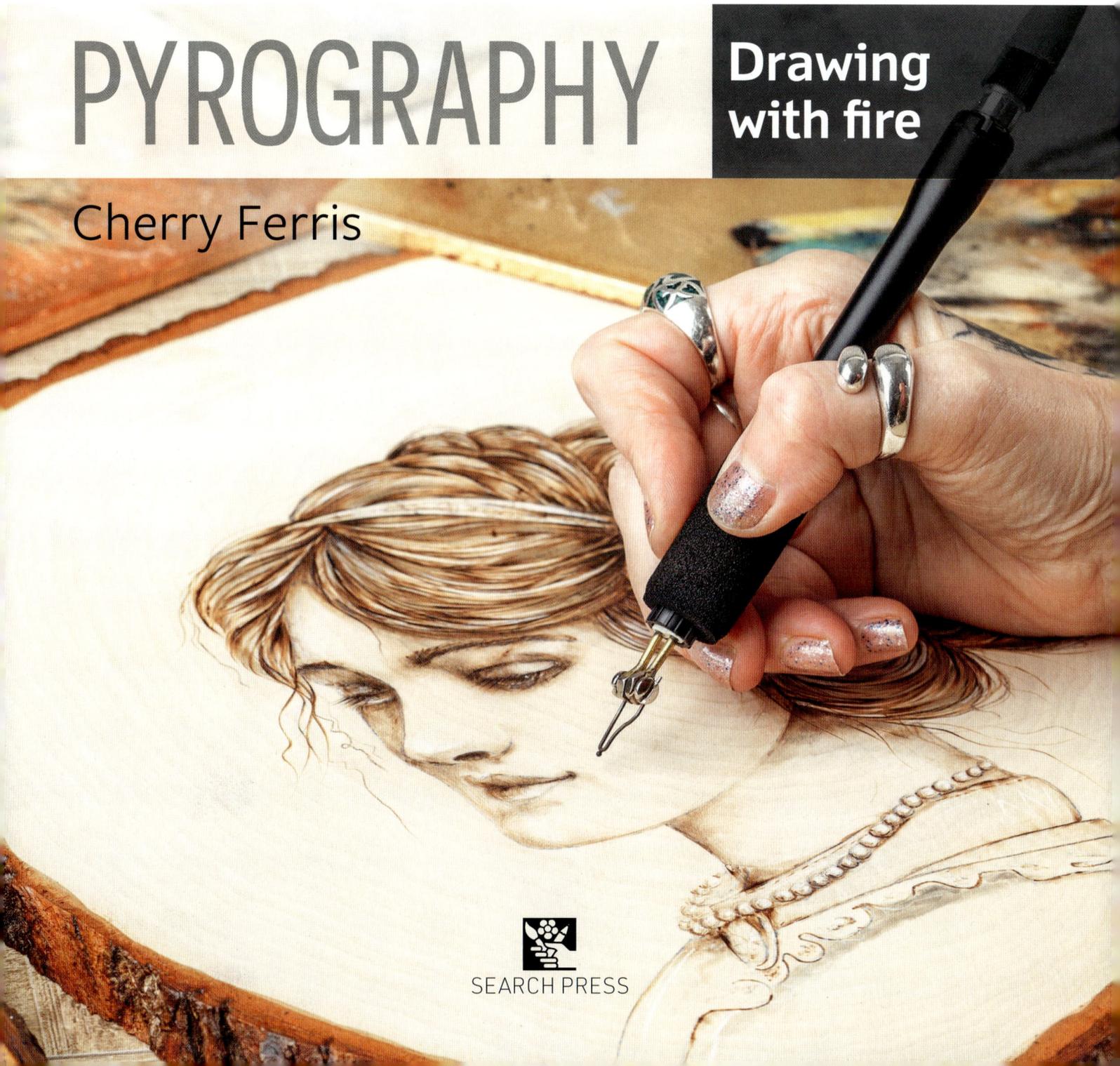

Search Press

CONTENTS

Just Around the River Bend 70 × 70cm (27½ × 27½in)

Pyrography with Inktense pencils on birchwood panel.

We have recently had otters and beavers reintroduced to our local river. This piece was inspired by the photography of Paul Clayden, who kindly granted me permission to use his image.

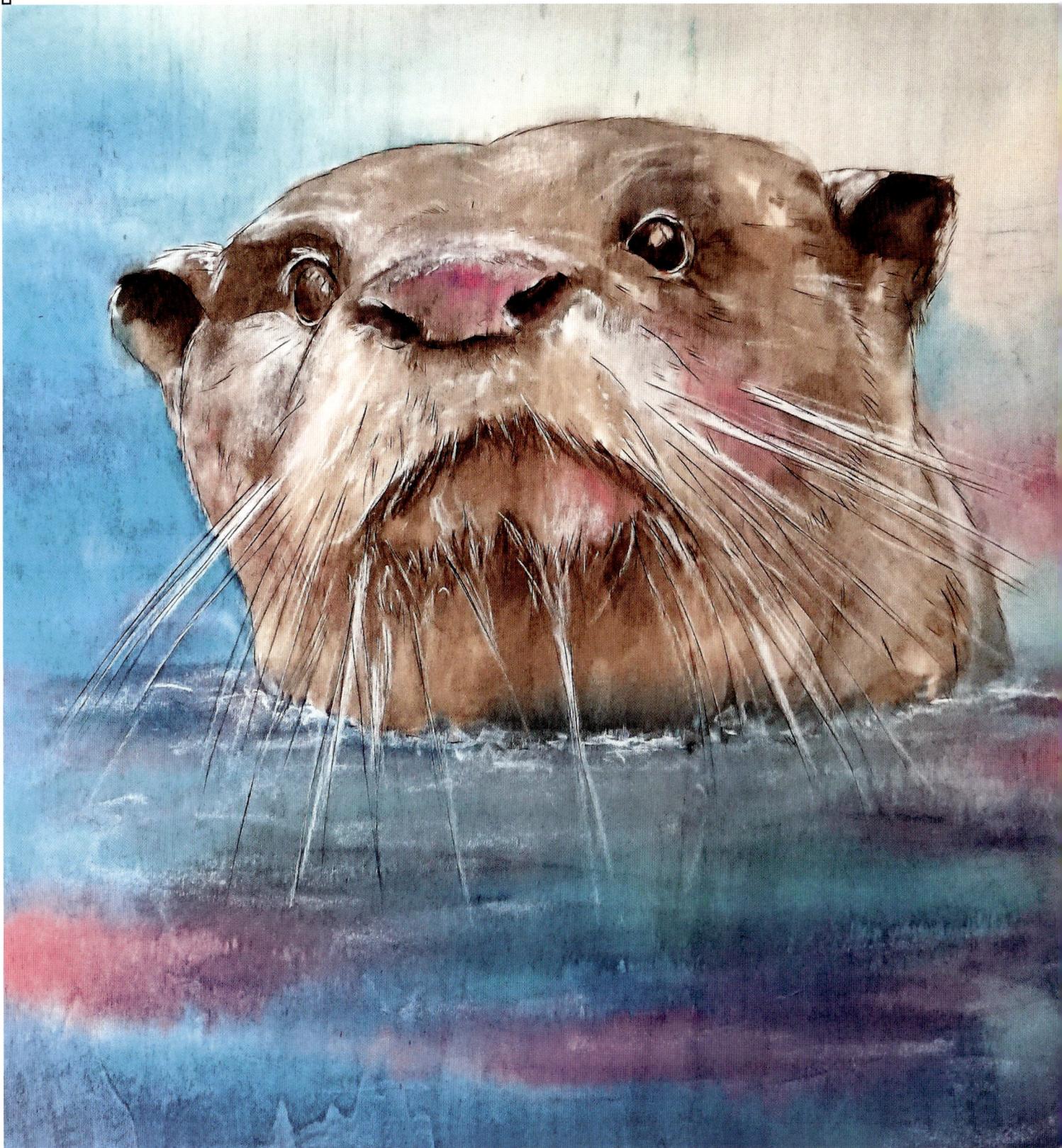

INTO THE FRAY

Art holds its own magic. Whether practised individually or communally, it connects people. A tangible manifestation of ideas, art has the power to stir the soul at a glance... that's why I'm fascinated by it! I have had no formal art training. All my experience has been built through trial and error, happy accidents and experimentation – an approach that has allowed me to explore some hidden avenues and secret paths. Through the combination of modern materials and a huge dose of wonder, I can offer you a fresh, new and innovative approach to traditional pyrography. Indeed, the techniques you can learn from this book will give you a skill set that can be very easily transferred to other art media and art styles.

Today, pyrography – literally 'drawing with fire' – is experiencing an exciting new wave of popularity and innovation, but the craft was something I came across, quite by accident, a number of years ago when I was a little lost and without a tether. I was a thriving, busy tattooist with my own studio, enjoying life in beautiful Cornwall, when my husband and best friend fell chronically ill. There was no doubt in my mind that I would become his carer: it was one of the easiest decisions I have ever made. However, it did involve selling up my business and relocating. It was then that I began searching for a different creative outlet for my art: a different way to use my skills and experience. It was then that I discovered pyrography.

I had stumbled across an art form that not only offered the flexibility to create images of a line and wash nature similar to that of tattooing, but would also allow me to explore a more lifelike and realistic approach to art. By experimenting with the detail, tips and temperature, I could bring the wonderful intricacies associated with nature and the natural world to the standard of fine artwork. As an added bonus, the art form also incorporates both texture and scent, and uses a natural canvas gifted by nature herself.

I so love to share my passion, process and enthusiasm with others. This book is for all you creatives, artists and woodburners – whether experienced or just setting out – who are looking for something new and exciting. It's a fun ride: a piece of wood, a pyrography machine and a few simple supplies are all you need to get started – so jump in and set your imagination free.

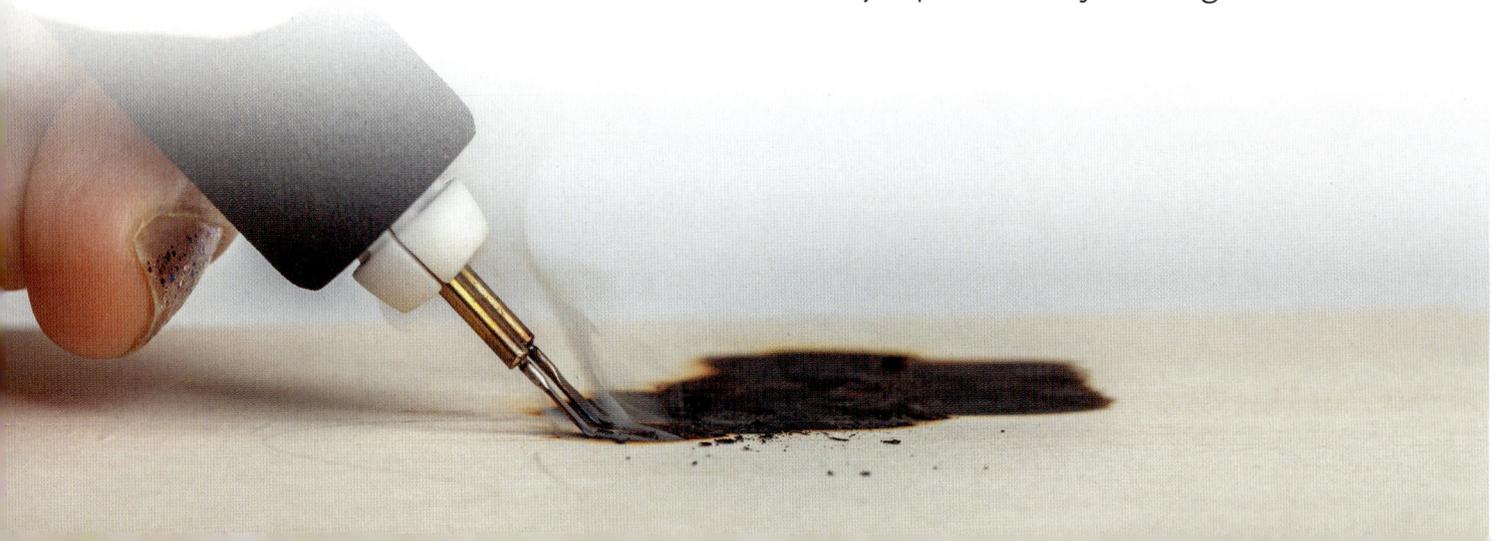

Art holds its own magic. Whether practised individually or communally, it connects people.

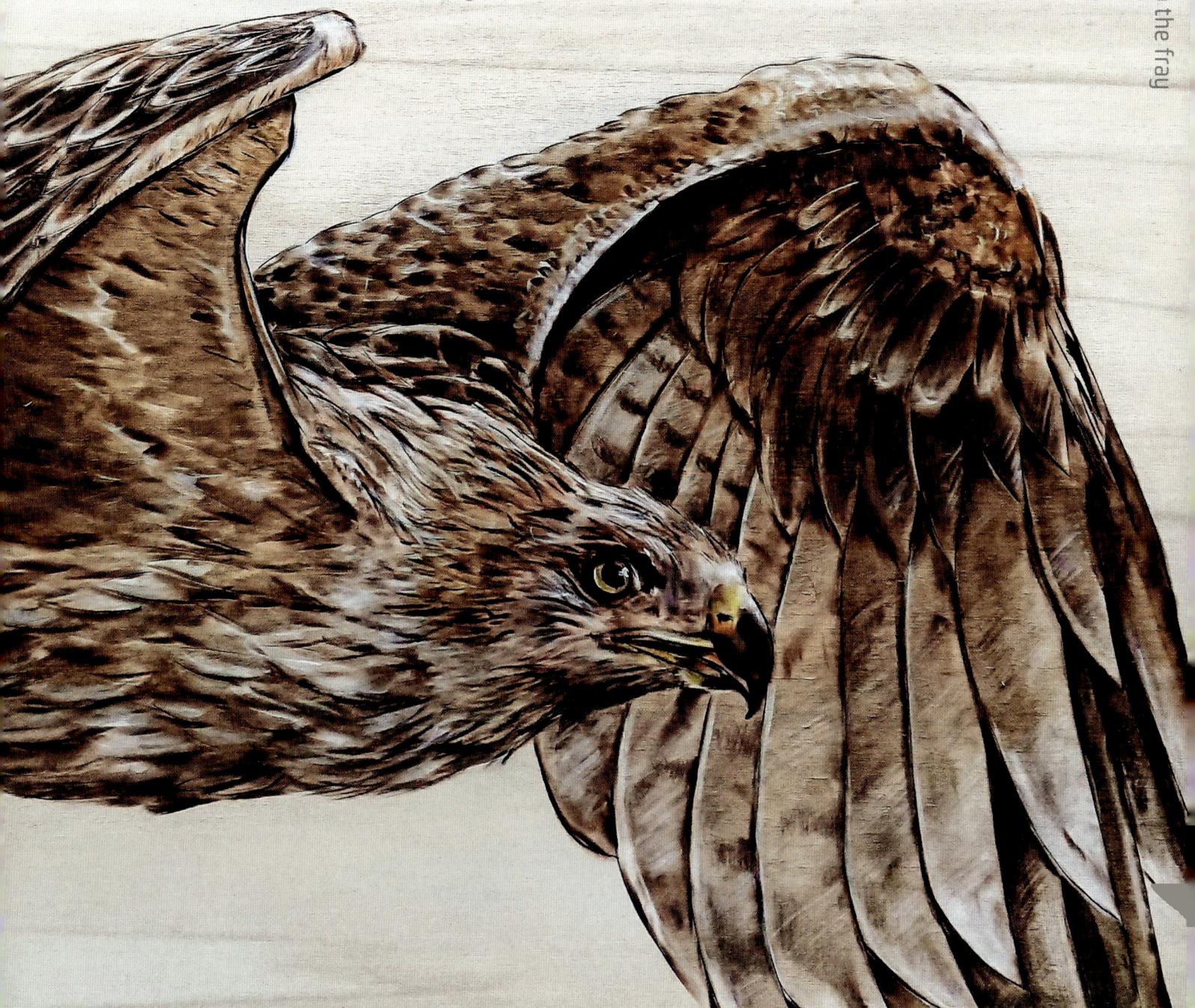

Red Kite 40 × 30cm (15¾ × 11¾in)

Pyrography and white pencil on poplar panel.

This piece was a super smiley surprise gift created for the Managing Director of Antex, a pyrography tool and soldering iron manufacturer. We were doing a little work together one day and mulling over all things pyro when he very kindly offered me some 'Firewriter' machines to teach with. I was blown away! During our chat I had discovered one of his favourite birds was the red kite – the rest is history.

THE INVITATION

'The journey of a thousand miles begins with just one step.' **Lao-Tzu**

As an art form, pyrography is the process of mark-making on wood or another suitable surface, using heat to scorch, burn and manipulate an image – the word itself, *pyrography*, has its roots in the Ancient Greek words for 'fire' and 'writing'. Through the ages, fire has been a powerful and enduring symbol of life and passion, and has been used by humans for millennia. For me, harnessing that energy into an art form and being able to create on a natural canvas feels so intuitively right!

Pyrography is a very physical, tactile craft that combines heat, metal and – more often than not – wood. It engages and stimulates the senses in a way that no other art form does. It relies upon your senses of touch (temperature, pressure, texture), smell (all woods have their own unique smell – some even smell like Christmas!) and sight (watching the wood change colour before your very eyes is like alchemy).

Whether you wish to take up woodburning as a hobby to create personalized gifts or artwork for friends and family;

or you choose to embrace it as a unique art form, either as a standalone process or incorporated into your mixed media practice, I wholeheartedly believe pyrography has a little something for everyone. The choice and direction of how you add it to your melting pot of 'artliciousness' is totally yours. Inside this book you will find guidelines and prompts to get you started on your journey, as well as secrets and tips to encourage your own creative risk-taking. Of course, if you feel yourself moving away from my suggestions and exploring your own path, then just go for it!

It's a myth that pyrography has to take ages to complete a piece. Throughout this book you will come across some 'mini burns'. These are fun little projects designed to hone your skills, develop your confidence, and play with new ideas. Each one is designed to be completed within half an hour or less – just in time for another cup of tea.

This is your invitation to the world of drawing with fire. Let's get started!

Mehndi Lotus 20 × 24cm (8 × 9½in)

Pyrography and watercolour on handmade rag paper board.

No matter how chaotic life is, flowers will still manage to find a way to bloom – even in the darkest of places. They are nature's true survivors; fragile, yet steadfast and strong – and that is so true for the lotus flower. This is a pyrographic interpretation of a beautiful tattoo that I did on a client who, against all odds, fought and survived a life-changing event.

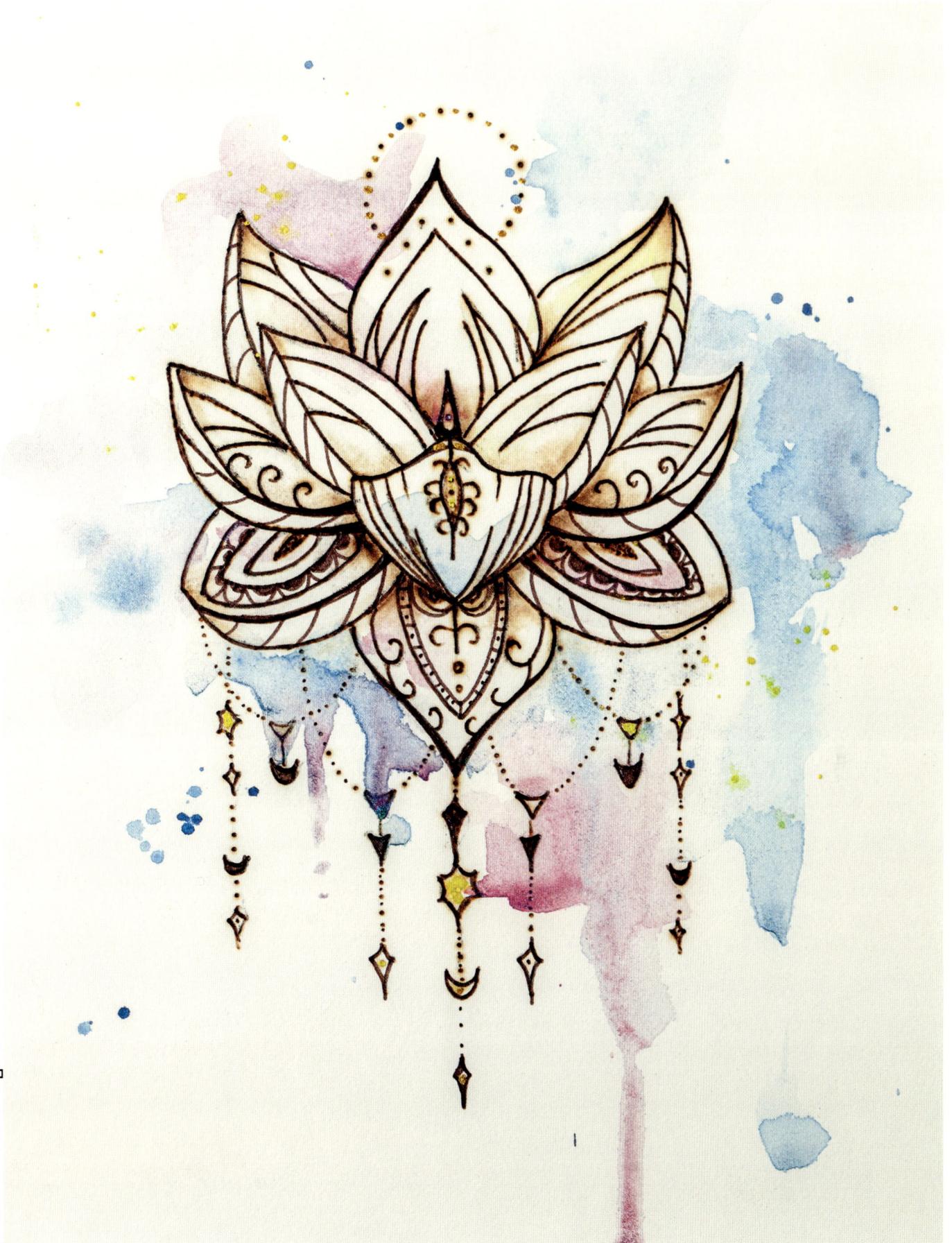

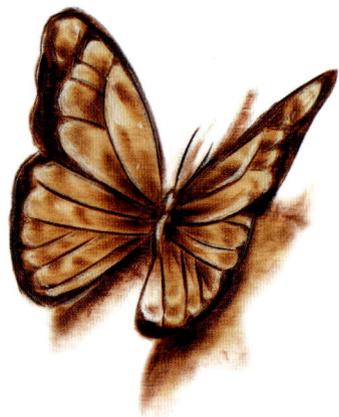

The spark

My mind works like a 'thought butterfly', constantly flitting and spinning around with ideas, colours and considerations. I often have three or four pieces of work on the go at the same time and move between them. Some ideas are insistent as a petulant child, jumping the queue and demanding to be painted straight away, while others slowly dance and swirl around my imagination, like a colourful phoenix rising from the ashes. Over time they slowly gain form and gather momentum until metamorphosing and bursting free into an exciting new concept.

Someone recently said to me that 'to be taken seriously' a 'real artist' had to have distinctive style, colour palette and medium. That certainly got me thinking! Art isn't always created for monetary gain. My art is for me. It's a reflection of how I'm feeling and it's created from the heart. Why do we have to pigeonhole what we create? I enjoy finding beauty in the tiniest detail, I love creating atmosphere and explosions of beautiful sparkly colour. I'm passionate about woodburning, but that doesn't mean that I like any other art form any less: I adore the ephemeral jewel-like quality of watercolours, the sumptuous buttery yumminess of acrylics, the spellbinding Midas touch of gold leaf and the beauty of coloured pencils all lined up like tiny rainbow soldiers in their boxes... there are so many exciting possibilities. Why should we settle for just one instead of adding them together?

'I dream my painting then I paint my dream.'
Vincent Van Gogh

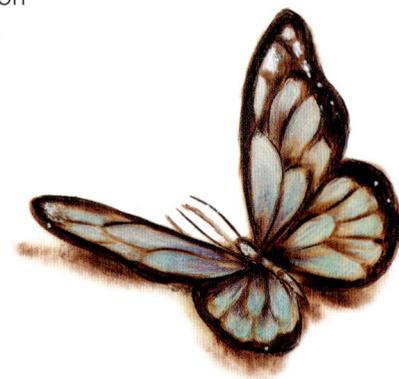

As the weather changes and the seasons turn, so can we. Though I am just one person, I am a mother, a wife, a lover, a friend, a grandma, a confidante, a wild woman, a musician – all these things and more. In the same way, my art does not need to stick to a particular style or medium.

The day I stop exploring, experimenting and playing with colours, paints and ideas will be the day my sun stops shining. That person was quite right: I do flit between media and styles, and I do enjoy fusing techniques together – but I am a happy art butterfly. I say embrace your uniqueness and individuality, smile at convention... then spread your wings and let your imagination fly. Shine brightly like the supernova that you are and don't let others dim your beautiful light.

Come with me on a journey of creativity and mixed media, all draped lovingly around the very capable shoulders of pyrography. A fusion and wonderful melting pot of ideas and techniques where modern meets traditional and which will complement and add a new dimension into your own style of artwork. Create what makes you happy.

Gesso

Dorlands wax

Inktense

Pyrography and mixed media

I want to take you on an exploratory journey – consider this
a personal invitation into my world, with a golden ticket to an
exciting voyage of adventure, wonder and innovation. Within
these pages I offer new skills and techniques that can be
considered, transferred and integrated into other art forms
as part of an exciting and experimental mixed media toolkit.

Pyrography has allowed me to create exciting new artworks
and a mixed media approach that can benefit the advanced
pyrographer and beginner alike. There are an infinite
number of ways that these projects can add another layer
of dynamism to your pyro work, and I hope that it will also
entice and enchant anyone who has never experienced
pyrography before.

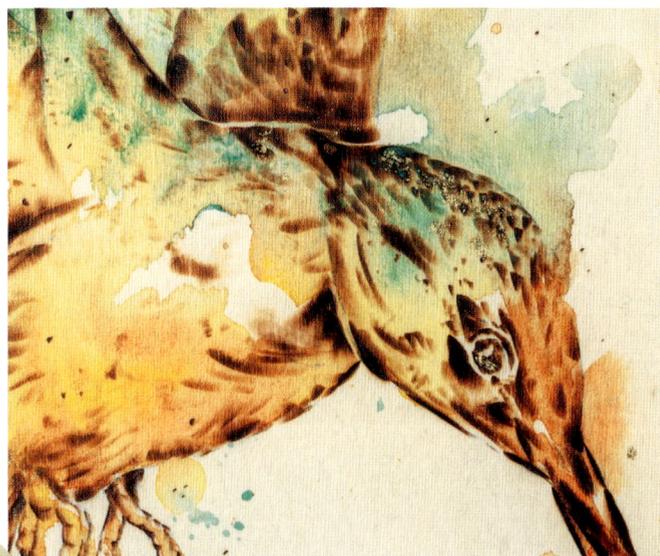

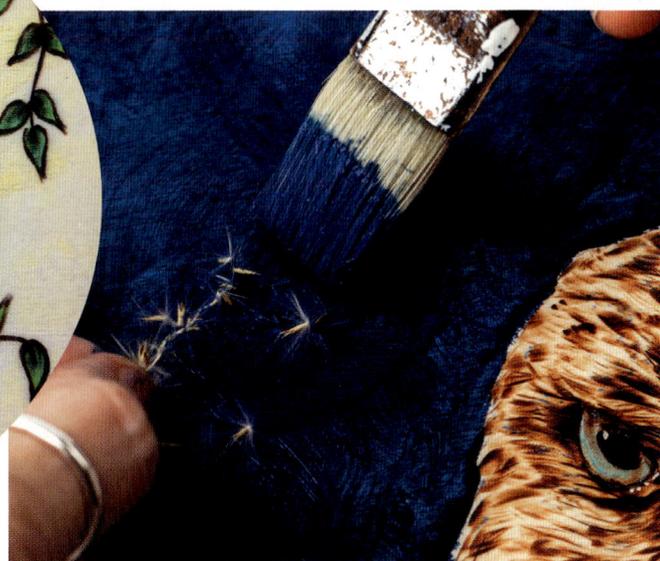

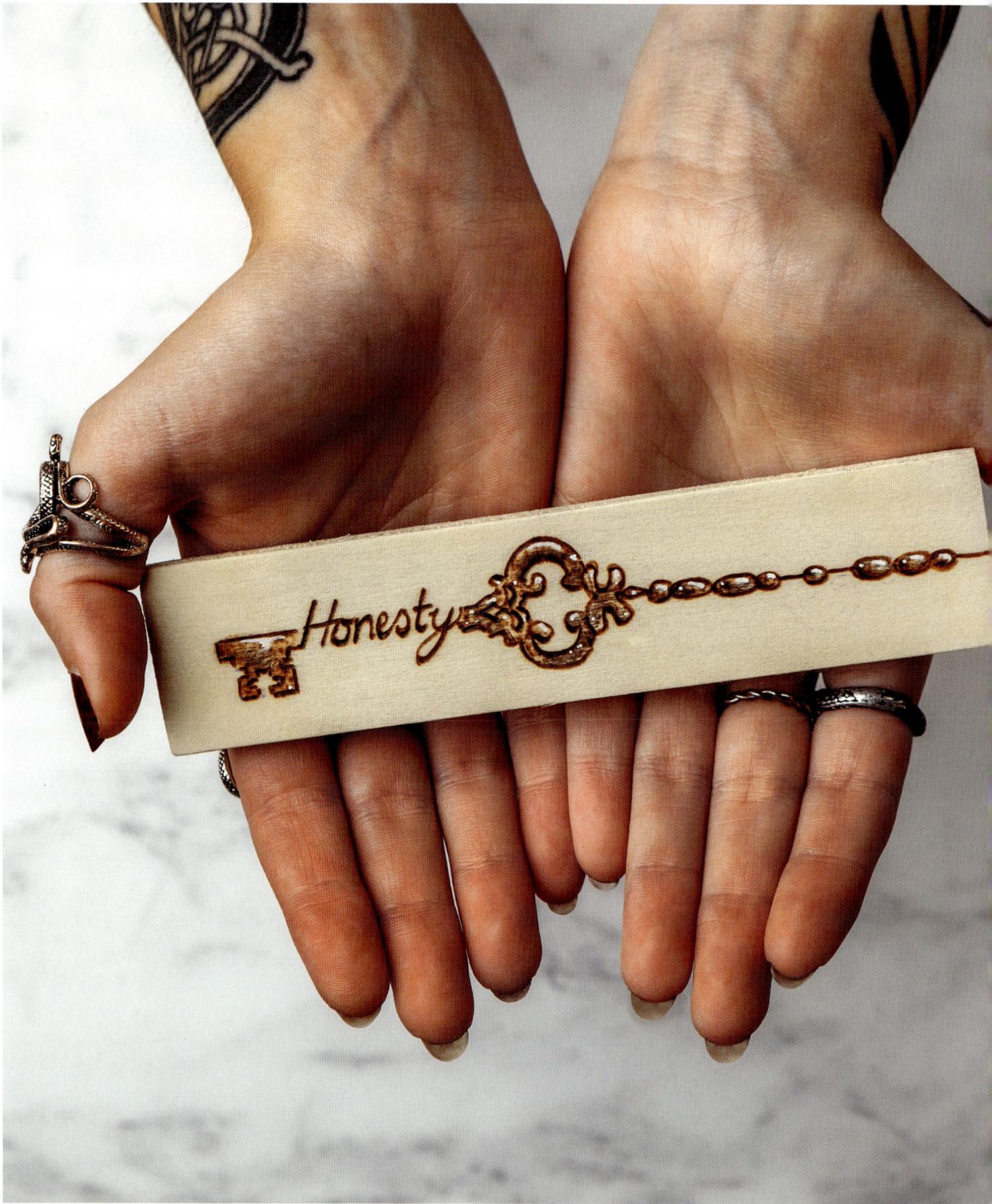

FEEL THE BURN

The art of modern pyrography has been around since Victorian times, stemming from the techniques blacksmiths and artisanal leather workers used to transfer bespoke designs onto organic materials using a hot iron heated on the forge. This type of branding effect was commonly referred to as 'poker work'. Today, the advance of technology means that the toolkit required for scorching wood and leather has become more accessible (no forge required!), but the principles remain exactly the same: you draw and create with fire – how exciting is that?

PYROGRAPHY BASICS

Welcome to the world of 'toasties', as pyrographers are known. This chapter is a grab-you-by-the-hand, whistle-stop tour of some of the kit and considerations you need when practising pyrography. To the beginner, pyrography can appear bewildering at first, but with a little practice all the elements in this chapter soon become second nature, I promise! Over the next few pages we will look at choosing a pyrography machine, the different surfaces you can burn on, how to set up your workspace, and how to transfer your designs.

There are many different machines out there and so much advice on ways of doing things. What I offer here is simply what works for me. I encourage you to try as much as you can and find what works for you. Be a magpie, take it slow, be patient, embrace new ideas, build your foundation skills, then spread your wings and fly.

One of the beauties of toasty life is that pyrography can be as simple or as complicated as you want it to be. Indeed, for next to nothing you can buy a solid point machine, collect a bit of driftwood and start creating! If you're a pyro veteran, you may wish to skip to the next chapter, but if you're anything like me you'll want to hang around and lose yourself amongst the pages – you never know what hints, tricks and little glimmers of magic you just might find.

I came to pyrography from the angle of a tattooist, and wood became my substitute for skin. Your story will be different. As a technique, the potential of pyrography is vast. How you approach it is up to you! There are no wrong or right ways. You may currently prefer pure unadulterated pieces of traditional pyrography, but I'd like to show you that, with a little creativity and know-how, the craft can be integrated and combined with other media to produce something fresh, exciting and new. No matter what you choose, give things a go!

Once you start, prepare to be beguiled. This wonderful craft holds an integral warmth and beauty found in no other art form.

Key to the Door 15 × 4cm (6 × 1½in)
Pyrography and white pencil on birch panel.

These little affirmations are a great way to use up the off-cuts of wood from larger pieces of work. They are also a fab way to gain confidence with your mark-marking, try out your tips, or practise on a new type of wood. They are quick, fun, stress-free and make great gifts. This piece was completed in just ten minutes with the Antex Firewriter and a white pencil (Derwent Drawing 7200) for highlights.

PYROGRAPHY MACHINES

Selecting the right machine for your style and budget is one of the biggest decisions you'll make. Let's look at the different types available to help make things clearer for you.

Most standard pyrography machines consist of a transformer (power unit) with an AC converter housed in a sturdy reinforced plastic or steel case. The pyrography pens for these units are usually a separate component that plugs into the unit via a universal jack or similar.

Selecting a pyrography machine on a 'try before you buy' premise can be bit tricky as not all are widely available. I have purchased all my machines on the strength of peer reviews, recommendations and information from online forums and I've not been disappointed. A little research goes a long way. If you're unsure what to buy, always stick to well-known brands, makes and models. Prices can vary considerably from place to place, so shop around.

Most pyrography machines tend to fall into two general broad categories: solid point machines and hot wire tip machines. Both types are perfectly fine to use, and each has its advantages and disadvantages. Let's look at each type more closely now.

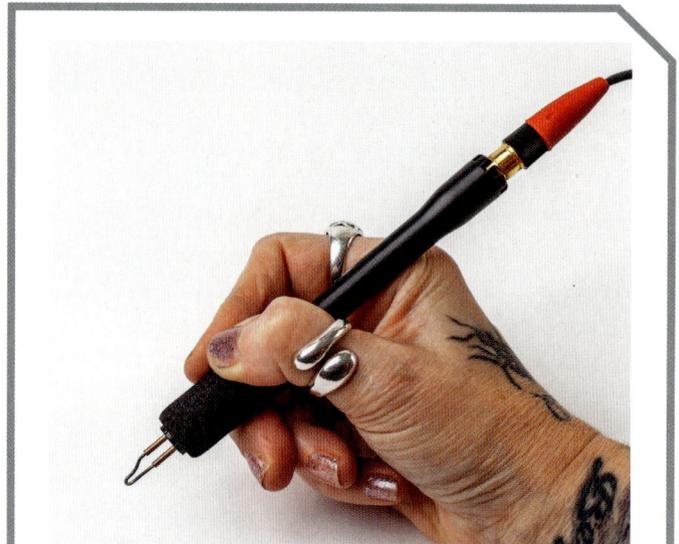

Holding the pyrography pen

Whichever machine you choose, you hold the pyrography pen in much the same way as you hold a normal pen or pencil, with a light but firm grip. Be sure to keep your fingers away from the hot tip. Most pens have some form of insulation on the shaft to aid extended periods of burning.

Which machine?

If I had a penny for every time I've been asked the question, 'what machine should I buy?' I would have a huge copper mountain! Like so many things within the creative arena, the machine you choose will come down to personal choice, availability, preference and budget.

The UK, where I am based, has limited stockists and a smaller range of machines available compared with the USA and other countries. However, as pyrography's popularity grows, more stockists are coming online and a wider variety of machines are becoming accessible and available.

Like most tools, pyrography machines are offered with a number of extra features, and manufacturers frequently advertize different options to make theirs stand out, but in all honesty, almost any pyrography machine is capable of creating a beautiful piece of work. It's what you do with it that counts! I know a number of amazing artists who actually prefer to use an inexpensive single-temperature fixed-tip machine over a high-end 'professional' variable temperature burner with all the bells and whistles – and their work is off-the-scale exquisite. One artist I know has been using the same fixed-temperature burner for the past three decades, and is still not looking to upgrade!

If you're considering purchasing a new machine to start your pyrography adventures, I suggest that you avoid any of the super-cheap imports which are promoted on many online sites. Although they are easily accessible and the price is tempting, the majority of these units are cheap for a reason! They are often made with inferior substandard components, overheat easily and can be very dangerous to use.

Solid point machines

A typical solid point machine looks very similar to a traditional soldering iron. They are the more easily sourced (and most recognizable) type of pyrography machines, often found on sale in craft shops and hardware stores.

Fixed-temperature solid point tip machines are the least expensive of all the burners available and a great place to start if you have never experienced woodburning before and would like to experiment to see if you enjoy it. Beware – it can quickly become an obsession!

Solid point machines often come as a set with a number of interchangeable solid tips. These interchangeable tips tend to be made from brass and will take time to heat up and cool down. The tips must be left to cool before switching them over, which can at times become frustrating.

With care, a full range of tonal values can be achieved using a solid point fixed-temperature machine, but I often find the tip size, shape and single temperature of these machines less responsive and more difficult (though not impossible) to use for my style of artwork.

Some solid point machines offer a degree of temperature control. However, because the tips are generally quite dense, they still have a limited and delayed responsiveness to any subtle changes in temperature. They also cool down and heat up much more slowly than their hot wire tip counterparts (see page 16). This can, however, be used to the artist's advantage, as it facilitates the ability to burn for longer passes without having to wait for the tip's heat to recover.

Solid point machine

Solid point machines can be a great starting point for the budding pyrographer. They are reliable and robust, and some kits offer a range of interchangeable tips in a variety of shapes. Solid point machines hold their heat well and are great for harder woods. This is my little Hot Tool. Don't be deceived by its size – the clue is in its name!

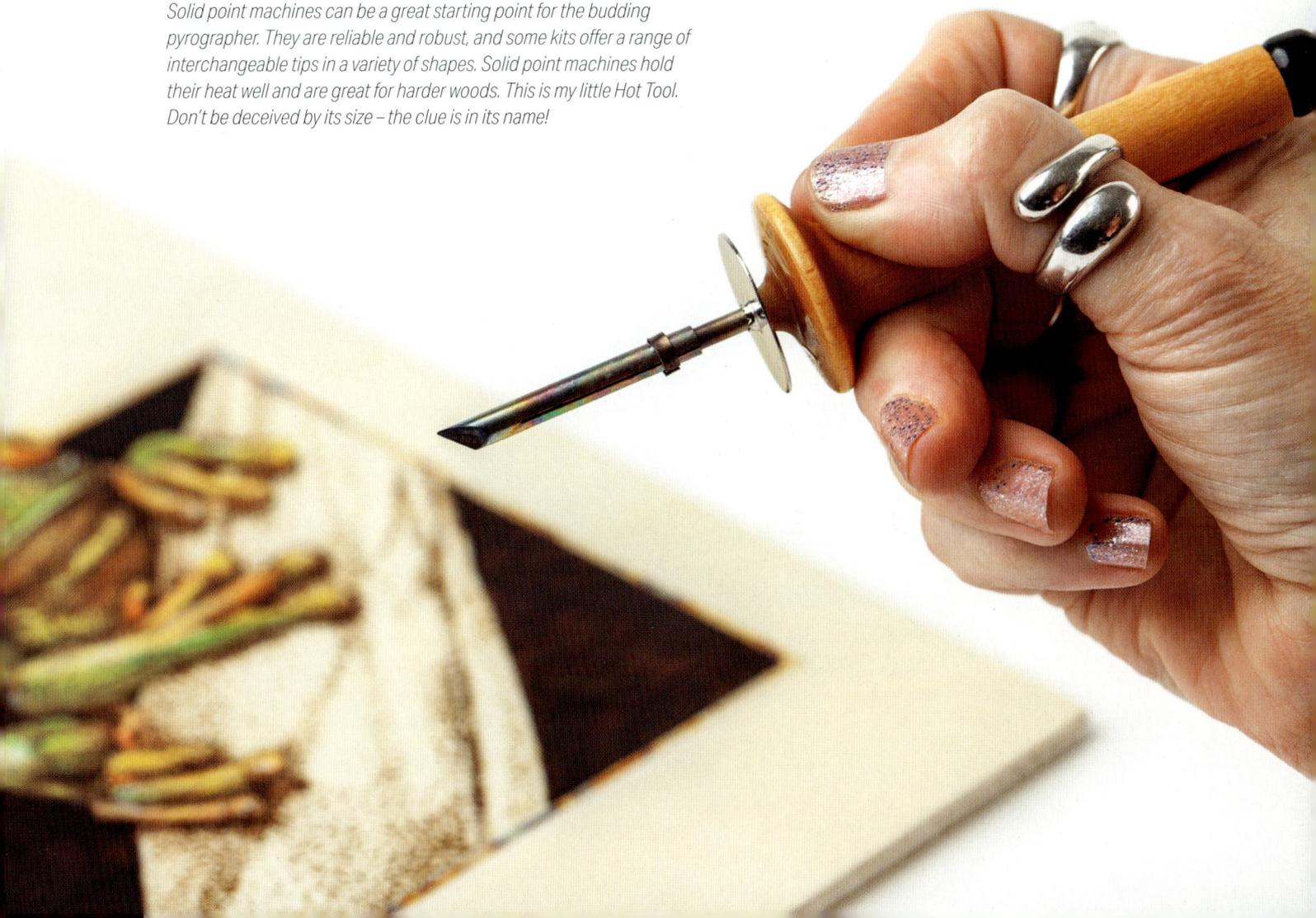

Hot wire tip machines

Hot wire tip machines tend to be more expensive than their solid point cousins. The big advantage over most solid point machines is that hot wire tip machines allow you to vary the temperature. Most entry-level models offer dial control for the temperature and some form of pen which attaches to the unit.

Some manufacturers offer the use of both fixed-tip pens and interchangeable tip post pens (sometimes called ITPs) with their machines. This can be useful and is something to consider if you are experimenting or on a budget.

Fixed-tip pens These have a specific tip permanently welded to the end of the pen. You swap from pen to pen depending on your project or the shape of the tip you want to work with. Simply connect the pen to the main unit, switch on and off you go.

Interchangeable tip post pens These make experimenting with different tips more affordable, as you don't have to purchase multiple pens: you simply swap out the different tips on the same pen unit. Different manufacturers have different methods of attaching or mounting the tips on the pen. The Antex Firewriter (see overleaf), for example, uses a screw clamp system to secure the tips, which feels solid.

You can purchase single tips that are compatible with your model. Indeed, some tips can be used on a number of different models – though always check this with your unit's manufacturer before use. Alternatively, you can try making your own tips with a length of nichrome (nickel–chrome) wire which is fun, cheap, and a great way to create a unique custom tip. If you choose to do so, always check that the gauge of wire you are using is suitable for your machine. If you fancy having a go yourself, there are details to get you started on page 35, and lots of great online videos which cover tip-making.

We look at tips in more detail later on.

ADJUSTING THE TEMPERATURE

Most variable temperature burners use a dial to alter the temperature. However, the pyrography scene has seen some interesting recent developments. Razertip have brought out a unit, called the P80, with some exciting new concepts including a digital touchscreen and a universal switching power supply to ensure it works anywhere in the world. Further, the P80's tip heat stays constant regardless of input voltage changes, while the touchscreen interface provides 700 different heat settings with unprecedented accuracy and repeatability: such an innovative step forward!

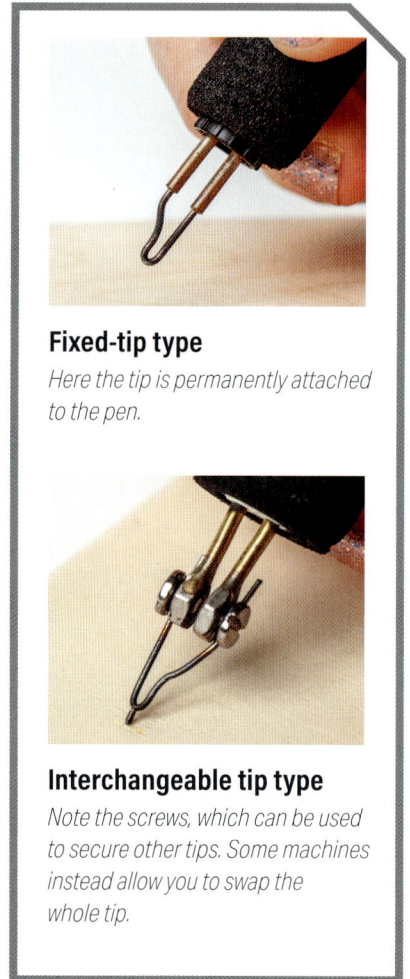

Fixed-tip type
Here the tip is permanently attached to the pen.

Interchangeable tip type
Note the screws, which can be used to secure other tips. Some machines instead allow you to swap the whole tip.

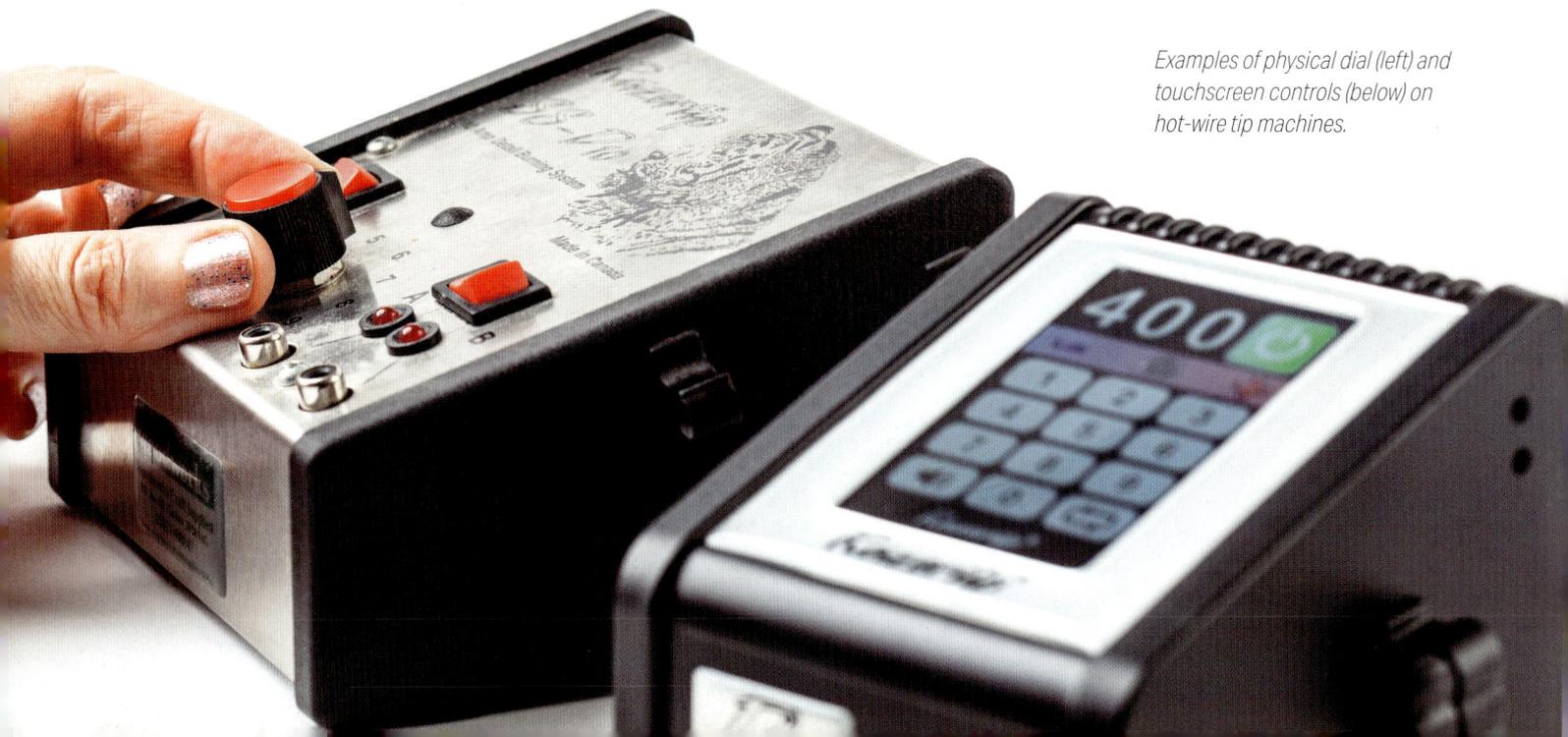

Examples of physical dial (left) and touchscreen controls (below) on hot-wire tip machines.

Hot wire tip machine

Variable temperature hot wire tip machines are the machine of choice for many pyrography artists, particularly those who enjoy fine detail and subtle shading. They offer increased flexibility and responsiveness through temperature control, thereby allowing the artist to move from the gentlest of smudgy faint tan lines as the tip kisses the wood, right through to deep, dark, bold, rich chocolatey marks – all at the flick of a button and in a short space of time.

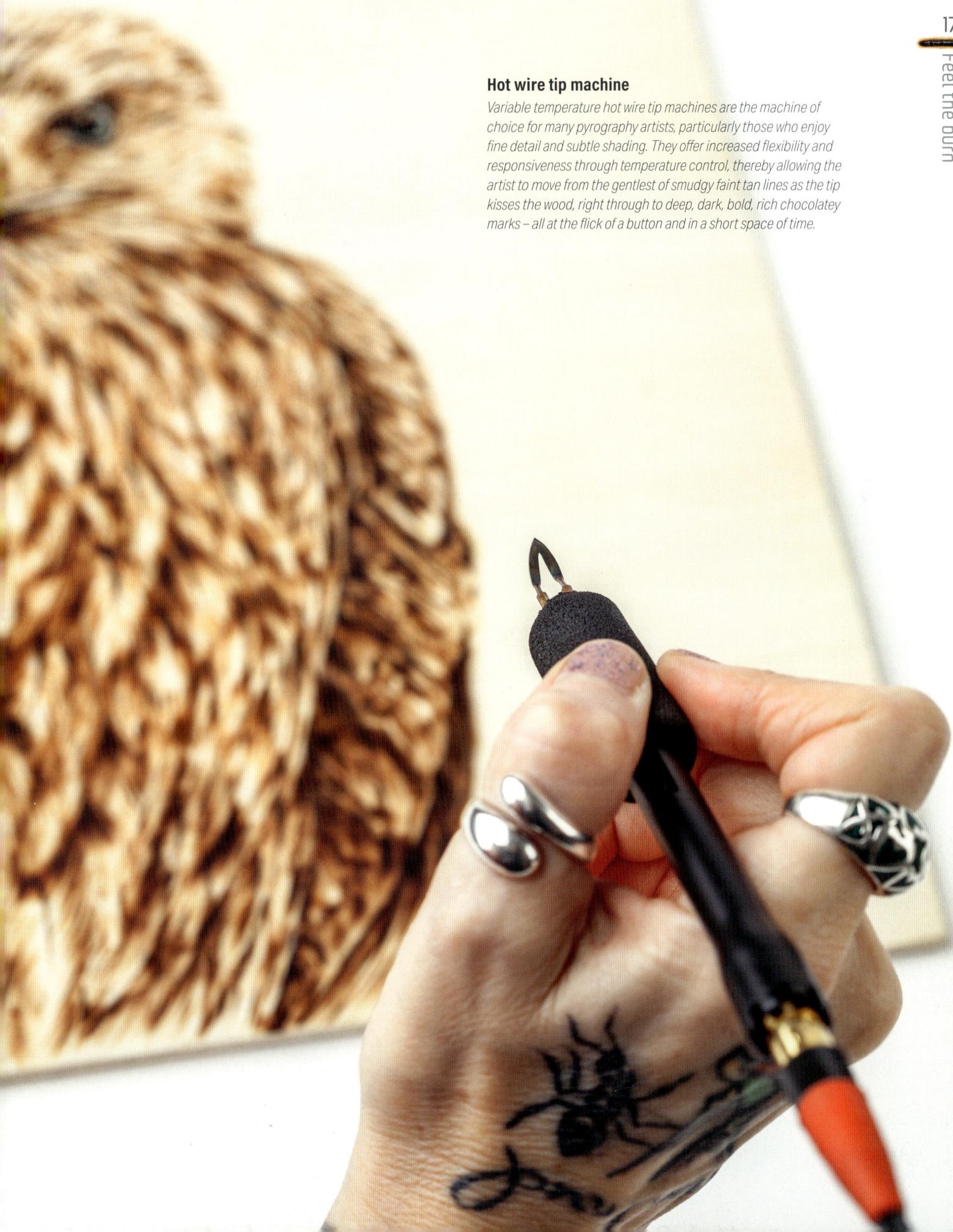

MY MACHINES

I have tried a number of machines over the years and have settled on three quite different burners, reaching for each at different times depending on what I'm doing and how I feel. Sometimes I'll use a particular machine solo, and at other times they are all invited to the party. I enjoy each for very different reasons. They are an integral part of my creative universe and I fondly refer to them by the nicknames I've given them: the Grunt, the Workhorse, and the Detailer. However, you certainly don't need lots of machines to produce a single piece of work. These machines simply suit me and the way that I work – and before you ask; yes, I'm still coveting others!

In general, I tend to favour using hot wire tip machines for the majority of my work. I enjoy the responsiveness to temperature change and the fact that the tips cool down and heat up quickly.

I use a lot of fixed-tip heavy duty pens and I find them more robust than interchangeable tip post (ITP) pens – I'm not particularly delicate and err on the clumsy side. I also find them more reliable and direct as there are fewer connectors involved. Fixed-tip pens allow me to get immersed in my work as I don't have to wait around for tips to cool down and fiddle about with changing them.

Some artists really enjoy the versatility of the interchangable tips, which allows for a variety of custom tips for a small investment. However, I always find that the right tip is never on the end of the pen when you need it – and when your creative juices are flowing, it can be time-consuming and distracting to change tips.

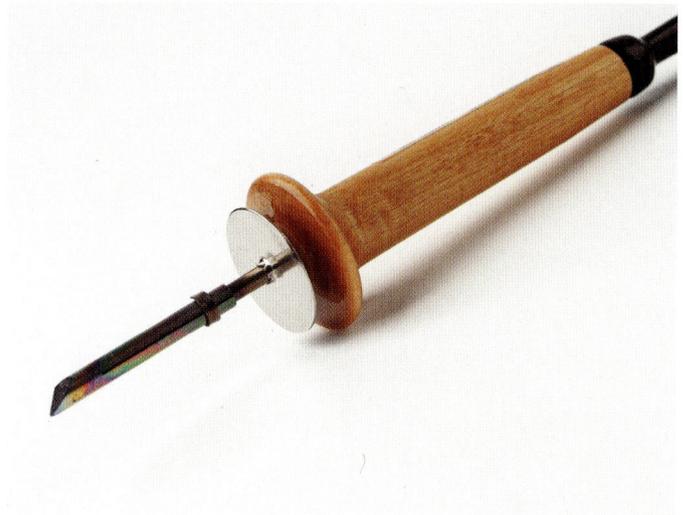

The Grunt – NM Newman Hot Tool

This is a solid point machine which features a lightweight, thin, varnished wooden handle that is lovely to hold. I call it the 'Grunt' (deliberately ironic, as it's the smallest and lightest of my three machines) as it packs a mean punch. I use it most often when I want a lovely juicy bold black line, particularly on harder woods. I also like to use it for infilling dark backgrounds and for powerlining (see page 116) and bold lettering.

The pen allows for long periods of burn-time and still remains relatively cool because the heating element is directly under the tip. The Hot Tool reaches 420°C (800°F) in under two minutes, so there's little time wasted while the tip heats up. There are a range of additional tips available for it, but I almost always use the tip supplied as standard in the basic kit. Manufactured in the USA, the 240V version works fine in the UK with a suitable two-pin adaptor.

Cables and safety

Pyrography machines are electrical units and therefore require a little care when burning. All pyrography pens are attached to the base unit by some form of electric cable. For safe practice, ensure that the cables are kept well clear of the work area and trailing cables are kept under control so they don't inadvertently pull the pen off the table. Most base units offer some form of clip or housing for the pen. Get into the habit of storing the pen on the clip when not in use.

When switched on the pen tips will be hot! Do not let the tip come into contact with any part of the cables and keep the hot tip clear of your clothing and skin.

Some bigger, chunkier tips require a more robust, heavy-duty cable, so ensure that your tips and cables are matched. If your cables are getting unexpectedly and unusually hot, switch the machine off and find out why.

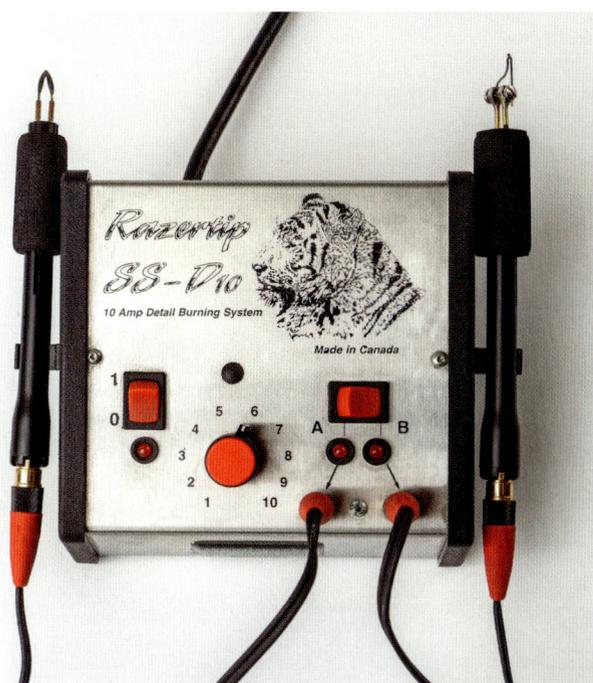

The Workhorse – Razertip SS-D10

A hot wire tip machine, the SS-D10 is my trusty reliable Workhorse. It has a great range of tips and the pens don't get excessively hot when you're burning for long periods of time. Its dual handpiece capability – you can have two pens plugged in simultaneously – allows you to change between them with the flick of a switch.

Razertip pyrography tools have been setting the standard for hot wire tip machines since the mid-1980s. They feature near-instant heat response which you adjust with a simple dial. You can also choose among three different handpiece types. Standard pens are the smallest and most compact option, great for general work. Heavy-duty pens, my favourites, are more robust and tough, with heavier connector posts and chunkier tips. They tend to require a higher heat setting to compensate for the beefier build, so are best used with a heavy-duty cable (as shown by the red connectors above). Razertip helpfully colour-code their cables: black plugs on the RCA connectors indicate a standard cable, while red plugs indicate a 16-gauge heavy-duty cable for maximum current flow.

Razertip's BPH interchangeable tip pen allows you to exchange tips or even make and use your own. With hundreds of stock tip shapes for you to buy, many of which are unique to Razertip, the unit can meet most of your pyrographic needs and grow with you regardless of what type of artist you are. I really like the range of shading tips too. Razertip also produce adaptor cords which enable you to fit Razertip pens on other pyrography wood burner models, an option which is worth considering if you'd like to try their products but don't have their unit. However, do check the voltage and ampage compatibility on your base unit first, and if unsure, contact the manufacturer for advice.

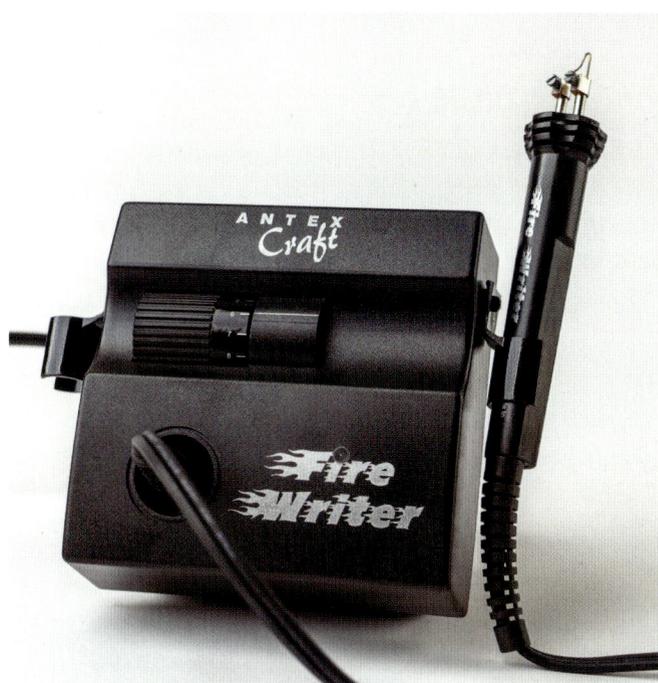

The Detailer – Antex Firewriter

I refer to this as the Detailer, and it is a relatively new addition to my team. It has quickly become my go-to for fine delicate work and detail and is the only UK-manufactured machine that I currently use. A relatively new hot wire tip machine to the market, it is a sturdy little machine with a great weight. It offers variable temperature control which is adjustable to 920°C (1688°F) allowing a great range of shading and colour definition when burning. The starter kit includes the writing tips and a slim, lightweight interchangeable tip post pen with screw-locking. You also get five nickel chrome wires if you fancy having a go at making your own tips (see page 35 for more on this).

It has a great entry level price point, too. I use Firewriters for all my demo and workshop classes. They hold up really well to the punishment.

Choices, choices

If you are considering importing a machine from abroad, check that the voltage of the appliance is compatible with your country of residence – many pyrography machines are built for the US market and operate on a 120V two-pin system, and so require a step-down voltage transformer and pin adaptor to allow the unit to operate safely elsewhere. Some manufacturers' machines – like my 'Grunt' here – offer different voltage options on purchase, which is handy.

WHAT SURFACE?

Most natural untreated surfaces can be used as a suitable canvas for pyrography. Some are easier to burn than others; some require greater preparation and some require a more considered approach. Common surfaces to burn include wood and watercolour paper, but you can also use gourds, vegetable tanned leather, unbleached cotton and linen cloth. Some artists also experiment with bone, horn and other textile materials.

My usual surfaces for creating art with pyrography tend to be wood panels and paper, although I do enjoy dabbling on other surfaces. I particularly enjoy using reclaimed timber, including pieces of driftwood foraged from the beach and gifted from the sea. Driftwood should be soaked and cleaned in fresh water and dried before use.

What not to burn

There are some surfaces which you should avoid burning! Refrain from burning any type of wood which has been varnished, sealed, treated or painted. Burning such materials can release dangerous toxic fumes.

The same applies to any wood that has been coated with preservatives (such as pressure-treated wood used for fencing); any kind of plastics or acrylics; and all types of medium density fibreboards (MDF), no matter how tempting it is! If you are unsure whether a material contains carcinogenic or other potentially dangerous additives, check the manufacturer's website wherever possible. There is more on this subject in the Safety guidance on pages 172–173.

Paper

If you're going to burn on paper, use a good quality paper. It is infinitely more forgiving than thin, flimsy, cheap paper. Look for heavyweight 640gsm (300lb), artists' quality, acid-free paper, which will stand up well to the rigours of burning and layering.

With a little practice, working on textured paper is possible and can add interest and unusual effects into your work. To begin with, however, a good quality Hot Pressed (HP) rag or wood pulp paper is a great place to start, particularly if you want to use subtle shading techniques or watercolours. These are my go-to papers for mixed media pyrography pieces. I like to buy large sheets and cut them down to the size I want to use.

Bockingford HP watercolour paper
Great all-round, forgiving watercolour paper.

Canson Artboard
This is art paper mounted on archival conservation board. It provides a strong, robust working surface that is acid-free and doesn't tear or curl when adding watercolour or ink washes.

Two Rivers paper
Beautiful handmade papers from a small company in England, these are available in full imperial sheets – 76 x 56cm (30 x 22in) – or handy little quarto size boards – 28 x 22cm (11 x 8¾in). Being so sturdy, if you don't like what you've created on one side, you can turn it over and use the other.

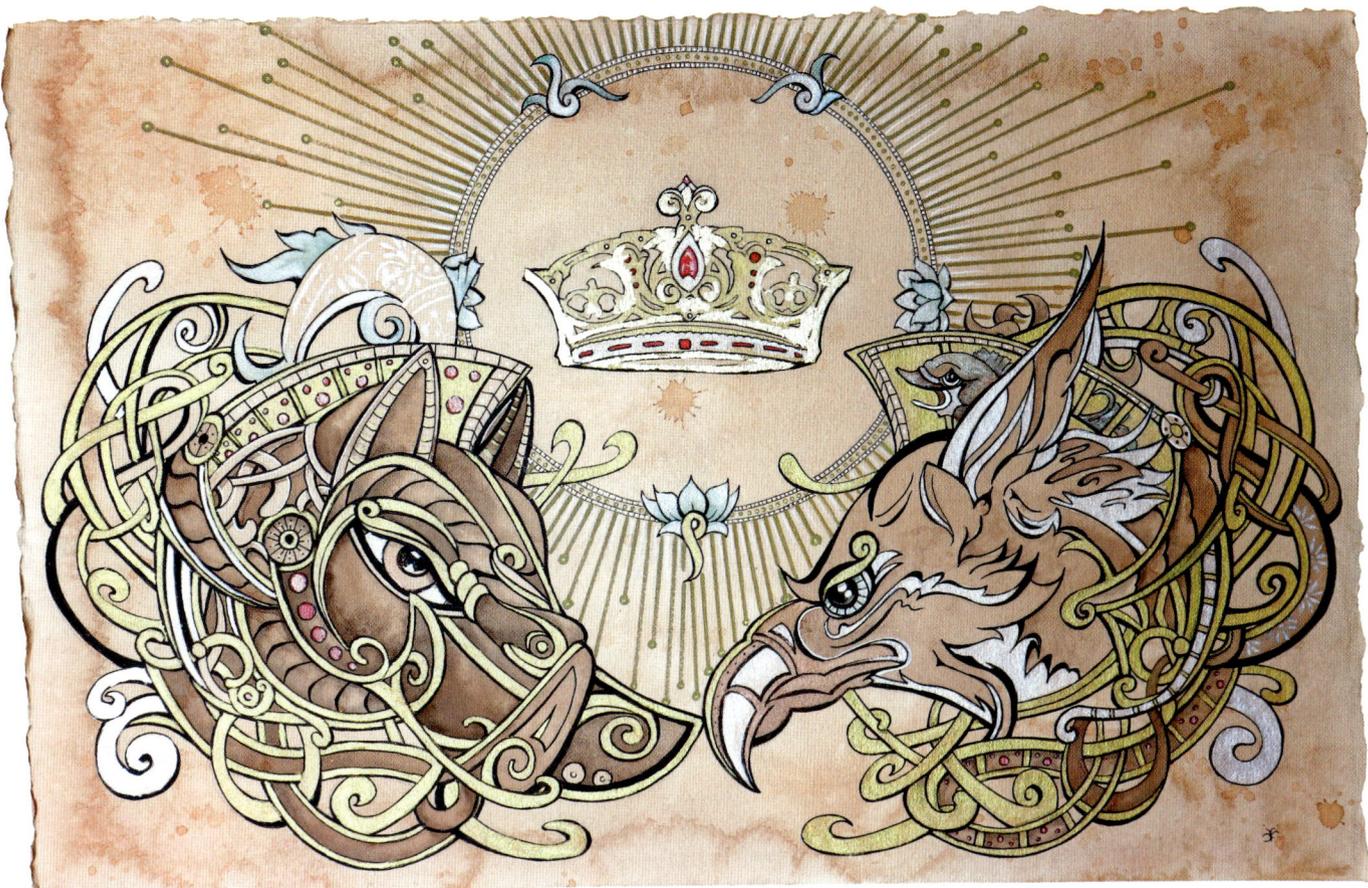

The Duel of Powderham 76 × 56cm (30 × 22in)

Pyrography, gilding, pen, ink and tea on Two Rivers watercolour paper. From the collection of Charles Courtenay, 19th Earl of Devon.

A number of artists were invited to take inspiration from objects within Powderham Castle in Devon, UK. My contribution was a take on the castle's coat of arms. Burned and shaded using the Razortip D10, I aged the paper with tea and walnut ink before applying layers of metal leaf and ink to the knotwork and lines around the crown. To strengthen the contrasts I used a black Posca pen to accent key lines, and added white floral detail to the serpent, echoing the shapes within the gryphon.

Burning on paper

Burning on paper can be used as an interesting, exciting and cost-effective alternative to using wood. You may be surprised to know that paper is actually quite a resilient surface when it comes to burning. It is also easy to acquire, plentiful and affordable – all qualities that make it great to practise upon. It also has the advantage of being suitable for framing, should you so choose.

I began experimenting on paper a couple of years ago when a very dear friend gifted me a beautiful sheet of handmade rag paper produced by the Two Rivers paper company in Somerset, England. It was a joy to behold. My first lines were very tentative as I was nervous that the paper might go up in flames. I equipped a general writing tip, turned the temperature down really low, flicked the power on and held my breath. You can imagine my surprise to discover that the temperature needed to burn the paper was considerably higher than that for the wood which I had just been burning!

Paper requires a more gentle and patient approach than wood, particularly for shading, but with a little practice the results can be quite spectacular. Most styles of pyrography transfer well to paper but I particularly like pen and wash style work; mixed media pieces; and classic soft shading with those beautiful sepia tones.

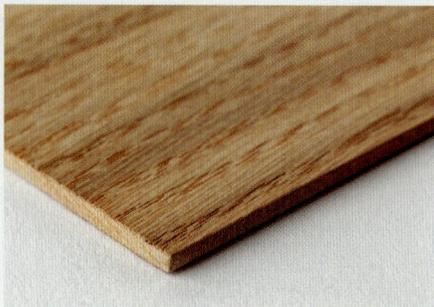

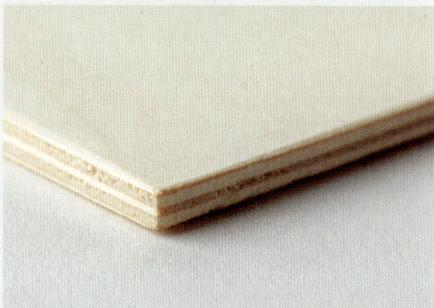

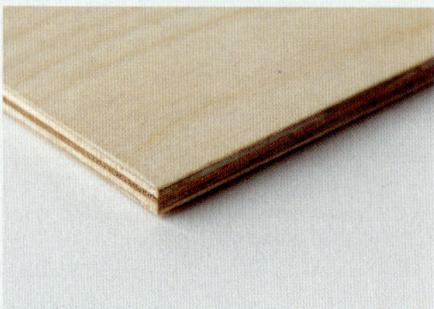

Wood panels

Panels of wood preseve none of the natural edge of the wood – they're the most commonly available form of timber. From top to bottom, these example panels are oak, poplar plywood, and birch plywood.

Wood

Wood is a natural and renewable product and is the go-to canvas for most toasties. There's such a wide array of wood types and each holds its own secrets. Most of them are wonderful woods such as maple, oak, birch and ash, all of which make a great canvas! Choosing a type of wood to burn is a personal choice. The availability of the wood and its subsequent price may govern your decision – pieces of wood fluctuate in price from shop to shop and from country to country, so be savvy and shop around. Depending on my project, I like to burn on either live or waney edge (see opposite) timbers, or, for larger pieces, pre-cut plywood panels.

Timber panels Besides the species listed above, basswood and poplar wood are firm favourites with many pyrography artists – myself included. Readily available almost everywhere, both basswood and poplar have a lovely pale creamy aspect and finely-packed grain, which offers the pyrographer a good range of tonal values. Basswood can be more expensive but it's one of the most forgiving and versatile woods to burn, and can often be bought in rounds, slices and panels. The rounds and slices often retain the bark, which offers a natural frame to your work. I like to think that when you use timber with the natural edges still intact, the native spirit of the wood lives on within your work.

Plywood panels Made from poplar and birch, these are much cheaper than timber and can be a great place to start for the beginner as you can easily cut them into bitesize pieces. If you're burning any kind of plywood always be careful not to burn to below the laminated wood layer, as burning the bonding agents and glue can release toxic fumes. I favour 5mm (¼in) or thicker panels: less than that and the panel tends to warp with the heat.

Plywood is often graded to reflect its appearance and quality, but the systems vary depending on the country in which the plywood is produced, which can lead to some confusion. Typically, if you are buying plywood for your pyrography work, look for AB grade plywood for the best aesthetic appearance (particularly with poplar). This is one of the better grades of plywood and denotes that the surface of the panel should be consistent in appearance with no large variations in colour: great for fine detail. Small pin knots may be present in AB plywood, but they should measure no more than a few millimetres in diameter.

B grade plywood shows more of the natural look of the wood and colour changes within the grain pattern. It may contain larger smooth sound knots but should be free from open knots and plugs. B grade birch and poplar are interesting to work on and offer some contrasting effects that can add texture and interest to your work.

I recommend that you avoid BB and C grade plywood, as it can contain open knots, plugs, discoloration and even some splits – unless, of course, that's what you are after.

HOT TIP

The recent ethos towards upcycling and reducing our carbon footprint has prompted a mindful shift and an increase in the popularity of sustainably sourced timber, and recycled or repurposed woods. A fellow pyro artist friend of mine cleverly uses old kitchen unit doors made of solid wood for the majority of his work. He finds them at the local skip or on freecycle sites, collects them and sands off the varnish (or paint) back to the natural wood.

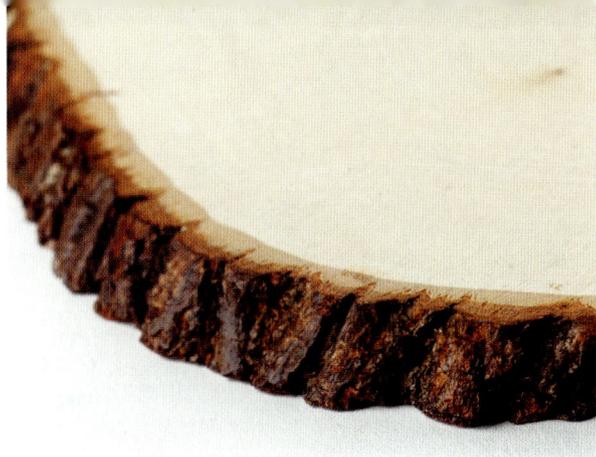

Live edge
*Live wood means that the edge of the trunk has been preserved –
there are no machine-cut edges (apart from the faces, of course!).
This example is basswood.*

Waney edge
*In contrast to live wood, waney edge has at least one machined
edge. This example is willow.*

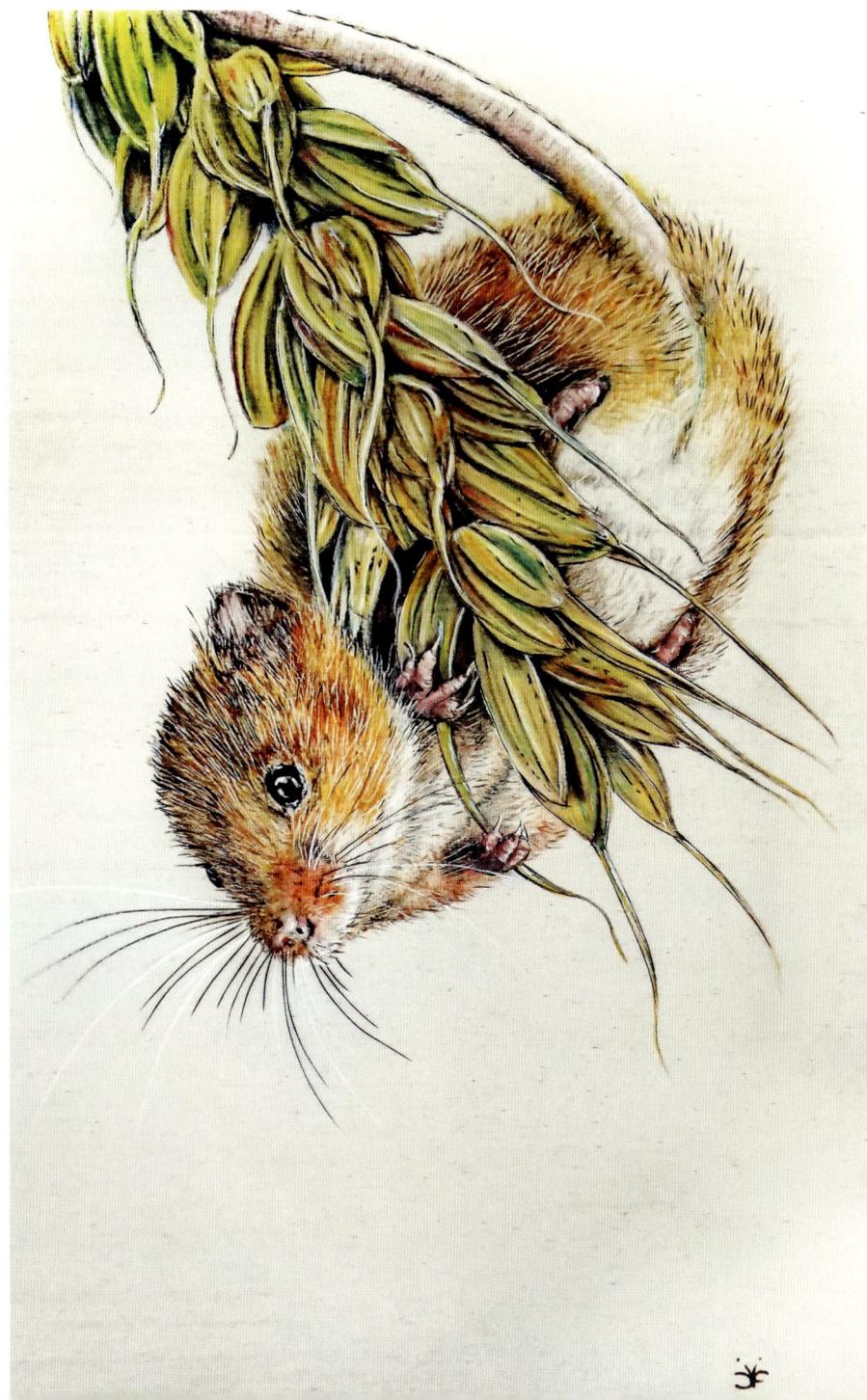

Harvest Mouse 30 × 40cm (11¾ × 15¾in)
Pyrography and mixed media on a poplar panel.

'Yellow her hair as the golden wheat
Scurrying the harvest for bounty to eat
When winds come sweet on sun-kissed crops
She gathers her wealth from nature's gift shop.'

*This cheeky little critter, burned with a skew tip
using my Razertip SS-D10, was an experimental
piece that incorporates coloured pencils
(Polychromos and Lightfast) and Zest-it (a pencil
blend solvent). I wanted to try to achieve a
painterly effect using a dry medium without the
need for a 'ground', and at the same time allow
the pyrography underpainting to show through.
Poplar wood works well with the transparency,
texture and luminosity of coloured pencils due to
the paper-like quality of the panel's surface, its
fine grain and pale colour.*

OTHER EQUIPMENT

Your machine and 'canvas' of choice will probably be your biggest decision and outlay when you are beginning to explore pyrography. However, once you start you will:

- Become a wood fanatic
- Start hoarding the contents of the kitchen drawer
- Wade through the cobwebs at the back of your shed to find all manner of useful paraphernalia that you never realized you had!

Shown here are just a fraction of the optional extras that will make your life as a toasty that little bit more fun. Few, if any, are essential, and I encourage you to explore what you already have before buying anything more. If you already paint, for example, you will have lots of interesting items that you can utilize and incorporate within your pyrography pieces.

Rest assured that if you don't do much painting, the colouring aspect is always just an optional extra. We'll look at the materials we need for that later on in the book, when we look at incorporating mixed media with pyrography.

Sketchbooks, pencil and eraser.

Paintbrushes, palette knives and other mark-making tools.

The magpie effect

Once you have your machine, most of the other bits of kit can be repurposed from around your home with a little bit of creative thinking. That's the beauty of pyrography. An old tin lid is great for safely storing the tips you are using for a project, for example.

You can dig through your garage or shed for useful bits and bobs, too. Sandpaper, old rags and bits of tape are useful for prepping work – I favour a painter's masking tape called FrogTape® because it's relatively low-tack and seals well to wood, which creates a great microbarrier to prevent liquid tracking along the grain when using mixed media techniques. Pliers, small screwdrivers, compasses, sharp blades and metal rulers will also help with creating designs, burning and scratching out highlights.

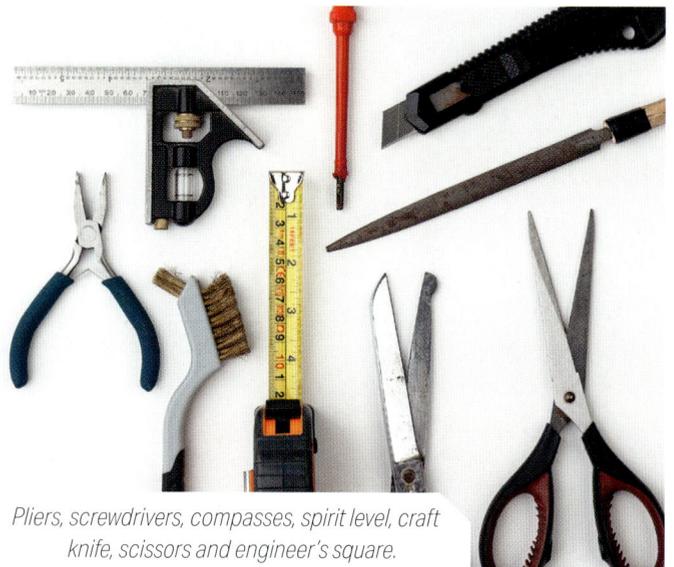

Pliers, screwdrivers, compasses, spirit level, craft knife, scissors and engineer's square.

Found materials.

Gesso, grounds and painting mediums.

Water pot, palette and kitchen paper.

Sandpaper, strop, rags and tape.

The indispensable hot cup of tea!

SETTING UP A WORKSPACE

Pyrography is a wonderful, tactile and interactive way of creating art but it's not without its risks. In addition to heat and fire safety, there are a few common sense guidelines that should be followed in order to keep yourself and those around you safe.

You should always work in a well-ventilated room. A flat, stable and ideally heatproof surface, such as a kitchen table, is all you need for pyrography. Make sure you have enough space for both your work and your machine, and that you can work comfortably without getting tangled up in the cables.

When I'm building up dark areas in my work, I always incline the piece slightly by resting it on an old drawing easel that I've adapted. Having your work at an angle prevents you from leaning over the piece into the path of the smoke. I also use a bench-mounted extractor fan to draw the smoke away.

Smoke and draughts

Most pyrography techniques create little to no smoke, but when you are burning sumptuous dark backgrounds, or you simply have the pen's temperature dialled up high, smoke can become an issue. There are a number of simple ways to avoid excessive smoke inhalation.

Watch out for draughts! Cold air blowing across the tip when you are working can result in an inconsistent and 'bitty-bumpy' burn, particularly with wire tips, which are particularly prone to cooling quickly. The same problem can occur from fans which blow across your work area.

Draughts can create a vicious circle. The burn appears inconsistent, so you turn up the temperature on your unit; the increased temperature creates more smoke; it's smoky so you ventilate more, which increases the draught; the burn becomes more inconsistent... and so it continues.

Some artists prefer to use a fan pointed away from the work piece to 'pull' the air away rather than blow it; indeed over the years I've seen some clever creative adaptations of fans and flexible extractor hoses which work a treat.

There are also masks, filtration and personal protective equipment available to ventilate and clean the air. I personally find masks cumbersome as they hinder my involvement, experience and vision, but sometimes safety trumps this discomfort. Consider different approaches and see what works for you. See the Safety guidance on pages 172–173 for more on this.

Masks
Using a mask is always advisable, especially if you have a particularly smoky burn or are sensitive to airborne irritants. The type of mask you use is down to personal choice and the level of filtration and protection you require. I use lightweight fitted dust masks with a filtration pad. They are comfortable across the nose and don't get in the way of my working.

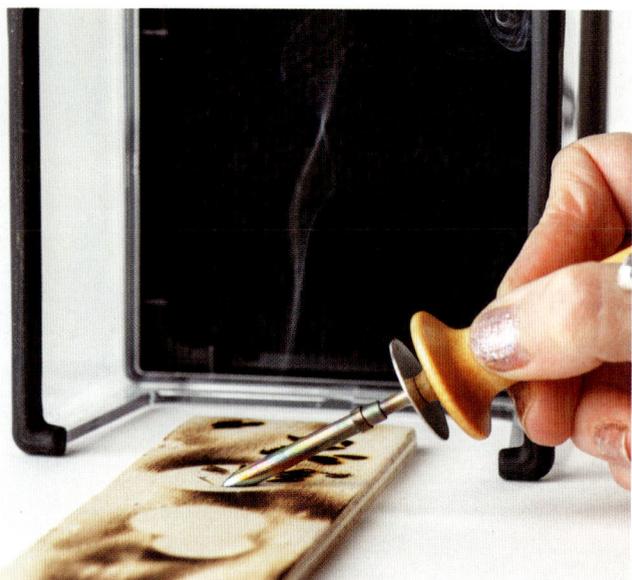

Extractor fan
An extractor fan is a great piece of kit to keep your pyrography workspace fresh and clear of smoke. I favour Razertip's Razair Mini, which offers multi-stage carbon filtration, a versatile transportable design and quiet operation. The soft hood grip also allows it to be placed on top of your project close to your burn area, which helps to ensure maximum smoke capture and filtration. It is also small enough to pop into your bag to take to workshops and events.

Preparing your wooden surface

Good preparation is the key to a good burn and can often be overlooked when you first start out. Whatever wood you decide to use – even timber art panels and woods bought from a specialist – will likely require sanding to prepare and smooth the surface before burning. Inadequate preparation will lead to an inconsistent burn, drag resistance on the tip, and unsightly burn flares.

I use a Ryobi ROS300 300W random orbital sander with a dust collector to prepare wooden surfaces for most of my work as it's easy to use and it doesn't scuff or damage soft wood surfaces. I always follow that up with a little hand sanding using 220 grit sandpaper.

If you prefer, you can of course skip the orbital sander and sand it all down by hand, working through the grades of sandpaper from rough to smooth. When hand-sanding I always wrap the sandpaper around a small block of wood which helps to apply an even pressure across the flat surface area. Always use a mask to protect yourself from airborne particles when sanding any wood or other materials.

Once you've finished sanding, wipe down the surface of the wood with an old rag or large, clean, soft paintbrush. Avoid transferring unwanted natural oils from your hands to the prepared wood by limiting touching the surface. Rest your hand on glassine paper (or similar) when working.

HOT TIP

Inverted belt sanders have a tendency to indent and mark large, soft, flat surfaces, but they are great for smaller pieces such as coasters, rounds and fobs.

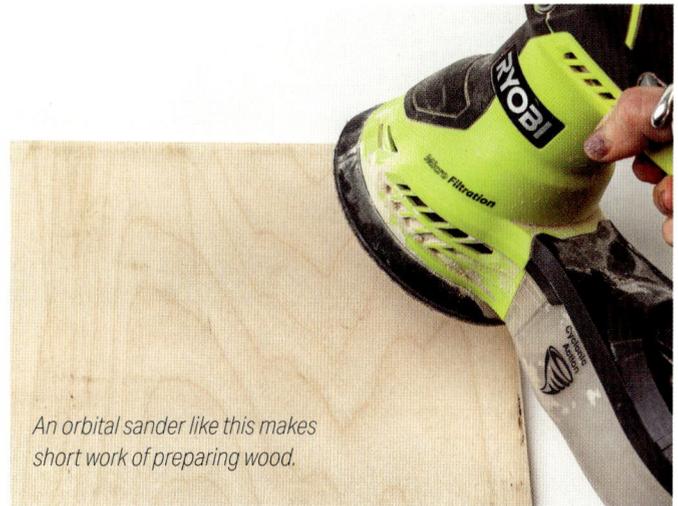

An orbital sander like this makes short work of preparing wood.

Disc sanders can leave distinctive marks, so working over the surface with fine grit sandpaper will help to smooth it.

To finish, run a clean dry cloth or soft brush over the prepared surface to clear any surface dust.

DRAWING UP DESIGNS

There are no erasers in pyrography! Sketching out your design before committing to wood is always a good idea, freeing you up and helping to avoid time-wasting and costly mistakes. I usually prepare my sketch or ideas on a piece of tracing paper or layout paper that has been cut to match the size of the piece of wood on which I'm working. This helps for a number of reasons, namely:

- You can see if the composition works and make final changes before committing to wood.

- Some woods can be expensive. Proper preparatory work gives you breathing space and takes the pressure off getting it right first time.

- Drawing directly onto some soft woods can indent the surface. If you need to move a line or rub something out, the original mark or line can often be picked up in the burn unless you re-sand that area.

- Excessive graphite on the surface of the wood can affect the quality of the burn.

- If you wanted to resize an image from your sketchbook or photograph to fit your piece of wood, you can easily transfer the image using the graph method or use a lightbox directly onto the paper – leaving no messy lines on the surface of the wood.

Time and care spent in preparation before you begin is invaluable. Here I'm using a pencil to work on a piece of layout paper that has been precut to match the size of the piece of wood I'm planning to work on; doodling and positioning the main outline for the French bulldog. I'm not interested in detail at this stage, instead concentrating on just the key shapes. I will move elements around and reposition lines until I'm happy with the composition.

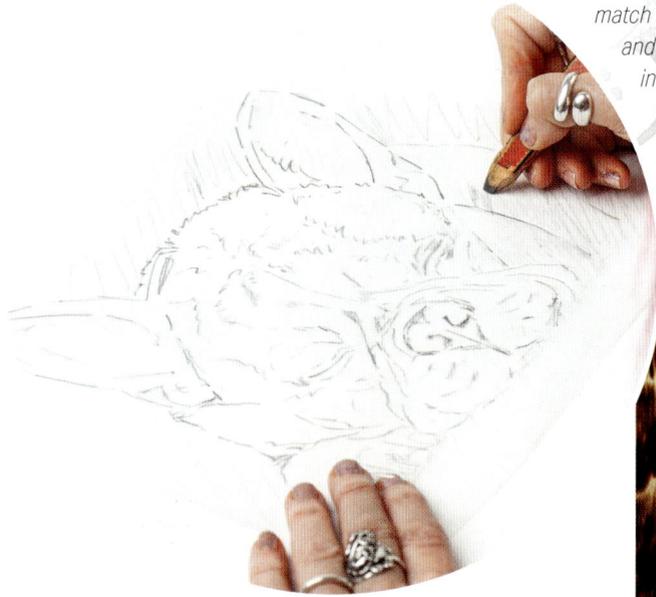

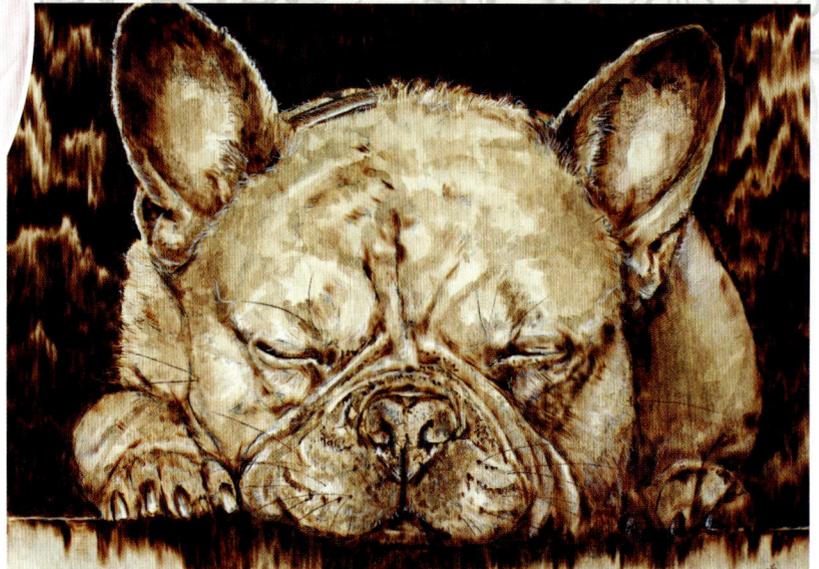

Work in progress on wood, following the key shapes of the sketch once the design had been transferred across. The finished artwork can be seen on page 62.

Transferring your design to the surface

With your design complete, it's time to transfer it onto the prepared wood (or other surface). I typically transfer just my key lines to establish the general shapes and fill in the detail when I'm burning. I avoid using carbon or graphite to transfer onto wood, as it can interfere with the quality of the burn. Instead, I use one of two different transfer products, depending on the colour of surface I'm burning on: white for darker backgrounds, and blue for lighter backgrounds. Both products offer a clean crisp tracing of your original design.

Saral white wax-free transfer paper This can be purchased on a roll and will last for ages. It doesn't contain grease or graphite and so it doesn't make the tip skip. It's also easily removed from the surface of the wood with a kneadable eraser or a damp cloth.

Frisk Tracedown A blue transfer paper, this comes in A4- or A3-sized sheets (21 × 30cm/8¼ × 11¾in or 42 × 30cm/16½ × 11¾in). Buying the larger sheets is more cost effective.

To transfer your design, simply trace over the outline as described below.

1 Tack the design into place on the surface with low-tack masking tape along the top edge. Taping just the top edge allows you to lift your transfer sheet occasionally to check on your progress without moving the design.

2 Place a sheet of wax-free tracedown paper between your image and the wood. I'm using poplar wood here, which is a light surface, so I'm using blue tracedown paper.

3 Use a dry ballpoint pen, mechanical pencil, or an embossing tool that's not too sharp to start to trace over the outline using a firm, even pressure: heavy enough to transfer your image but not so hard that you indent the wood.

4 Lift the transfer sheet up to check the lines are transferring correctly, then continue until the design has been transferred onto the surface of your wood. If the result is particularly dark, gently blot the lines with a putty eraser to make them lighter.

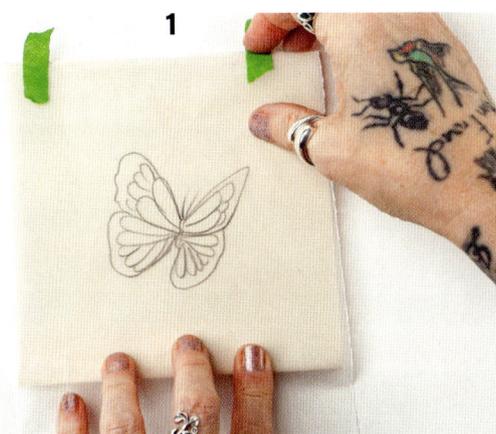

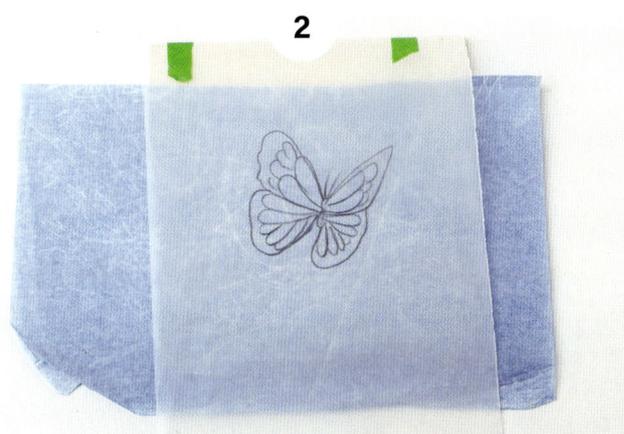

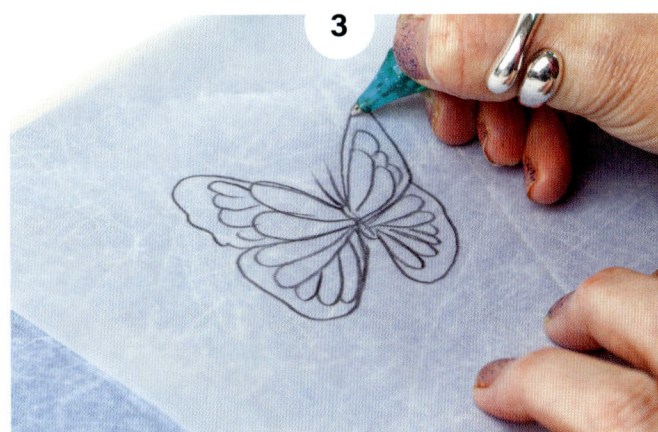

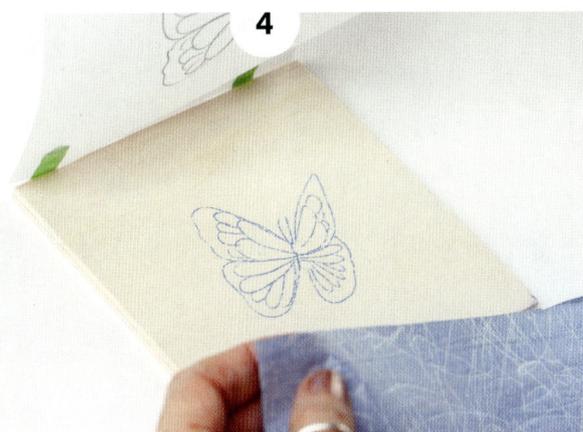

HOT TIP

Here's a great tip from my days of tattooing. If your favourite ballpoint pen runs out of ink, don't ditch it – keep it and use it for a transfer/embossing tool, it will make one of the smoothest transfer tools you'll have. They were like gold dust in the tattoo studio – woe betide anyone who touched mine!

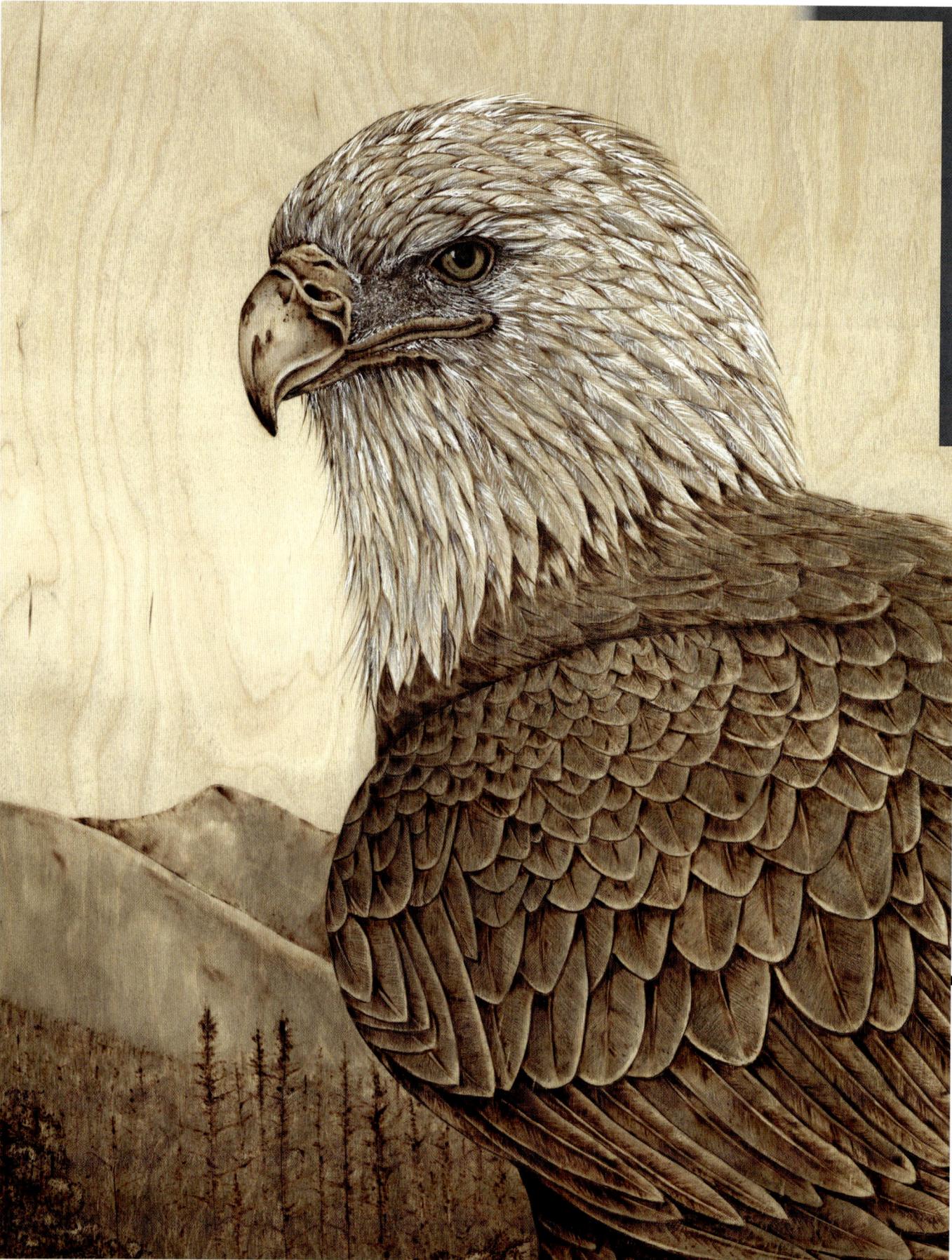

EXPLORING LINE AND CAPTURING TONE

One of the most beautiful aspects of pyrography is the wonderful warm, rich sepia tones that can be created by applying varying amounts of heat to the surface. The results remind me of the photographs of old, and of gentler, slower-paced times. There's a whimsical charm in each drawn line and a commitment with every stroke that I find simply captivating.

Once you have established a familiarity with your surfaces, woodburning tools and tips, and feel that you have developed a level of confidence in your lines and tonal marks, you can begin to explore art styles that will bring your pyrography to life and give it a distinctive visual impact.

ART STYLES

Throughout the book, we look at some specific artistic styles that you might wish to pursue with your pyrography. These range from an illustrative style (see pages 40–41) that evokes woodcuts and classic book illustration to various tattoo styles (see pages 118–119) and a looser pen and wash style (see pages 112–113). All of these are available to you, but all rest on the fundamentals of line and tone, which we explore in this chapter – get these right, and you'll open a magical toolbox that will let you do almost anything with your pyrographic art!

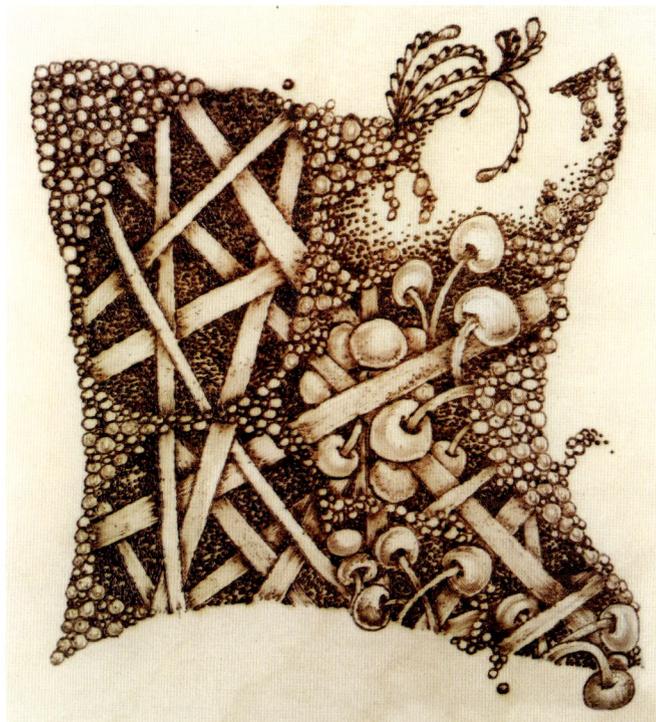

Spirit Seeker 40 × 60cm (15¾ × 23½in)

Pyrography and white pencil on birch panel. In the collection of Monica Hennessey.

'Stand strong… For when storm clouds gather, the eagles soar whilst the small birds take cover.'

There is a lovely myth that a glimpse of a bald eagle can enliven the spirit. Spirit Seeker was created using the Razertip SS-D10. A flat shader was used for the majority of the piece with a writing tip for out-of-focus trees and foliage and a skew tip to hint at the detail in his feathers. I used a white pencil to create contrast in the feathers on his head. The background was left blank to showcase the grain of the wood.

In the Garden 20 × 20cm (8 × 8in)

Sitting outside on a still Midsummer's day, I created this zentangle style burn with no preplanning or sketching. Inspired by my garden, the lines, patterns and textures were created directly on the wood using a writing tip in much the same way that you would use a sketchbook and pencil.

MARK-MAKING

The golden five

Now that you are all set up and poised to go, let's have a look at what goes into creating tone, quality mark-making and colour consistency. Pyrography is a relatively physical process. To get the most out of your burning experience you need to consider and manipulate a number of variables: your surface, speed, pressure, heat and the tip you are using. Altering any one of these 'golden five' will have a direct effect on the appearance, quality and consistency of your burn.

Surface What are you burning? The surface or medium you are burning will make a huge difference to the result. Different woods respond in their own sweet way to temperature, pressure and tips; and some varieties are easier to burn on than others. In addition, just as canvases require priming with gesso, and paper requires sizing before you can paint on it, most surfaces for pyrography need some form of preparation to facilitate a successful, smooth and quality burn (see page 27).

Speed How fast are you moving the tip across the surface? The speed at which you move your tip across the surface of the wood will be reflected in the quality, depth and colour of your burn. Too fast and the line will skip and appear patchy. Too slow and your line can overburn and create a halo effect. Keeping that line at a consistent speed can take a little practice, but will soon become second nature. The angle of your approach is closely related to speed, too.

Pressure How hard are you pressing down with the tip onto the surface of your work? Most tips require very little pressure to work effectively. Skew tips in particular are very sensitive to pressure and can easily break or bend.

Heat How high is your temperature set? It's better to start at a lower temperature and then turn up the heat: it's far easier to make things darker than trying to lighten up a dark burn. It's also good to remember that different tips require different heat settings. Typically, shaders and tips with large flat surfaces require more heat than thinner wire tips.

Tips What tip are you using? Is it a solid tip or a wire tip? A skew tip? A shader? The tips you use will have a direct effect on the marks you make, just like a paintbrush. Different tips create different lines and different textures; some behave more like a branding iron. Each tip has a physical shape and it's the shape of the tip that helps to create different marks and effects. Let's look at them now.

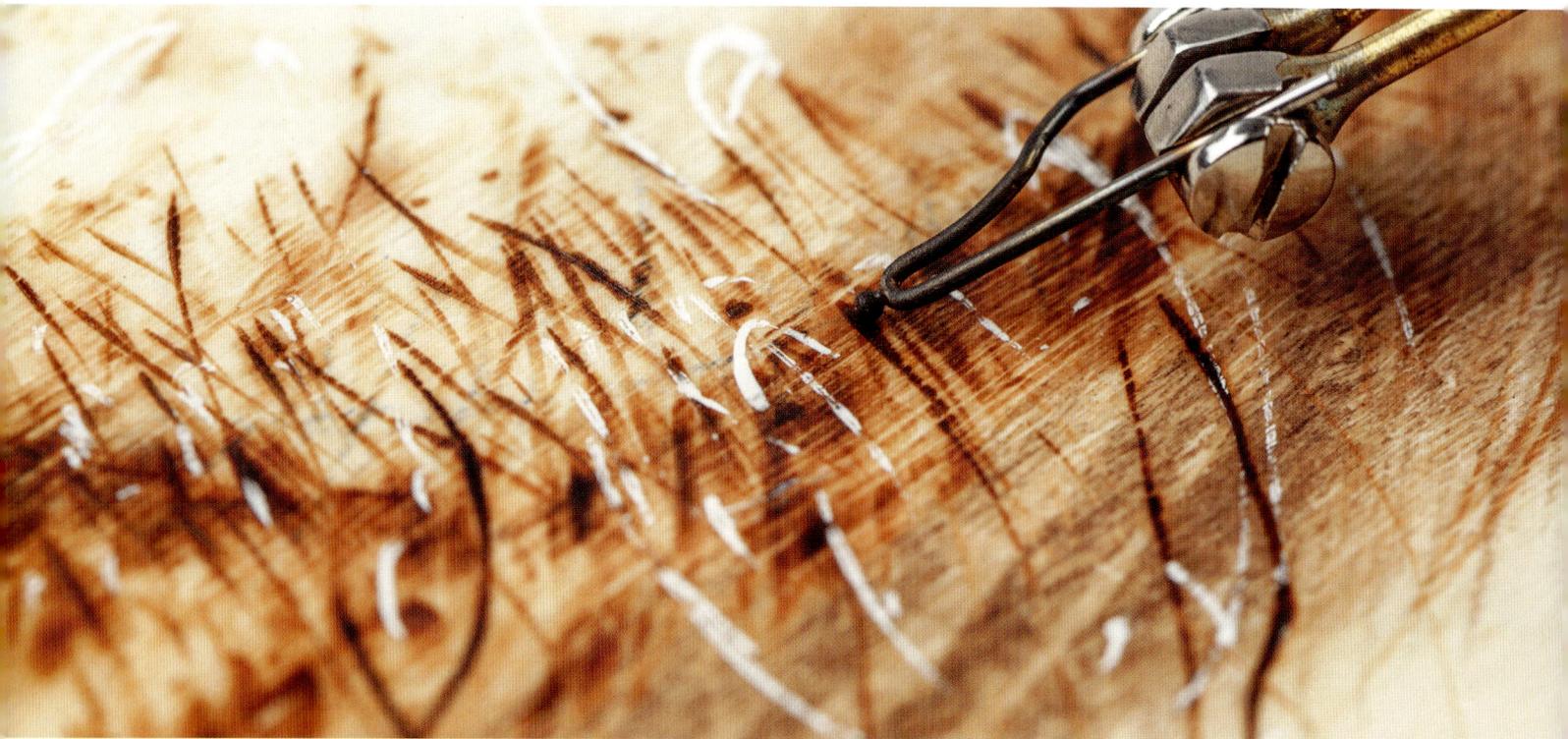

The tip

Selecting the right tip to get the right mark is one of the most overlooked aspects of pyrography. The tip is the area of the pen that heats up and has direct contact with the material that you are burning. It's the physical end of the process and the point at which the magic happens. It is the manipulation of the tip, the speed of delivery, and the temperature of the pen which are the key to a successful burn.

Tips are utterly essential – I think of them as the 'rain that grows the seeds' – but the sheer range can also be quite bewildering. To make it worse, the names of some tips can (and do!) vary between manufacturers and countries which can be confusing. Some tips are also custom-made, and therefore unique to a particular machine. Thankfully, however, most tips fall into one of three broad categories: **writer**; **skew**; and **shader**.

The following pages look at some ways to get you started with each of these types of tip, but I encourage you to play, explore and experiment beyond these. You'll be surprised by the different marks, tones and textures that can be created. The tips you choose to use can go a long way in distinguishing your style, too.

It is worth spending some time getting to know your tips and what they are capable of; each type has a different personality, feel and voice.

The majority of manufacturers design their pyrography pens and tips specifically for use on their units, although some pyrography machines that use interchangeable tip post (ITP) pens allow the use of different brands of tips on their pen. For instance, a number of the Razertip tips can be safely used on the Antex Firewriter pen. Some manufacturers even offer conversion kits that will allow you use pens from different systems with their unit. However, if in doubt regarding the capability of your unit to integrate with other systems, tips and pens, always contact the manufacturer before trying it out.

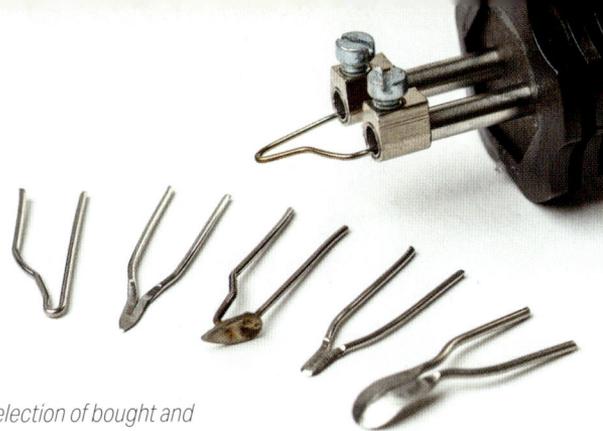

A selection of bought and custom-made tips.

More unusual tips

Once you start experimenting, certain tips will become as important to you as a favourite paintbrush to an artist. You will find some you like, some you love, and some that you end up wondering why you ever bought them! Some manufacturers offer wonderful, exciting and innovative tips that can transform your pen into a lean, mean mark-making machine – a few of the more common types are below:

Feather former Designed for creating feathers on bird carvings, these tips are made of wrapped wire that burn multiple lines on contact. With practice, feather and hair textures can be achieved by using the tip, in various positions along its length, as a way to make marks (rather than as a stamp). I like to use the corners of a feather former for delicate wispy details.

Bead makers Available in various sizes, these semi-circular tips are used to form round raised circles by indenting the surface. Each mark creates half a bead: great for scales on fish and mermaids, or, when paired, making small circles.

Scale tips Similar to bead makers, these are elliptically-shaped. Each depression of the 'scale tip' creates a deep curve that pushes the wood behind the mark, leaving a clean raised scale of a uniform size. They come in a variety of sizes and are handy to create texture and patterns, and indicate repetitive shapes such as roof tiles, pebbles, and leaves.

Specialist tips

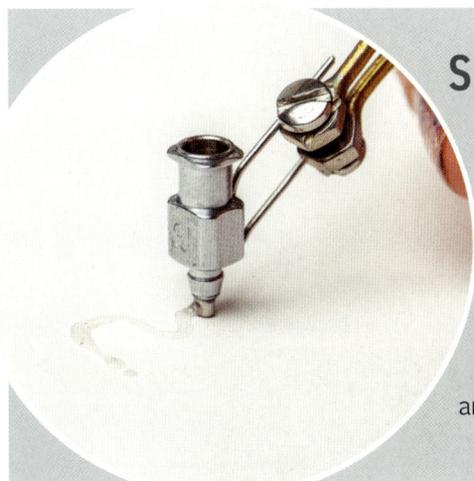

One tip that particularly excites me at the moment, as a mixed media artist, is the Razertip wax writer pictured here. Available in two sizes, this super-cool 16 gauge tip allows you to transform your pen into an instrument that will draw with melted wax. The wax is held in a tiny bowl above the nib and is designed to be used at low temperatures. I find the possibilities super exciting as it expands the capabilities of my machine and allows me to integrate it in a different way into my work. Some may say 'is it really pyrography?', to which I say, 'Is the moon made of cheese?' Probably not – but anything that excites and inspires you is a good thing and certainly worth pursuing in your art!

Attaching and changing tips

Changing tips is relatively straightforward. It goes without saying: always leave a tip to cool down before you change it.

To change the tip of fixed-tip pens or solid point machines it's as easy as switching off the unit, removing the pen (or tip) from the connection point and changing it for another. Refer to the manufacturer's guidelines if unsure.

If you are using an interchangeable tip post pen (such as Razertip's BPH) the tips are usually attached by two screws and plates or similar; these can be changed as shown below. Before switching the power back on, make sure the screw contacts are not touching each other, as this will cause a short circuit. The current will bypass the tip and can ultimately damage your unit.

More metal requires more current. When replacing a tip on a interchangeable tip post pen with a tip that contains substantially more metal (such as larger shaders, formers, or custom-made tips), ensure that the cable attached to the pen is able to handle the necessary extra power. If you're unsure, or using a tip from a different system, it's advisable to check with the machine manufacturer. I've found that a heavy duty cable, although less flexible than a standard cable, also facilitates faster tip heat recovery on all my tips and pens using that machine. See 'Cables and safety' on page 18 for more on using cables.

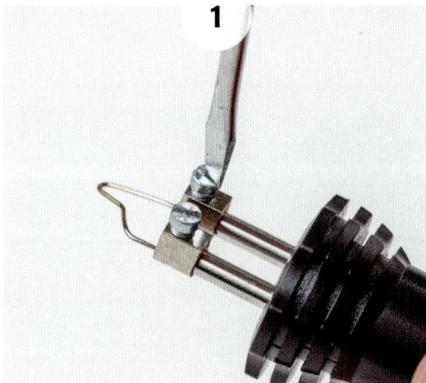

1 Make sure the pen is unplugged and the tip is cool. Use a screwdriver to loosen the securing screws. There's no need to remove them entirely.

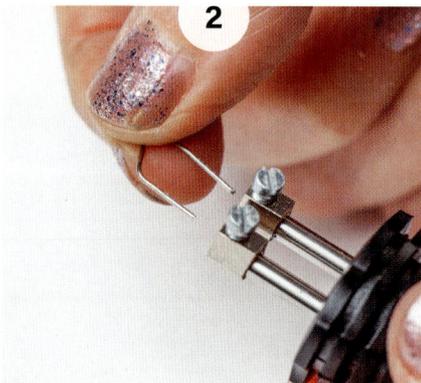

2 Gently lift the old tip out and put it away safely.

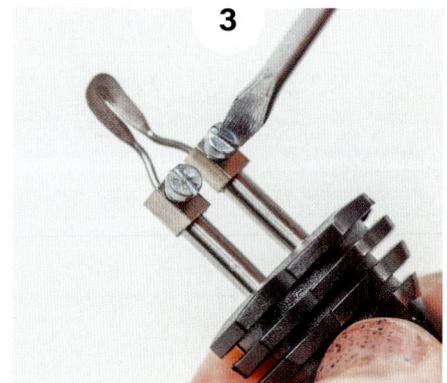

3 Insert the new tip and tighten the screws. The screws should be tightened securely enough to create a good electrical and mechanical contact but not overtightened, as this risks damaging the tip and stripping the threads.

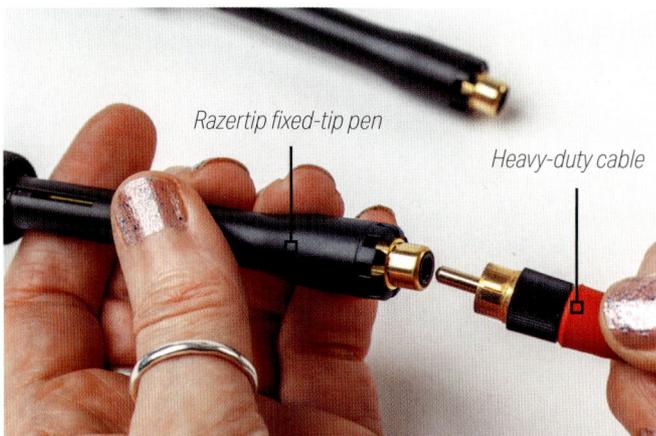

Razertip fixed-tip pen

Heavy-duty cable

Swapping pens

Some systems offer fixed-tip pens rather than changeable tips. For these, unplug the cable from the pen and re-attach it to the new one.

As with an interchangeable tip post pen, make sure the cable is appropriate to the new pen: the more surface area to the metal tip, the more ampage is required to heat it up. Large tips work better with a heavy-duty cable. If you ever notice the cable itself heating up, try swapping it for a heavy-duty cable.

Creating your own tips

Making your own tips can be a fun (and frugal) way to experiment with mark-making. Here we'll create a simple writing tip using wire. I like the loops in writing tips to be 'stepped' rather than central, as it gives more resistance when working and allows you to get right over the top of the work. This is part of the appeal of creating your own tips: you can adjust them to just how you like to work, and therefore create marks that are unique to you.

Nichrome wire is necessary for making your own tips, or you will damage your machine. An alloy of nickel and chromium, nichrome wire can be bought in small reels which come in various thicknesses, or gauges. The lower the number, the thicker the gauge. Most common sizes used for making tips are between 22 and 26 SWG (standard wire gauge). Your machine's handbook will advise on the gauge which will work with your particular machine. Some machines even come with a number of ready-cut lengths of nichrome wire to get you started.

Making your own tips can become quite addictive. Whether it's for fine work, decorative work, lettering or heavy-duty shading, there are a multitude of variations you can create with just a single piece of wire. You can check out my YouTube channel for more ideas, and feel free to make them how best suits you.

1 Using the wire cutters, snip around 30mm (1¼in) of nichrome wire off the reel.

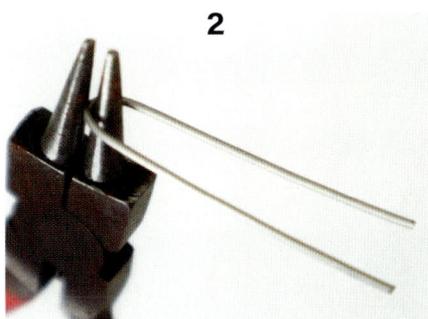

2 Bend the wire into a basic 'U' shape with round-nose pliers.

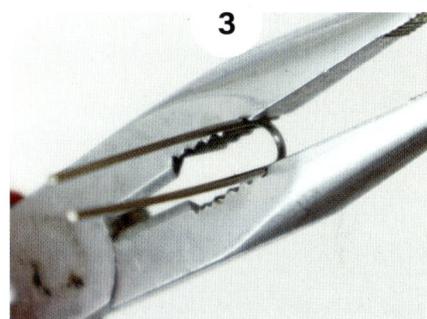

3 Holding the open ends of wire in your other hand for stability, pinch the tip of the 'U' together with the flat-nose pliers.

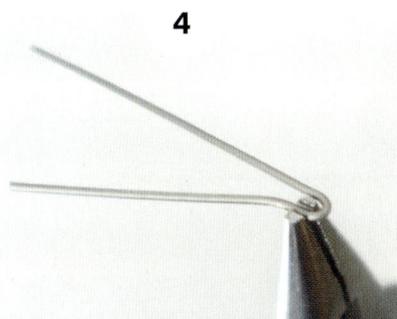

4 Place the pliers along one side of the wire, about 5mm (¼in) from the pinched end. Bend the 'leg' out to around a 45° angle to create a step as shown.

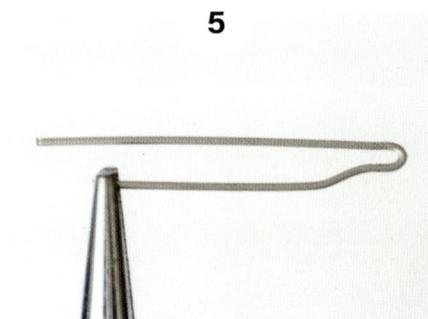

5 Create a bend back on the same piece of wire to correspond to the width of the interchangeable tip post of your pen. Trim both sides to length with your wire cutters.

Variations

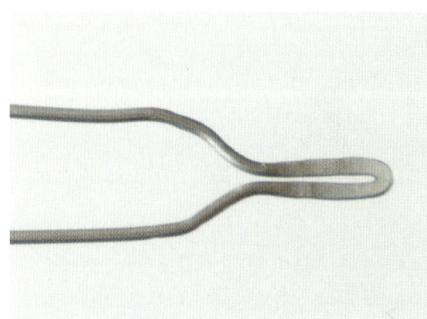

The wire loop is a super versatile tip. You can make the tip point as wide or as fine as you like. You can double back the 'loop' on itself completely to make a single tip: great for fine lines and tiny dots. You can make it sharper by squashing it with the pliers, flattening it with a hammer or filing it down. This example has been tamped down with a hammer to create a small shader.

Fitting and safety

To fit your tip, simply unscrew the terminals on your interchangeable tip post pen and insert one end of the loop into each terminal. Tighten the screws firmly, securing and clamping the ends – exactly as shown opposite.

Using a gauge of wire that is too thick for your machine is not recommended and could overload your machine.

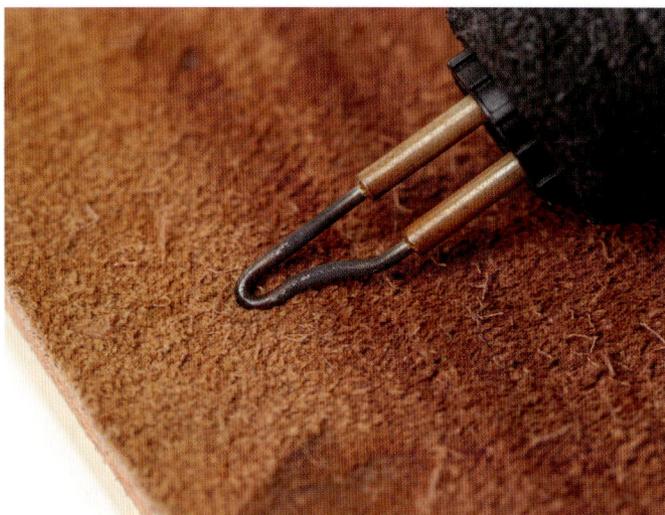

Cleaning a wire writer tip
Rub the tip across a strop loaded with aluminium oxide compound. This will gently abrade the carbon away, leaving a clean tip.

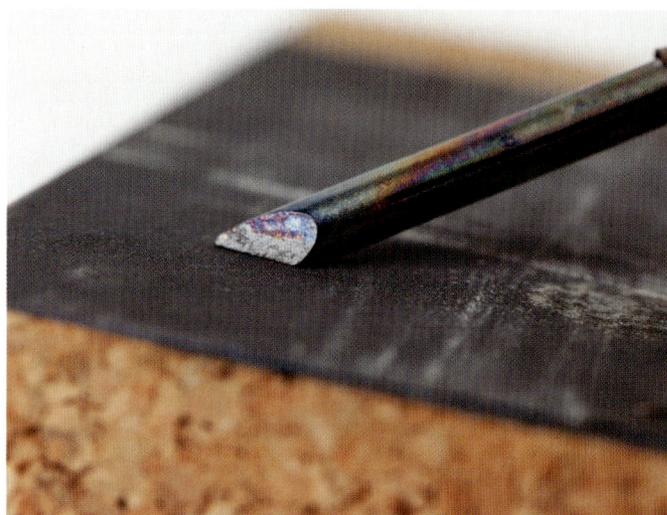

Cleaning a solid tip with sandpaper
Fix a fine grit (220–240) sandpaper to a sanding block using tacks. Gently pass the tip at an angle across the sandpaper. An emery board can be used in the same way.

Care and cleaning of tips

Over time and with prolonged burning, carbon deposits will naturally build up on the tip, which will require cleaning. Excessive carbon build-up on the tip of your pen can cause the following problems:

Dirty tips Carbon build-up on the tip will greatly reduce the effectiveness of heat transfer from the tip to the wood, resulting in inferior jumpy lines that skip and vary in width and colour. A dirty tip may also transfer the black carbon build-up from the tip to your work, creating unslightly black streaks or uneven blurry burns.

Scratchy tips When burning, particularly with shaders (spoon and flat), your tip can sometimes feel 'scratchy' and produce an uneven and unsightly blend and tone.

There are a number of methods for cleaning dirty tips (some are shown above) and most artists have their own preferred ways. My method is to use a leather strop with a small amount of aluminium oxide compound on it. I use this for cleaning all my tips, both solid point and wire. The cold tip is drawn repeatedly across the surface of the strop to remove the carbon build-up. I find this method more gentle on the tips and less abrasive than sandpaper. It also buffs the tip back to a nice shine.

Other artists use a fine grit sandpaper (220–240) or an emery board to remove the build-up before buffing the tips with an emery cloth or a fine silicon-carbide cloth (more suited to solid tips). Alternatively, you can gently drag the tip at a right angle across a sharp metal edge, such as a Stanley knife blade, which will scrape the carbon away.

Whatever method you use, always ensure a tip is completely cold before cleaning. When metal is hot it becomes more malleable and can easily be damaged and bent: this is particularly salient to wire tips.

Scratchy tips can easily be resolved by allowing the tip to cool and polishing it. I polish tips with my strop with an oxide powder on. If that doesn't work, I pop a pair of gloves on and use wire wool. Other artists use very fine grade wet-and-dry sandpaper (1200 grit plus) or nail buffers, either of which will polish up your tips nicely.

Knowing and maintaining your tools will make it much easier to get good results. It's really hard to draw with a blunt pencil: it skips, jumps and creates smudgy, nondescript lines. So what do you do? You sharpen it. Working with a woodburning tool is no different. Think of the tip like your pencil, pen or paintbrush.

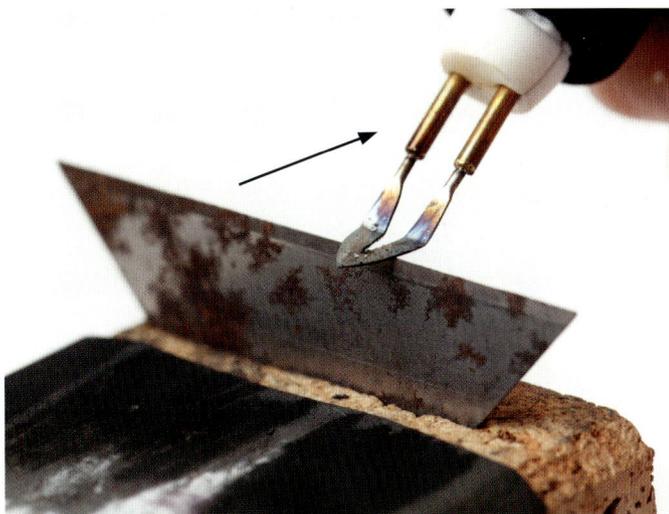

Cleaning a flat tip with a blade

Burning dark backgrounds and heavy shading can cause carbon to quickly accumulate on the bottom of a flat shader tip. A Stanley blade fixed upside-down in a cork block can be used to clean the residue. With the tip at a right angle to the blade, gently pull the tip towards you across the blade, as shown above.

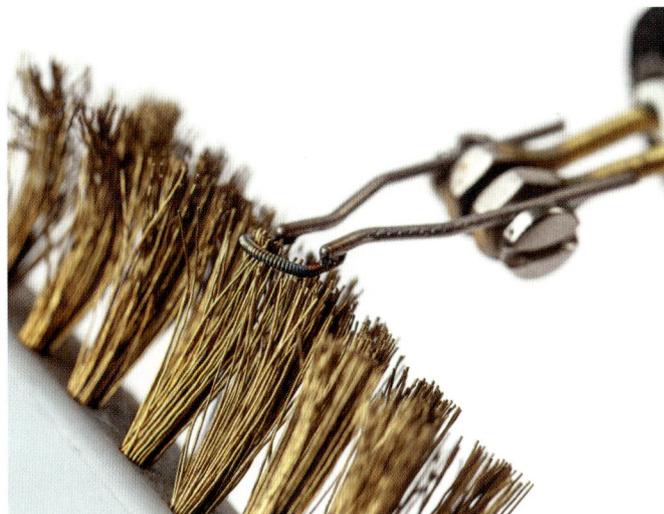

Cleaning a feather former with a wire brush

Specialized tips and formers benefit from a gentle tickle with a wire brush. It gets into the nooks and crannies of the tip without blunting or smoothing any edges.

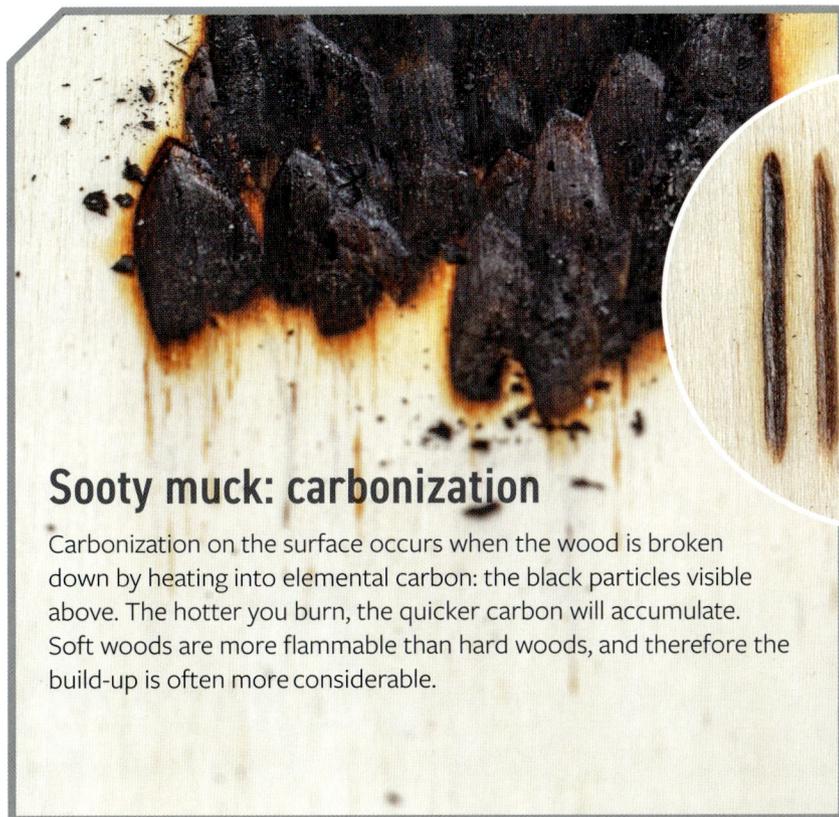

Sooty muck: carbonization

Carbonization on the surface occurs when the wood is broken down by heating into elemental carbon: the black particles visible above. The hotter you burn, the quicker carbon will accumulate. Soft woods are more flammable than hard woods, and therefore the build-up is often more considerable.

Overheating

Too hot a wire tip can quickly scorch the wood. The two lines on the left have been made with the tip at the correct temperature for the wood, while the tell-tale 'halo' effect on the right-hand lines shows the tip has been used too hot.

Samplers

It's a great idea to create a sampler for each new tip you have. You might think of a sampler as a doodling playground – just pick up a tip and take it for a walk on the wood. Samplers allow you to explore and experiment with tip temperature, mark-making and movement speed. Some artists like to grid a piece of wood and work in formal squares, creating a different mark in each square – as in the example below. I usually prefer to let the work flow freely and treat the wood like a sketchbook page, as in the example opposite.

Samplers are a great place to practise and build up your muscle memory before you start on an artwork, as once committed to wood, marks cannot easily be erased.

I often refer back to my samplers when I'm looking for textures and interesting infills. It's invaluable practice and will give you confidence in your application and approach to a piece. Practice, confidence and experimentation will take your work to the next level.

STARTING POINT

If you find yourself stuck for inspiration, take a look around you. Look at textures and patterns and try to interpret and realize them on wood. Think of hard and soft edges; fur and skin; organic and inorganic shapes – or simply just play.

Look at the golden age of illustration, an unprecedented period of artwork and storytelling in books and magazines between the 1850s and 1920s (see also pages 40–41). Colour was non-existent and so artists described atmosphere, mood, tone, depth and form by linework alone. Repeated marks were used to express texture and form; and various qualities of line were used: some expressive and powerful, others more subtle and abstract in appearance. These are great concepts to bring to your sampler, and pyrography work in general.

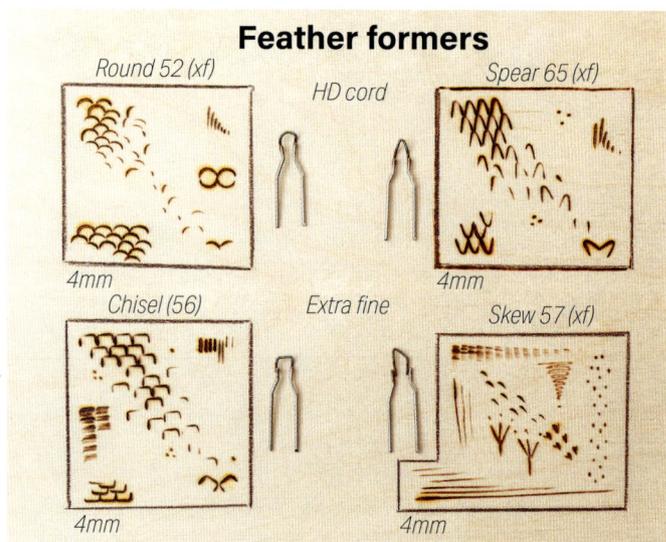

Feather formers

Round 52 (xf) HD cord Spear 65 (xf)

4mm 4mm

Chisel (56) Extra fine Skew 57 (xf)

4mm 4mm

Feather former sampler

A little doodle piece to explore mark-making with a few different shapes of feather former (see page 33). It was interesting how differently each one performed. In this exercise I mainly used the formers as stamps, allowing the shape of the tip itself to guide the marks. It was fitting that a round feather former made one of the nicest little suggestions of a bird!

HOT TIP

Burning too hot too soon is a common mistake when you are starting out. Areas that are overburned with excess temperatures can appear uneven, bumpy and unsightly. When you try to correct the problem by burning a further layer to darken down the patchy areas the hot tip will displace the crispy underlayer exposing more yet light wood – it becomes a vicious circle. The high temperatures can cause an increase in carbon build-up on your tips, too (see pages 36–37 for advice on cleaning your tip if this happens).

Try playing with patterns, squiggles and unconventional marks. Create texture and tone by repeating the same marks over and over again. Try overlapping marks and adjust how swiftly or slowly you draw a line. Consider the difference between burning against or with the grain of the wood. Explore different edges of the tip and alter the pressure across the foot. Let the world drift away and get lost in your creations.

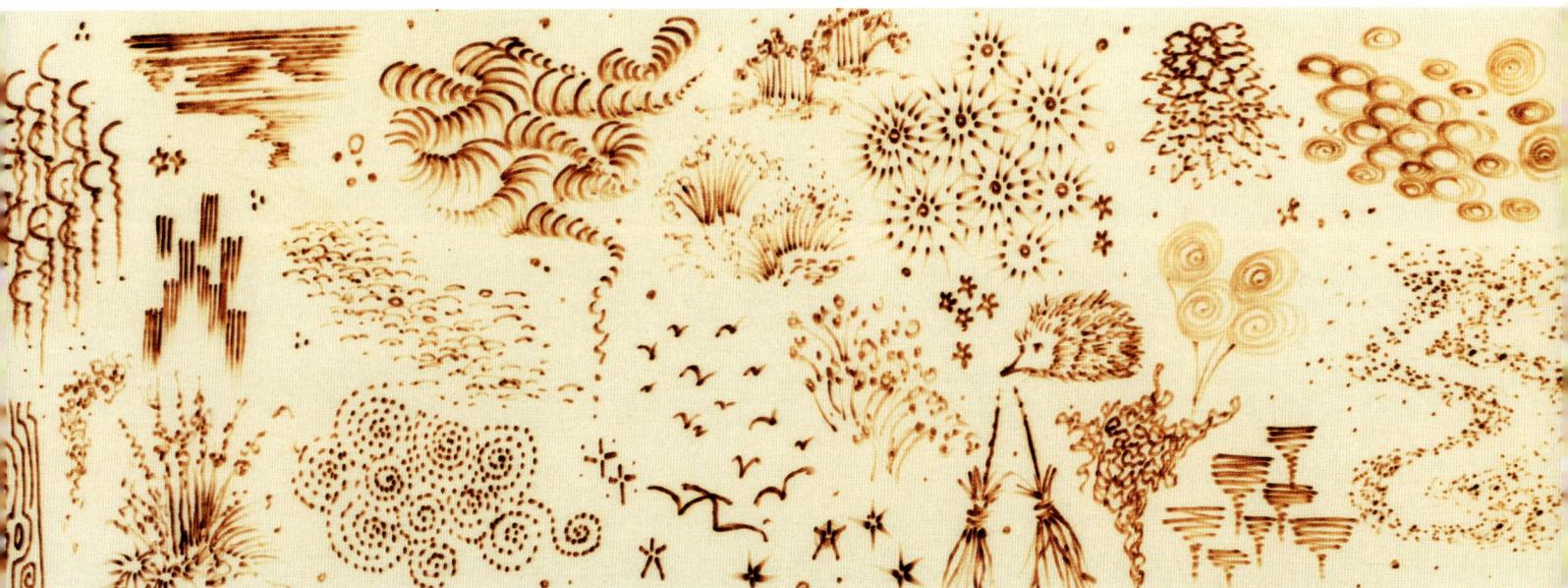

HOT TIP

Try merging different textures together to create complexity and contrast. Darker lines can be used to make the lighter areas stand out.

This sampler was created on an off-cut of poplar wood, and shows a variety of marks made simply by doodling. By recording details like which tip and temperature you used for each, you'll be able to easily replicate the mark at a later date. To make this easier, I usually leave a small space at the side of each set of marks – this allows me to add a letter or number here that corresponds to my notes.

ILLUSTRATIVE STYLE PYROGRAPHY

Illustrative pyrography is a style that is recognizable from the beautiful pen and ink images produced in print by Victorian artists such as Arthur Rackham, Harry Furniss and Louis Rhead. Linear linework and cross-hatching techniques are used to create tone and form similar to the engraving process in printmaking.

The illustrative approach is a style very close to my heart, as these are the images I grew up with, as a child with my head in the clouds and my heart full of fairytales. One of my favourite illustrative artists was William Heath Robinson, an illustrator and engraver (1872–1944) who produced the wonderful ink drawings for *The Poems of Edgar Allan Poe*.

Studying the drawings of the illustrative masters can be a real treat, particularly if you can get to see the original works rather than the printed page. It's not about copying and trying to draw like them, but rather about seeing and understanding the images and how the artist used linework to make them. Studying an illustrator's work will train your eye to notice the effective economy of subtle and delicate touches and how they use simple lines to inform shape, mood and form. This is at the heart of the illustrative style of pyrography.

Working in an illustrative style

When burning in an illustrative style, skew tips, writing tips or the edge of a spear shader are used to engrave the wood using a process of thin linear lines with varying strokes, in a series of patterns to describe the tone and form of the subject.

No shaded infill is used. Instead, lines are built up, overlapped or cross-hatched to create a more densely packed and hence darker, area. The changes from dark to light areas are created by balancing the numerous burned strokes and density of line against the background. Unless you intend to use colour, you need to preserve the natural surface of the wood (or paper) for the lightest areas and highlights.

Hatching and cross-hatching are the most common marks used to render light and shade in illustrative work. You can read more about these techniques on page 57.

A sampler (see page 38), on which you can try different combinations of linear strokes, pulled curves and cross-hatching to describe form and create tonal values, is a very useful way to practise mark-making for the illustrative style.

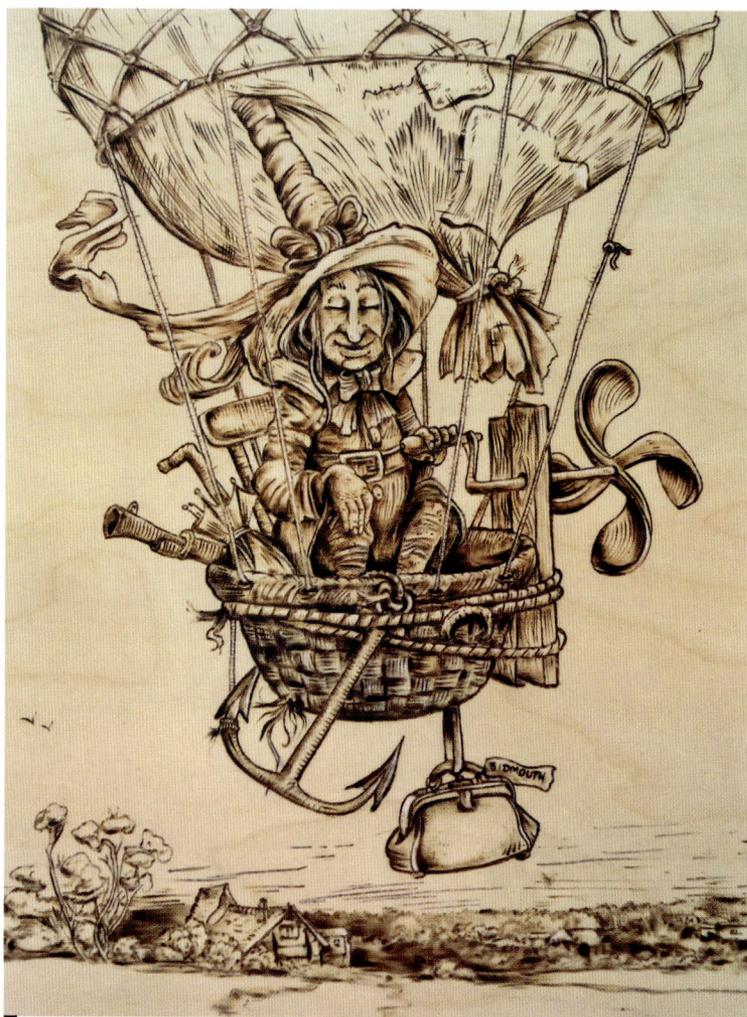

Old Granny Ogg 30 × 40cm (11¾ × 15¾in)
Pyrography on birch panel.

A personal homage to a hero of mine, William Heath Robinson. This is my pyrographic rendition of an illustration he made for The Adventures of Uncle Lubin *(published in 1902). It is an image that has stayed with me since I first saw it as a child. I used a variety of round and flat shaders and skew tips for this piece.*

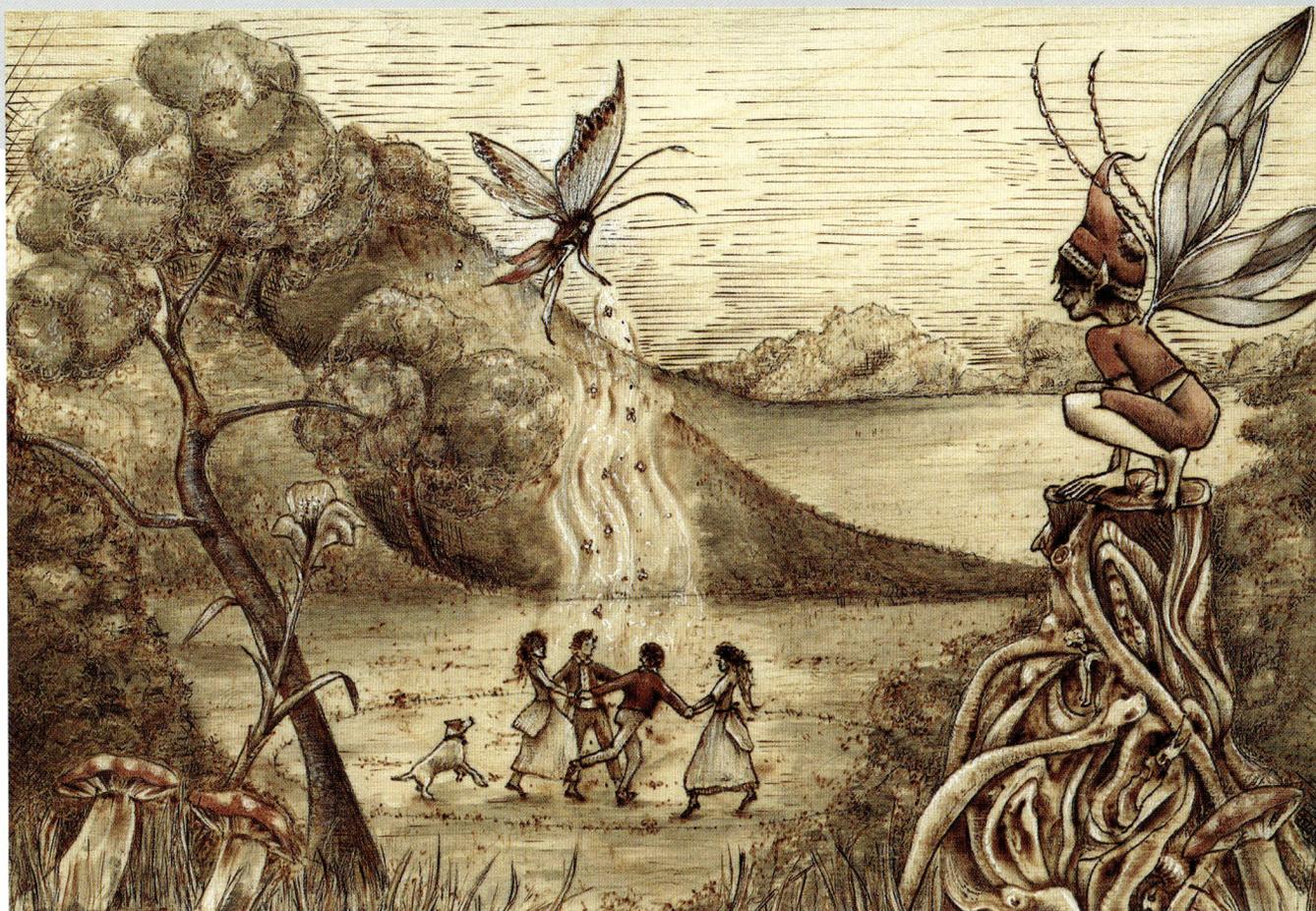

Midsummer's Dream 40 × 30cm (15¾ × 11¾in)

Pyrography and coloured pencil on poplar panel.

'Childhood dreams and wildheart days... to hope... to wish... to dare...'

Midsummer's Dream *was an illustrative-style pyrography piece created in response to a celebratory anniversary open exhibition of Rudyard Kipling's book* Puck of Pook's Hill *illustrated by the great Arthur Rackham. Artists were given a short extract from the book to use as inspiration for their submission.*

Foliage

Prior to burning, I used an empty ballpoint pen to draw in the foliage. When a shading tip was subsequently worked over the area, it skipped the indented lines. Cross-hatching was used for the shadow areas in the canopy.

Foreground stump

I used a flat shader to produce negative shading on the tree stump. This helps to bring the detail forward.

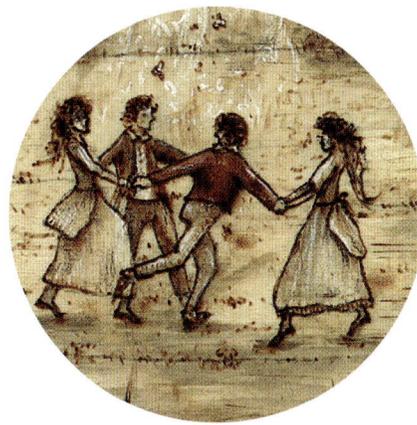

Figures

A fine writing tip was used to create the impression of the children; a gentle touch helped to ensure the suggestions of line and movement.

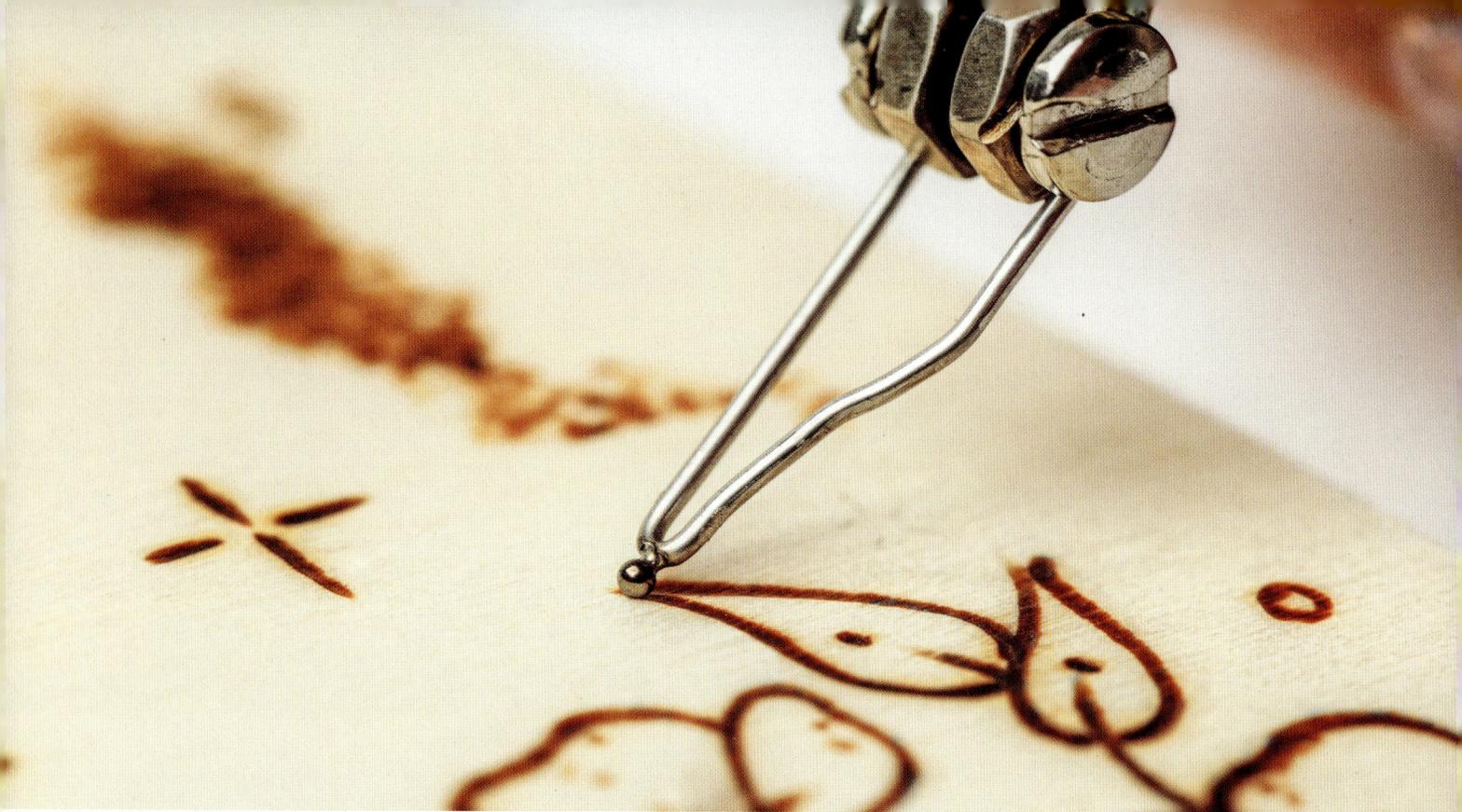

Mark-making with the writing tip

The writing tip, or simply 'writer', is the sort of tip that usually comes supplied with a pyrography machine – think of it as a standard or default tip. It's aptly named for its purpose and mark-making with it is very like using a pencil or ballpoint pen. As such, it's great for freehand work. Ball tips, ballpoint tips or stylus tips are variations on the writing tip and give you similar results.

The writing tip is designed to gently glide along the surface of the wood in any direction. It is well-suited to loose lines, all types of curves, circles and lettering. With practice it can also be used for infilling areas, soft shading and stippling. It's a great tip to sit down with and get to know, particularly for beginners to pyrography.

Longer lines can take practice and require smooth, well-sanded wood. The writing tip scorches the surface of the wood as it glides, and so it is sensitive to the contours and furrows in the grain. Speed of burn also plays an important role in a smooth line. Move the tip too quickly and the line will appear to skip and look patchy – this is because the tip is losing too much heat to the wood and is unable to recover to burn effectively. Conversely, work too slowly and the heat will blow out the line with unsightly feathery-looking blooms.

Take some time and take the writing tip for a spin. Try burning on a sanded and a non-sanded surface and compare the results; you'll be surprised by the difference a well-prepared surface can make.

Ball stylus tip on an interchangeable tip post pen.

When I use a writing tip or ball stylus, I find it most comfortable to pull the tip towards me, rotating my work as I go, rather than to work away from me.

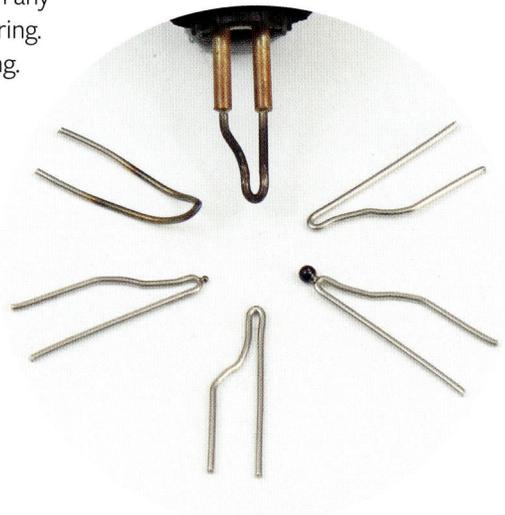

A selection of writing tips.

Writing tip sampler

1 Straight lines.

2 Cross-hatching.

3 Fill shading with parallel lines.

4 Stippling – this is done by tapping the tip on the wood repeatedly.

5 Short line fill – this also looks effective with small 'tick' shapes.

6 Scumbling – this effect is produced by making small, repetitive circles.

7 Varied pressure line made with a locked wrist. Notice how the line goes thick and thin as different parts of the writing tip comes in contact with the wood when drawing a curve.

8 Tight curves.

9 Random curves with the wrist following the shape of the curve – notice how the line remains uniform.

10 Birds shading. These dark birds were built up with layers of scumbling, while the top bird was rendered with a gentle short line fill.

11 Shading using short line fill layers. There are more layers on the darker areas.

12 Shading using stippling.

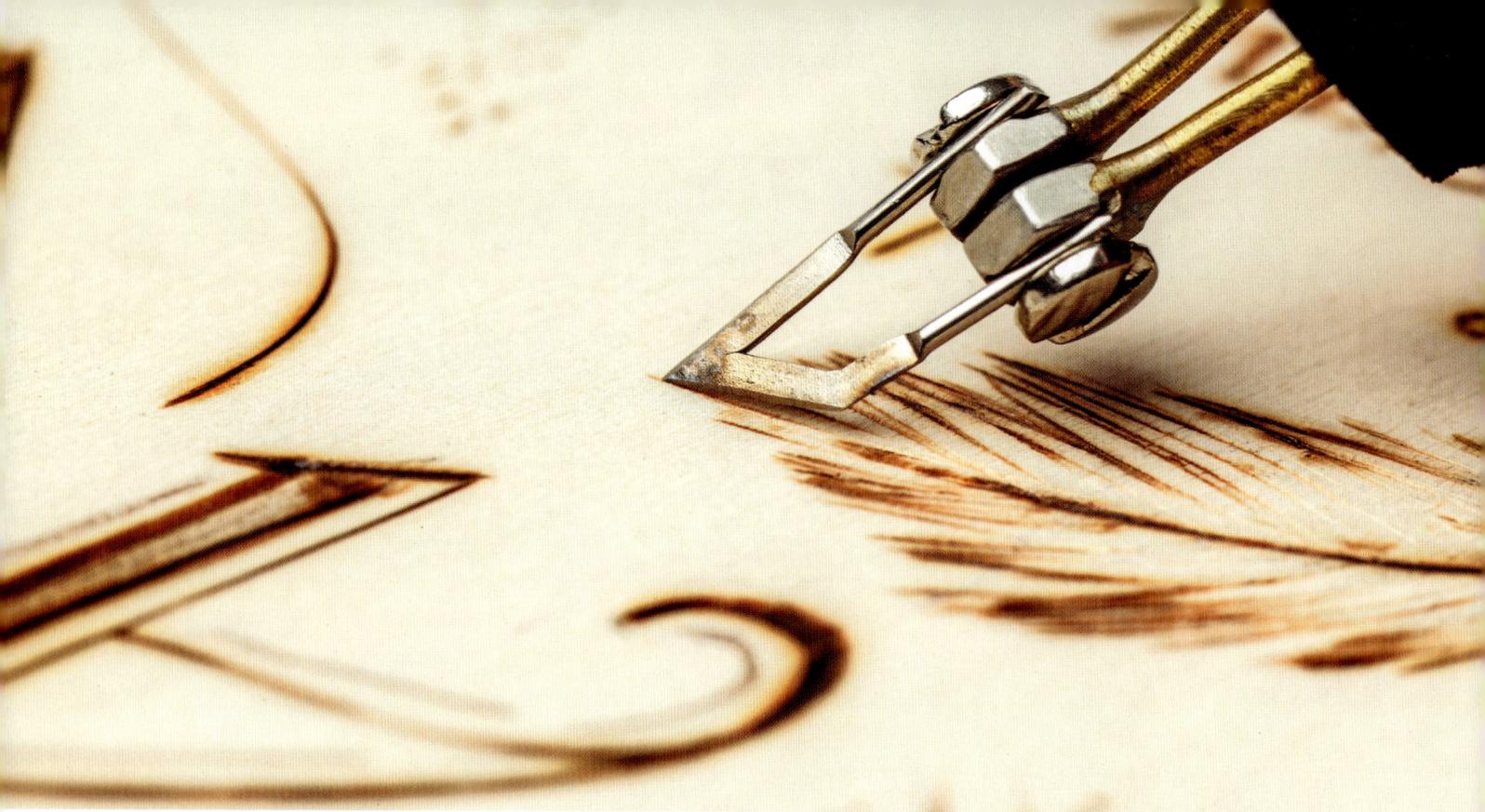

Mark-making with the skew tip

With the appearance of a straight, narrow, knife edge, the skew is one of the few tips designed to burn into the wood as opposed to gliding on the surface, and so it needs to be kept clean and sharp. Don't force it into the wood; simply let the tip do the work. Forcing the skew into the wood and straining it into tight curves will invariably damage or break the tip.

Due to the smaller surface area of the tip, they require very little pressure to burn. They can burn hot, too, so watch the temperature fluctuation when you switch between tips.

Skews are a graceful tip and like to be kept moving in a continuous motion, which means they can be used successfully for large lettering without tight curves. They are a great go-to for creating crisp cross-hatching and for use in more illustrative pieces. They are also wonderful for depicting short animal fur, linear shading and technical/architectural drawings.

Tone and depth can be created by varying the distance between the lines. They feel very different to a writing tip, so take time to create and explore mark-making with a skew tip, and in particular, practise creating the gentle rolling curves that are the speciality of this tip.

Skew tip on an interchangeable tip post pen.

I often hold the skew tip pen upside-down and gently use the toe of the tip to create the tiniest of marks for subtle stippling, shadowing and tone shifts. Turn the heat down when burning those fine lines as it's easy to flash a line out (see 13 on the sampler opposite). For super fine lines, like whiskers, I always switch to a small skew, it's well worth the time and effort.

A selection of skew tips.

Skew tip sampler

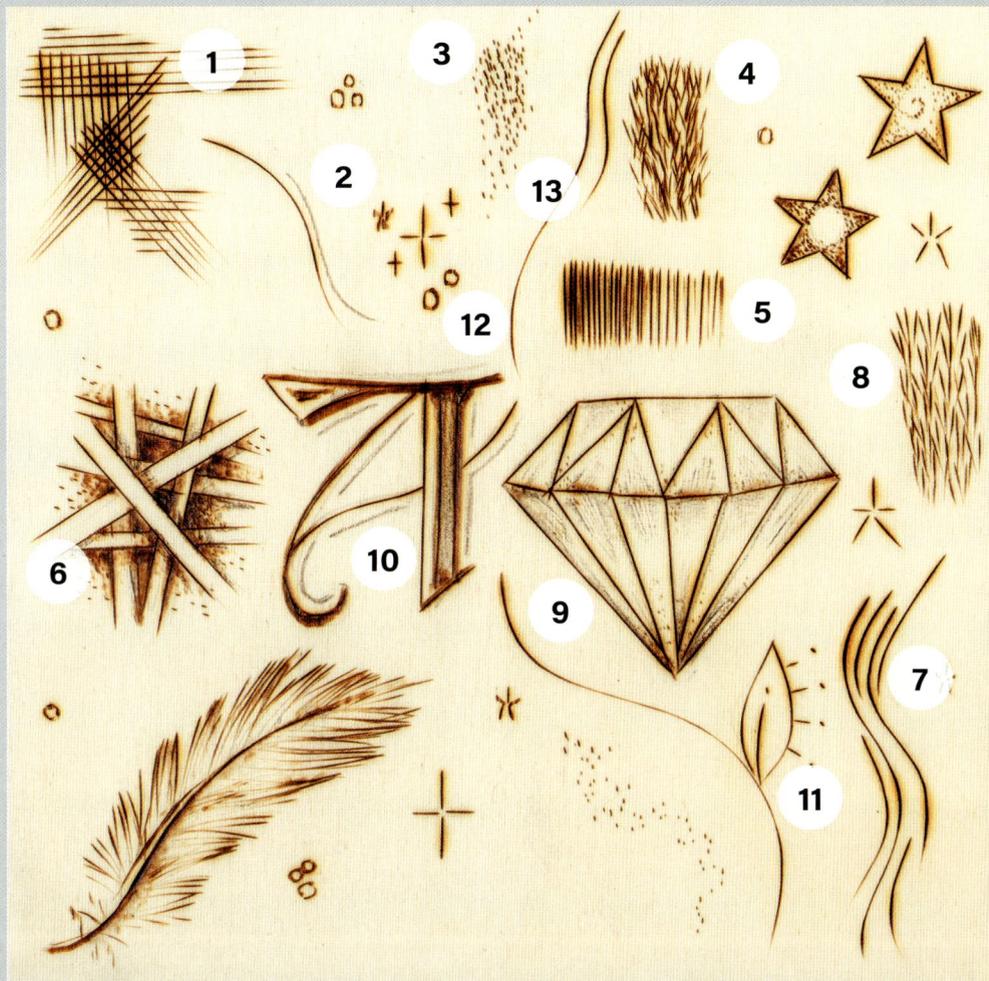

1 Straight lines and cross-hatching.

2 Lazy curves.

3 Gentle stippling using the very tip of the skew.

4 Tapping the foot of the skew perpendicular to the wood – varying the angle makes interesting organic patterns. It's also great for short fur.

5 Fill shading using parallel lines.

6 Lines and stipple shading to create the illusion of depth.

7 Varying the pressure to create texture and line width.

8 Short lines askew fill shading – also great for grass, feathers and texture.

9 Crisp line and low temperature short line infill for shading.

10 Thick and thin lines using parallel fill shading.

11 Shapes built up from lazy curves, short lines and stippling.

12 Small circles made using the toe of the tip with the pen upside-down and no pressure – just gently kiss the surface of the wood with the tip and keep it moving.

13 Flash burn – heat from the skew tip has coloured the area immediately next to the line. Turn the heat down or increase speed of application to avoid this.

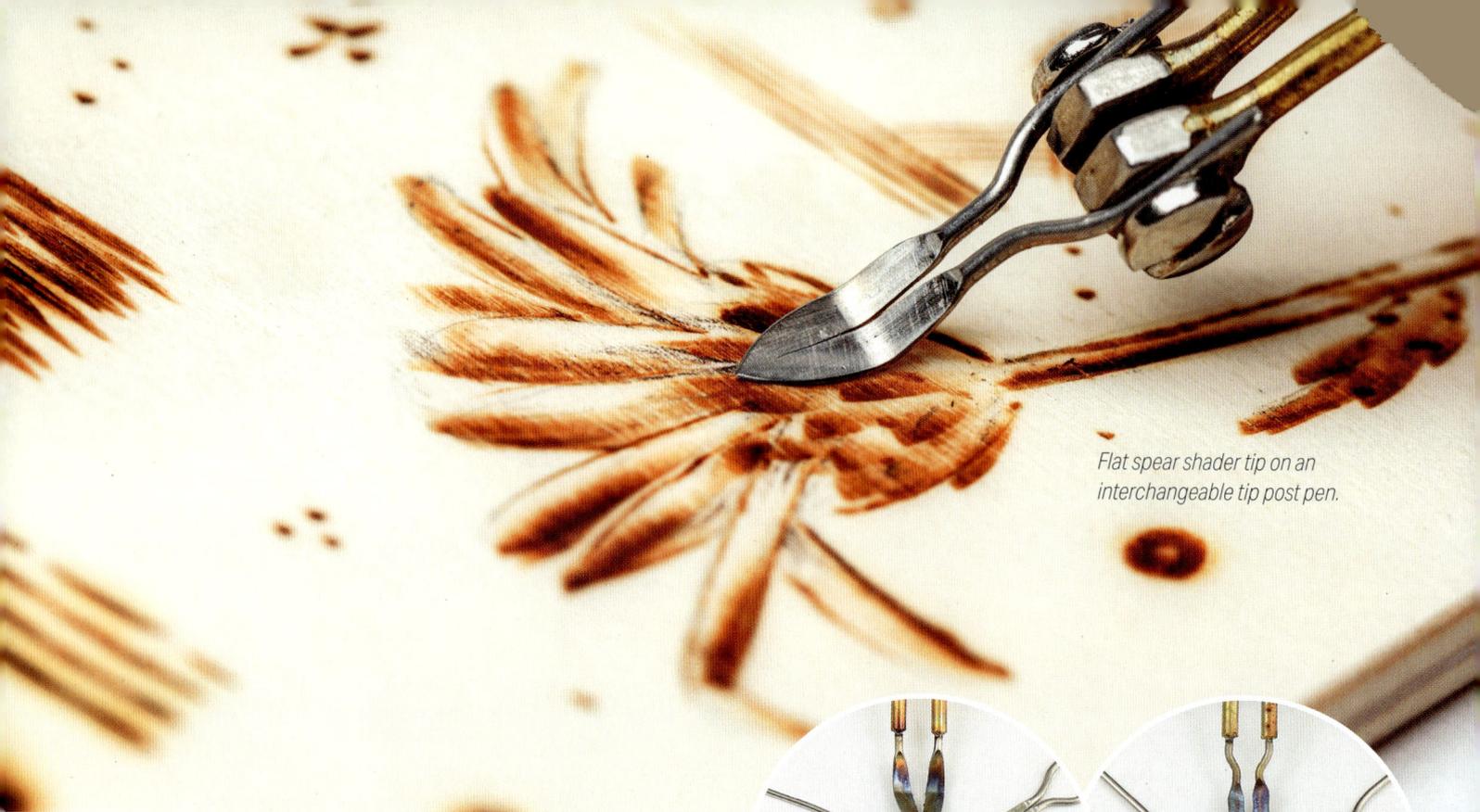

Flat spear shader tip on an interchangeable tip post pen.

Mark-making with the shader tip

Shader tips come in many forms. Designed to scorch large flat marks, they are great for infilling flat areas and rendering gradients of tone in a form through the gentle overlapping of layers. Shaders tend to be used by either sweeping the tip from side to side or pulled towards you. The toe and side edge of the shader can also be used to add further interesting marks and texture, and to pull thinner lines. Shader tips come in two main shapes, namely the 'spoon' and 'flat'.

Spoon shaders Taking their name from the spoon-like shape, these are easily identifiable. Due to their concave shape, the base has a smaller surface area than the flat shader but they are more forgiving when shading soft overlapping layers to build up tonal gradients. Spoon shaders can be pushed in multiple directions and are great for stippling effects. To fill areas of shade you can make small circular movements, using a light pressure and allowing the tip to do the work. Consider the speed of your circles as they have a direct influence on the colour of your burn. The toe of the spoon shader is also great for shading in small tight spaces.

Flat shaders Sometimes referred to as spear shaders, these tips come in a variety of sizes and shapes. They look a little like a tiny trowel and are personal favourites. Flat shaders are designed to be gently pulled over the surface of the wood. The flat shoe of the tip scorches a relatively large surface area, making them great for soft shading, backgrounds and tonal gradients. It's a tip that takes a little practice to get the hang of, but once you understand how to use it, you won't look back.

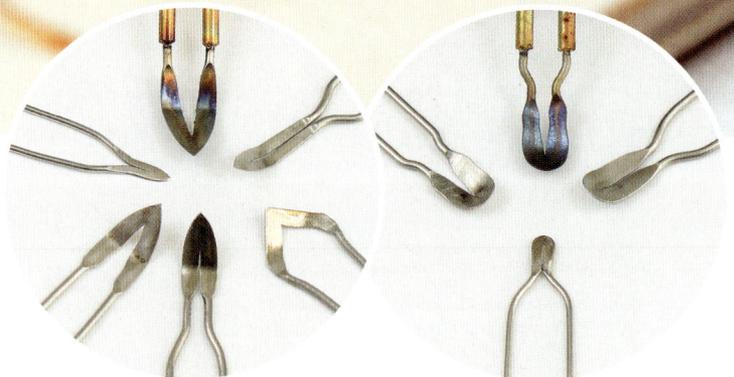

A selection of shader tips; flat shaders on the left, spoon shaders on the right.

The flat shader can be used in a variety of ways for different effects. It can be pulled towards you to create overlapping lines to infill small areas; swept from side to side, gently kissing the wood, to produce soft smudgy effects; or used in small circular patterns to build up tone and texture. The side and pointed toe of a flat shader can create bold tight lines and add texture. The toe is also great for getting into tight corners. All of these are shown in the sampler, opposite.

Speed is required when using a flat shader. Leave it too long in one place and you'll brand the wood with an imprint of the tip's shape – just like a domestic iron left too long on a shirt. The same can happen if the temperature is too high: the tip will become an instant stamp when introduced to the wood and create a shape with stark edges which will be difficult to disguise or cover.

If I'm working on a very soft wood and want a gentle smudgy mark, I blow very gently across the tip before it reaches the wood to take away some of that initial heat, then ensure I keep the tip constantly moving in graceful, sweeping balletic movements once it makes contact with the surface.

Shader tip sampler

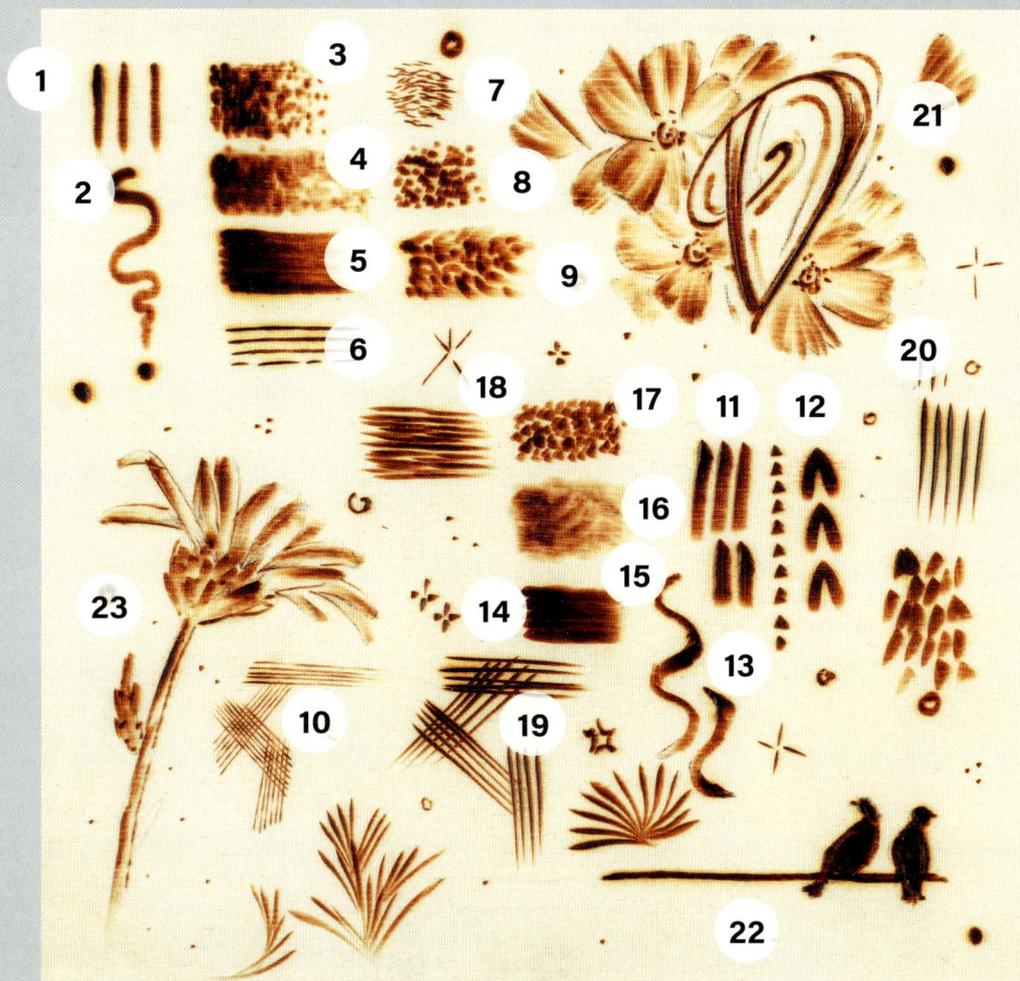

1 Bold straight lines with a spoon shader.

2 Curved lines with a spoon shader.

3 Stippling with a spoon shader.

4 Scumbling with a spoon shader.

5 Fill shading using a spoon shader to make parallel lines.

6 Lines using the toe of a spoon shader with the pen held upside-down.

7 Tapping the toe of a spoon shader with the pen held upside-down.

8 Tip scumbling using the tip of a spoon shader held at 90°.

9 Short line askew, using the tip of a spoon shader held at 90°.

10 Delicate fine cross-hatching with the toe of a spoon shader and with the pen held upside-down.

11 Straight lines with a flat shader.

12 Mark-making with the toe and foot of a flat shader. Using a flat shader as a stamp or brand iron is great for creating textures such as fish scales or snake skin.

13 Curves with a flat shader.

14 Varied pressure curves with a flat shader.

15 Parallel line fill with a flat shader.

16 Scumbling with a flat shader.

17 Stippling using the toe of a flat shader.

18 Short line fill with a flat shader.

19 Cross-hatching using the side edge of a flat shader.

20 Lines using the toe of a flat shader.

21 and 22 Combining a flat and spoon shader.

23 Combining various marks using a flat shader.

MINI BURN – BEE HAPPY

I love bumblebees! Those busy little barrels of sunshine flying through the air and humming amongst the flowers – how can you resist? *Bee Happy* is a super-smiley introductory and forgiving mini burn to get you buzzing with those tips. It's designed to be completed with a basic standard wire loop writing tip, but it can also be tried with a flat shader (side on), a ballpoint tip, or even a solid point machine. Why not try it out with a number of different tips and compare results? You'll be surprised at how versatile some of those funny-looking tips are.

I've used a poplar coaster for this mini burn, but you could use any small softwood panel, such as birch or basswood (avoid pine). If you don't have wood, try using a heavy hot-pressed (HP) paper.

MATERIALS AND TOOLS

Surface: 8cm (3¼in) diameter poplar coasters

Materials: Derwent Drawing Chinese white pencil (7200) (optional)

Tools: Razertip SS-D10 and wire writing tip, tracing paper or layout paper, blue transfer paper, burnishing tool (a ballpoint pen or hard pencil will do)

The reference image is taken from one of my paintings.

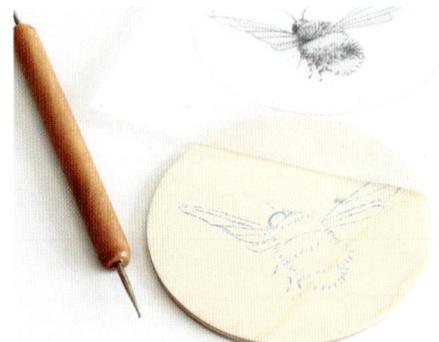

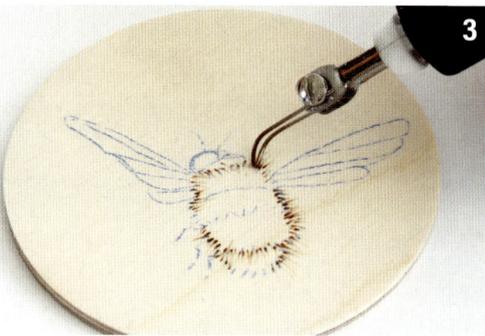

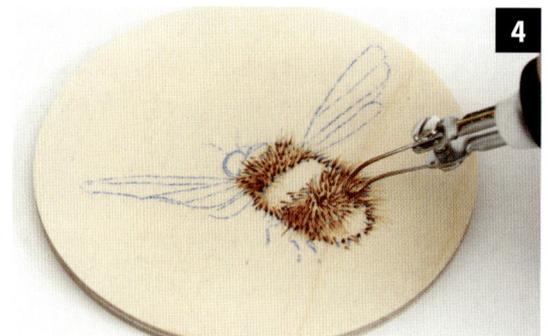

1 Sand your wood (see page 27) until the surface is really smooth, then cut a piece of tracing paper to the size of your coaster or small panel and adjust your drawing of the bee to fit the shape. To begin with, don't attempt the bee any smaller than I have here – approximately 7.5cm (3in) from wingtip to wingtip.

2 Position your drawing over the wood and transfer it to the wood using a burnishing tool and blue tracedown paper (see page 29).

3 Using the Razertip SS-D10 and a writing tip at a medium heat, start creating the short lines of the bumblebee's fur (if you are using a different machine and/or tip, you'll need to adapt the temperature). Think of the lines like the end of a small tick-mark: as you flick the line up, bring it away from the wood to create a clean sharp exit. The length of your line will also affect how your bee looks: the longer the line, the shaggier the fur. Be mindful that your lines follow the form of the bee too.

4 Complete the darker areas of the bee's fur using those same flicked lines. The closer together you put the lines, the darker the area. Vary the direction of the stroke in some places to create interest and texture.

5

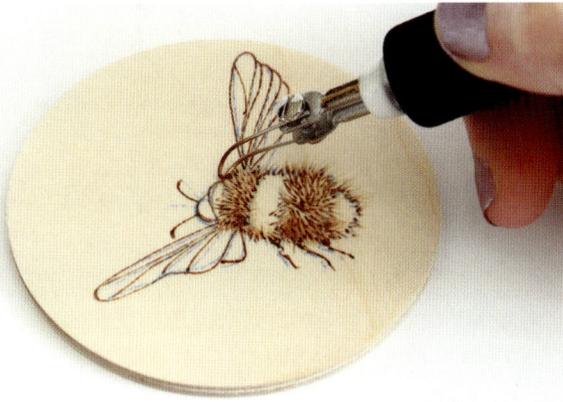

5 Next we are going to create the longer lines on the wings. There's no need to press hard, it's all about control – you want your tip to glide along the surface like an ice skate. If you're unsure, practise on a spare piece of wood until you feel more comfortable. You are aiming to get an even burn along the length of the line. If your line's looking blobby, see page 171 for some tips on getting a clean mark.

6 Use the tip to add dots to the wings, face and lighter parts of the body areas to add definition to those areas. Add dots to the head in much the same way. Try to keep them even and light. Keep building up those tones, alternating between short clean lines and dots to create texture and form, until you feel he's finished.

Well done! That's the scariest bit out of the way. You should now have a feel for the tip and the surface you're working on.

6

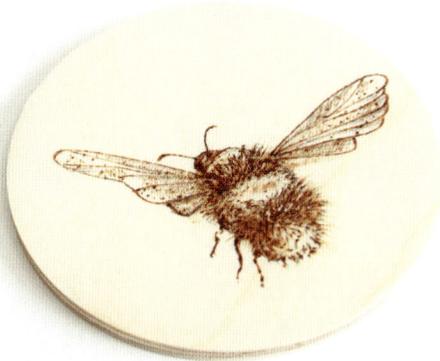

Bee Happy 8cm (3¼in) diameter

You can choose to add some white at this point if you fancy. I think it gives some nice contrast to the piece, but you may choose to leave it as a pure pyrography piece. If you would like to use white pencil, then simply apply it in the lighter areas in the same way that you applied the short strokes in step 3.

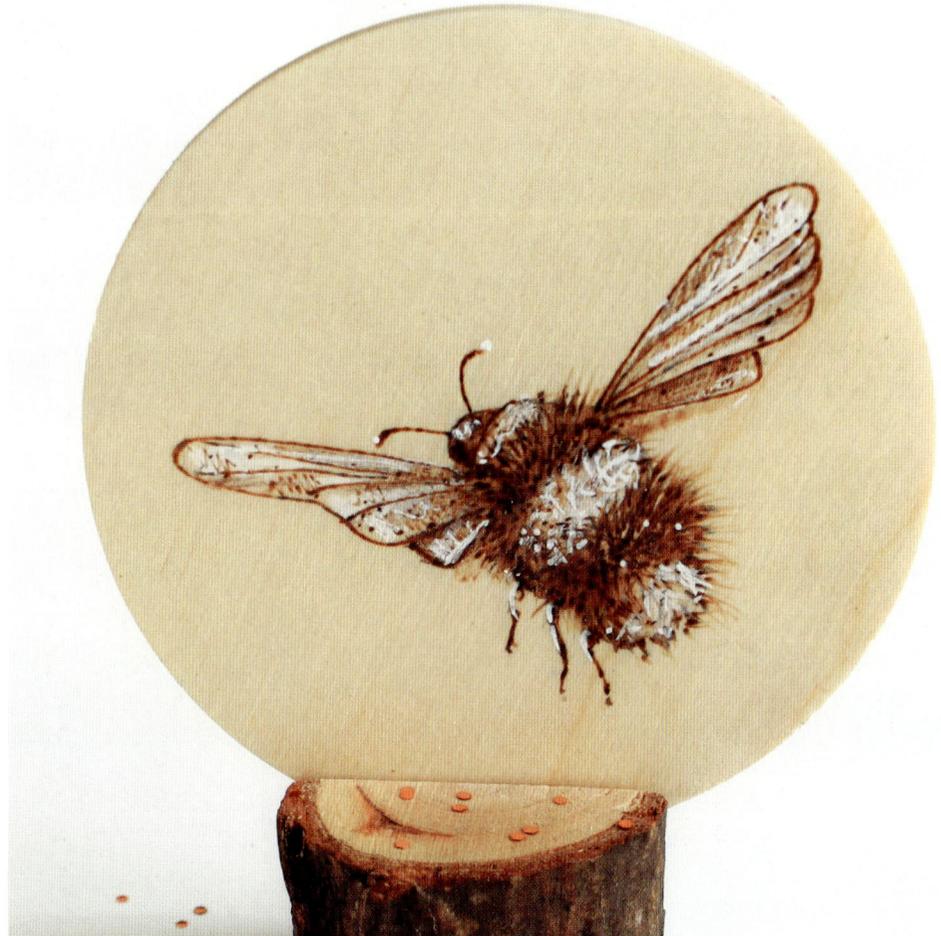

MINI BURN – 3D BUTTERFLY

This exercise will let you experiment with a flat shader, giving you practice in using the toe, edge and flat of the tip to develop both line and tone. Before you start, follow the steps on page 29 to transfer a simple butterfly shape onto your wood.

MATERIALS AND TOOLS

Surface: Poplar panel, 15 x 15cm (6 x 6in)

Materials: Derwent Drawing Chinese white pencil (7200)

Tools: Razertip SS-D10 with flat shader tip, blue transfer paper, putty eraser

1 Set the pyrography machine on a medium temperature. Use the edge of the shader to make fine marks with the toe of the tip. Don't press down hard; let the heat of the tip do the work. Start on an area that will be naturally dark so that you can disguise it later by drawing the shading in from the line.

2 Shader tips are awkward to make tight curves with, so feel free to turn the wood where possible to avoid having to make awkward angles with your hand or the tip.

3 Continue working over the design lines.

4 Begin to add the shading with the flat of the shader. Start in the darkest areas, gently stroking the tip over the surface in the direction of the form. Poplar will turn dark very readily, so there's no need to build up the tone in multiple layers as there would be with a harder wood. This means you can achieve the correct depth of tone in one swoop – but be careful not to overwork it.

5 With the darks in place, turn to the midtones. Reduce the temperature on your machine slightly, and use repeated strokes of the flat of the tip out from the butterfly's body to build up tone on the wings more gradually. This will give a feathered effect.

6 Use a putty eraser to remove the blue tracedown marks from the design.

7 Decide which direction the light is coming from – in this example, from the top left. All the shadows should be made away from this light point. For shadows, it's better to have the temperature down low, so you can build up the tone gradually, rather than risking making too-dark marks. Make tiny circular marks with the flat of the tip, and keep it moving. This ensures you avoid making definite marks, and instead achieve a smoky, soft effect.

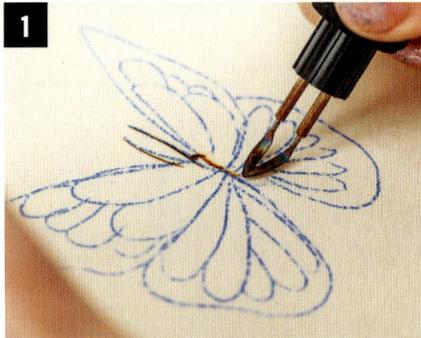

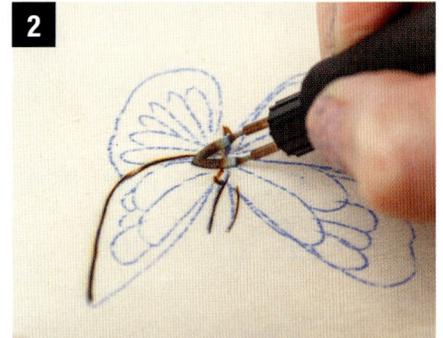

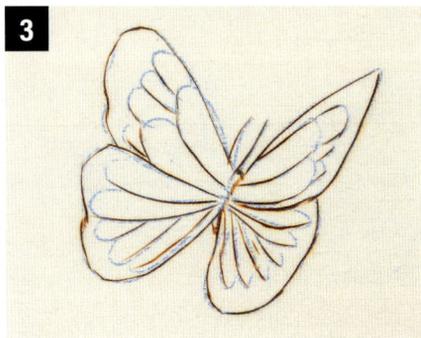

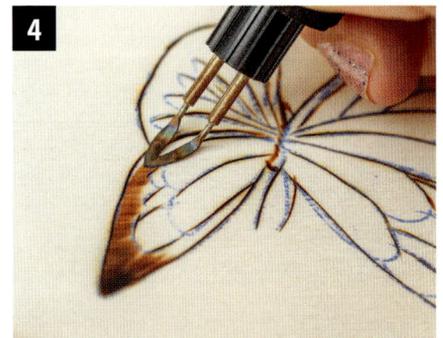

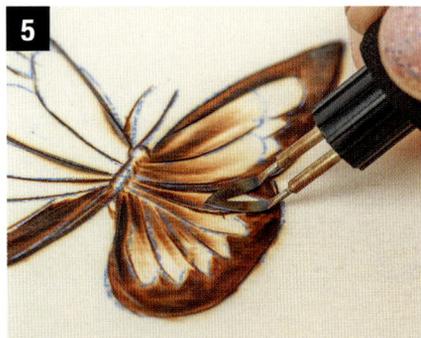

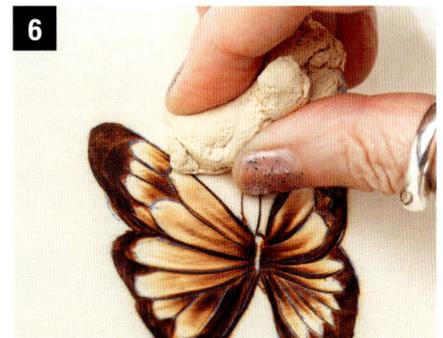

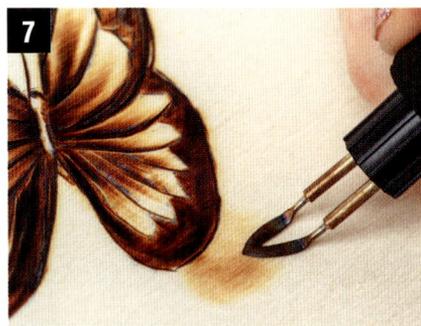

HOT TIP

Blow lightly on the tip before applying it to the wood. This cools it a little, ensuring you don't go in too dark initially.

3D Butterfly 15 x 15cm (6 x 6in)

The finished mini burn is shown above, alongside a similar one that has been taken a little further with watercolour pencils (below). We'll look at how to expand your pyrography options with colour later in the book.

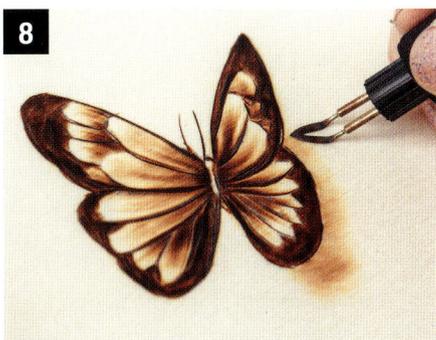

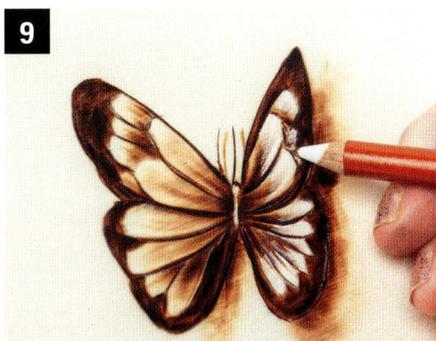

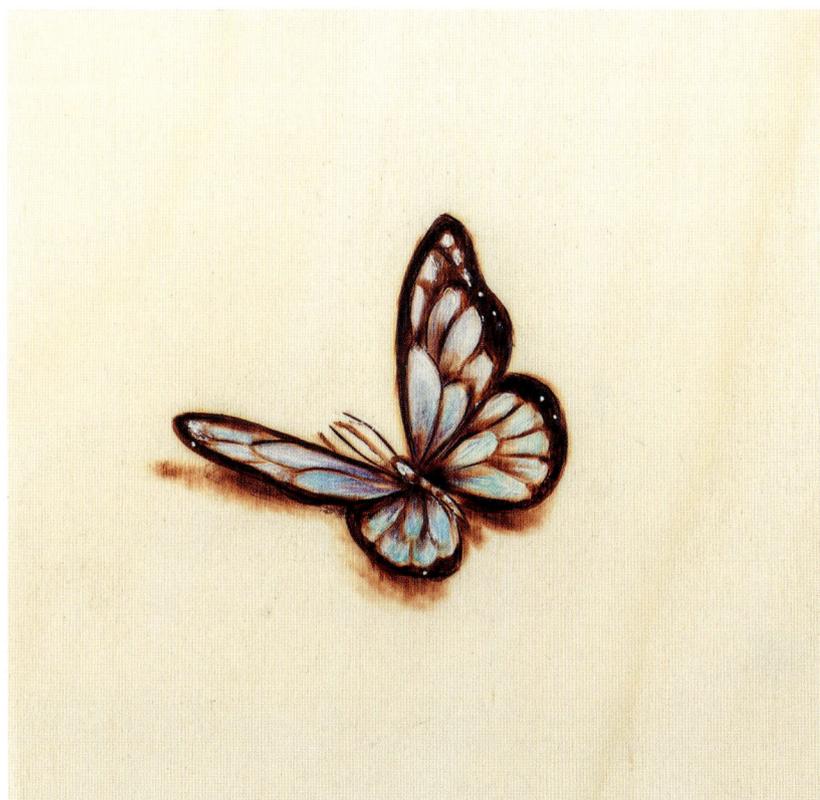

8 Gradually build up the shadows with the smudgy marks. Keep the darkest part of the shadows next to the butterfy itself, and make them lighter further from the butterfly. Don't be afraid to work over the edges of the butterfly itself – this will connect the butterfly to its shadow, and because it's relatively cool, you don't need to worry about scorching the existing dark areas. Just make sure to keep the tip moving!

9 Once you have developed the shadows to your satisfaction, use the white pencil to add a few highlights to finish.

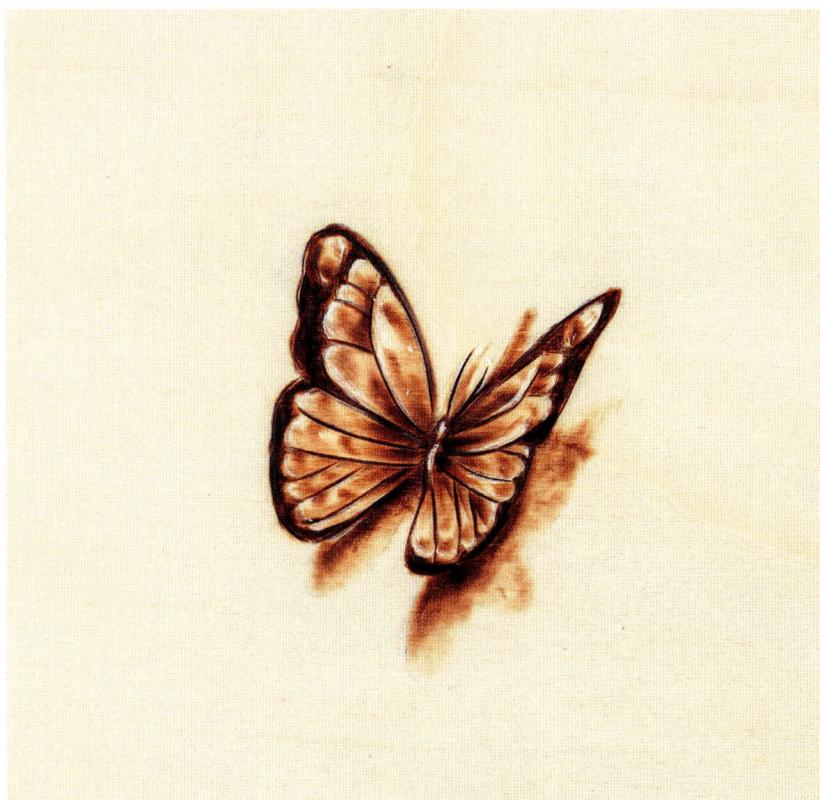

TONE, TONE, TONE!

One of the wonderful things about pyrography is that you don't have to worry about mixing colours, it's all about your values. Tone is created through heat (temperature), technique and layering.

Identifying the values – lights, darks and midtones – within your work early on will enable you to successfully create a sense of atmosphere, depth and space. Any parts of the wood that you do not burn will become the lightest areas – and therefore the highlights.

But be aware – different woods burn at different temperatures and different machines burn at different heats. There's a lot of variety there! To remove the guesswork and give yourself a fighting chance, you can create a tonal scale for each type of wood (or other surface) that you burn on.

What to include?

Creating a tonal scale for each new surface really helps to predict the colour values and will allow you to confidently tackle the darks. Below are a few pointers to get you started, while the exercise opposite will take you through the practical aspects of making a tonal scale.

Wood Creating tonal scales for each surface on which you work will quickly build up into a handy reference library. It's therefore very sensible to keep track of which type of wood you worked on! I write the name of the wood at the top.

Machine and tip I include notes on which machine and which tip I've used – you'll notice that I've made marks with both a writer and a shader.

Numerical scale Breaking up tone into a numerical scale that matches that of your machine makes it easier to use as a reference. My Workhorse machine, the SS-D10, for example, has a temperature dial that ranges from 1–10, with 1 giving the lightest possible tone you can create with the tip, and 10 as the darkest. Note that I include a '0' on my tonal scale as a control – that is, the mark is made while the tip is cold. This ensures you have a quick idea of what the natural colour of the wood is for comparison. Wood naturally varies, so if your next piece of poplar (for example) is a hint darker than your tonal scale, you can easily adjust.

Surface tone

Of course, not all woods will allow as varied a range of tones as the poplar example here. The darker the wood, the more you restrict the tonal range, which can impact on your depth of field and can make highlights tricky too. Lighter woods such as poplar, birch and maple will give you a wider tonal range to play with, resulting in stronger contrasts and brighter highlights.

If you're thinking of tackling a highly detailed piece, or looking to complete a high contrast image in pure pyrography, think carefully about which wood you choose to begin with.

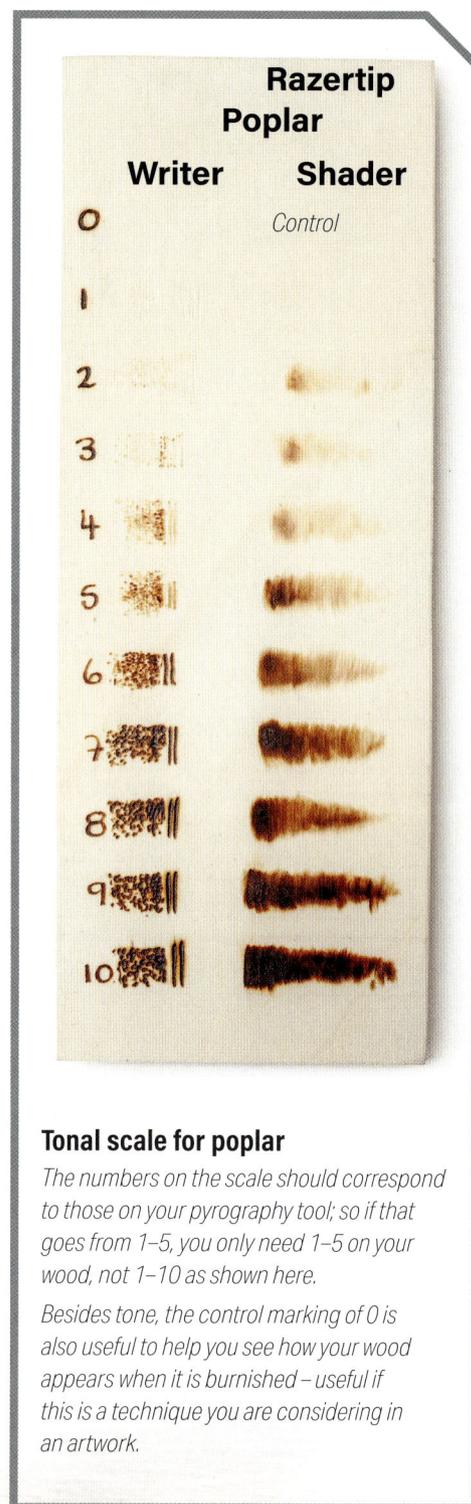

Razertip Poplar

	Writer	Shader
0		Control
1		
2		
3		
4		
5		
6		
7		
8		
9		
10		

Tonal scale for poplar

The numbers on the scale should correspond to those on your pyrography tool; so if that goes from 1–5, you only need 1–5 on your wood, not 1–10 as shown here.

Besides tone, the control marking of 0 is also useful to help you see how your wood appears when it is burnished – useful if this is a technique you are considering in an artwork.

CREATING A TONAL SCALE

This super-effective simple exercise will really help you to assess your tonal values and temperature settings while you work: lights and darks can be really deceptive. It also allows you to confidently dial up the temperature without unnecessary concern.

When making a tonal scale, it's important to use the same wood and tip for your scale as your intended project: different woods and tips will behave differently, so you won't get an accurate tone comparison.

1 Using a writer tip, add the numbers 0–10 (or the appropriate increments for your machine) down the side of an off-cut of the same wood as you'll use for your project.

2 Using the first tip you intend to use on your project – in this case a ballpoint writing tip – turn the temperature to 1 on your machine, and make a typical mark or set of marks next to the 1 on your scale. You will likely find that the tip doesn't make a visible mark at very low temperatures – that's not a problem, so don't worry.

3 Turn the machine to the next value (2 here) and make a mark, at a similar pressure for a similar time, next to the 2 on your tonal value.

4 Continue in the same way down the scale. Keep your marks consistent.

5 You'll likely find tips behave very differently to each other. Small tips, like this writer, burn very hot because there's such a small surface area. Even at setting 8 here, a halo of damaged wood has appeared; don't feel you have to continue past this point. There's little sense in testing things that you know you'll never use. Here, I've put an X next to setting 10, to remind myself never to use the tip this hot on my project.

6 Repeat the process for the other tips you intend to use. Here, I tested a flat shader tip; using the flat, the edge and the toe of the tip to see the marks each makes. Note that, since the flat has got a large surface area – and therefore doesn't get quite so hot as the ballpoint writer – you don't start seeing visible marks until further down the tonal scale, but you can use it right to the end without unduly damaging the wood.

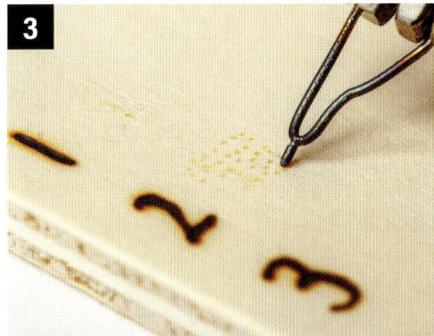

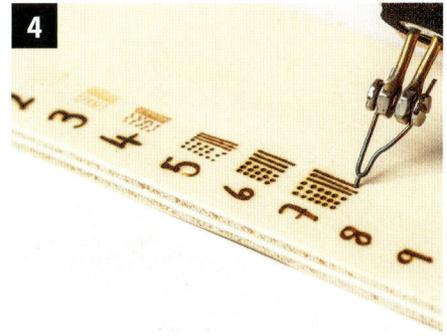

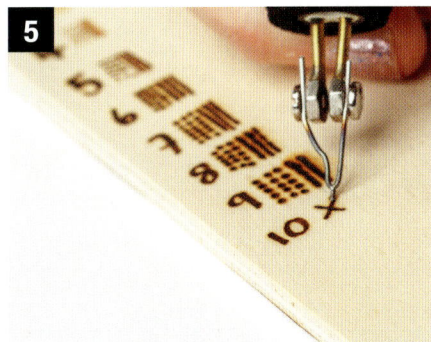

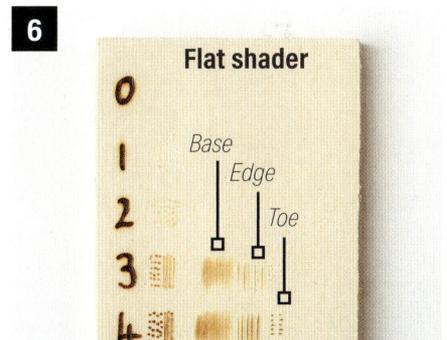

The finished tonal scale

At this point, I add notes to remind me which machine I was using, what the surface was and which tips were used. Note that we don't make a mark next to 0 (unless we are considering burnishing) as this is the control value; the colour of the wood in its natural state.

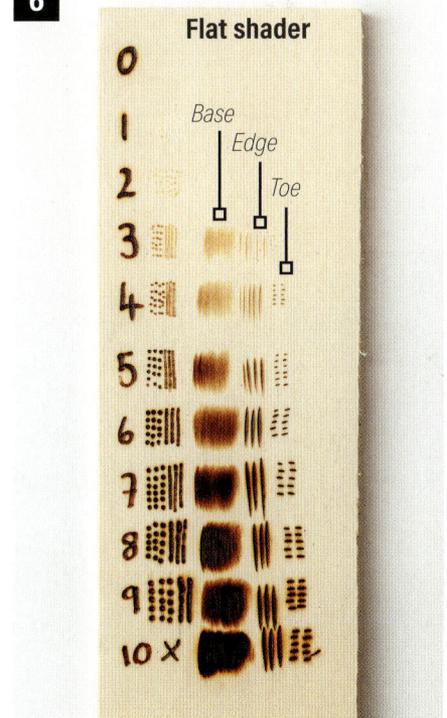

Simplifying: converting to sepia

If you are working from a reference photograph, you can use an image manipulation app or program like Adobe Photoshop to alter your reference image to sepia tones. Let's look at putting all this tonal talk into action using a fabulous photograph of a French Bulldog. It's a great quality reference image with some lovely contrasts, colours and textures. By converting it to sepia, identifying tones and cross-referencing them with your tonal scale is made much quicker and easier.

Using this technique is a great way to free you up in your art and painting practice, as it prevents you becoming colour-obsessed. It will allow you to purely focus on the shading and tonal values, and also aids with identifying the light source.

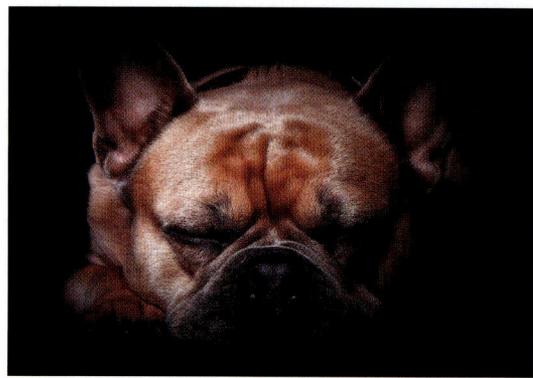

Picture credit: Myléne2401, via Pixabay.

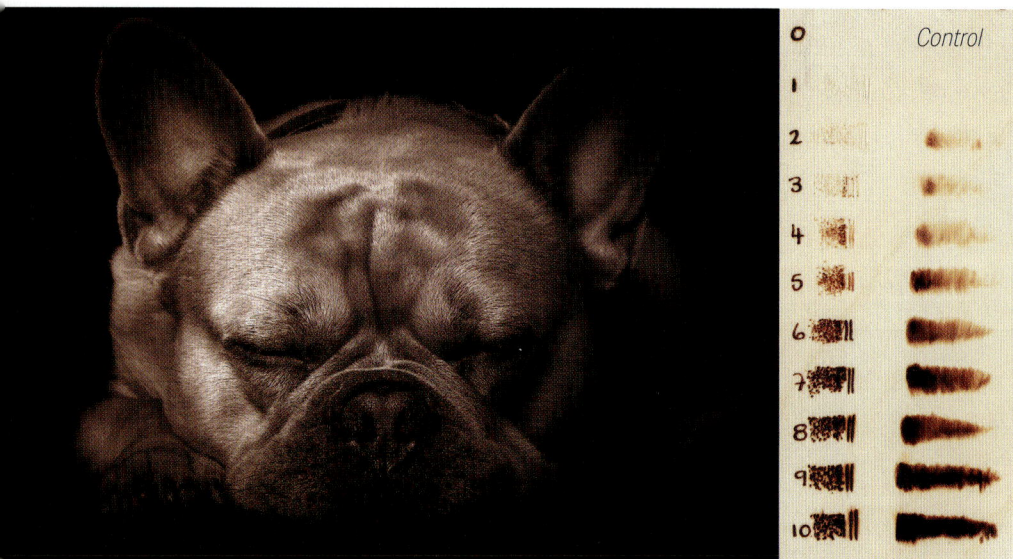

HOT TIP

If you want to push the contrast a little more and add a touch of spice and drama, try adjusting the saturation setting of the reference image in your app, or play around with the black point and/or vibrancy settings.

1 Alter the reference image to sepia in your app. This strips out the colour except for warm hues that correspond well to the base colour of the wood.

2 Print out a good quality image of the adjusted picture – you can now compare much more easily with your tonal scale.

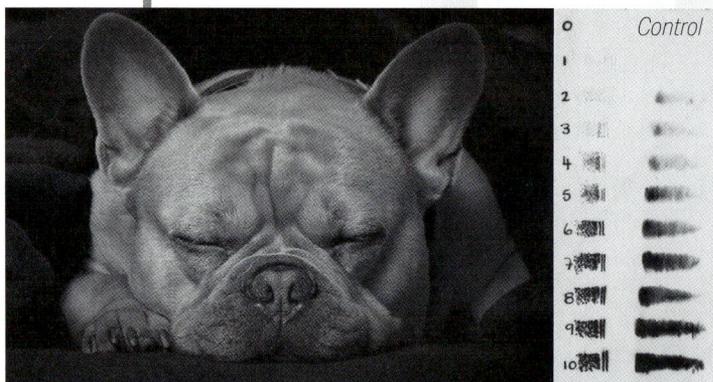

HOT TIP

If you find it difficult to manipulate images digitally, then simply photocopy your coloured reference image alongside your wooden tonal scale. The result will be a greyscale version of both wood and tonal scale, allowing you to cross-reference that way.

USING YOUR TONAL SCALE

Holding your scale next to the picture will make it easier to compare tones in isolation, giving you an indication of the temperature setting you need to set for your tip. In time and with practice, you will begin to recognize the tones from your sepia reference image against the wood (or other surface) – but it's always useful to have a tonal scale handy to double check.

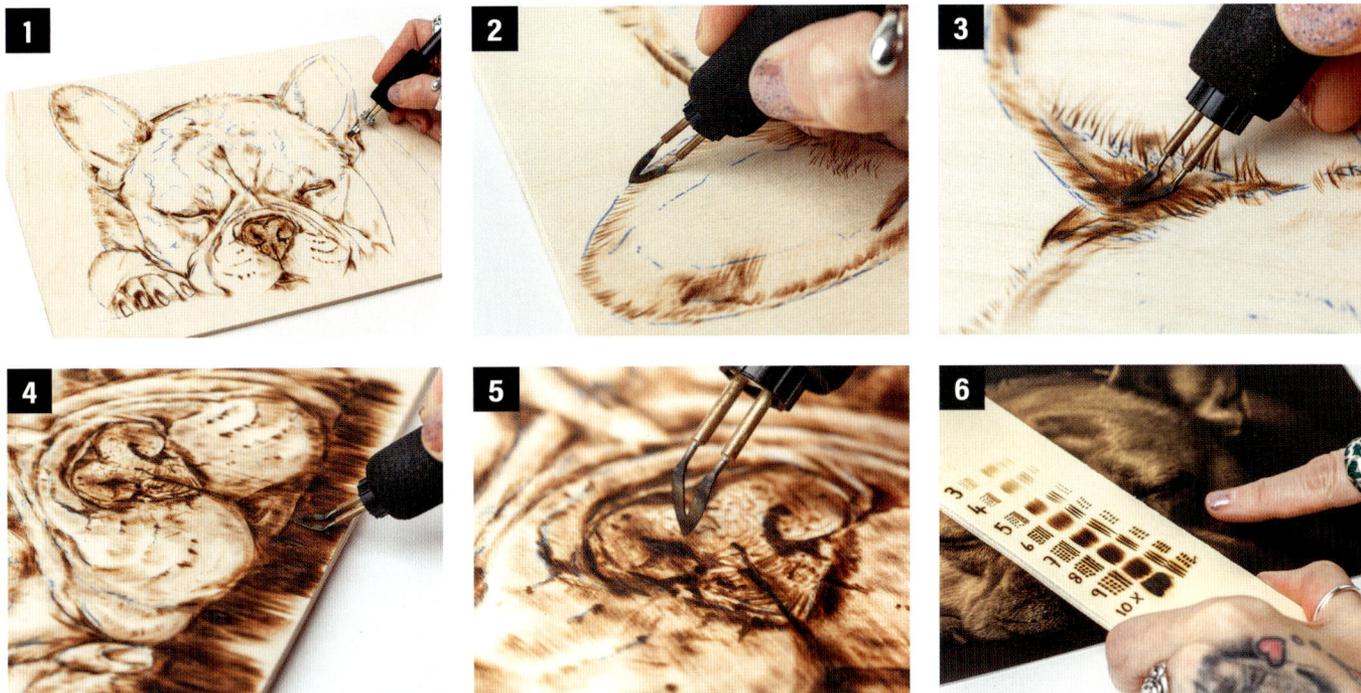

1 Begin sketching out the basic lines and midtones using the flat shader tip.

2 Use the side of the flat shader to create the fine lines for fur. Use a medium heat and stroke the pen in the direction of the fur.

3 Use the base of the flat shader to add some midtone shadows.

4 Add deep shadows in the same way, using repeated applications of overlapping marks towards you.

5 Use the toe of the flat shader to add some wandering marks to suggest the texture of the nose.

6 As you continue to build up the dark tones, check the tone you're creating by holding the tonal scale next to your sepia reference image. This dark area, for example, matches the mark made at setting 7 with the flat of the flat shader.

7 Match the temperature setting for your tool, and confidently continue to shade using the foot of the tip, building up those darks.

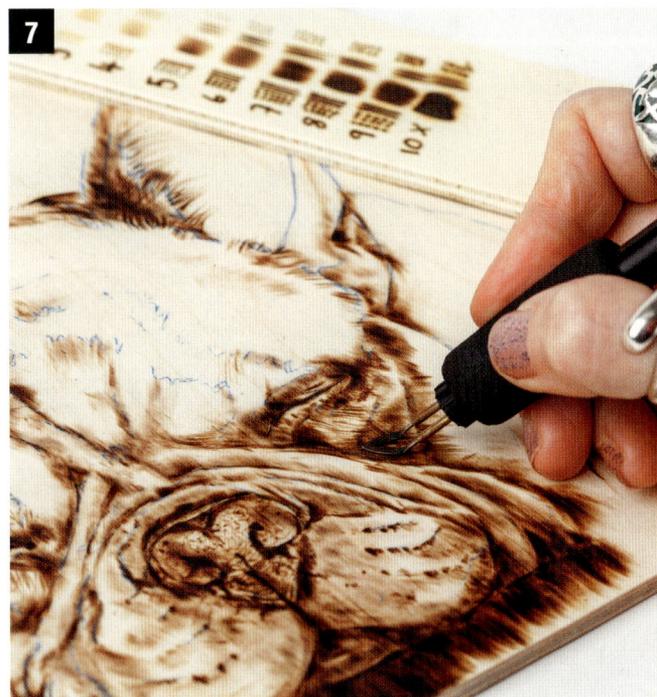

The finished bulldog can be seen on page 62.

CREATING FORM WITH TONE

There are a number of interesting ways you can create form with mark-making techniques. The three most common techniques in pyrography are stippling, hatching and soft shading. Certain tips are better suited to certain techniques, but if you don't happen to have them in your collection, basic tips can be adapted to create similar marks with a little practice and creative thinking. Each technique can be used independently or can be combined together throughout a piece. Let's get your burn on and look at a few key pointers in a bit more detail.

Form with stippling

Stippling can be used to create the illusion of form and tone with a series of small uniform dots.

The tips most suited to stippling are ballpoint stylus tips, but you can try using a writing tip or the toe of a flat shader. Once you have the technique nailed, try mixing things up a little: incorporate dots of different sizes or, if you have a variable temperature machine, layer dots at different temperatures. You might explore using a different shape – the results might be surprising.

For this example, I'm working on Crescent HP artboard, but feel free to use any surface you like.

1 Draw a circle lightly in pencil on your surface (I've drawn around the lid of a jar). Decide where your light source is coming from. For this illustration I've chosen around 1 o'clock and slightly from the front.

2 With a medium heat and a ballpoint writer tip, hold the pen more upright than usual. Begin marking areas of shadow following the form of the sphere. Group the dots closer together towards the base, to build up the darkest area.

3 Continue building up the shadow and form of the sphere adding more dots to the darkest areas and less concentrated dots in the midtones and lighter areas. Graduate the dots randomly towards the area of highlight.

4 Turn up the temperature slightly and make another pass over the sphere (if you don't have a variable temperature machine, hold the tip in place longer to make a darker dot). Look at the shape as a whole and adjust the placement accordingly. Begin marking out the cast shadow, leaving a slight gap around the base of the sphere.

5 Erase the pencil marks and continue building shape and form with another layer of dots to define the edges and re-establish the shadow areas. Disperse dots away from the cast shadow.

Form with hatching

A great technique favoured by illustrators, hatching revolves around the humble line. Hatching is the creation of short quick strokes in one constant direction. The closer the parallel lines are made to each other, the darker the tone created. Cross-hatching is simply overlapping those short strokes in one or more different directions.

Practise parallel lines by drawing a series of hatching lines on a piece of scrap wood or HP paper with a variety of tips.

Hatching is particularly suited to the skew tip, which forms a crisp, clean line. If you don't have a skew, try using the side of a flat shader. A writing tip can be used, but the lines are never as well-defined.

Contour hatching is a variation on the basic parallel hatching technique shown below. It differs only in that the lines follow the contour of the outline you're portraying, rather than being straight.

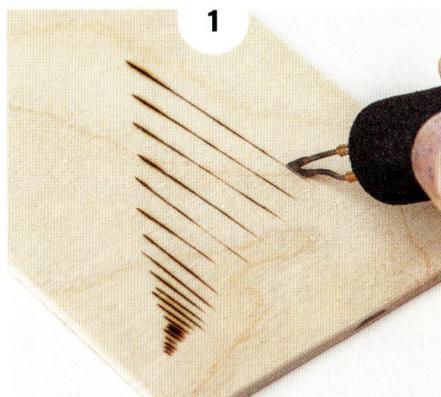

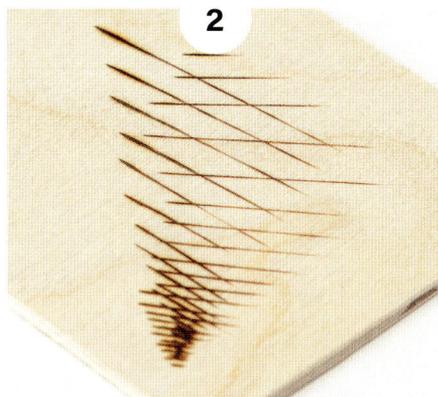

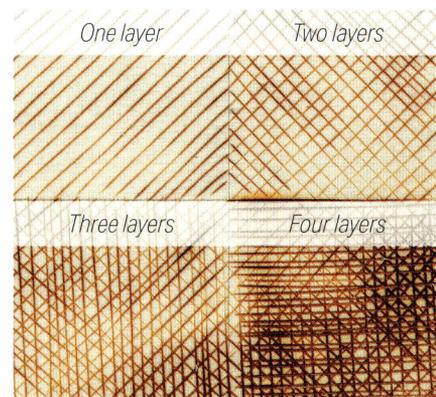

One layer Two layers

Three layers Four layers

1 Start by drawing a series of parallel lines. These lines can be vertical, horizontal or diagonal (it's up to you) but the lines should not cross and should remain parallel to each other. The spacing between them can be varied: the closer together, the darker the shading.

2 The basic hatch is the first step in cross-hatching. To cross-hatch, draw a second layer of lines over the first set, going in the opposite direction. Keep your lines smooth, controlled and parallel to each other.

Darker values can be built up with further layers of parallel cross-hatching lines in different directions. Practise adding darker tones to your sample by applying subsequent layers of lines at even distances (as shown above), then repeat the same using lines at varied distances to compare. Both methods are handy and great to integrate into your work.

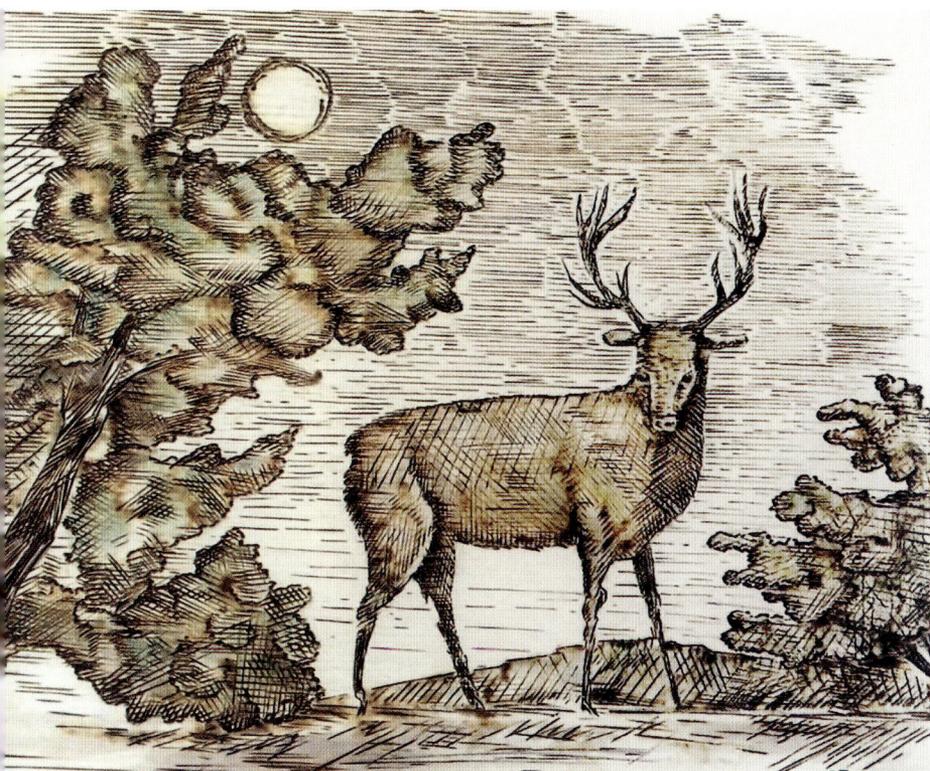

Stag and Moonlight 30 × 20cm (11¾ × 8in)

Most of the tone and interest in this image was produced using a skew tip and simple hatching techniques. Notice how the encroaching night-time atmosphere has been created by using differing sets of hatched parallel lines. The clouds are hinted at using simple hatched broken lines which vary in length. The distance between each set of lines increases towards the horizon.

Cross-hatching, using a variety of layers, was used to give the darker areas and shadows more definition. Simple contour hatching was used on the tree trunk and moon. Note the moon is one of the few areas in which no shading is used. It's left the colour of the wood and lights up the scene.

Soft shading

Soft tonal shading is perhaps one of the great signature styles of pyrography. Soft shading techniques are used to create beautiful rich gradients of tone to suggest depth and form, and a natural edge is created rather than a harsh outline. Tonal shading is all about control, patience and a soft touch.

You won't be surprised to hear that the tips best suited to soft shading are shading tips – but there are many ways to achieve good results. As you practise, you will find you own preferred method and tips. My personal preference for soft shading, for example, is an angled spear shader. As with all the former exercises, let your vision and intuition be your guiding light.

Controlling your temperature, speed and technique are the key to a successful soft-shaded burn. If you are using a unit with variable temperature, you will have more control over the burn. If you're using a unit with a temperature scale that ranges between 1 and 10, your working range should typically fall between the 2–4 setting for paler tones and 4–7 for the darker tones, which can be deepened by layering. Dialling the temperature up too high will cause the tip to begin to glow an orange-red which can permanently weaken your tip. It also creates an unsightly bleeding or halo effect outside your burn area on the wood when you mark-make or shade. If you don't have a variable temperature machine, you will need to experiment with speed to create the gradients: the slower you go, the darker the burn.

Building up soft transitions and paying close attention to tonal shifts can be used to produce very detailed and realistic work. It takes time, but it's worth it. Here are some key pointers to get you jump started on using the soft shading technique:

HOT TIP

Take a moment to consider the movement of your hand and your grip on the pen – if your hand is too tense or tight then that energy will be transferred to your work and can result in patchy uneven shading – shake your hand out and relax when you work.

SOFT SHADING HOT TIPS

- Use a shading tip. Place the flat foot of the shader against the wood and move it across the surface. Experiment and find what works best for you.

- When using a shading tip, the stroke will always be the darkest where you first touch the wood as the tip is holding the most heat then. As you pull through the stroke, the heat will dissipate into the wood and the tip will become cooler and so the burn becomes paler. Use this to your advantage: always pull your strokes from the darker shaded areas to light.

- The tonal value of your mark is not only determined by temperature but also by the speed of your stroke. Try slowing your stroke if it becomes too pale as you work.

- One of the best methods of building up areas of deep dark tone with a shader tip is to build layers with slightly overlapping lines in a series of passes, rather than going in with a high tip temperature.

- Build your layers up gradually. You can always go darker but it's hard to go lighter.

- A shading tip will pick up all those peaks and troughs in your wood, so ensure that the surface you are working upon is well-prepared and sanded. If you're working on wood and want to do a large soft-shaded piece, select a variety without a strong pronounced grain (basswood, poplar and birch are all good options). Hot-pressed paper and vegetable tanned leather are other interesting alternatives.

- Negative shading is a technique where you fade your shading to an outline edge or shape, then surround that shape with a darker burn. It's a great way to delineate boundaries and edges, as shown opposite. It's called negative shading because you are working in the negative, rather than positive space.

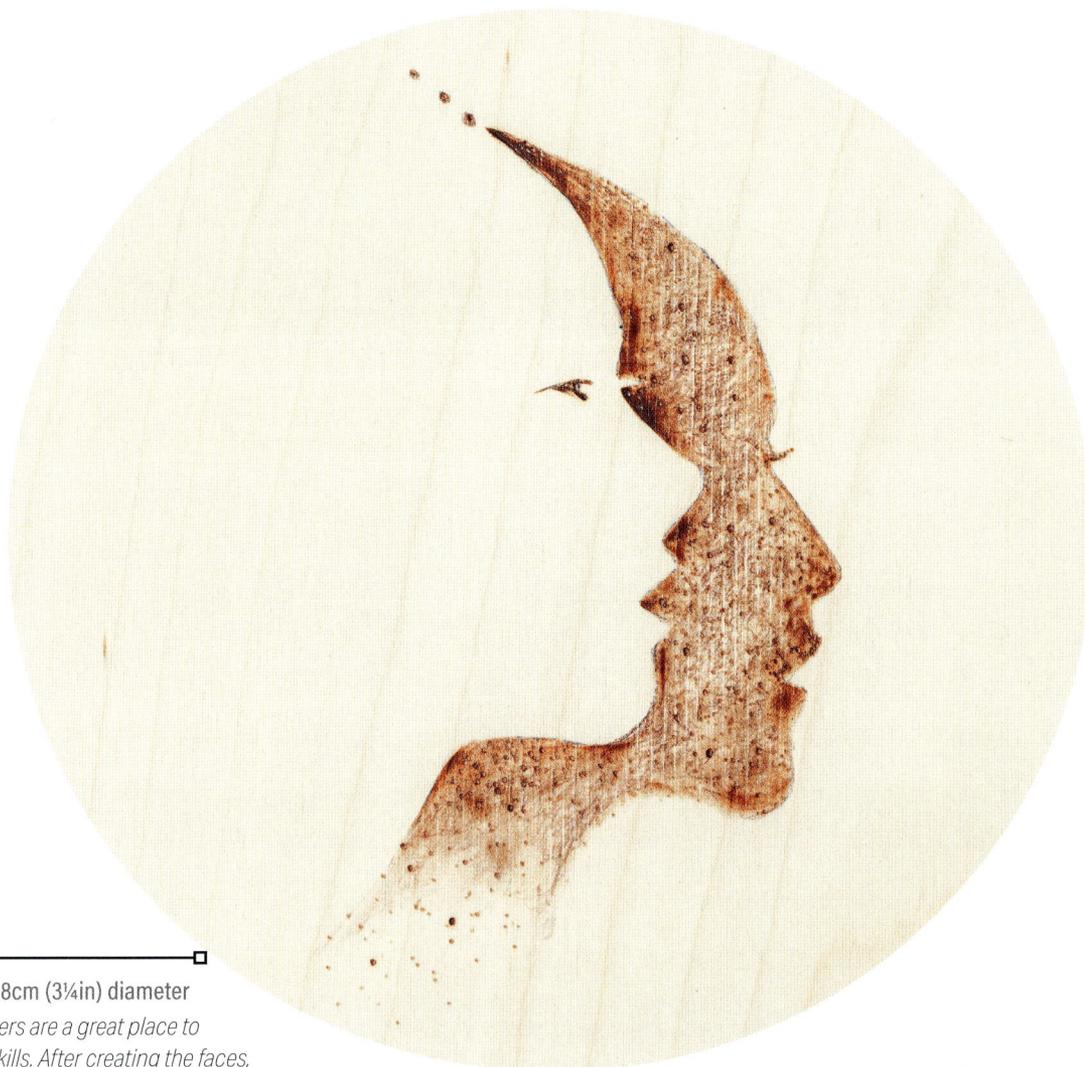

Two Faces 8cm (3¼in) diameter

Wooden coasters are a great place to
practise new skills. After creating the faces,
I used the tip of the shader to add some details and
dots (see detail, right). It's good to practise making different
marks with a tip, and will take this little exercise to the next level.

Negative shading

These two faces are a simple way to illustrate negative shading.
I built up negative shading here to suggest a face in front – it's
like an optical illusion created through use of tone. The more
distant face was shaped using no outline, carefully cutting in
to reveal a positive shape within the image.

Negative shading allows you to play with the reverse image,
allowing the wood to remain the main focus.

TREE FROG

The is our first big project. This little chap hops up across different chapters to show you how to incorporate and mix different elements of the book into a finished piece. 'Why a tree frog?' you may ask. A frog is a great place to start as it doesn't have too much skin texture to worry about, and has a 'clean' shape with defined lights and darks. Secondly, as the surfaces of both the frog and the plant are smooth, it's a great way to start working with tone without getting bogged down with texture. The final reason is that this is a book about the magic of art, and my grandma always told me 'you gotta kiss a few frogs to find a prince' – Winnie was never wrong!

In this part of the project we're going to be burning him a dark, smoky background to show him off in all his croaky glory.

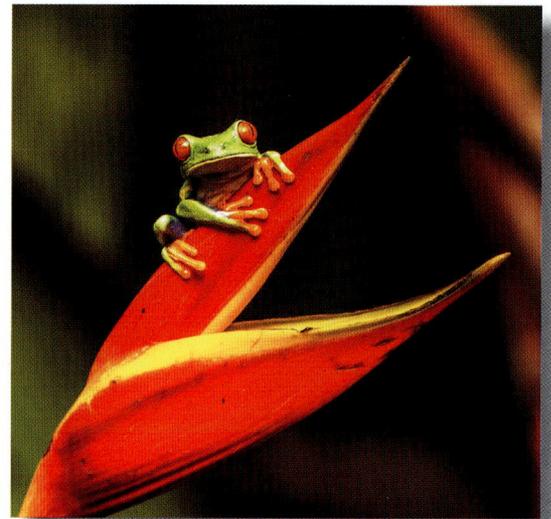

Picture credit: Zdeněk Macháček, via Unsplash.

MATERIALS AND TOOLS

Surface: Poplar wood panel, 30 × 30cm (11¾ × 11¾in)

Materials: None

Tools: SS-D100 with flat shader tip, or fixed point machine, blue transfer paper, burnishing tool (a ballpoint pen or hard pencil will do), ruler

THE INSPIRATION

Let's get started by checking out the reference image, above. Our frog friend is a light subject against a dark background. This offers a high tonal contrast which is rather pleasing, frames him well and looks quite dramatic.

Burning a black background is a great way to add drama and impact to a wood burning and enables lighter subjects to really stand out. The key to a great black background is patience and technique. Don't rush. Keep your shader flat and burn small sections at a time in a slow, controlled fashion and always (if able) follow the grain of the wood. If you attempt to burn too hot and too quickly your background will end up patchy and you can irreversibly damage the wood. If you press too hard or rock the shader tip from side to side when you work, you can dent the wood's surface and create an undesirable texture. Be mindful of how you hold your pen.

1 Transfer the image onto a well-prepared piece of poplar wood. Add a double square border as shown. Note that we break the border in places with the subject in order to add interest. Dark backgrounds can also create a lot of smoke, so work in a well ventilated area and with your work at an angle.

HOT TIP

You can choose to either burn along with this wonderful reference image or, if you feel more confident, then try using the same techniques and process on an image of your choice.

2 Outline the frog with a tip of your choice. I'm using the side edge of a flat shader. This initial line will create a 'buffer zone' to the heavier burning required for the background and protect the main subject from overburnt, smudgy edges as the temperature increases. Use the side of a flat shader and short descriptive lines which overlap to describe the shape and curves so it doesn't look too static.

3 Switch to the flat of the shader and extend the area of the buffer zone by gently pulling the lines away from the main subject. Take your time, don't press too hard and keep the tip flat to the wood. It's fine to extend the buffer lines around your subject into the dark area, as your marks will be integrated into the background.

4 Keeping your tip flat and using a gentle back-and-forth stroking motion, continue to block in the background, working on each area until it reaches the required depth of colour before you move to the next. If possible, try to make your strokes follow the grain for a smoother finish. It's slow and patient work. If the size of the background feels overwhelming, break the area down into smaller bite-sized chunks.

5 Continue until finished, moving your work around to accommodate the strokes. We'll rejoin our froggy friend on page 86, where we will start giving him some shape and form.

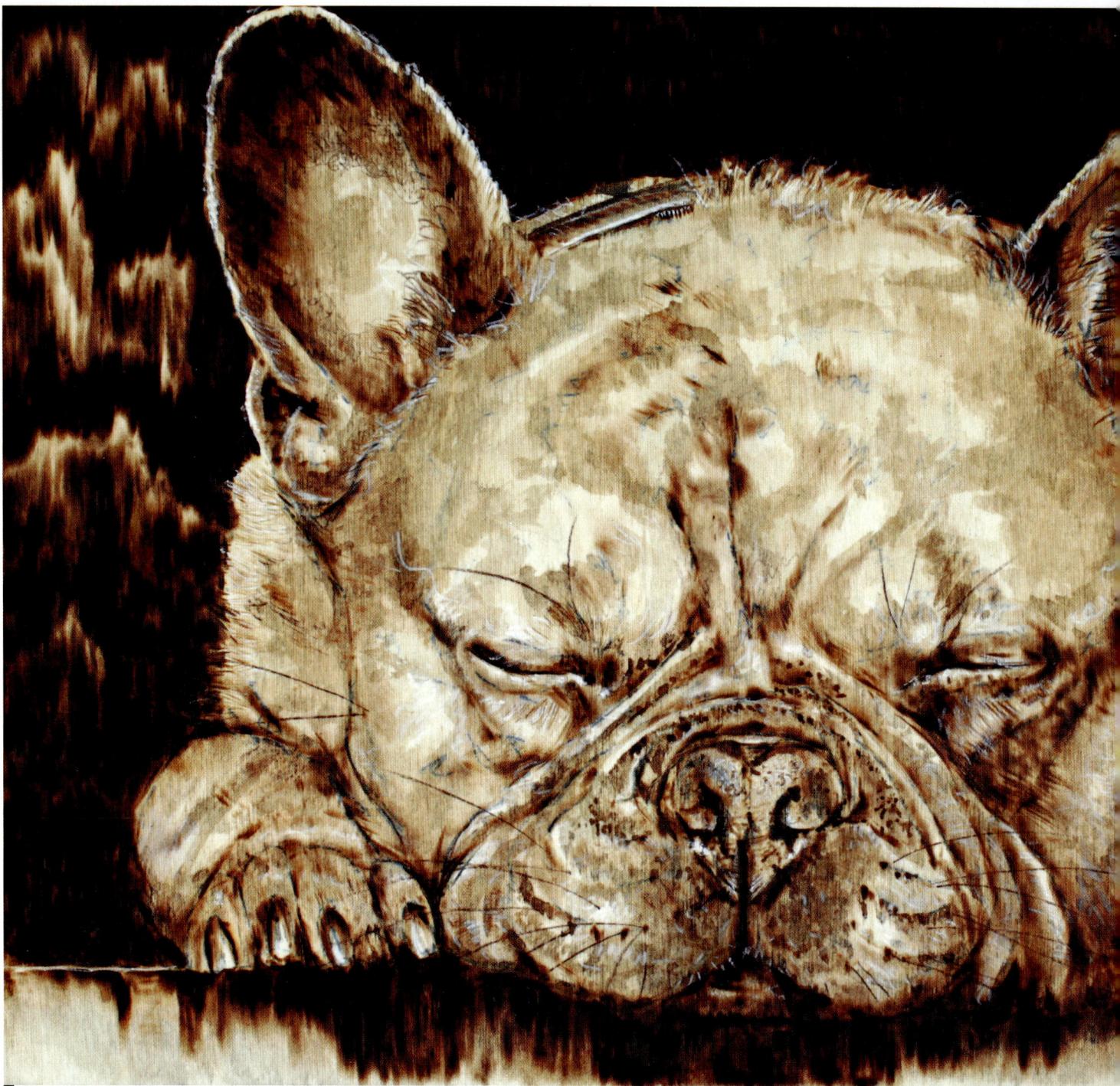

Frenchie 30 × 21cm (11¾ × 8¼in)

Pyrography and white pencil on birch panel.

'To dream of a place where the balls always fly,

And the moon's made of cheese, let sleeping dogs lie.'

As soon as I saw the photograph of this chilled-out little fellow, I knew that I wanted to create him on wood. He looked so content, relaxed and happy. I wanted to surround him with a dark, smoky background to increase the contrast of the piece and give it a dreamlike quality. This whole piece was done using just a flat shader.

DRAWING ON INSPIRATION

'It's not about what it is… it's about what it can become.'

The Lorax, Dr Seuss

I believe painting and creating is as natural as the rain. Small ideas and fireflies of inspiration fall all around us and collect into pools of ideas. Here they swirl, weave and whisper until they become a trickle, an inkling of intention that gathers momentum until it tumbles and spills onto your chosen canvas.

Pyrography, however, is a labour-intensive art form requiring time, controlled conditions and electricity, and therefore is typically studio-based. This formal, pre-planned and controlled way of working does not always come naturally or easily. Like many artists, I like to be spontaneous. There is a balance to be struck in order to ensure you can work the alchemical magic which will allow you to turn the water in your pool of ideas into the fire of action. This chapter of the book looks at where you can find ideas, and – importantly – how you can refine that initial spark into a practical plan.

THE UNIQUE RECIPE OF YOUR ART

Perhaps your art is not where you want it to be just yet? Don't worry. Always remember that every piece of art you create and every line you draw is an important part of the process and it's infused with a unique 'you-ness'. You just have to believe in the process, cut yourself some slack, and most importantly stop trying to be perfect. If you stop worrying about the destination and sit back and enjoy the ride, creativity and style development will follow. In the words of J.M. Barrie: 'The moment you doubt whether you can fly, you cease for ever to be able to do it.'

FINDING YOUR INSPIRATION

As general subjects, architecture, portraiture, wildlife and detail all lend themselves wonderfully to pyrography – but inspiration really can come from anywhere. Just look around you, see the world with the eyes of a child and trust in your own intuition. It's wonderful when you get that lightbulb moment, your fingers start to feel all fizzy and you just can't wait to get burning.

Sometimes it's a particular process that excites me, or a new way of approaching a piece of work. At other times it's the challenge of using a particular tip – or simply the wonder of 'how'? My advice is to look closer, and take the time to experience your surroundings fully. The tiniest detail can be intriguing and spark an idea, or you might find yourself drawn to the essence of a particular atmosphere – like the moment when you're stopped in your tracks by the radiant colours of sunset as the sun rests her sleepy head on the horizon, and the seagulls wheel across the sky.

My inspiration

It is the love of the natural gifts we have been given through nature – and increasingly the fear of losing the same – that is the unifying theme in all my art. I try to enlist the viewer into the emotion behind the art and strive to express the beauty, wonder, drama and fragility of the world around us. That moment when someone sees something that I have created and it touches them – when they 'get it' – that is the moment at which my art finds completion.

I have a very eclectic taste and I'm inspired by many things. Sometimes I am inspired to find magic in the tiniest detail, other times I'm drawn to the essence of an atmosphere, or the radiant colours of sunset as the moon chases her across the sky. More recently, I have felt compelled to use my art as a banner to raise awareness of the precarious plight and threats facing wildlife in today's harsh climate. Art can be an incredibly effective vehicle for communicating about tough topics in a non-confrontational way, and with it is the hope to ignite passion, awareness and perhaps an understanding in the viewer.

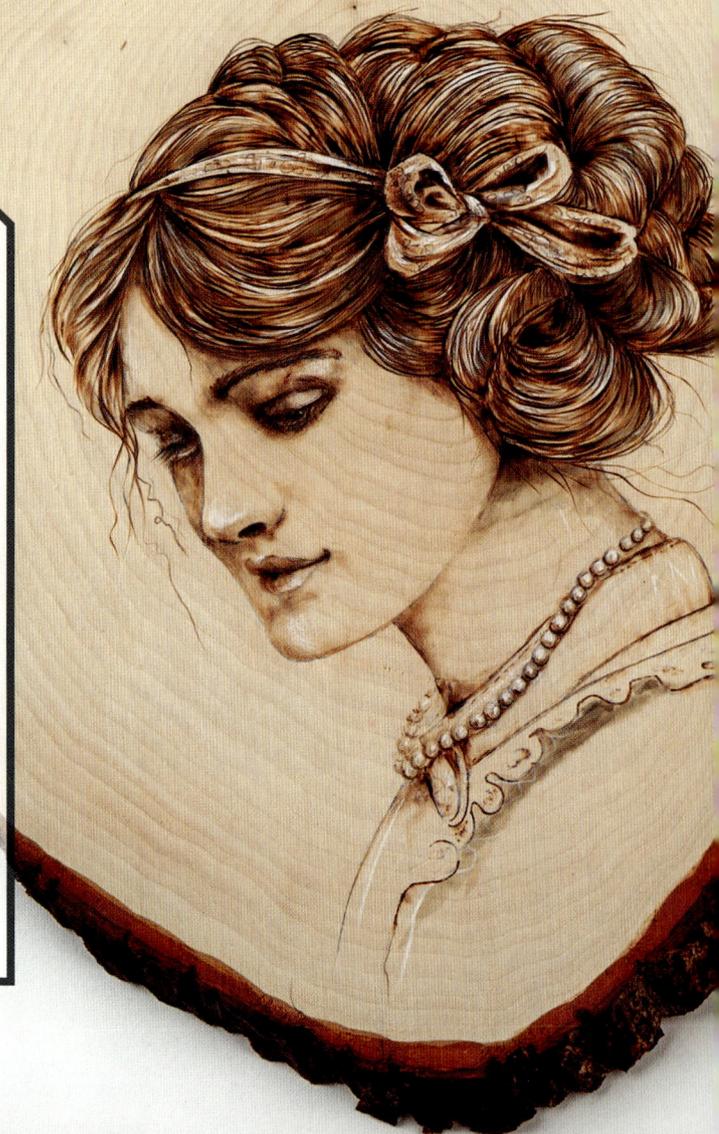

Words

I love words, they are important to me. Most of my work has words to accompany it in the shape of poems, phrases and sayings – I have included them in the captions for some of my finished artworks. They are fundamental to my art process. Sometimes words tumble around my head and wake me up at night asking to be painted – and so I keep a notepad at the side of the bed to write them down. Sometimes they form as I'm creating, taking shape and voice with every brushstroke. Words can create a world or trigger a single emotion and for me and they are an intrinsic layer of connection to my art: heart and mind working as one.

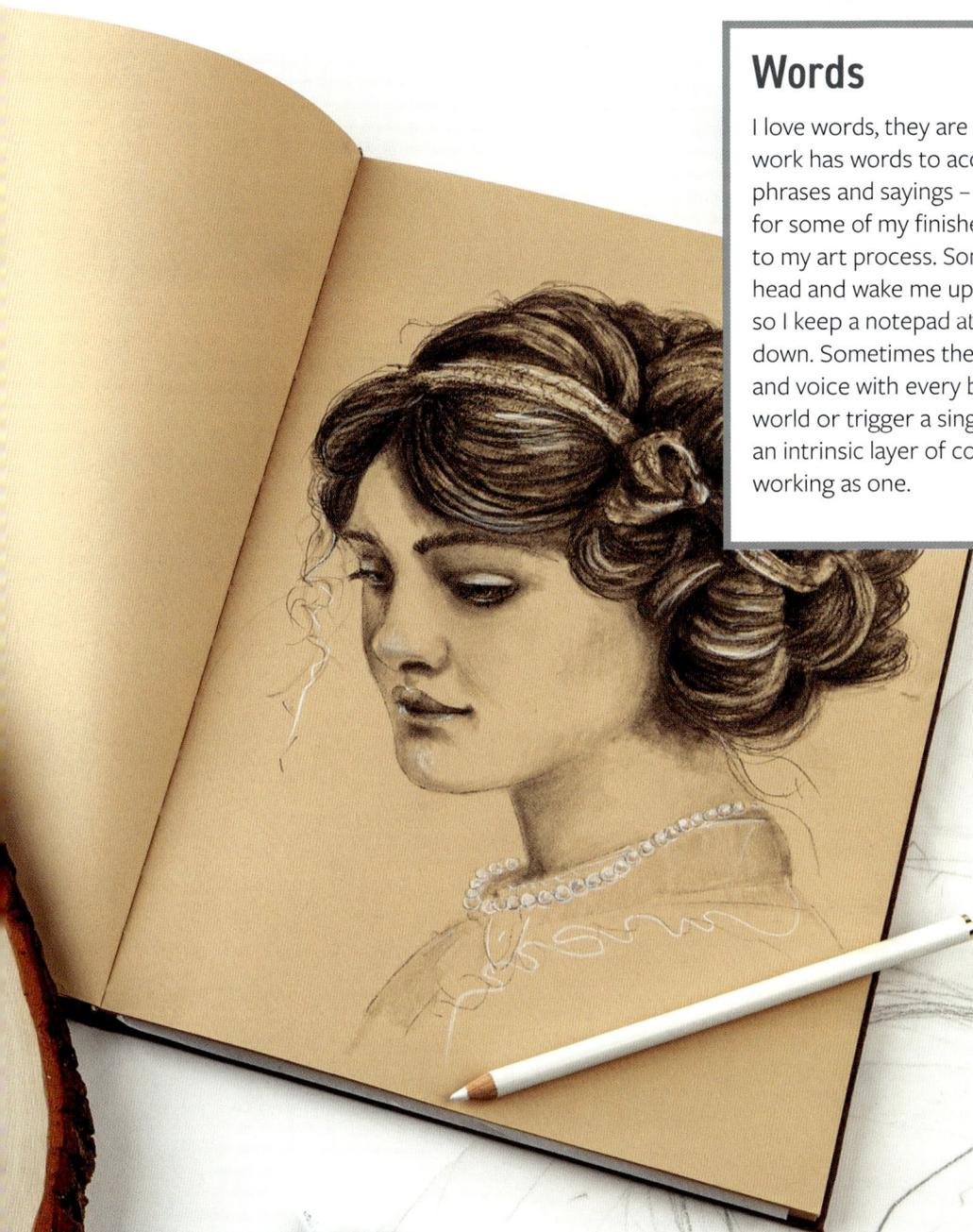

INSPIRATION FROM TECHNIQUES AND MATERIALS

I'm always playing with different media and techniques. Both can be valuable sources of inspiration. When I'm painting, I often wonder how I can transfer similar ideas or subjects to wood. Typically, if you can draw it, you can burn it!

I often switch between styles depending on what I feel like on the day and what I want to achieve. Many of us have transferrable skills from our work, lifestyles and experiences. Bring these to your art. Harness your emotions and create from them. I've swapped from drawing on skin to burning on wood, for example. Think of ways your own life skills can relate to your pyrographic art, and use these to guide and inspire you.

Listen to that inner voice. What do you want to create and what do you feel drawn towards? What do you want to say? Keep a notepad handy to jot things down and take pictures on your mobile phone of anything that inspires you. Collect images and sayings in a scrapbook for reference and doodle in sketchbooks – no-one has to see it but you.

Challenge yourself! Together with a few friends I started a group called 'Wobbly Wednesdays' when we were unable to meet up in person. As we could only communicate online, every Wednesday we took it in turn to pick a theme or challenge to inspire a new piece of work. The only rule was it had to be out of our comfort zones. What a giggle it was – and sometimes the seemingly impossible became the most rewarding. It just goes to show that you never know where a little adventure (or misadventure!) will lead you.

That's the wonder of art, you just unfold your creative wings and imagine your own universe. It's a safe technicolour bubble where anything is possible. Surround yourself with supplies that you love, experiment and play, find ways you like to work, learn the rules – then break them – and, above all, feel inspired to have fun.

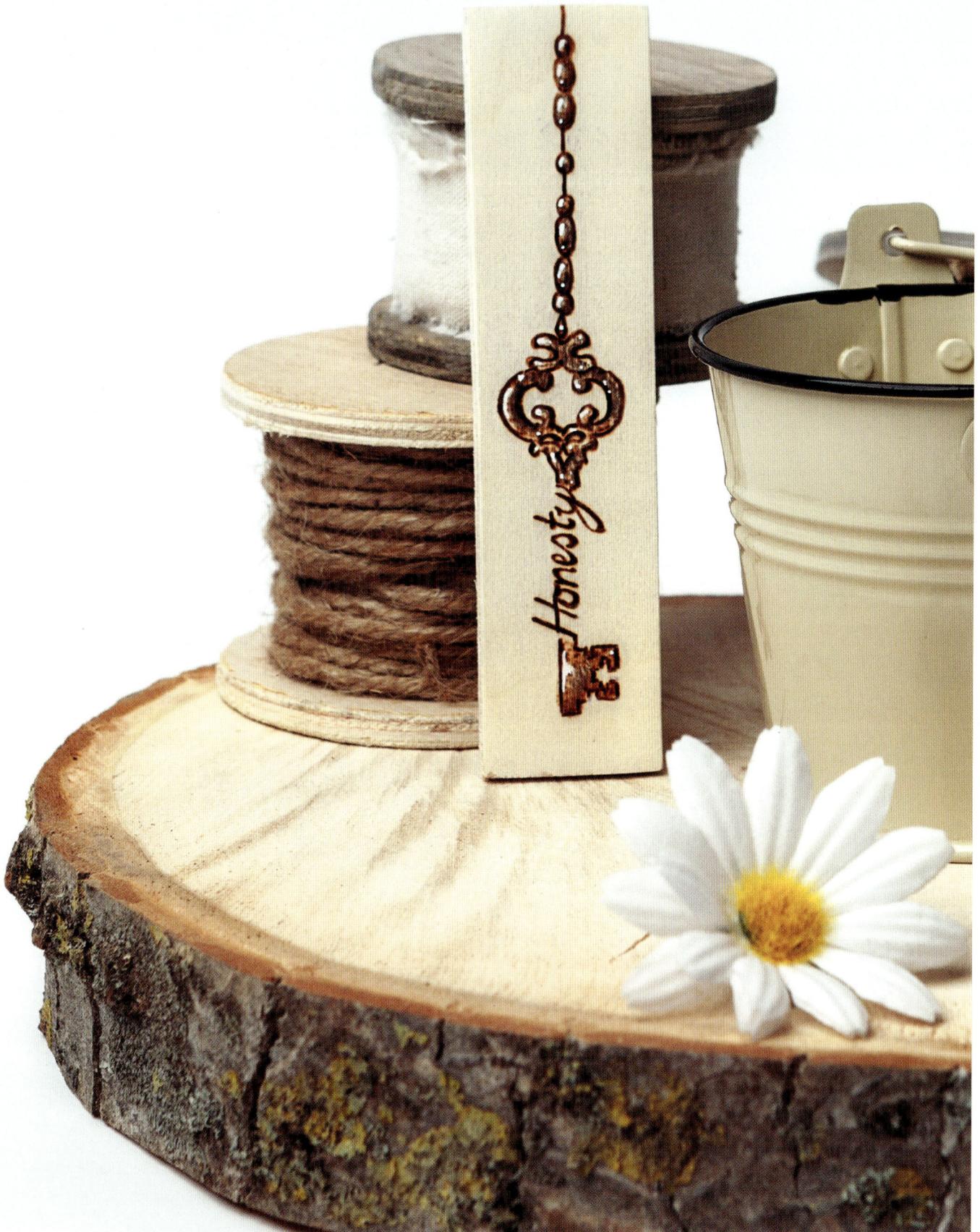

TURNING IDEAS INTO DESIGNS

Turning an idea into a design can be as simple or a complicated as you make it. Photographs make wonderful references but you should never be a slave to them. They are however, a great springboard into your work. Look for key shapes, composition and clean, connected outlines. Don't be afraid of moving things around to make a stronger image. Working from a photograph can be overwhelming, but remember: you're the boss. Use your artistic licence – and if you don't like it, feel free to make it up! We talk more about working from photographs on page 72.

 Line and poke work is a stylized technique that has been around since the beginning of tattooing, and it is all about simplification: describing an object using as a little information as possible (see page 118 for more on tattoo styles). It's a great way to get you thinking about what you are trying to say and what is important. In this exercise the focus for the piece is the hibiscus so the rest of the foliage is dismissed as excess noise and clutter.

THE INSPIRATION

While looking for an idea to show students how to create a simple line and poke tattoo-style burn, I found on my mobile phone this photograph of a beautiful hibiscus flower, taken on a day trip to the Eden Project in Cornwall.

THE RESULTING DESIGN

I sketched a simplified version of the flower onto layout paper cut to the same size as the wood panel I wanted to work on. Although simple, the design still needed to look pleasing, so the hibiscus flower was orientated so the stamen and leaves created a strong diagonal from top left to bottom right. An extra leaf was added towards the top of the flower to balance up the composition.

 To reaffirm the shape and check it flows nicely before transferring it to wood, try using a waterproof black marker to draw in the contours of the design on your layout paper, making any changes that are needed as you go. This step is also great for building muscle memory for when you come to using the pyrography pen.

MINI BURN – HIBISCUS

Line and poke work is a rudimentary form of depicting images – indeed, it's a form of non-machine tattooing that has been used throughout history and across cultures to mark the skin. Also called stick and poke, it involves applying ink to a needle (originally fragments of bone, quills or shaped wood) and then 'poking' it by hand into the skin, dot by dot. Such tattoos range in complexity from rudimentary dots, to detailed intricate pieces which take many hours and many sittings to complete. It's a technique that translates well into pyrography, as shown here.

 The key to successful line and poke work is the ability to simplify designs down to their basic forms and remove all the clutter – a fun exercise in itself, and a good example of how to turn an idea into a design.

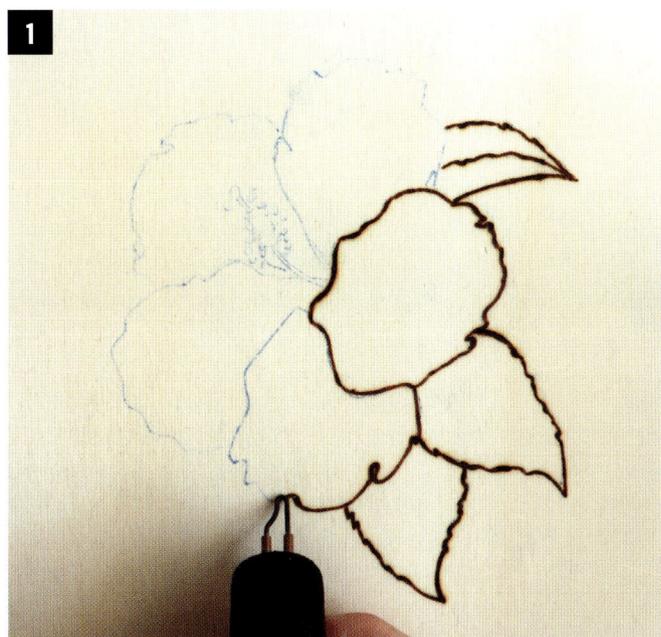

MATERIALS AND TOOLS

Surface: Poplar wood panel, 15 × 15cm (6 × 6in)
Materials: None
Tools: Razertip SS-D10 with writing tip and ballpoint tip, layout paper, blue transfer paper

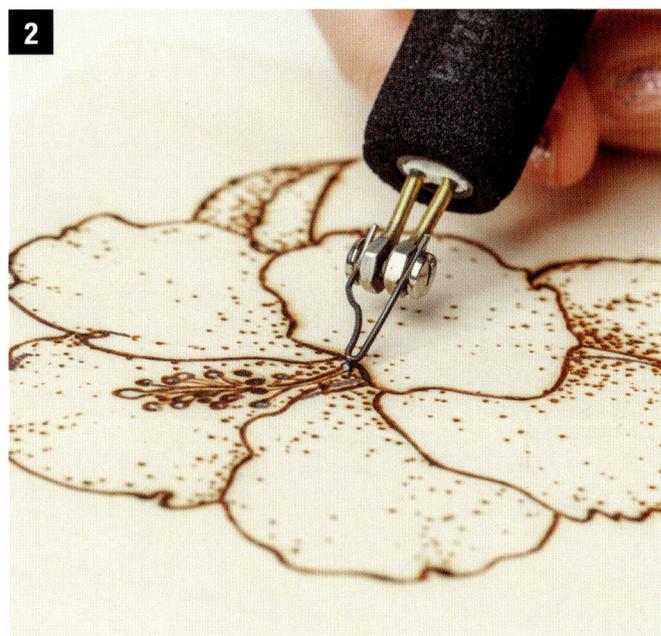

1 Transfer your design to your surface as described on page 29. Outline the hibiscus using a writing tip at medium heat with a strong, confident line.

2 Switch to a ballpoint tip and begin to 'poke shade' your image. Each poked dot should have a purpose. Consider your subject's form and areas of shade. Darker areas should have a greater density of dots. Keep your temperature and contact speed consistent to produce a simple but striking two-tone image. Remember, less is more with this technique.

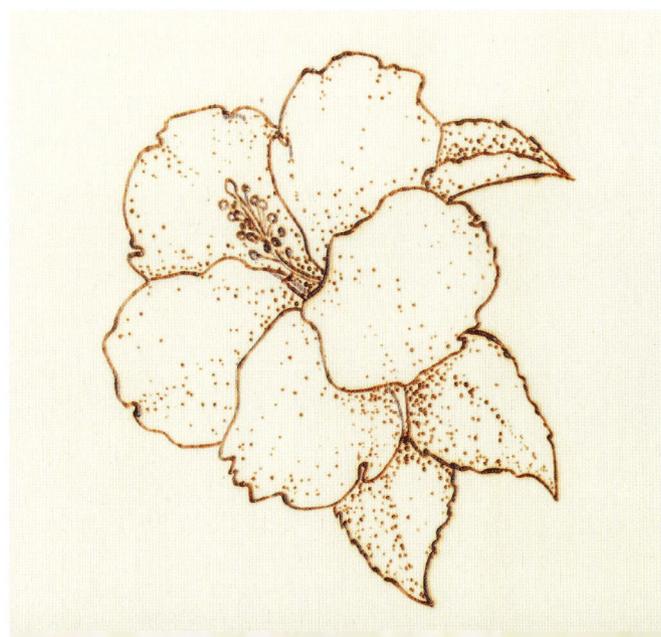

The tone and form of the finished flower is suggested with stippling. Although simple, it should be instantly recognizable as a hibiscus flower.

INSPIRATION FROM FRIENDS AND FAMILY

I mentioned earlier that inspiration for creative pieces of art can be gleaned from anywhere, including life experiences. This burning was born a lot closer to home. A lovely artist friend of mine, and an avid gardener, was the inspiration behind *Penny's Peonies*. She has the most amazing green fingers and everything she touches in her allotment grows and flourishes. In early 2020 her beautiful daughter Mel was unexpectedly diagnosed with cancer. Mel was such an inspirational, strong and vibrant woman and she sadly passed away a few short months later in her sister's arms.

Butterflies represent the spirit and personal transformation; many believe that they are messengers from the realm of spirit. So I decided to do a piece with the idea of a beautiful butterfly coming back to visit some peonies, one of Penny's favourite flowers. The butterfly chosen was one that enjoys the moors, one of the last places the family visited, and a firm favourite of Mel's. In the artwork, the peonies are grounded in our world and are reduced to monochrome. One of the flowers is facing away from the sun whilst the butterfly is vibrant, colourful and free.

I often play with contrasts of colour and tone, and enjoy how the two complement each other. I call this a 'colour pop', a technique we see more of later.

Earlier stages of the burn.

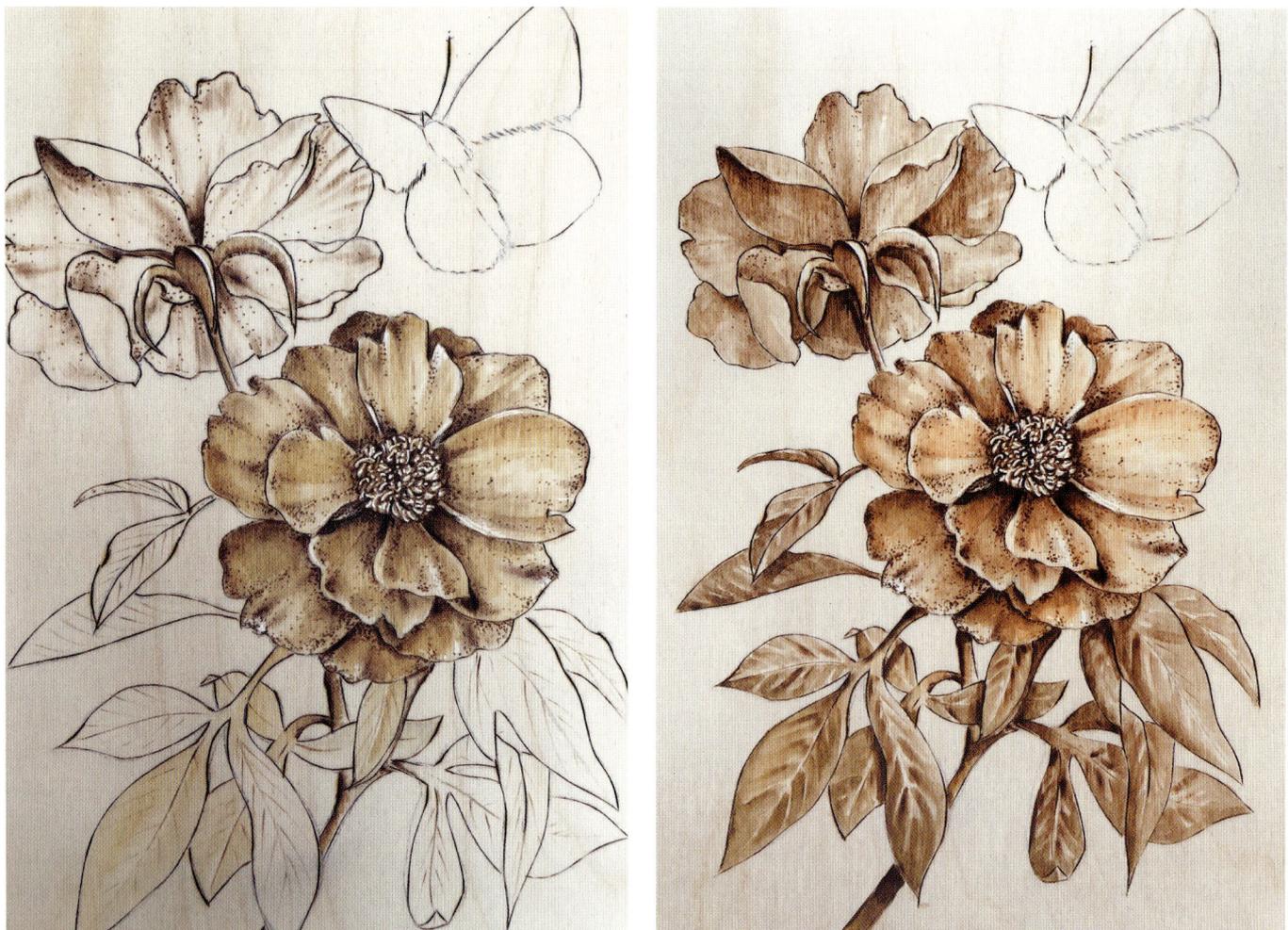

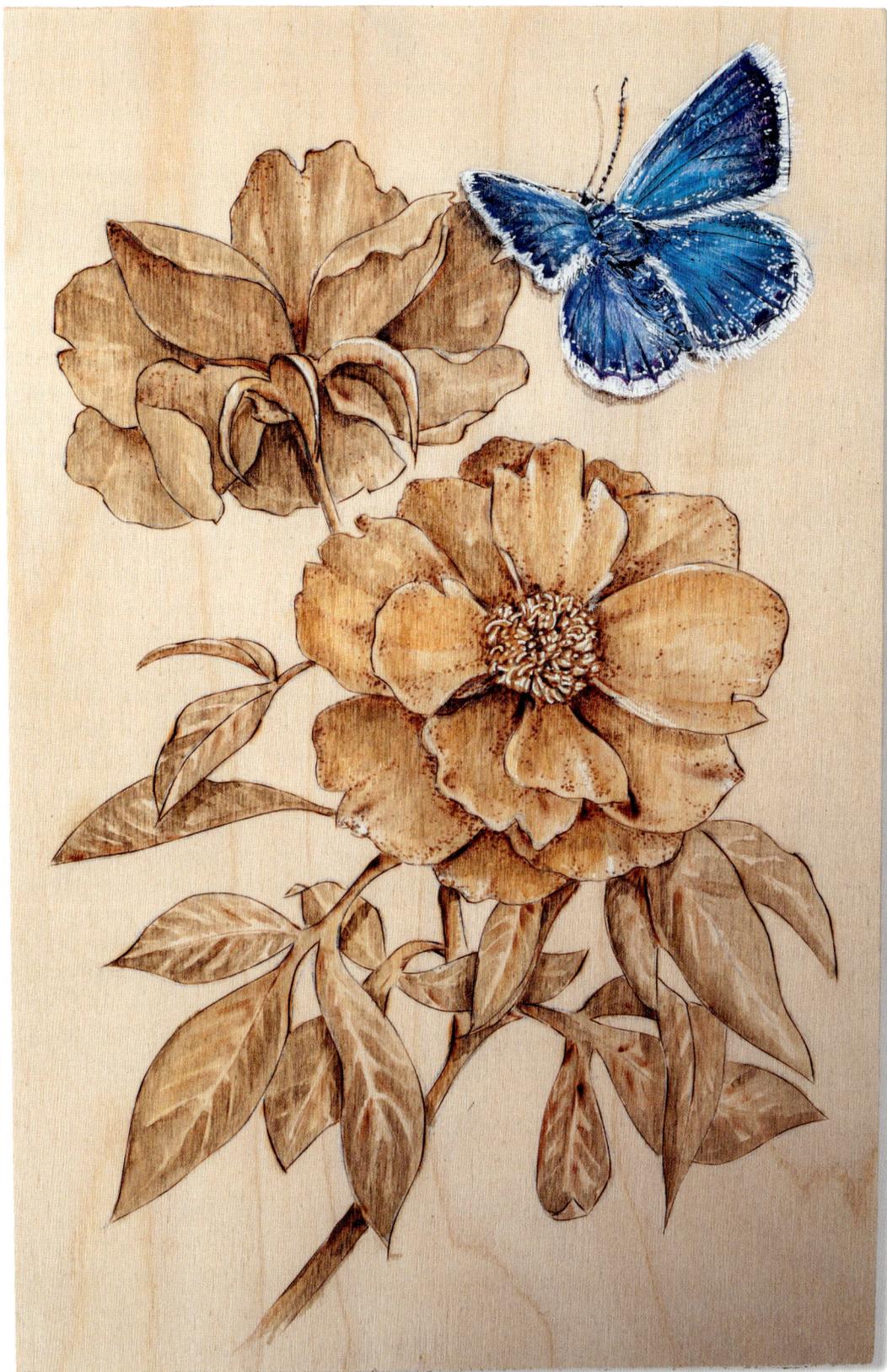

Penny's Peonies 30 × 40cm (11¾ × 15¾in)

Pyrography and acrylic paint on birch wood panel. In the collection of Mrs P. Lamb.

Producing a soft romantic feel and an organic form is a great exercise in soft lines and tonal shading. The majority of this piece was completed with a flat shader.

WORKING FROM LIFE AND FROM PHOTOGRAPHS

Many artists prefer to work only from their own reference materials, photographs, sketches, and *en plein air* studies. Working in such a way is undoubtedly wonderful, but to exclusively create in this way can be quite limiting. Take the subject of animals, for example. A wonderful artistic muse; their fur, hair, skin and detail lend themselves wonderfully to pyrography, but the subject matter itself can be tricky to capture. Animals are always on the move, which can make getting your own reference material difficult. It can become frustrating if you have a particular vision but lack the equipment, skill – or simply time – to get the detailed studies and images you need to realize your idea.

Apart from anything else, I certainly don't have many exotic species, let alone the creatures of myth and legend that I love to draw, roaming around the sunny plains of Sidmouth-by-the-Sea in the UK where I live! By leaving the photography up to skilled photographers, I have access to a much broader and deeper well of potential inspiration. It therefore suits me and my way of working to use other people's photographic references alongside my own. I often use them to supplement my ideas and inspirations; and I see no shame in doing so!

Finding source material

With all the above said, just using any old photograph or image that you find online will open a whole can of worms around copyright issues, particularly if you want to exhibit and sell your work. For this reason alone, choose carefully. If you haven't got any photographer friends, check out your local photography groups or clubs in your area. You will often find a wealth of talent and resources on your doorstep, and most are happy to share. Failing that, there are many wonderful free sites that you can visit online for inspiration to kick-start your creative process.

Always remember to credit the photographer of any images you use. Ensure that the image you use is royalty-free, unless of course you have received permission from the person who took the picture, or you have paid for the rights to use it. Great places to start are sites such as Pixabay, Unsplash and Pexels, to name but a few. These sites simply require you to set up an account with your email, and some offer you the facility to save images back to your own personal library. This helps no end with storage space and, more importantly, all your lovely images are kept in one place and at the touch of a button for whenever you require them.

Other sites such as Adobe and iStock Getty Images allow you, for a small cost, to buy the licence for a particular image. These tend to be high quality, high contrast images taken by professional photographers. However, if you simply want to use images as a springboard and direction for your own ideas, rather than a direct copy, you probably don't need to go down that route.

In short, always remember to credit the photographer, and ensure that the image you use is royalty-free; that you have permission from the person who took the picture; or you have paid for the rights to use it.

It's nice to return the favour by sharing the photographs you take. I do just this, and an artist friend of mine who's a fabulous photographer encourages artists to paint her images – she loves to see them!

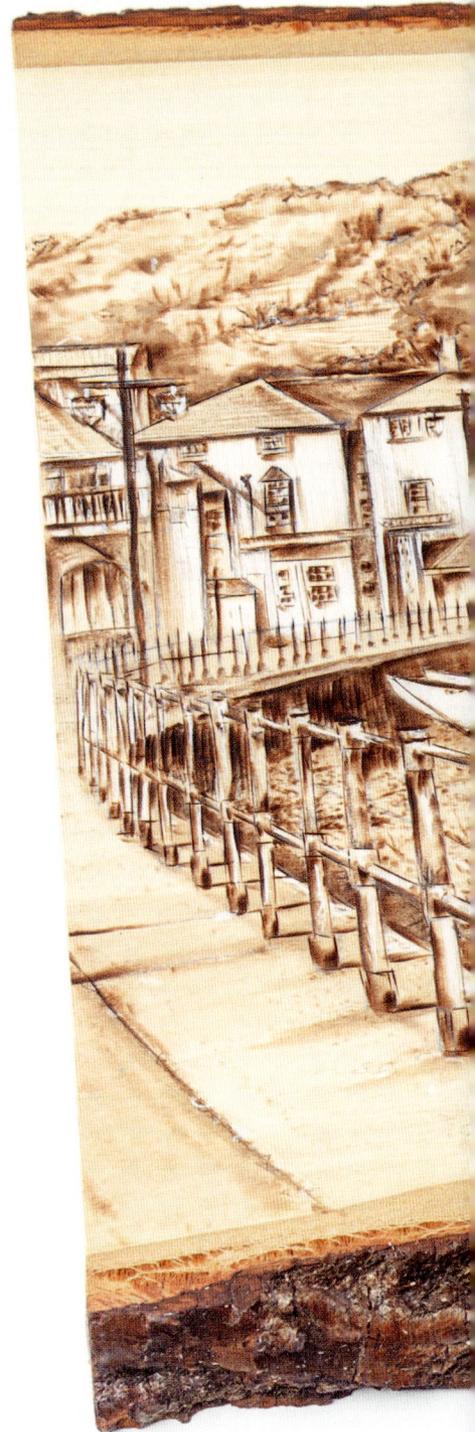

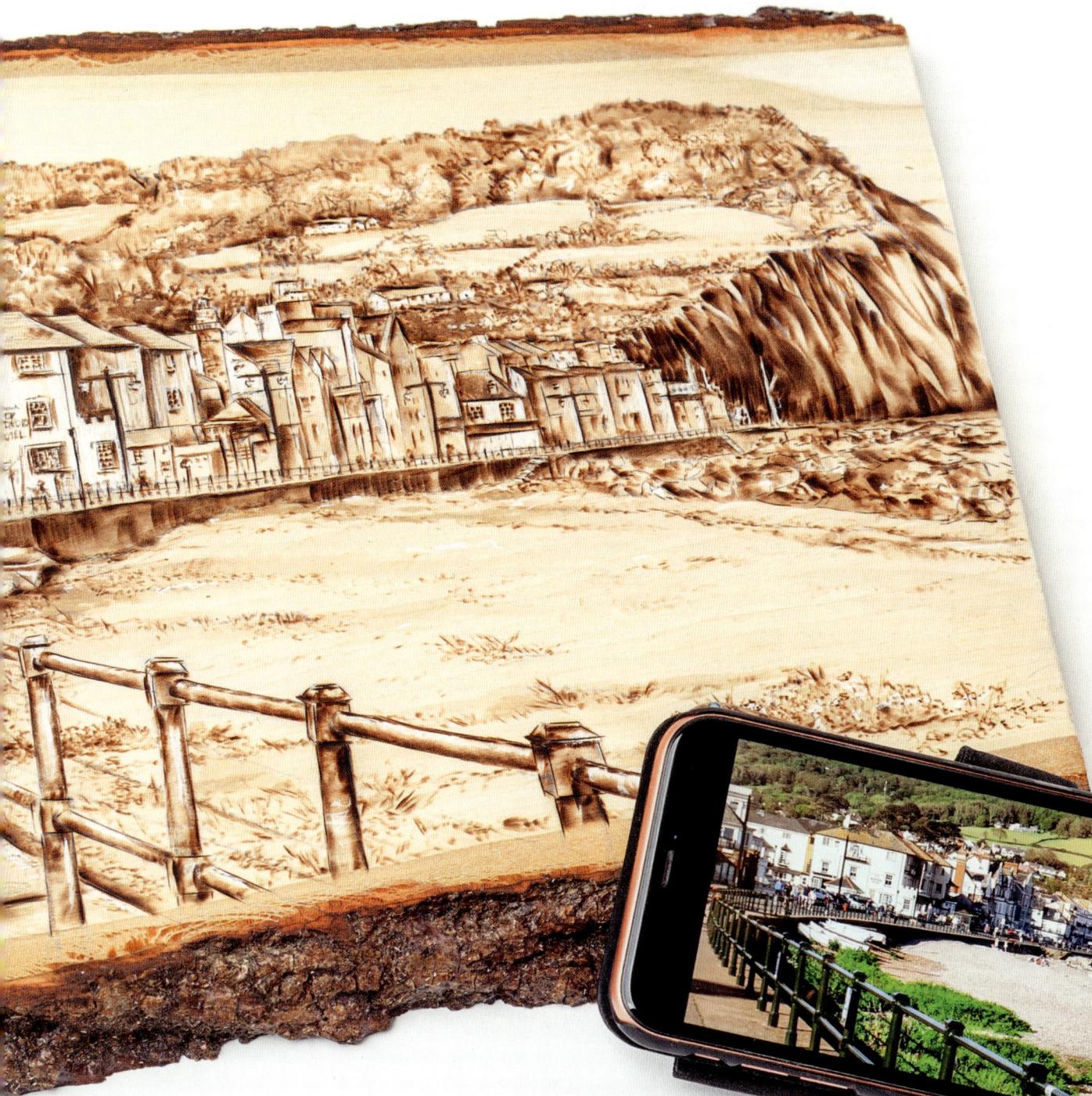

MINI BURN – SKETCH WITH FIRE

Sometimes it's fun to deconstruct things, leaving areas unresolved and loose. It might buck the tend of traditional pyrography, but approaching a burning in a more carefree manner will free you up and encourage you to experiment. Here we're going to take a sketchbook approach and create a fun little mini burn that shouldn't take any longer than half an hour.

We're also going to introduce splattering. Heavy-bodied acrylic is the only 'wet' medium that I consider using for splattering without a gesso or medium on untreated wood. The thicker consistency of the carrier that holds the pigments allows the paint to sit in suspension on the surface, rather than sinking in. This will change from brand to brand and as soon as you add water. If you're unsure, check it out on a scrap piece of wood. You can read more about paint on page 102.

MATERIALS AND TOOLS

Surface: Birch plywood AB grade (or similar), 20 x 30cm (8 x 11¾in)

Materials: Dark brown or black acrylic paint

Tools: SS-D10 with medium skew tip, writing tip or ballpoint, toothbrush

HOT TIP

Instead of a skew tip, you can use the side edge of a flat shader.

THE INSPIRATION

Perched atop a granite outcrop surveying the atmospheric Bodmin Moors and china clay mountains of St Austell, in Cornwall, stands a wonderful ruined hermitage. It's a sight to behold and looks like something that's jumped straight from the pages of *The Lord of the Rings*, carved from the very rocks itself. Built back in 1409 it has been surrounded by mystery and clouded by myth ever since. It's a lovely craggy subject to play with illustrative mark-making and perfect for a pyrography piece.

Reference photograph courtesy of John Stedman.

Splattering

Splattering is a haphzard painting technique in which paint is flicked or dropped onto the painting to create interesting textural effects. It's messy, but fun.

As long as you don't water down the paint too much, heavy-bodied paint splattered in this manner will happily sit on the surface of the wood and will not sink into the grain. If you're unsure, try it on a sampler first.

In this exercise, I used a toothbrush loaded with paint; offering it up to the piece around 10cm (4in) from the surface. I then pulled my thumb towards me across the bristles to 'ping' the paint at the surface.

My original pen and wash sketch.

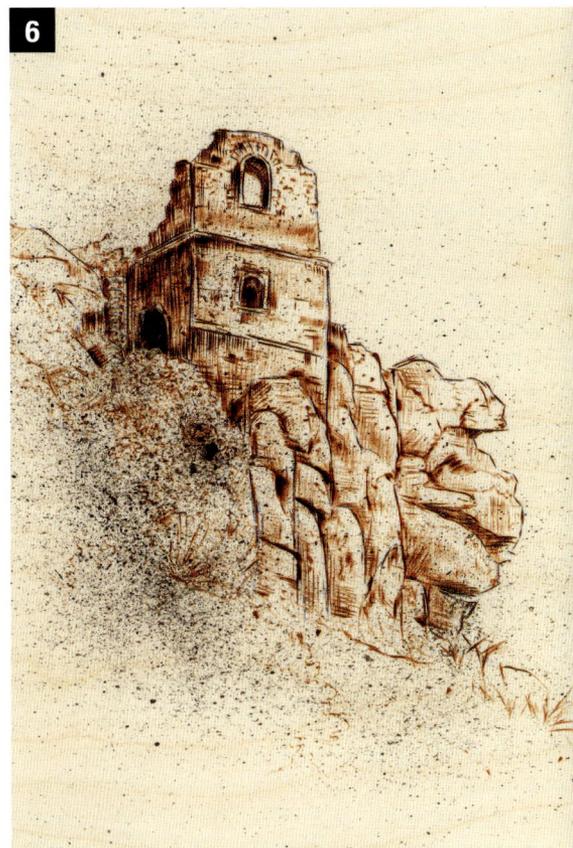

1 Transfer your sketch to your panel using the technique on page 29.

2 Using a medium-high heat, start burning the key lines. Skew tips tend to burn hot, so check your temperature before you burn. Keep your lines broken and not too neat, to indicate the derelict and worn nature of the subject. Work quickly and lightly over the wood.

3 Begin building up areas of shadow, dimension and interest on the tower using cross-hatching with the skew and other mark-making techniques that you want to explore. When tackling the tower, try to keep your strongest and darkest lines following the perspective of the building. Indicate rather than draw the brick work. Have fun exploring lines and form on the stones.

4 Switch to the writing tip and draw loose random lines and squiggles to suggest foliage.

5 Indicate the random lines on the rocks and start developing patches of shadow. Continue to mark-make, adding lines and contrast. Build up those darks in the windows and doorway. Remember: the closer the lines the darker the burn. Be gentle, you don't want to carve up the wood or overburn an area.

6 Add to the sense of wildness and decay by using a soft toothbrush to splatter (see opposite) some heavy-bodied acrylic paint on the foreground to suggest foliage and shadow.

HOT TIP

You could try using a spoon shader for the rocks in step 5. It would create some wonderful textures.

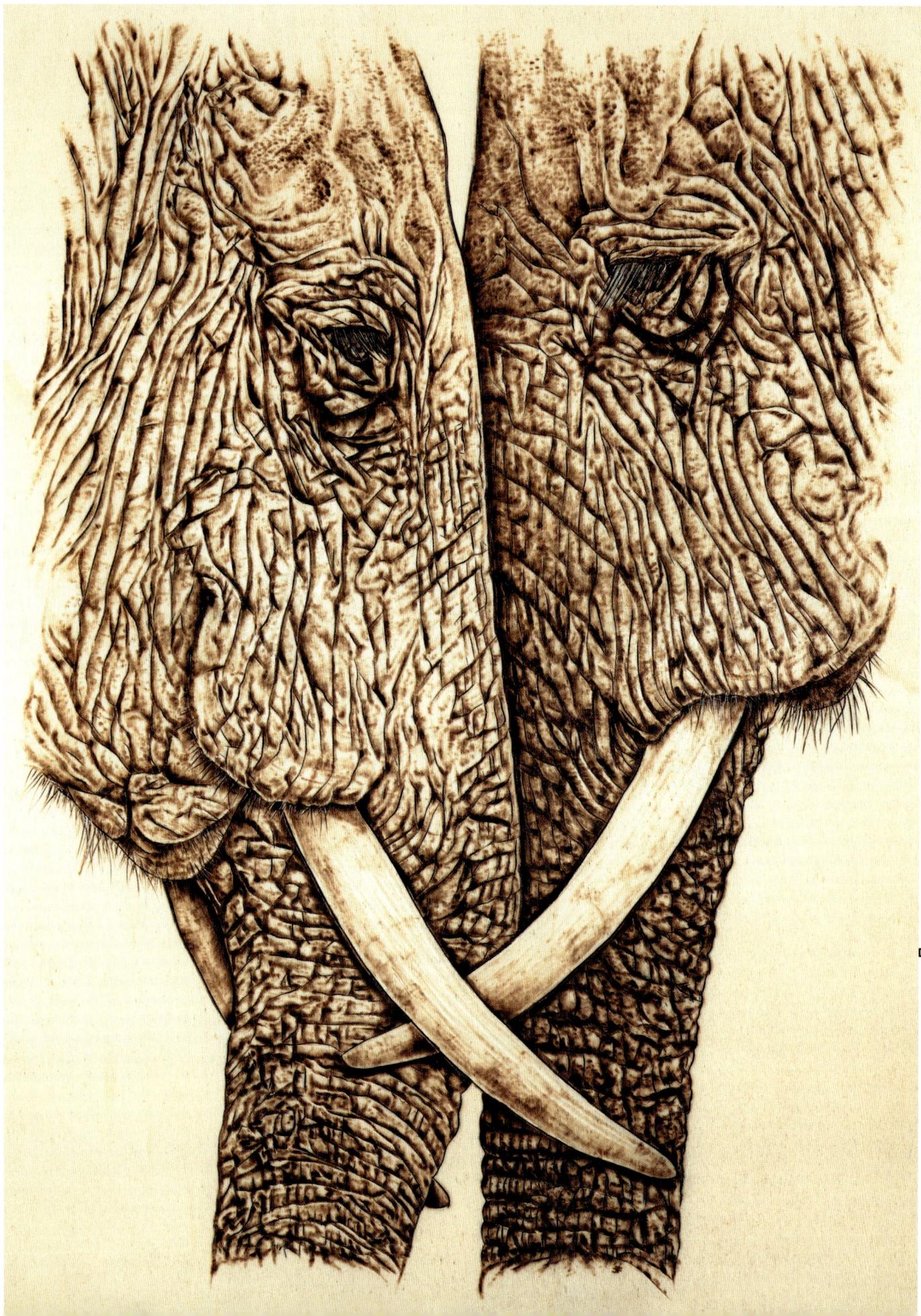

VISUAL TEXTURE

Although I'm a champion for mixing things up, this piece called for simplicity and honesty. I wanted to strip everything back to raw basics and create the burning using pure pyrography, no bells or whistles! This is when you become aware that foundations count: they are the structure that everything else is built upon. Taking time to develop your skills in mark-making and getting to know your tips and materials is crucial. The delights of adding colour, gold and resin beckon from later pages, but I assure you that time spent in the here and now, honing your skills, will pay dividends in the quality of your work.

Hello Old Friend, a large woodburning on birch wood, was done almost exclusively using a spoon shader to create the leathery look of elephant skin, gradually building up the tones with gentle layers. The completed piece felt as tactile as I imagined the skin might, with dimples, dips and valleys. It was a really moving piece to create.

Stippling

The finer texture on the forehead was created with stippling: tapping the foot of the spoon shader gently on the wood.

Skin texture

Created using a spoon shader, the lines were produced using the shader upside-down, while the bowl was used to create the shaded valleys. Using such a soft wood meant I was able to push the shader into the surface, resulting in a wonderful leathery texture.

Fine hairs

The fine hairs on the mouth and eyes were burned with a skew and added as final details at the end.

Tusks

The texture in the tusks was created using a burnishing technique. The cold tip of a spoon shader was first dragged along the tusk to indent the wood. This was followed by subtle, gentle shading using a flat shader in the direction of the tusks' form. This creates a hit-and-miss effect. The tip will catch on the peaks.

Hello Old Friend *40 x 50cm (15¾ x 19¾in)*

Pyrography finished with resin on birch panel. From a photograph courtesy of Mario Moreno. In the collection of Mrs S. Bevan.

'No distance of place or lapse of time can lessen the friendship of the heart.'

This is one of those moments when it is clear that using someone else's photograph is just perfect. My heart melted when I saw the original photograph of these two beautiful creatures. It was a moment in time captured by the super talented Mario Moreno on one of his wildlife safaris. These two elephants from the same family herd had been parted for a number of months and Mario was able to capture the moment that they were reunited. They came together, head to head and welcomed each other with love and friendship. I knew I just had to etch this timeless moment into wood.

THE YELLOW BRICK ROAD TO 'YOU-NESS'

Life's too short and precious to keep saving all of those wonderful art projects you have in your mind for when you think you're good enough. If it excites you, then have a go! Magic happens when we explore beyond our comfort zones. Even if it goes awry, this will allow you to work out what went wrong, change your approach and try again. You'll be amazed at what you can achieve when you're enjoying yourself.

By developing a discerning eye, trying new things and allowing experiences to influence you, your art and your life, you will open yourself up to innovation and inspiration and move from copying and learning to developing a unique style and voice all of your own.

I had completed a lovely painting in 2020 called *Magic of the Moonlight* (see right) shortly after the pandemic forced us all indoors. It was my response to a world that suddenly seemed so scary and bleak, and everything normal was turned upside-down. I just wanted to close my eyes and make it all go away! But out of the dark places and sad events, a strong light still shone forth. I was humbled by the positive stories, compassion and spirit of humankind that revealed itself during this crisis. *Magic of the Moonlight* was a painting inspired by that kindness and a wish for that light in the dark and a dream of better things that are just around the corner.

I thoroughly enjoyed painting this old, wise, eagle owl, and liked the way that the soft-focus starfield background complemented the detailed intricacies of the bird. It led to me wondering how I could do something similar on wood. I've burned numerous owls on wood – their beautiful big, soulful eyes and wonderful flamboyant feathers lend themselves particularly well to pyrography – but what about the background? How could I make it more colourful and look more transitional with a blurred focus skyline similar to the painting?

It was a tricky one! After some thought, I decided to focus on the textures and complementary colours of the warm brown pyro playing against strong blues. Fluid paints on wood typically run and bleed into the grain. They can sink and look unsightly and patchy – but every problem offers a new opportunity. I began experimenting with mediums and grounds on small pieces of spare wood to see how I could achieve a similar effect or result. I found that I could use modern products strategically in a creative, innovative way. By adapting a layered approach, I was able to bridge the two worlds and fuse them together. The process is explained overleaf.

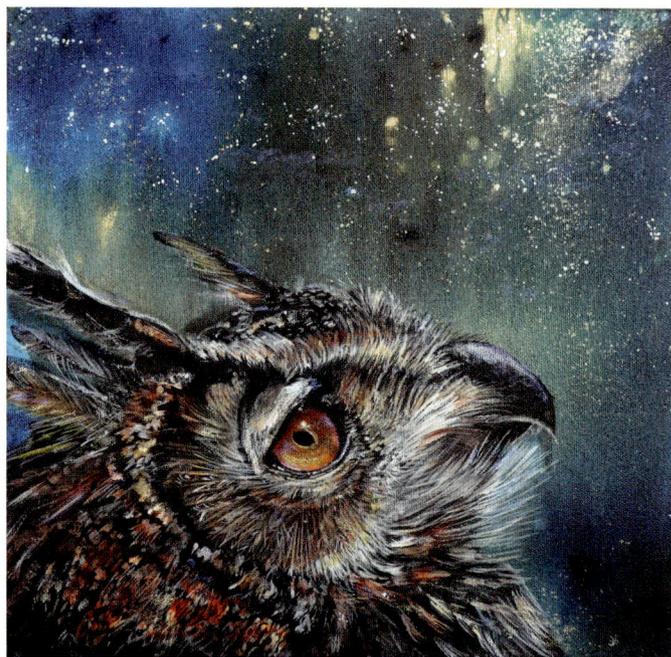

Magic of the Moonlight 50 × 50cm (19¾ × 19¾in)
In the collection of Mrs Gerdje Verspecht.
'The most magical things can happen... and it all starts with a wish.'

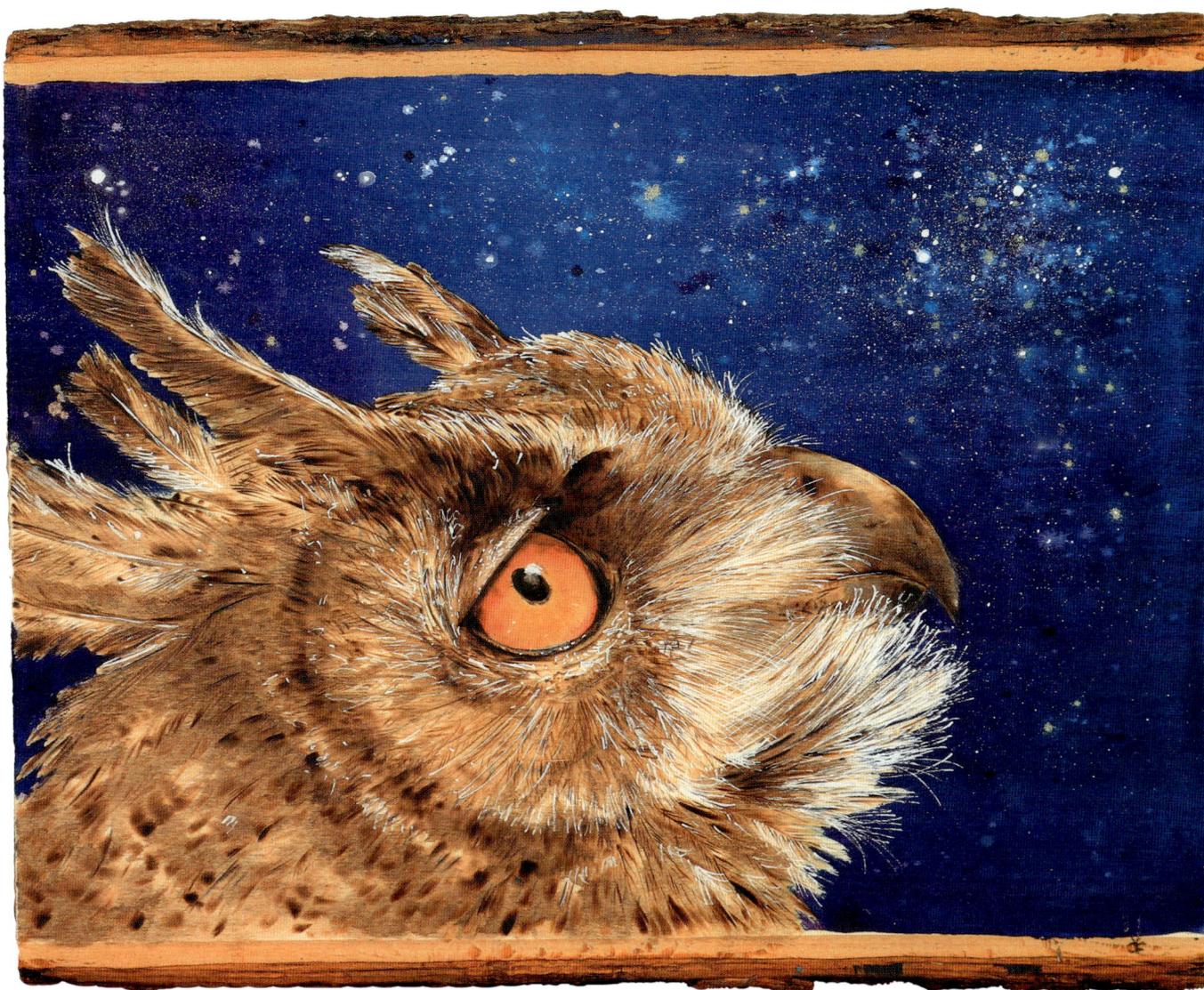

**Magic of the Moonlight II –
To Wish Upon a Star** 40 × 30cm (15¾ × 11¾in)

This was a really interesting experimental piece using modern grounds and masking fluid to create rich, saturated colour on wood. I really like the way the colours throw the pyrography forward.

I used acrylic marker (Posca pen) to add final touches to the owl in Magic of the Moonlight II.

MAGIC OF THE MOONLIGHT

This project is a great case study of a problem-solving exercise and an example of how inspiration, if you run with it, can lead you down interesting and new paths. Feel free to create your own interpretation of my owl, or substitute it with an idea or colours of your own.

MATERIALS AND TOOLS

Surface: Basswood panel, 40 x 30cm (15¾ x 11¾in)

Materials: Watercolour ground, acrylic inks and paints (Prussian blue, ultramarine, purple and white), white Posco pen (0.7mm), orange and yellow Inktense pencils

Tools: SS-D10 with skew tip and flat shader, blue transfer paper, putty eraser, masking fluid and an old brush

1 To begin, transfer the owl onto the basswood panel using blue tracedown paper. Use a skew tip and flat shader to establish the key shapes, direction of feathers and outline. (You could just as easily use a writing point if you prefer.)

2 Inks will create a fluid dramatic background – but they will sink into the grain of the wood. To avoid having to paint around every feather shard with a couple of coats of medium, masking out the owl is a better option. Use an old damp brush to apply the masking fluid around the outside of the owl to preserve the feathers. Take care to keep the marks loose and descriptive. Add more masking fluid along the edges of the bark adjacent to the burn so they don't get stained.

3 Apply two thin layers of watercolour ground to the background. Once dry, build up layers of acrylic ink using a wet-in-wet technique to create a star-field effect by splattering each layer with white and leaving it to dry in between coats. Using a combination of Prussian blue, ultramarine and purple in each layer, build up the tone in layers to darken the background towards the top left and bottom right corners. Once you reach the desired depth of colour, allow to dry. Splatter the dry top layer with white to create the brightest stars.

4 Remove all the masking fluid and begin the shading on the eye using the foot of a flat shader. Pay particular attention to the shadows and the intricate markings of the iris. You're looking for a connection here, so it's worth spending extra time to get it right. Hint at feathers around the eye using the side of the shader.

5 Add the feathers at the top of the head using the side of the flat shader. Take care not to burn onto the background (notice the soft halo effect around the feathers left by the raw wood). Speckles can be added using the shader's toe.

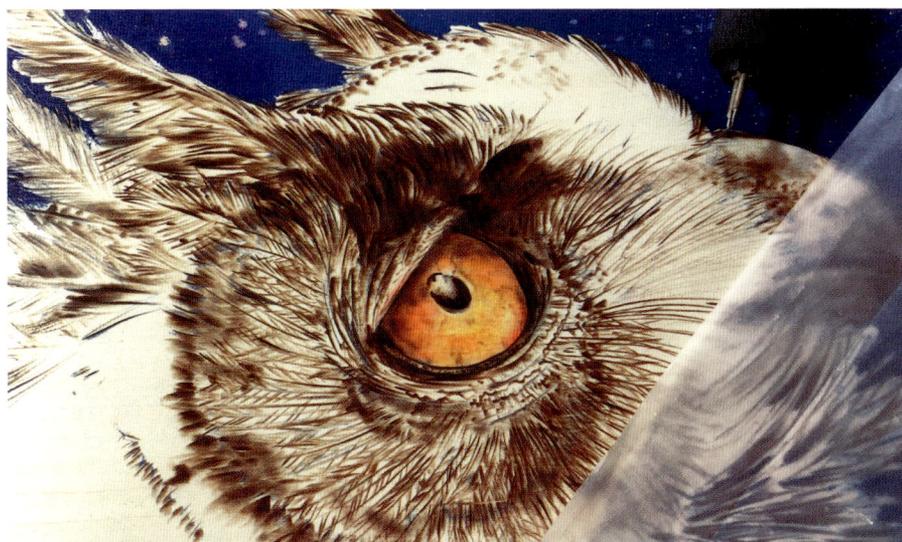

6 Time to move to the feathers around the face, which create a concentric circle around the eye. Use a skew tip at a low temperature to map them out, then swap to a shader to create shadows and depth. To finish this area, add dark marks to suggest feathers above the eye. The darks in and around the eye socket are essential to create depth and push the eye back into the head. Use orange and yellow Inktense pencils to add transparent colour over the shading within the iris of the eye.

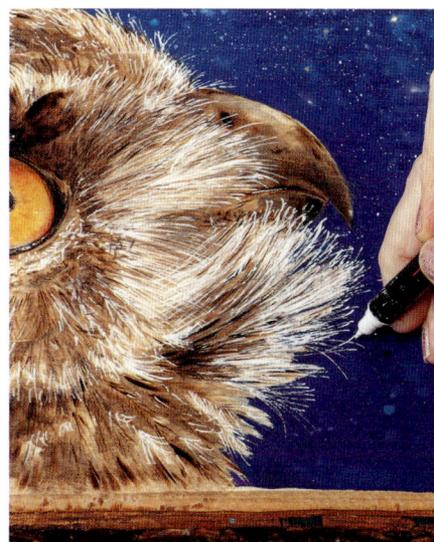

7 The face should remain the point of interest and the main focus, so the rest of the owl can be completed using less detail, switching between a shader and skew where appropriate. To finish, I touched in final highlights to the eye and suggested tufts of feathers using a white Posca pen. The finished piece can be seen on page 79.

STYLE ME UP

The style of any pyrography piece is anchored by the way in which you use your line, stroke, tip selection, pen temperature and how you manipulate your surface. Some pieces, of course, are a mixture of different styles all moulded together.

Up to this point in the book, we've looked at practicalities like gathering reference materials, experimenting with line and tone, and how to prepare a surface. Now we can look in more depth at some styles that you might like to explore. Creativity in the style you choose for a piece can really feed your inspiration, and experimenting with different styles, ways of working, different tips, and pushing your boundaries will help support the development of your own personal style.

There are as many styles as there are artists. Some may appeal to you more than others – and if that's the case, then brilliant: you are well on the way to finding your own voice.

To explore another style, you can create a practice board to test out the strokes and techniques. Techniques and art styles that transpose really well to pyrography, we have pen and wash, illustrative work, tonal shaded drawings, high contrast detailed pieces, architectural subjects and monochrome pointillism. I hope you enjoy trying out the different styles I've included in this book – and that the variety of them has helped you to realize the sheer scope of creativity possible from pyrography.

Some artists (myself included) enjoy mixing techniques and elements of different styles and integrating them together within the same piece. It's completely fine to do so, and how you achieve that is entirely up to you. Indeed, I often switch between styles depending on what I feel like on the day and what I want to achieve.

Likewise, if you start to feel overwhelmed by the choice, or the scale or detail of a piece, break it down. Taking small sections of a complex image will make it more manageable. Nature often repeats patterns, shapes and objects, so isolating parts of an object or image and working on small sections at a time can often help your understanding.

Let's further increase that confidence by exploring different techniques and styles. We've spent time looking at ways to create monochrome images, but now we can push things a step further. We'll use those skills to start creating more intricate pieces of work: let's 'do a Dorothy', step out of Kansas and head somewhere over that colourful rainbow.

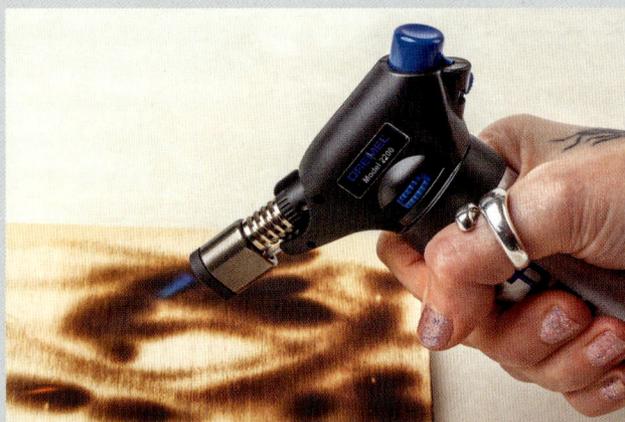

Using a blowtorch

Recently I've been experimenting with a mini blowtorch (a Dremel Versaflame 2200 stationary butane gas burner) to create an interesting and alternative way to scorch wood and produce instant darks and smoky patterns.

This small cordless heat gun is great fun to use and opens a whole range of new possibilities. With practice, it's possible to use it to create tones by regulating the flow of gas/temperature, controlling stroke speed and the distance from the wood. New tools open up new techniques, and can make certain effects easier to achieve.

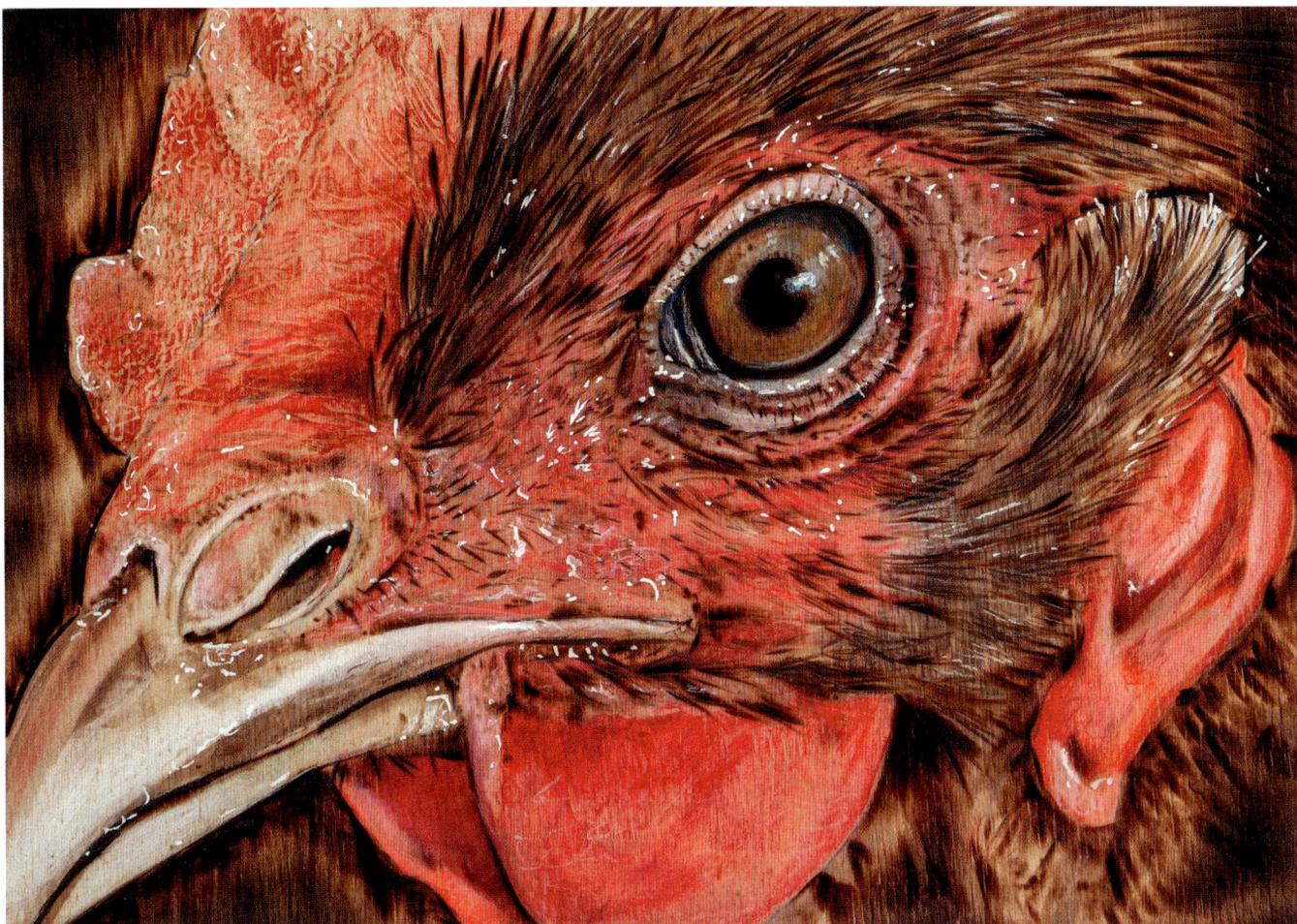

Portrait of a Chicken 30 × 20cm (11¾ × 8in)

Pyrography, coloured pencils and acrylic pens on basswood.

In this artwork, the dark background was completed using a blowtorch. The background was feathered (excuse the pun!) into a band of dark tonal shading, creating a buffer zone around the bird. The texture on the comb and wattles was created by using a clean, cold, writing tip to burnish a pattern into the wood. A coloured pencil passed flat over the textured area then gives the impression that the surface area has been raised above the background plane – as shown in the detail to the right. Whiskers, small highlights and other fine marks can be reserved in this way (a bit like batik wax resist). Be wary though, once such marks are committed to the wood they cannot be undone! Experiment by using tips, blunt knives and other mark-making instruments on a practice piece of wood.

This detail shows the buffer zone created around the bird using a flat shader – the scorching from the blowtorch is later brought right up to this buffer.

POINTILLISM STYLE: GOING DOTTY

Monochrome pointillism is a technique used in pyrography in which small, distinct dots are applied in patterns to form an image. We've looked at the stippling technique earlier in the book, but let's look at this style of working in more detail, as we're going to integrate it in the two projects on the following pages.

The dots that build up the tone and shape are created by gently and repeatedly stamping the tip onto the wood, a bit like a woodpecker. As explained earlier, in the sphere on page 56, the more densely the dot pattern is created, the darker that area will appear. Pale tones can be created using a more dispersed pattern of small dots and lower temperature settings.

Stippling

The main technique used in pointillistic pyrography is stippling. Because shapes and tones are built up slowly, it's a very beginner-friendly technique; and also great fun. Stippling is a great technique to mix with other styles too. Because it's quite subtle and a gentle way of shading, it's a great way to add depth to shadows or blend out transitions from light to dark.

Plans and practicalities

Before you start stippling take a moment to decide on how dense and how small you will make the dots. An image with lots of dark values will need more stippling than an image with plenty of light. If in doubt, try doing a set of dots on a piece of test wood and create different shades/tones by spacing out the dots different amounts. You can then reference this against your design as you create your project.

The best tips for a stippling technique are primarily variations of the writing tip, namely the ballpoint or ball stylus; or a small writing tip. For larger pieces of work (and bigger dots) you could try using the belly of a 'spoon shader' held almost horizontally and gently tap the wood.

The smaller the dots the tip can make, the more realistic your image will look – but this must be balanced against the additional time it will take you to build up the tone. Experiment with your tip choice, temperature and dot patterns to see which combinations give you the best results on a practice piece of wood.

Here are a few pointers when approaching a pointillism project. With your drawing/reference laid out in front of you, have a think about:

- The light source and the direction of the light. The light will determine what areas need more stippling and which areas need less.

- The value of the drawing. How dark or light are the colours? Value is closely related to light. If you are unsure, then transpose your reference into either a monochrome or a sepia image (see page 54). Check where your light, dark, and midtone areas correspond to on your greyscale image.

- Look for key shapes in the drawing. You'll be creating all the figures, objects and textures without using any lines, so pay attention to form, shape and shadow and recreate them with your stippling. Use negative shading and temperature to your advantage.

- If you're short on time but still need those darks, try using a pen with a larger tip to create larger spots in the dark value areas.

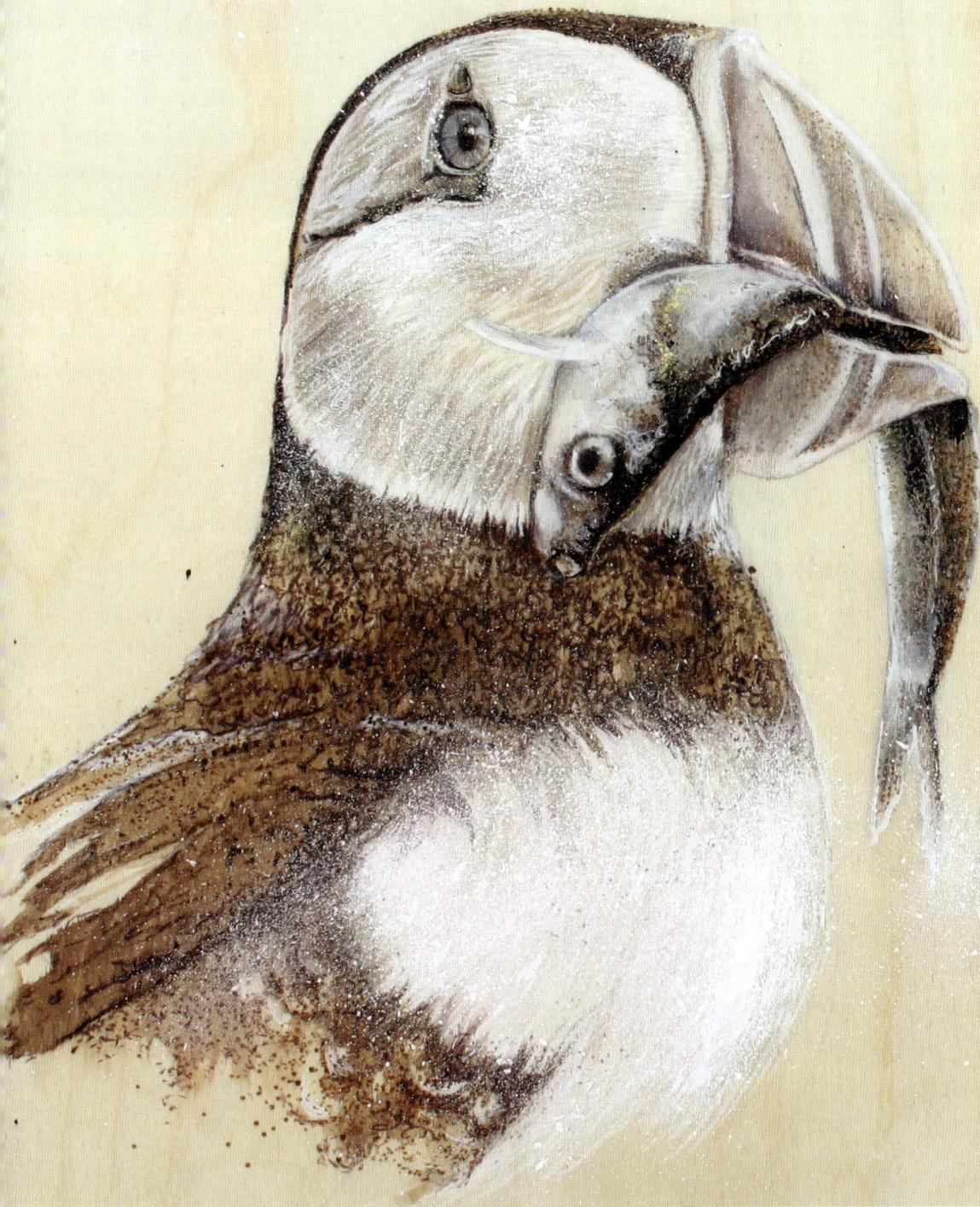

Puffin 30 × 30cm (11¾ × 11¾in)

Pyrography on birchwood panel. From a photograph by Angela Pearson.

I used an Artex Firewriter with ballpoint stylus tip for this pointillist piece. Stippling was used to create the main body and form of both puffin and fish. Layers of white pencil were then added to the lighter sections of the bird. It was finished with dotty splatters of white heavy-bodied acrylic paint.

TREE FROG TONE

Remember our frog from earlier? With the background in place, we're now going to start building up the tone on the branch and frog to suggest form.

Stippling is a fun, forgiving and simple way to create an image without having to worry about shading. Simply create the tone and form with layers of dots using a pyrography tip much like an ink pen. This technique works equally well on both wood and paper.

Don't be a slave to your reference photograph. You're the artist, after all. You could choose to stipple your image in a more dramatic or suggestive pattern. For example, stipple all your dots in rows/columns or diagonal lines to suggest texture or form. Here, I chose to add the patterns to the frog's leaf in order to add interest and suggest form.

MATERIALS AND TOOLS

Surface: Existing frog piece from page 61
Materials: None
Tools: SS-D10 machine with ballpoint tip

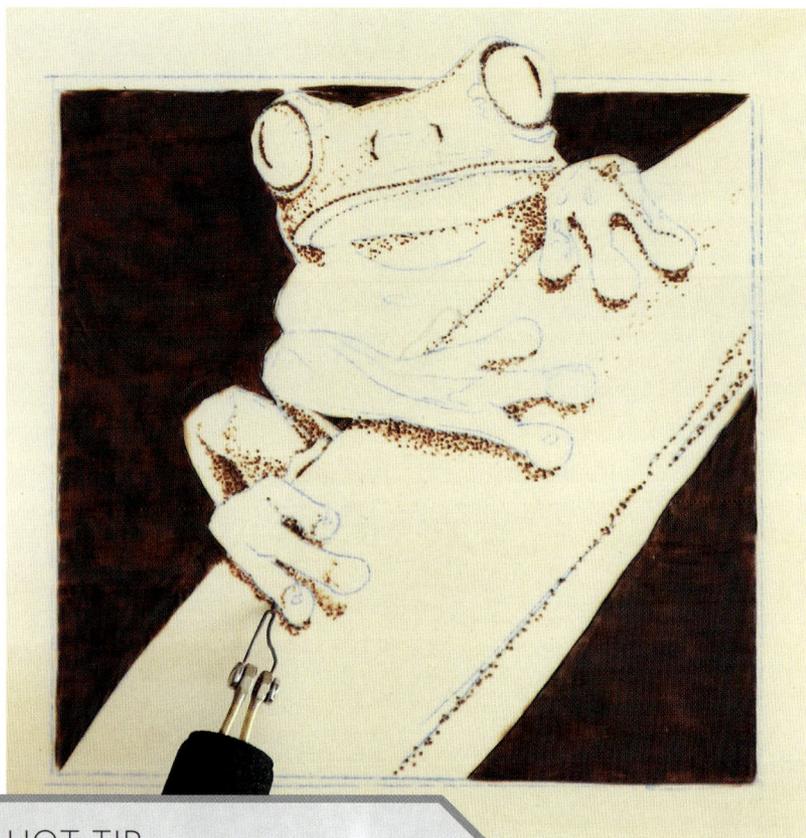

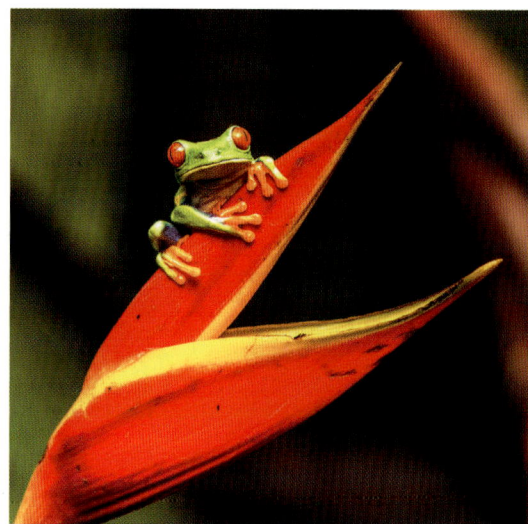

Picture credit: Zdeněk Macháček, via Unsplash.

HOT TIP

Start in the darkest areas of your subject. Why? Because there is room for error in the darker sections. It also gives you a feel for the temperature and wood – and it's great to get those darks and shadows in to give you a feeling of form.

1 Looking at the original reference, decide where you will begin stippling on your image. Using a ballpoint tip, confidently place the dots close together to create the darker areas. Watch the temperature – you don't want halos around your marks.

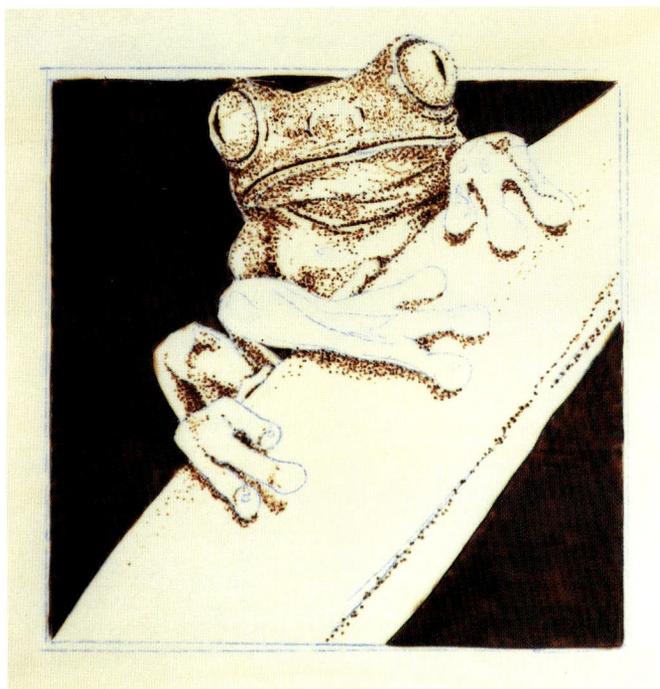

2 As you develop the major dark shapes, start stippling in broken patterns away from the shadows to begin forming the contours of your image. Take your time – you can always add more marks but you can't take them away. When viewed from a distance these dots will appear to be lines and areas of shade. Close-up though, you'll see them as they really are.

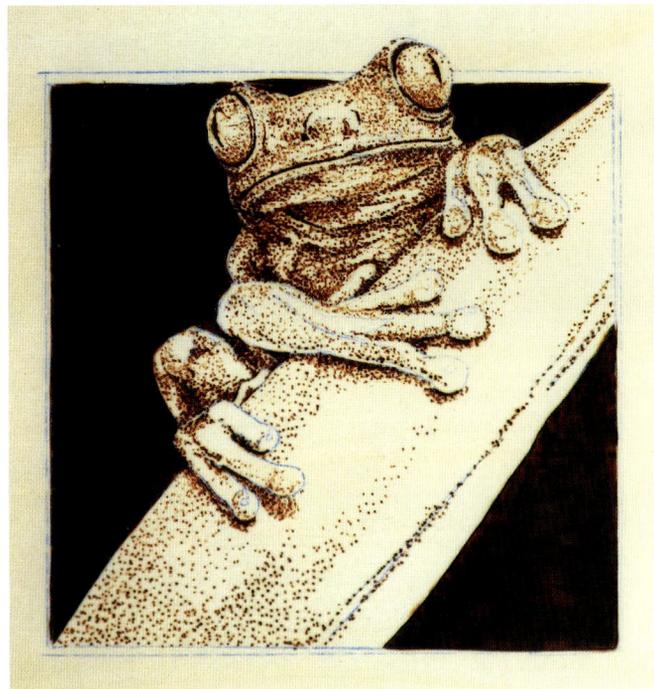

3 Develop the midtones using random dots and leaving more space between the marks. Carefully reserve the wood for the lighter areas. Gently break into those lighter areas with the odd dot or two so the lights don't look too harsh.

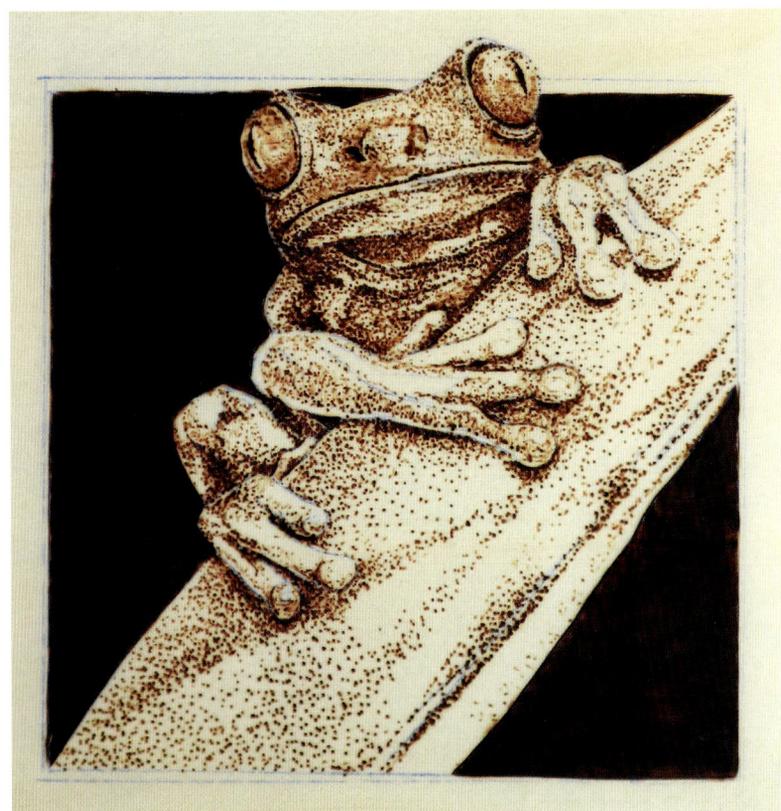

4 Assess your subject and adjust the tones accordingly, layering dots as you go. It's the frequency and layering of the dots, not how hard you press, that will give you rich darks. When you're finished, remove any blue marks from the transfer paper using a putty eraser. You can leave your frog like this, or he can hop along another step as we add colour – see page 110.

TIMES GONE BY

Portraits can appear complex and daunting to a beginner, as they include many different aspects. If you try to tackle everything at once it can soon become overwhelming. Breaking down the image into its component parts and tackling each part separately – face, hair, then accessories – will make what at first appears intimidating much more approachable.

Where things are complex, it's good to simplify where you can. This goes beyond just the order of work. I wanted to use this project to demonstrate how versatile even a single tip can be. My invitation to you for this project is to try using a single tip to create soft marks, shading and texture to produce a realistic portrait.

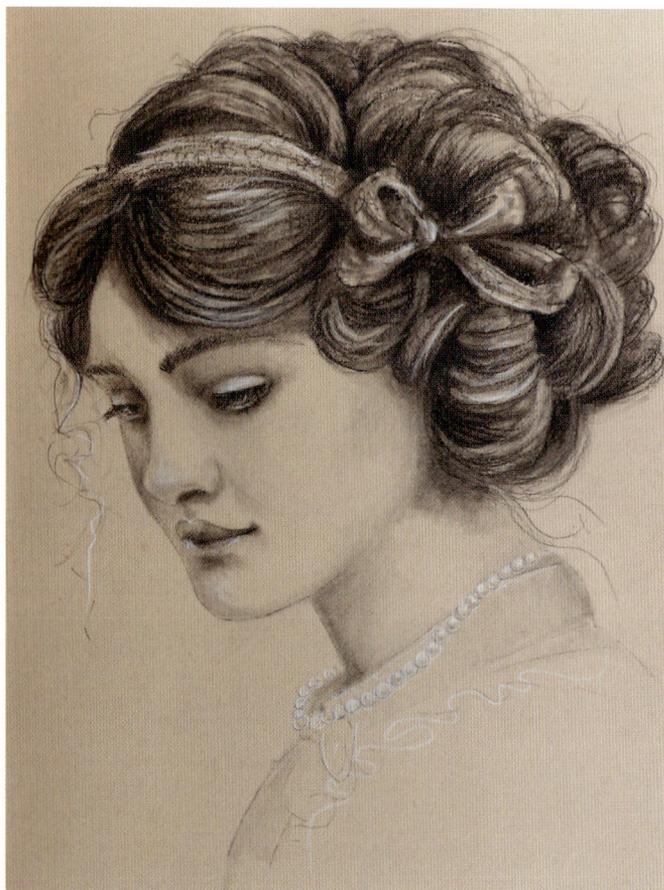

MATERIALS AND TOOLS

Surface: Large basswood round, 30 x 40cm (11¾ x 15¾in)

Materials: Derwent Drawing Chinese white pencil (7200), white glue or matt medium

Tools: SS-D10 machine with flat shader tip, large old brush, layout paper or tracing paper, blue transfer paper

THE INSPIRATION

The idea for this piece was taken from this drawing in my sketchbook, based on, and inspired by, a Victorian London socialite of times gone by. Feel free to use this image – or create an image of your own from which to work.

SEALING THE WOOD

Prepare your wood surface, making sure it's smooth, and seal/fix the bark if you're not using a panel. I use Mod Podge (a white crafting glue; you could use PVA) or Liquitex professional matt medium on the bark. The water-based glue acts as a sealer, glue and finish; stabilizing, adhering and protecting the bark from flaking off when handling the wood.

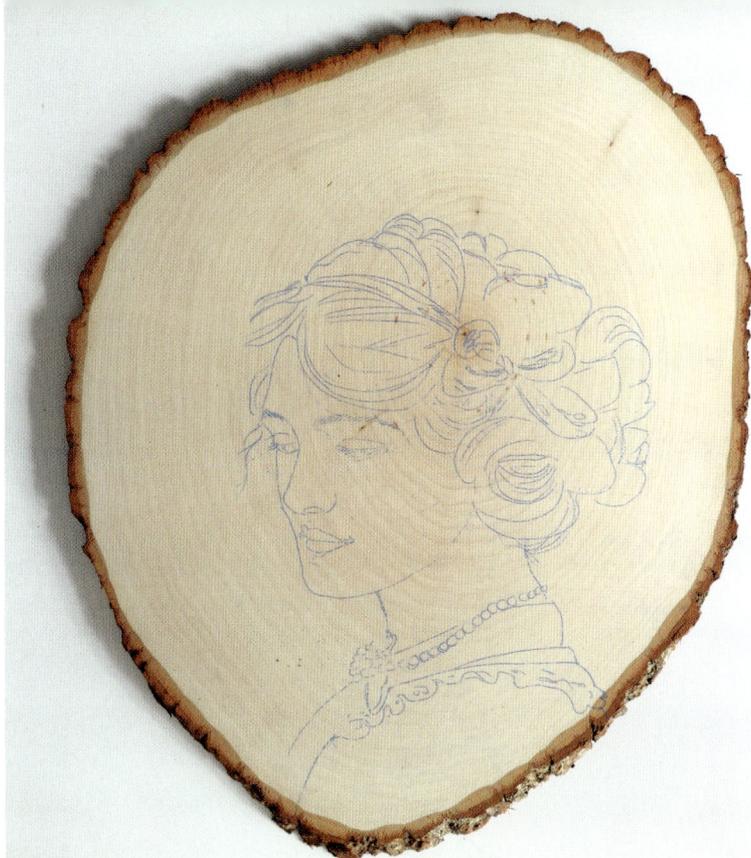

1 Transfer your design onto the basswood round using tracing paper or layour paper.

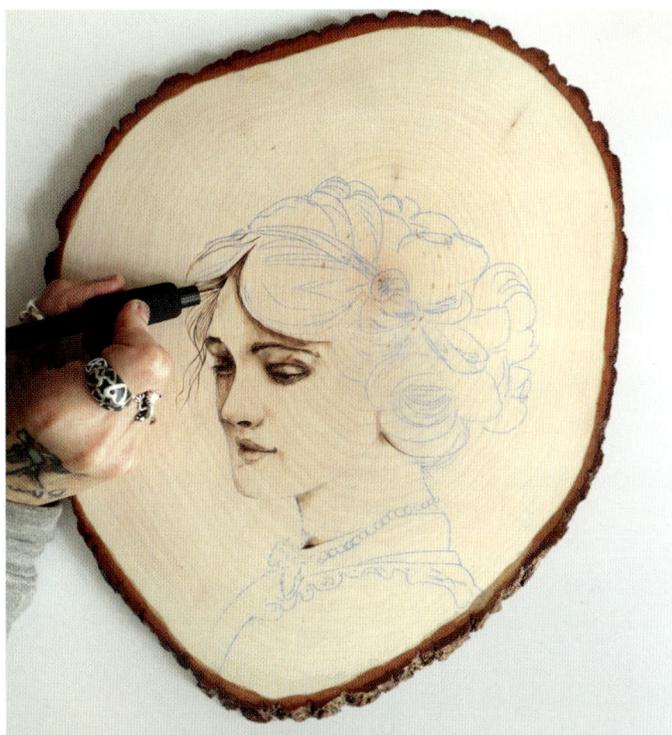

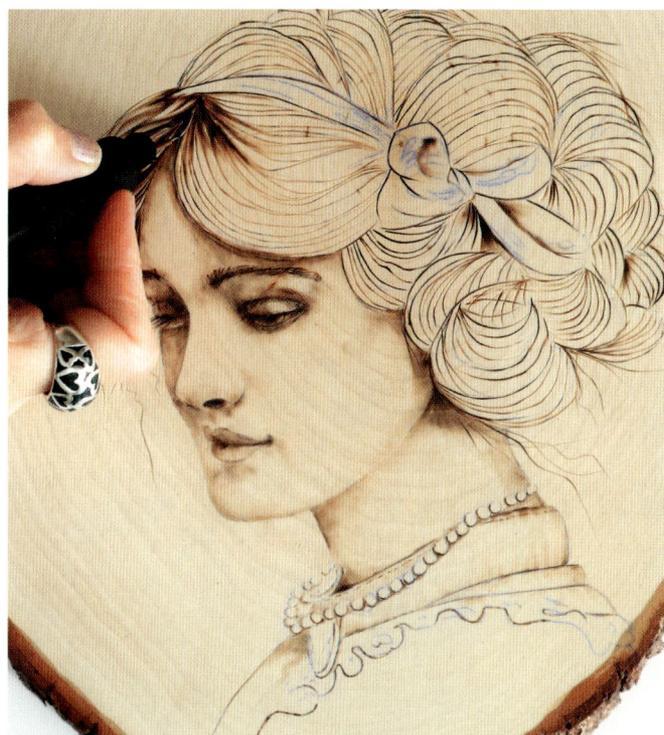

2 Make your first marks tentatively. Begin to hint at the shadows of her face with the flat foot of the shader using light smudgy marks following the form and contours of her face. Keep your temperature low and build up areas by gently layering. Ensure that your tip isn't too warm when it's placed on the surface of the wood by gently blowing across the tip to cool so that it doesn't brand the surface. She's young, so keep your marks light and soft and keep your tip moving. If unsure, practise on a sampler.

3 Deepen the shadows around the lips and eyes and begin to add shadows to the hairline, neck and blouse to create the form. Turn the shader on the side and begin to create the texture and movement in her fringe. Don't press hard, let the tip do the work.

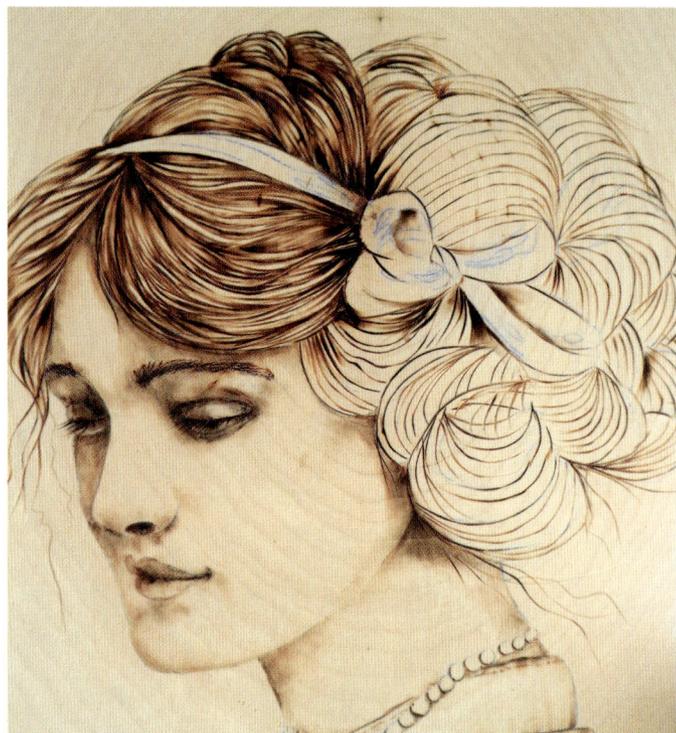

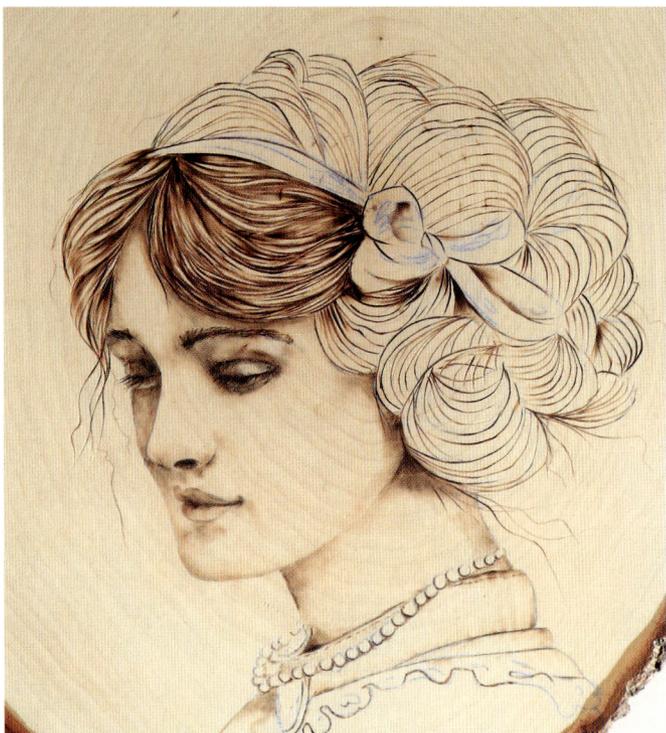

4 Keeping the shader on its side, begin to suggest the movement and framework of her hair. Think of each curl as a section and work methodically, section by section, to build up the foundations of this part of the portrait. Keep the lines soft, broken and light. Suggest the ruffle of her blouse in a similar way.

5 Turn the temperature up to a medium heat and use the foot of the shader tip to begin adding texture and colour to the hair. When burning hair, work on the shadows and movement around the strands of hair and blend them towards the lighter areas. Use the lines you just added to guide your shading, but avoid falling into the trap of creating lines of uniform thickness. Instead, think of the shapes that the shadows of the hair make as they move across over other strands. Working away from you, stroke your lines from the edges and intersections of each area towards the centre of that section, rotating the work as needed. Work methodically over the head, taking care that your shadows and lights are united, or lost in each other without any hard marks.

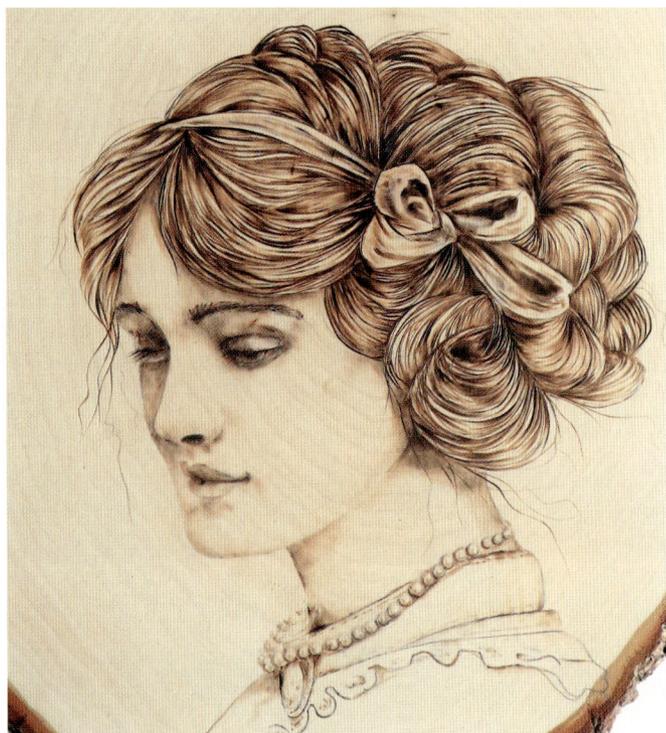

6 With the hair completed, turn your attention to the bow in her hair. Use the flat of the shader to suggest shadows and folds within the material, and keep your lines soft and flowing. Use layering in the creases to increase and intensify the darks. Next, add small smudgy circles in the beads and suggestions of shadow in the stone on her necklace. Keep your touch light.

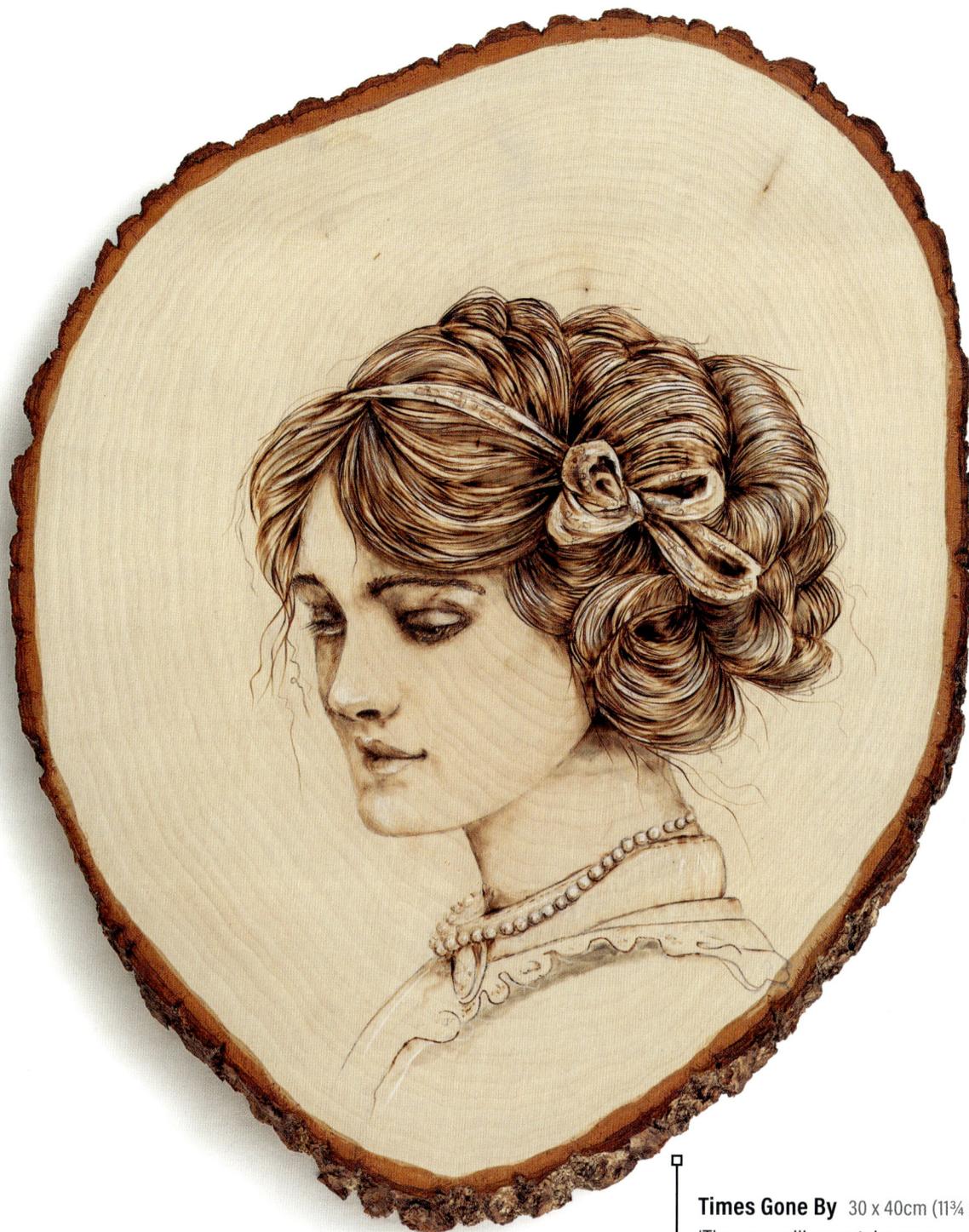

Times Gone By 30 x 40cm (11¾ x 15¾in)
'The years will never take away,
Our chance to start anew,
A new beginning for each heart,
Upon the morning dew.'

7 Assess the piece as a whole and adjust the darks and contrast in areas if needed by layering rather than ramping up the temperature. We want to create a nostalgic other-worldly romantic feel, not a high contrast image. Here, I chose to add a smudgy soft shadow line under the ruffle of her blouse. Finally, pick out the brightest highlights with a white pencil to finish. When highlighting a portrait with minimal shading such as this, create your highlights to follow the form or contours of the face. It gives it a more three-dimensional feel.

SIDMOUTH SEAFRONT

There's nothing more busy than a seafront in summer. This is a great exercise to get your teeth into: simplifying an architectural scene and flexing those shading muscles.

 Sometimes you can look at a piece of wood and it suggests a subject hidden within it. It's a bit like cloud-gazing – allowing your mind to quieten frees your imagination to tumble, dance and fly, and to suggest echoes of images within the shapes of the grain and outline of the wood. A live-edged piece of basswood was one such piece that whispered Sidmouth Seafront to me. The grain of the wood suggested the undulating hills behind the town, the raggedy cliffs and the scattered shadows cast on the pebbled beach.

MATERIALS AND TOOLS

Surface: Basswood panel, 40 × 30cm (15¾ × 11¾in)

Materials: White glue or matt medium (optional), Derwent Drawing Chinese white pencil (7200)

Tools: SS-D10 machine with skew and flat shader tips

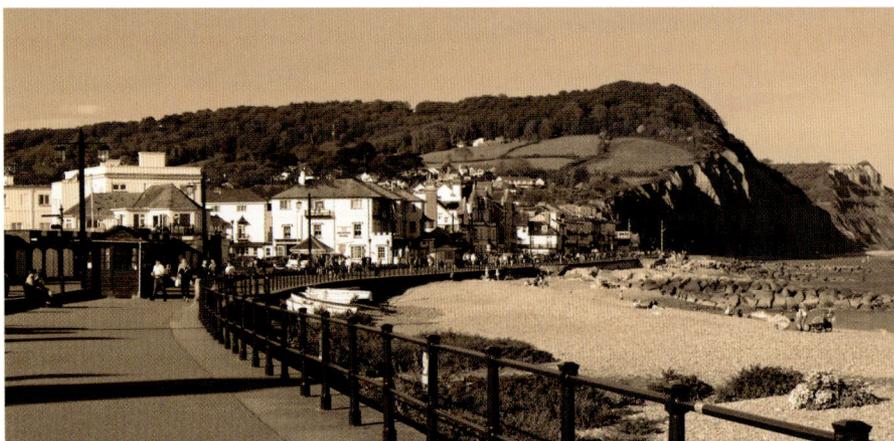

Reference photograph author's own.

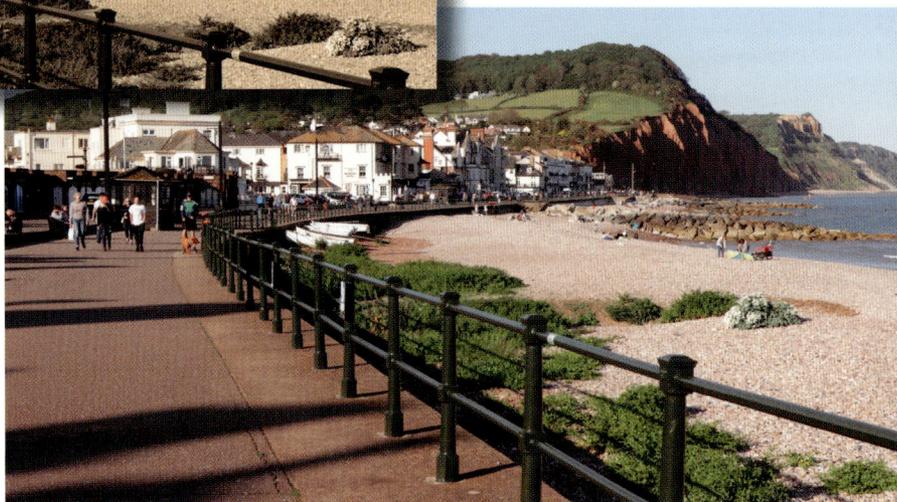

THE INSPIRATION

I feel blessed and count my lucky stars that I live in beautiful Sidmouth. I'm a stone's throw from the sea, the river and wonderful parklands. Choosing a subject to paint within all this inspiring loveliness is the hardest thing ever – it's all too much of a good thing!

 I really liked the idea of the railings curving into the picture and leading the viewer to promenade past the distinctive Sidmouth lampposts, and I invite you to have a go at recreating this beautiful part of the coast using shading techniques and a simple highlight.

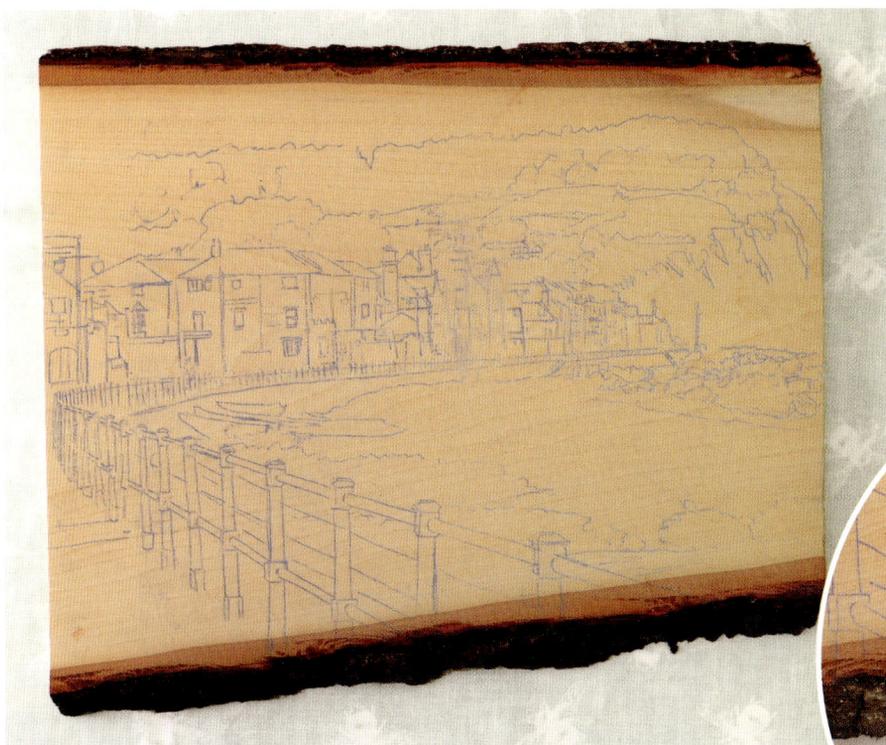

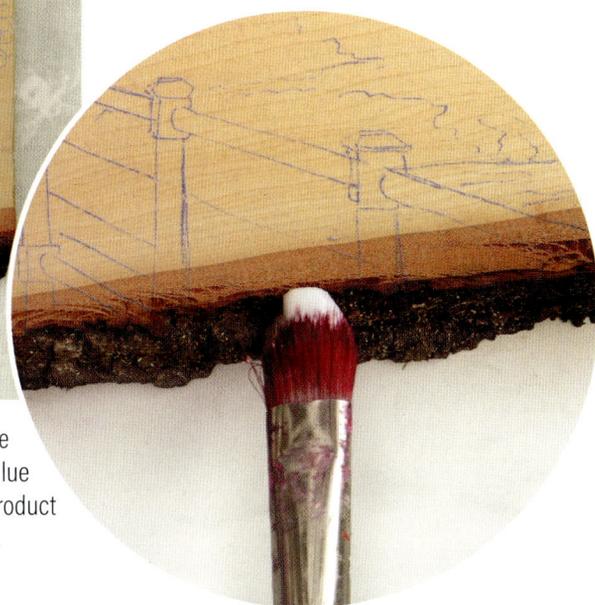

1 Once you have simplified, sketched out and transferred the composition to the piece of basswood, strengthen the bark on both sides of the wood with two layers of white glue (Hardcoat Mod Podge), allowing it to dry and cure in between coats. Ensure that the product is used solely on the bark and does not encroach on any area(s) that you plan to burn.

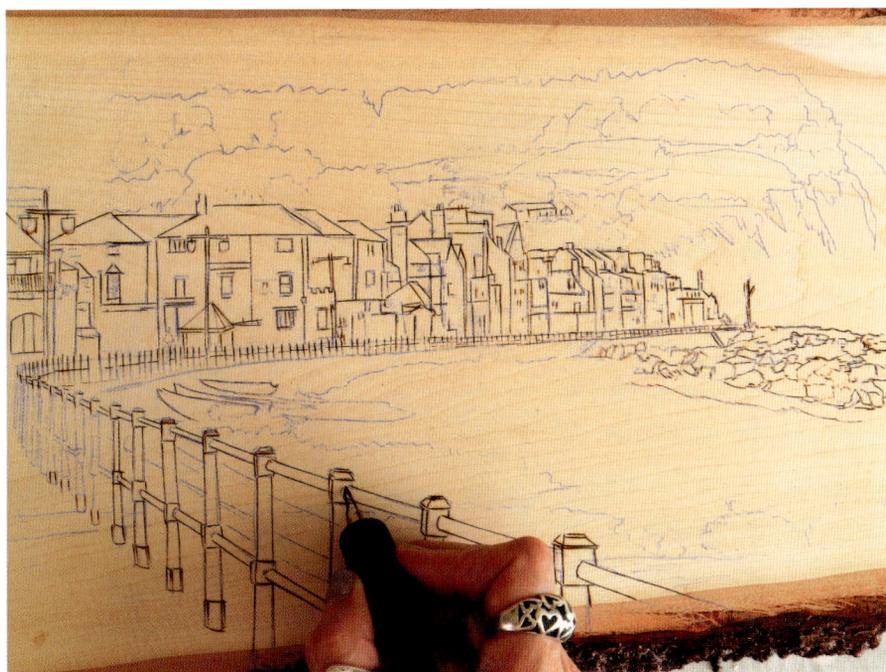

2 To begin burning, use a small skew on a low-medium heat to begin to pick out the buildings and railings using light sketchy outlines. Take care not to scorch the wood or burn too deeply. Suggestions of windows and doorways can also be added at this stage, paying close attention to perspective and the orientation of the line. However, nothing needs resolving at this point. Consider how the rocks are suggested, using broken lines – at this stage, you want to indicate shapes, rather than draw around them.

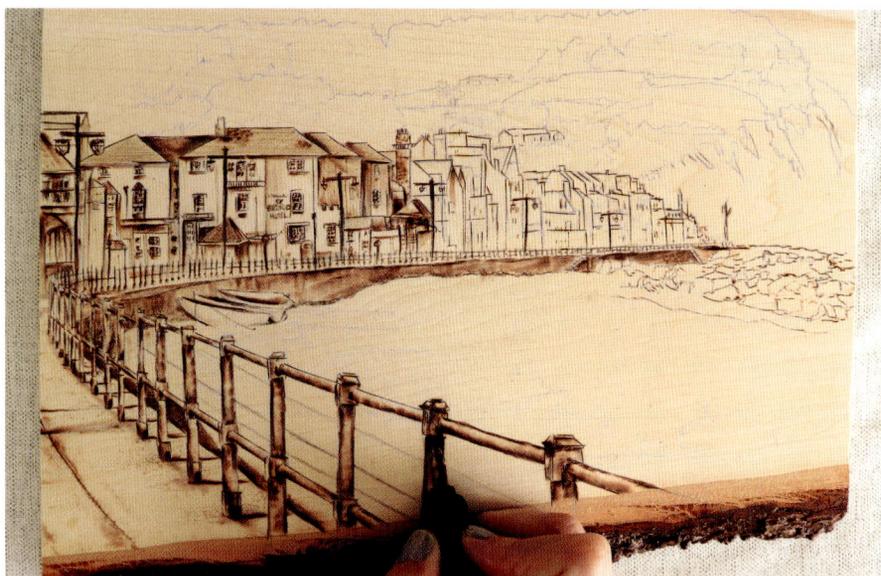

3 Switch to a flat shader and, on a low-medium heat, begin creating the midtones and shadows on the railings and buildings, paying close attention to where your light source is coming from. On this particular occasion it was an early summer's evening, with a cloudless sky and a gentle glowing light coming from the left. Be mindful of preserving your highlights as you work.

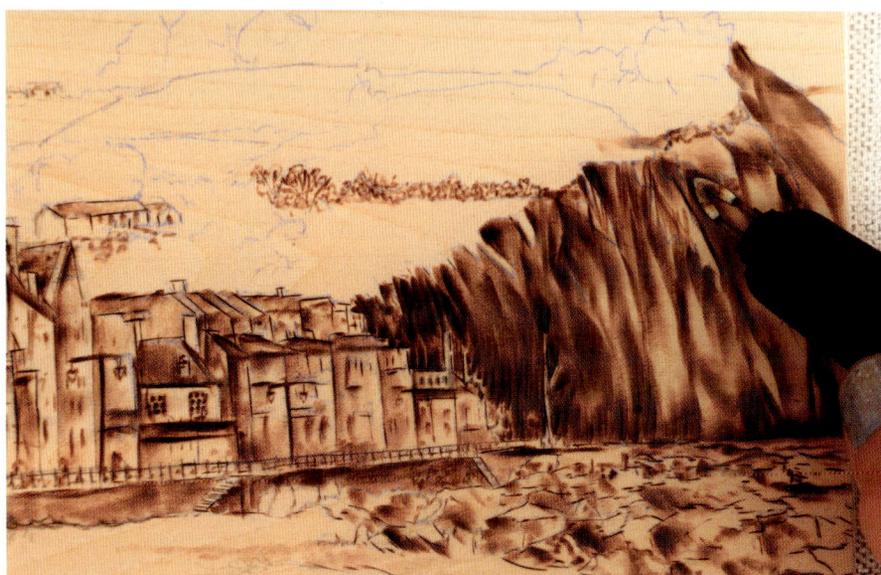

4 Once the buildings are established, turn up the heat a little and begin blocking in the rocks and cliff face using both the foot and side of the flat shader to create the craggy shadow areas. Be sure to reserve the flagpoles (watch the heat around these areas as they can soon be lost). Once the shapes begin to emerge, take a second pass and work the heat into the crevices to give depth and impact. Turn the heat down and begin having fun mark-making using doodles to suggest hedge boundaries. If you're unsure at any stage, practise on a sampler before returning to the project. Keep your marks varied using the toe, the foot and the side of the flat shader.

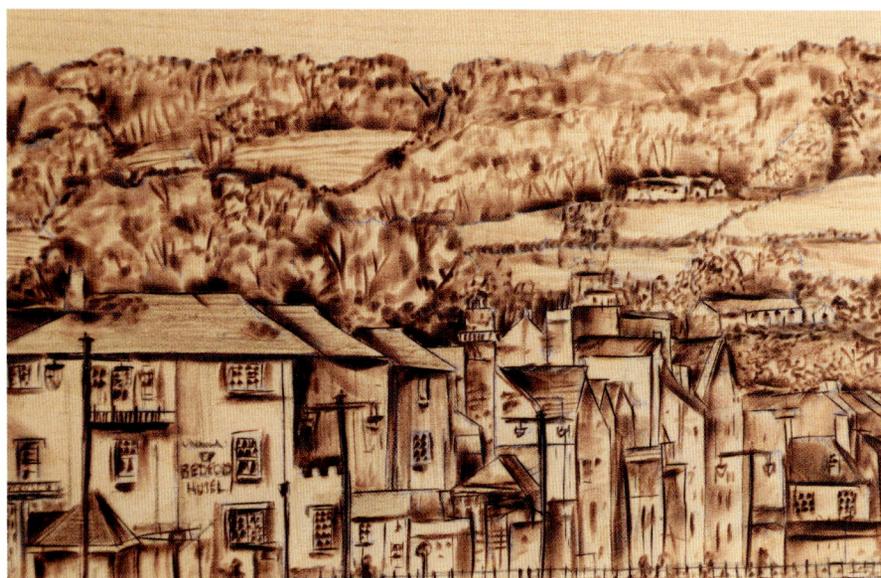

5 Continue working over the background and foliage using marks and patterns to suggest trees and fields. Create darker shadows at the base of the trees and field edges, then turn the heat down low and run the shader across the fields to create furrowed lines to give dimension and form (don't make these too neat or straight). With these complete, make a third pass over the whole picture, darkening any areas that need it.

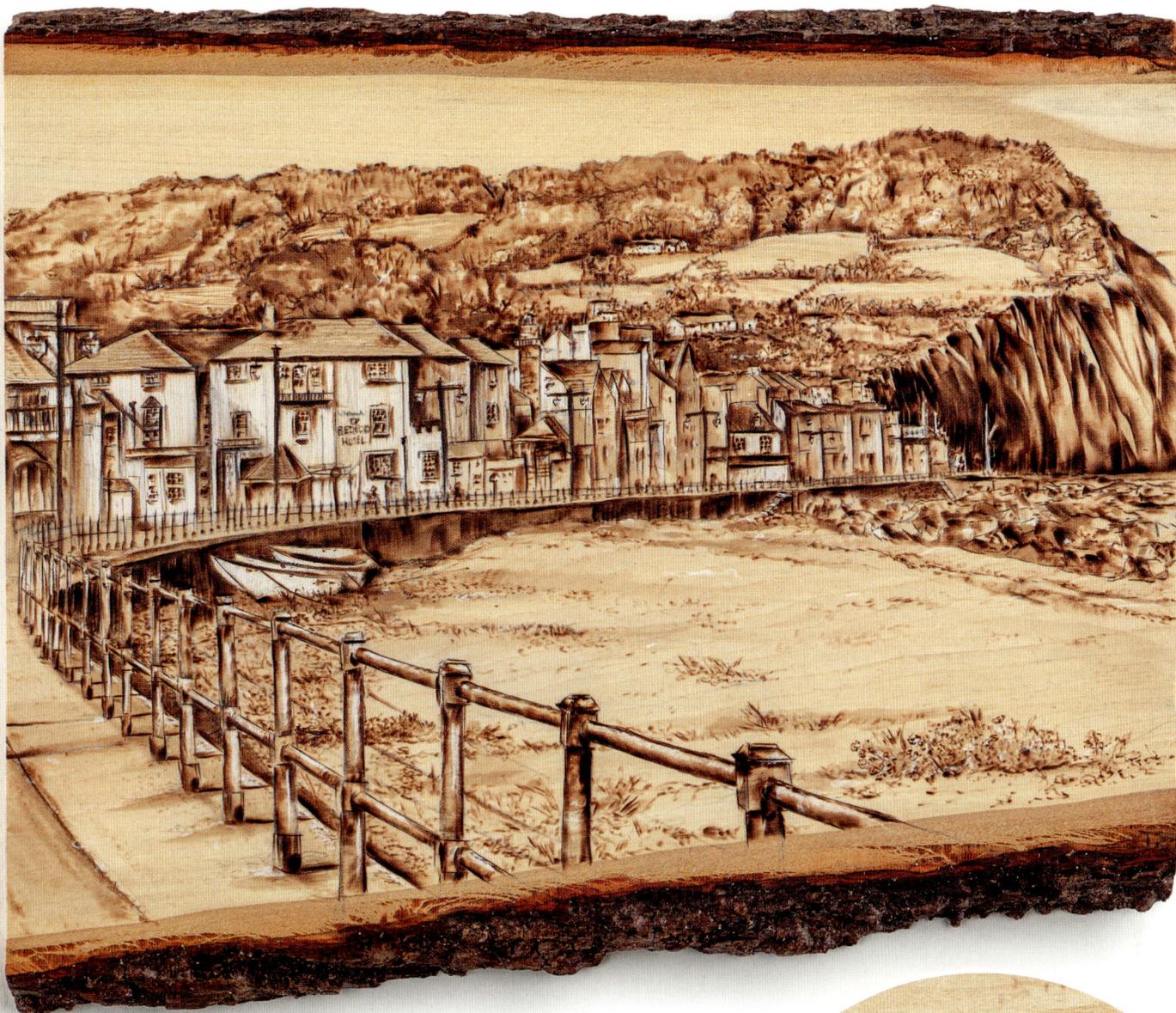

95

6 Continue adding tiny flowers to the foliage in the foreground using the toe of the flat shader, then turn the temperature down quite low and drag a few shadows across the pebbled beach. It's important to keep the tip moving when creating light smudgy shapes, as you don't want 'brand marks' at this point!

At this point, stop, assess the picture as a whole and adjust as necessary. Remember – you can always add but you can't take away. Using a white pencil, begin to add in the highlights and suggestions of white buildings and boats. Stroke your pencil in the direction of form and build up the colour and intensity in gentle layers – though do not add pencil marks in any area that you are still burning.

Detail of the tiny flowers.

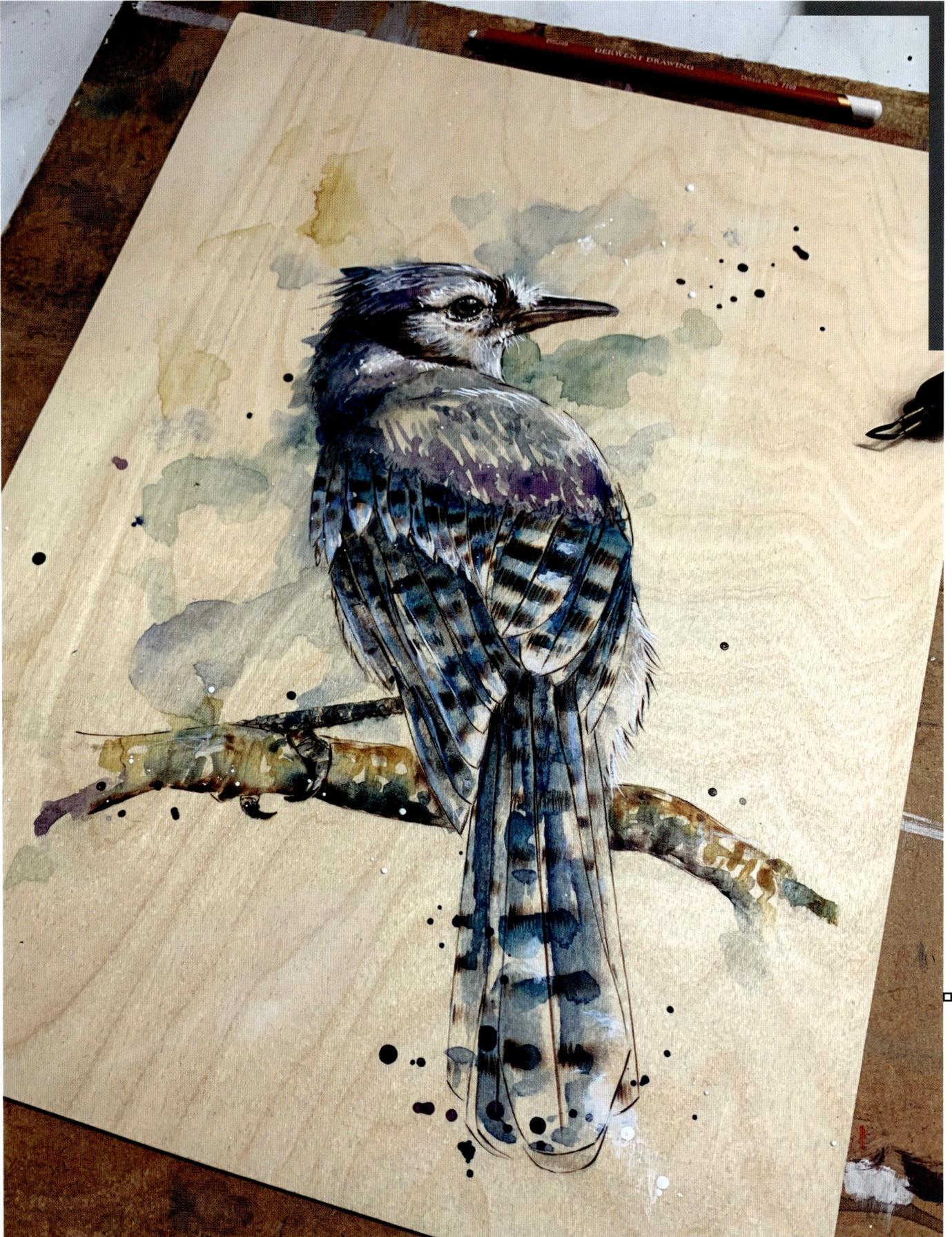

COLOUR YOUR WORLD

I adore colour, it has the power to make you feel so many different things all at the same time! From the brightest highlight, to the subtlest tonal shift, colour can connect us, lift us up and recharge our creative energy. What could be better than spending time splashing colour around and experimenting with techniques, then bringing them all together to create something new and exciting?

INTRODUCING MIXED MEDIA

As much as I love pyrography, it can sometimes feel a little too beige and flat to me. Some pieces cry out for a splash of vibrancy, a tickle of pizzazz and a more colourful voice to become a unicorn in a field of horses. Purists might argue that mixed media isn't really 'true' pyrography and dilutes the essence of the craft – but I say do what makes you happy. If you love colour and want to mix it up, then push those boundaries.

It's good to experiment – the world is full of so many wonderful possibilities. Some paints, media and products work well with wood and can be integrated into your pyrography artwork with ease, while others require gentle persuasion, a little coaxing and some extra prep work before they'll play nicely. The good news is that mixed media techniques can be quite forgiving and, with the know-how in this chapter, most of your favourite supplies can be incorporated into your work one way or another.

This part of the book is an exciting melting pot of ideas, products and colourful layers – so jump on board. All I ask is for you to take a deep breath, keep one eye on your destination, your mind in the moment, and try not to worry about any mistakes along the way. You'll soon find that magical moment when the idea that you were dreaming about manifests itself into a piece of artwork that really makes you smile.

Time to dive into mixed media – gather your courage, follow your curiosity, and bravely burn on.

True Blue 30× 40cm (11¾ × 15¾in)

Pyrography, paint and pen on birchwood panel.

A piece I did for the SAA (Society for All Artists) to demonstrate how pyrography can be used as a contemporary art form and integrated with mixed techniques. It's thus a lovely fusion of old meets new.

This blue jay was created using a pen and wash approach, explained on pages 112–113. The lines were made with a pyrography tip – then sealed. Once dry, watercolour paints were applied using a wet-in-wet technique to soften the lines and give the piece vibrancy and interest. If you'd like to give this particular piece a try yourself, more details can be found on Bookmarkedhub.com.

COLOUR ME UP

The most important thing that I've learned about colour over the years, is that it's highly personal, emotive and subjective. There are many theories and rules about what you should and shouldn't use, ideas about limited palettes, debates about colour wheels and suchlike. It can leave an emerging artist bamboozled and confused. My advice is simple: if you're feeling frustrated and overwhelmed, throw caution to the wind and bin the rulebook! If a colour excites you and resonates with how you are feeling in that moment, then go ahead and use it. You will, in time, discover your own personal colour palette and automatically reach for 'your' go-to colours. This, after all, is your voice, and yours alone.

If you feel particularly challenged by a colour but it excites you, then spend a little time playing and experimenting with it. See how it makes you feel and what it can do for you. Make friends with it and ask yourself how well it integrates with your other colours, palette and art materials. Some colours are great harmonizers while others can be bold, brash and intrusive – but sometimes, that's just what you need to get the conversation started!

A cornucopia of art supplies can be used alongside your pyrography. With a little bit of know-how, both wet and dry media can be brought to the Toasties' party. Traditional materials such as acrylics, inks and watercolours (even those bought on a whim and lurking in the back of the drawer) can be coaxed into use. Let's not forget about glitter, either – after all, what's life without a bit of shine and sparkle?

What colours to use?

This is a question I've been asked so many times, and my answer is always the same: the colours you choose should excite you, they should make you happy and they will naturally change over time.

Some artists choose to limit their palette to a few primary colours and mix the rest. This can be a great discipline in colour theory and it can most definitely harmonize your work. However, I'm a total colour magpie and a limited palette just doesn't work for me. I enjoy the super bright intensity of the quinacridone colours, and some of the pinks, turquoises, golds and silvers that I favour would be nigh-on impossible to mix from a limited palette. If a colour grabs you, inspires you and makes you want to use it... then why not?

Don't let 'having the wrong colour' stop you. Use whatever you have at hand, play and experiment. If a paint doesn't granulate and you want it to, then try adding a drop of granulation medium, throw on some salt while it's drying to create patterns, or sprinkle in a little mica powder to make it shimmer. There are no rules! Approach colour with wonder and enquiry.

Adding colour to your pyrography piece can take your artwork into a different dimension. Whether you are considering a full-on coloured piece or simply adding some subtle highlights or lowlights to complement the rustic and natural beauty of those sepia tones, selecting the right tool for the job is key.

What media to use?

Different media offer different properties. Each has its own unique quality. Watercolours and inks, for example, shine with their luminous transparency, ethereal colours and iridescent golds and silvers; acrylics boast bold, buttery, scrumptious pigments and luscious jewel-like colours that can dance and blend on the wood; and coloured pencils offer subtle colour shifts and tiny details in a rainbow of beautiful shades.

I mostly use water-based products to inject colour into my pyrography. Watercolours, acrylics and inks are all water-based, and can be used alongside traditional coloured pencils (both wax- and oil-based) and more unusual dry media like Inktense.

Water-based products don't always play nicely with wood. They have a tendency to sink into the surface and track along the grain, producing unsightly feathering and blurred edges. Fortunately, with an understanding of your materials and the use of modern grounds and gessos, most of your favourite art supplies can be adapted for wood and brought along for the ride. Before we look at the paints, let's look at how we prepare the wood ready to receive them.

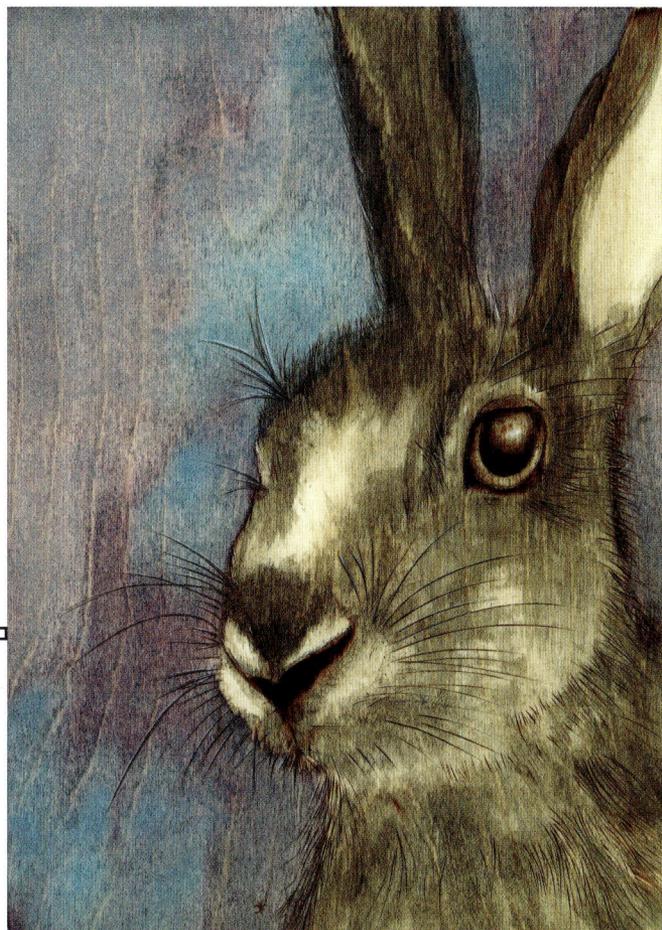

Hare Today 15 × 20cm (6 × 8in)

Pyrography with watercolours and walnut ink on birch panel.

This was a small experimental piece that I created to play with colours, just as you might in a sketchbook. Wherever possible, I favour transparent colours as these allow me to layer and glaze while allowing the brilliance of the paint or woodgrain in the layer below to shine through. They also allow the option to optically mix on the wood, which can create a wonderful vibrancy and depth of colour and tone.

Getting the surface ready: gesso and grounds

Wood is a living and breathing canvas, and the density of its fibres will vary across the surface. A porous, raw natural product, wood needs a gentle coaxing to accept water-based media. Adding watercolour or inks to untreated wood does not work well: they bleed and sink into soft woods, and bead and slide off hard woods. That's where gesso, grounds and similar preparatory mediums come in.

Before we look more closely at these, it is important to bear in mind that once you have applied gesso (or indeed any ground) to an area, you can no longer burn there, as the fumes released when heated could be detrimental to your health.

Gesso Brushed onto the surface and left to dry, or cure, gesso (pronounced 'jess-oh'), will swiftly become the experimental pyrographers' best friend. Once cured, the wood (or other surface) is ready to receive colour, paint and other mixed media paraphernalia. There are many brands to choose from, and it is available in different colours. Because I don't want to detract from the beautiful grain and natural form of the wood, and I want the colour elements to feel integrated into the design, my go-to gesso products are Liquitex Professional in transparent and white. Both apply easily, and dry to a matt, non-yellowing, water-resistant surface, with very few brushmarks and a small, even tooth. Gesso is relatively easy to work on with other dry media, liquids or paint.

Watercolour ground Watercolour ground includes an absorbent ingredient that makes it receptive to watercolour and gouache paints – think of it as an absorbent primer, rather than a sealer. Grounds can be used independently of gesso. However, if the surface is very porous (such as very soft woods), seal it first with a transparent gesso. I favour Daniel Smith's watercolour ground (available in white, black and transparent), which can be applied to most surfaces, including wood and gourds, using a brush or foam pad.

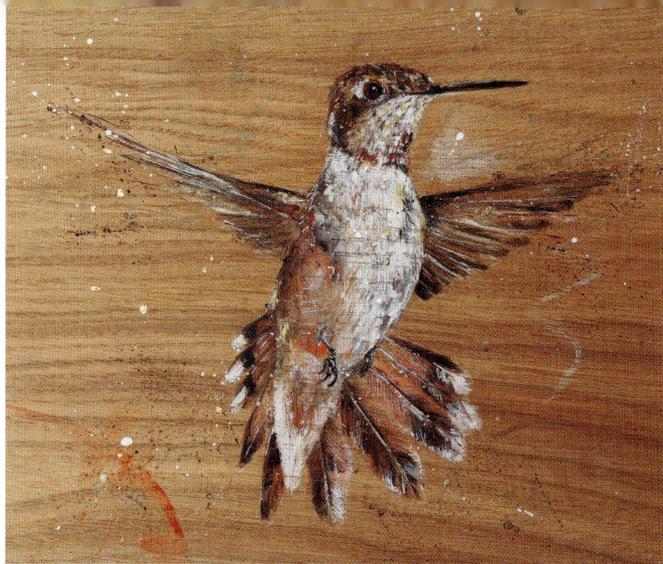

This hummingbird was burned on an oak veneer panel. Two thin layers of transparent watercolour ground were applied to the whole panel, enabling me to use white gouache, diluted metal ink and splattering techniques.

Mediums Medium is a catch-all term covering various gels and sizes. Typically more lightweight than gesso, mediums act as a lightweight sealer. They look milky when you apply them but dry to a transparent finish. They can be added on top of gesso, paint, metal leaf and more, and act as a way to seal that layer into your work. They are also great glues for attaching and incorporating all manner of objects into your work. Mediums tend to do what they say on the tin. Gloss mediums, for example, dry to a shine: great for sealing in metallic elements and painting over eyes to give them a glossy finish. Matt mediums, on the other hand, dry dull. The two can be used interchangeably.

If you are unsure what to use, be guided by your intuition and experiment. If something's a bit shiny and you find the surface too slippery to work on, consider applying a matt medium – this is great for coloured pencils and dry media in particular. If you're thinking of applying watercolours or inks, consider a watercolour ground. However, if you want to obscure something, knock an area back or even start over again, consider an opaque ground. It will obliterate all that's under it.

Gessos, grounds and mediums are the key to successful water-based mixed-media techniques on wood. Understanding how these materials work will unlock the ability to add scrumptious colours to your work.

From left to right: black gesso primer, heavy structure gel, metal leaf size (top), watercolour ground (bottom), clear gesso and matt medium.

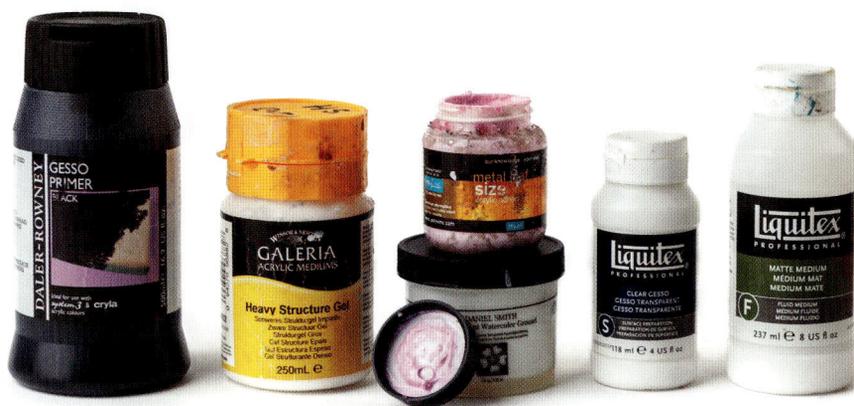

THE WORLD'S YOUR OYSTER

Here are a few ideas to play with once you are ready to start layering with colour. Think about what you are trying to achieve, then grab a product and have fun. Ensure that you rinse your brushes thoroughly after using any gesso, watercolour ground or medium. They all tend to dry quickly onto brushes and, because most are polymer-based, they will set solid.

- Using a damp brush, create a thin layer of gesso over your existing work (or area of interest) to give both dry media and paints something to adhere to. It acts as a barrier to preventing wet media like watercolour from seeping into the grain of the wood (see *Pyro and the Peacock* on pages 114–117).

- Use a credit card to smooth the product over your work. This helps to push it into the grain of the wood and thus create a smoother surface. Alternatively, you can swirl your credit card over the wood to create beautiful curves and marks which look great under gold leaf backgrounds (you can use a textured ground or modelling paste too).

- Using a dry brush to apply the medium will allow you to create textured marks, random patterns, happy trails and interesting doodles. Transparent gesso can be used directly on top of either the wood or painted layers to lock in that layer, thus creating a new layer (increased tooth) to work back into. This is handy for coloured pencils as they can quickly begin to slip and slide.

- Once cured, you can sand gesso with a 120 grit sandpaper to create a beautifully smooth, eggshell-like surface, similar to that of hot-pressed paper.

- You can use transparent gesso, ground or medium as a 'glue' to attach all manner of interesting things to your mixed media creation, or it can be used to prepare/mask particular areas of your work surface to receive a different medium (see *Magic of the Moonlight* on page 79, for an example of this).

There are new products coming out all the time, so keep an open mind, experiment and try things out. Just remember never to burn in an area you have covered with a medium.

HOT TIP

Sometimes art terms can be rather confusing and some words mean more than one thing. 'Size' is a word that is often interchangeably used with gesso, grounds and mediums. It can also be used to refer to various types of glue and binders. Metal leaf size, for example, is actually a water-based glue used for gold leaf.

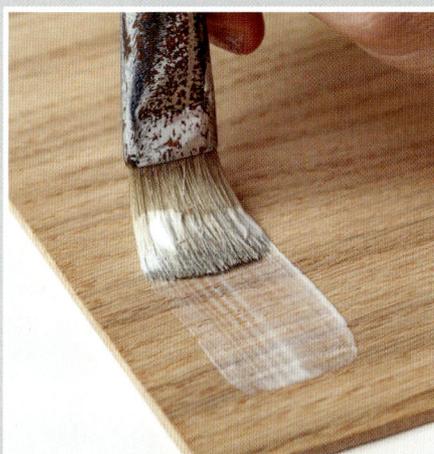
Gesso being applied with a brush.

Gel being smoothed with a palette knife.

Ground being applied with a dry brush.

Gesso and mediums are great for incorporating found materials into your work.

PAINT

To create a colour pop with paint on untreated wood, lay down a couple of layers of white (or transparent) gesso directly on the wood in a single area and leave to dry. You can then get creative: go ahead and build up some luscious layers of yummy paint over the gesso. The paint will look super fresh and sing against the pyrography.

I recommend using artists' quality paints. The colours are more vibrant and pure than students' quality paints, and they contain less filler, so a little goes a long way. In terms of what colours to buy, you can get by with a basic selection of a couple of yellows, reds and blues and mix your colours, but I like to use premixed colours that excite me. It gives me a visual head-start and helps with my decision making.

Brands I enjoy are Schmincke, Winsor & Newton; and I particularly like Daniel Smith – how could you not be inspired by colours with names like sleeping beauty blue, serpentine green and moonstone? These are scrumptious, unique colours created by grinding the earth's materials and minerals to form amazing paints. I also use handmade paints such as those created by independent manufacturers like Artistic Isle. I'm happy to intermix brands, it's the colour that I'm interested in. Be aware that some colours with the same name (such as burnt sienna or Prussian blue) can vary immensely in appearance and consistency from brand to brand, so when you find one you like, stick with it.

HOT TIP

Acrylic paint pens and markers are a super convenient way to add accents of colour and highlights. There's normally some form of Posca pen within arm's length wherever I'm working.

Watercolours The ephemeral, transparent jewels of the paint world, watercolours react like living things and never behave quite how you expect, which makes them so exciting to use. Watercolour comes in pans or tubes. I'm happy to use either (or both!). To use watercolour effectively on wood, particularly for wet-in-wet techniques, you need to use a ground or gesso. Unprimed wood will absorb the paint unevenly across the surface and watercolour will naturally creep along the direction of the grain. Absorption of too much water can cause a wood panel to swell or split.

Gouache Gouache is an opaque watercolour, sometimes known as body colour, and tends to be sold in tubes rather than pans. Gouache paints consist of a natural pigment, binding agent (normally gum arabic) and water. I use them in much the same way that I would use any watercolours. They hold a little ace up their sleeve as they allow the artist to work from dark to light – impossible with watercolour. Designed to be opaque and bright, be mindful where you use gouache within your burn, as it will dominate and cover the texture and colour of the wood.

Acrylics Versatile, fast-drying and durable water-based paint that comes in tubes, acrylics offer strong bright colours and plenty of specialist types, such as interference paints, which change colour depending on the angle at which you view them. Acrylic paints can even act as glue! Their vibrancy and covering power is second to none, and I love using acrylic paints for a contrasting 'pop' of strong opaque colour.

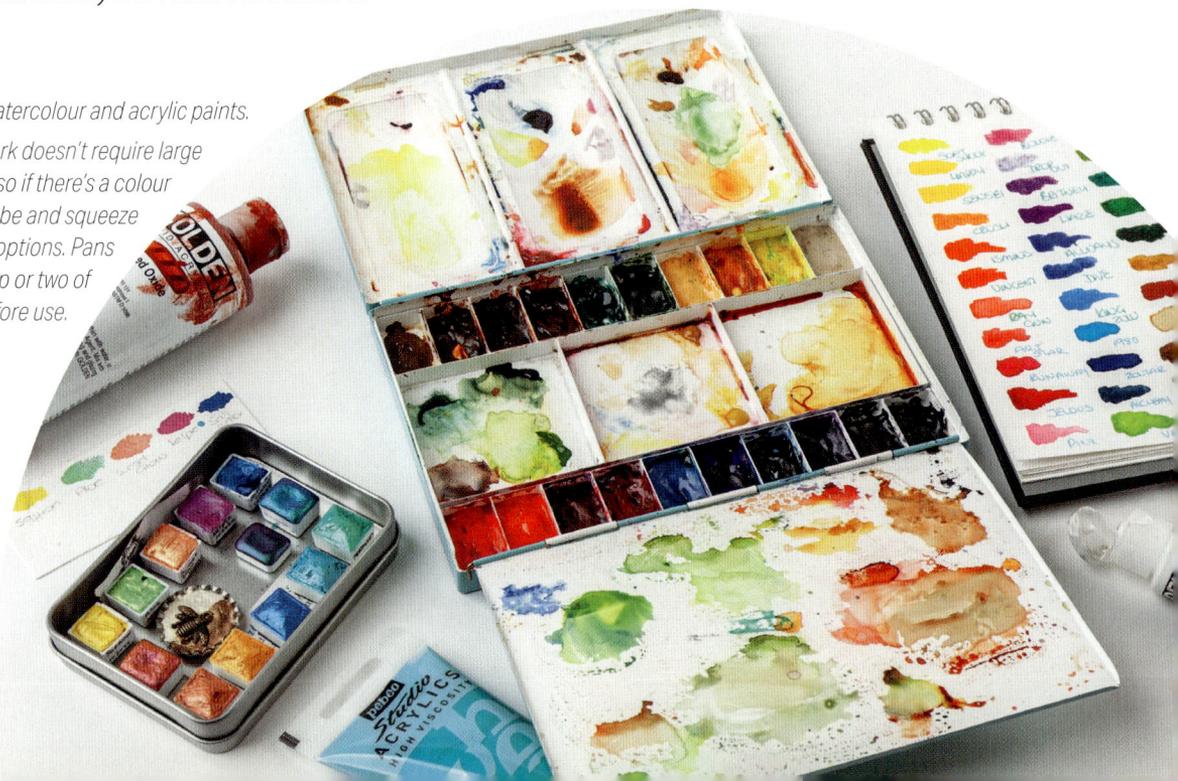

A selection of my watercolour and acrylic paints.

Most pyrography artwork doesn't require large amounts of watercolour paint, so if there's a colour I use a lot of, I buy a large tube and squeeze some into a pan so I have both options. Pans can be activated with a drop or two of water a few minutes before use.

PAINT QUALITIES

To get the best out of your paints in general, and watercolours in particular, you need to get to know their characteristics because each pigment has different properties. Think of them like little characters. Some colours will stain and cannot be lifted out, while others sit happily as granules on top of the surface of the paper or wood and can be removed with a damp brush or sponge. Some colours are quite solitary and grumpy, liking to sit and occupy their own space, while others love to mingle, flow, and play happily with their neighbours. It's great practice (and fun) to spend time exploring each of your colours and unfolding their secrets. It can be fascinating to watch.

When I'm buying any colours, I typically look for products that are lightfast and are non-staining so that I am able to lift them out should I choose to. If a staining colour is used on wood it can be nigh-on impossible to lift out of the grain – though this property can also be used to your advantage. It's just knowing your materials, what they do, and how you can make the most of them within the project you are working on.

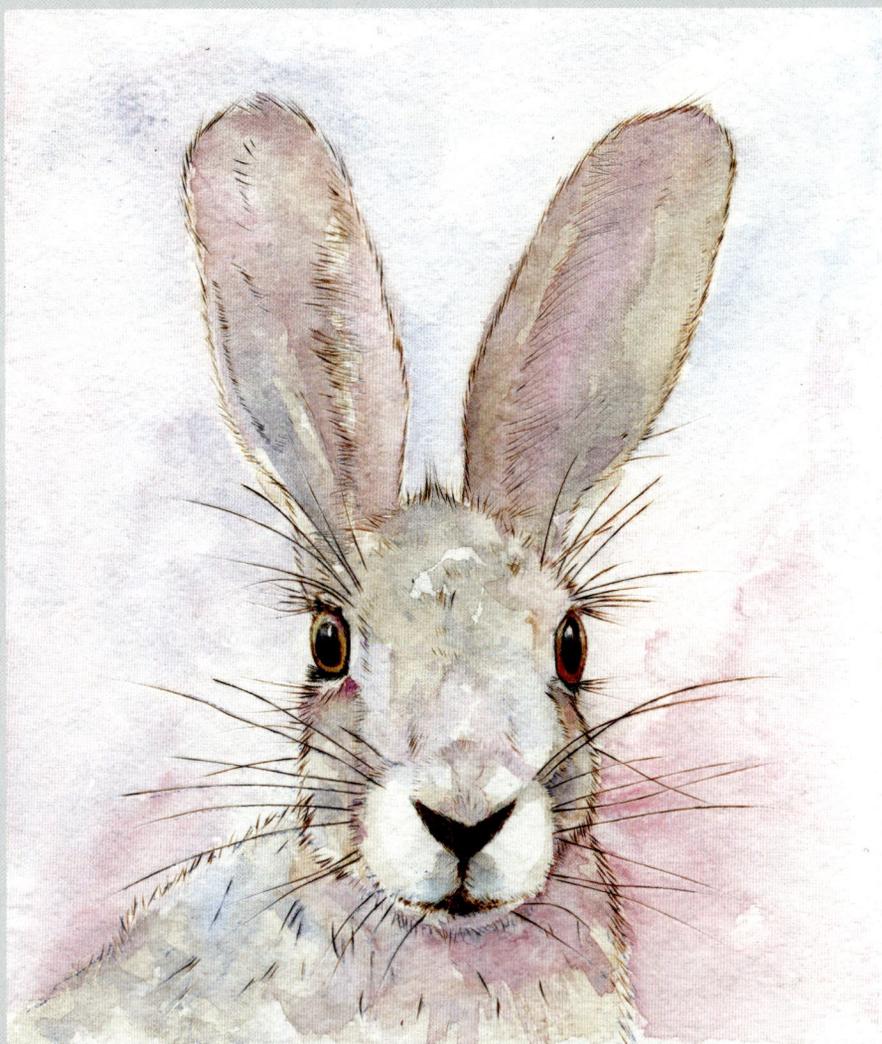

Spirited 30 × 40cm (11¾ × 15¾in)

Pyrography and watercolour on cold-pressed rag watercolour paper.

'Light as the moon's path over the sea, the hare dances over the land.'

I'm always of the mind that you 'guide' watercolours rather than paint. They behave like the untameable ocean, so learn their ebb and flow and enjoy the ride.

HOT TIP

Create your own quirky handmade palette by attaching a small strong magnet on the bottom of each watercolour pan and place them in a small metal tin. Even the tiniest of tins can normally fit six half pans and you can swap the pans in and out depending on your mood. Old-fashioned tobacco and snuff tins can make interesting and unique fun palettes.

You can often find me creating little metal tins of inspirational watercolour loveliness, squirrelling away exciting colours into tiny collections that can fit into my bag and be taken on adventures.

INKS

Inks come in a wide range of colours and finishes, and are a wonderful way to add subtleties, depth and interest to your pyrography work. Use analogous colours such as warm browns, oranges and yellows to add harmony to your piece, or choose complementary colours such as bright blues, aquas and greens to really add impact and sing against the sepia tones of your burn.

Inks can be separated into two broad categories: water-soluble (such as calligraphy inks) or waterproof (such as acrylic inks). Both types are fabulous to use, though I tend to use waterproof acrylic inks on wood as they do not diffuse and seep into grain as much as their counterparts. They also lend themselves to layering techniques without reactivating. I enjoy using both types of inks on paper.

Calligraphy inks have some wonderful subtle colours and some water-soluble inks split into their different component parts with the addition of water, which can be quite beautiful. Be aware that many calligraphy/drawing ink colours are fugitive and not lightfast. This isn't a problem if you are using them to experiment with or if you're creating work as gifts for people, however if you are selling your work, you will need to consider the longevity of your finished piece. Particular inky favourites of mine are:

Tom Norton Walnut Drawing Ink A wonderful, intensely pigmented, water-soluble ink that creates beautiful, warm, natural, rich browns that can be used to enhance some of the darker areas of pyrography and line work, or watered down to a soft blush, giving just a hint of colour. This ink offers outstanding performance with watercolour pen and wash techniques, such as layering to darken 'burnt' tones, or adding water for light washes. You can also use a wet brush to lift out colour from areas of this ink: impossible with acrylic inks. It's also lightfast and acid-free, which are added bonuses.

Daler Rowney FW Acrylic Sepia Ink FW Acrylic Inks are highly pigmented, water-resistant artists' inks with a high degree of lightfastness and intermixability. The ink can be used straight out of the dropper, or diluted to achieve the most subtle of tones. Sepia, in particular, is great for layering, adding depth and form and creating texture.

Krishna inks Vibrant fountain pen water-soluble drawing inks in a range of beautiful shades. The brainchild of Dr Sreekumar, these have evocative names such as Sheen Monsters, Happy Colours and Dynamic Colours – how could you resist? Some colours are a combination of pigments and are designed to split during application. Particular favourites of mine from this range are Pencil, New Myrtle and Cinnamon.

A selection of inks.

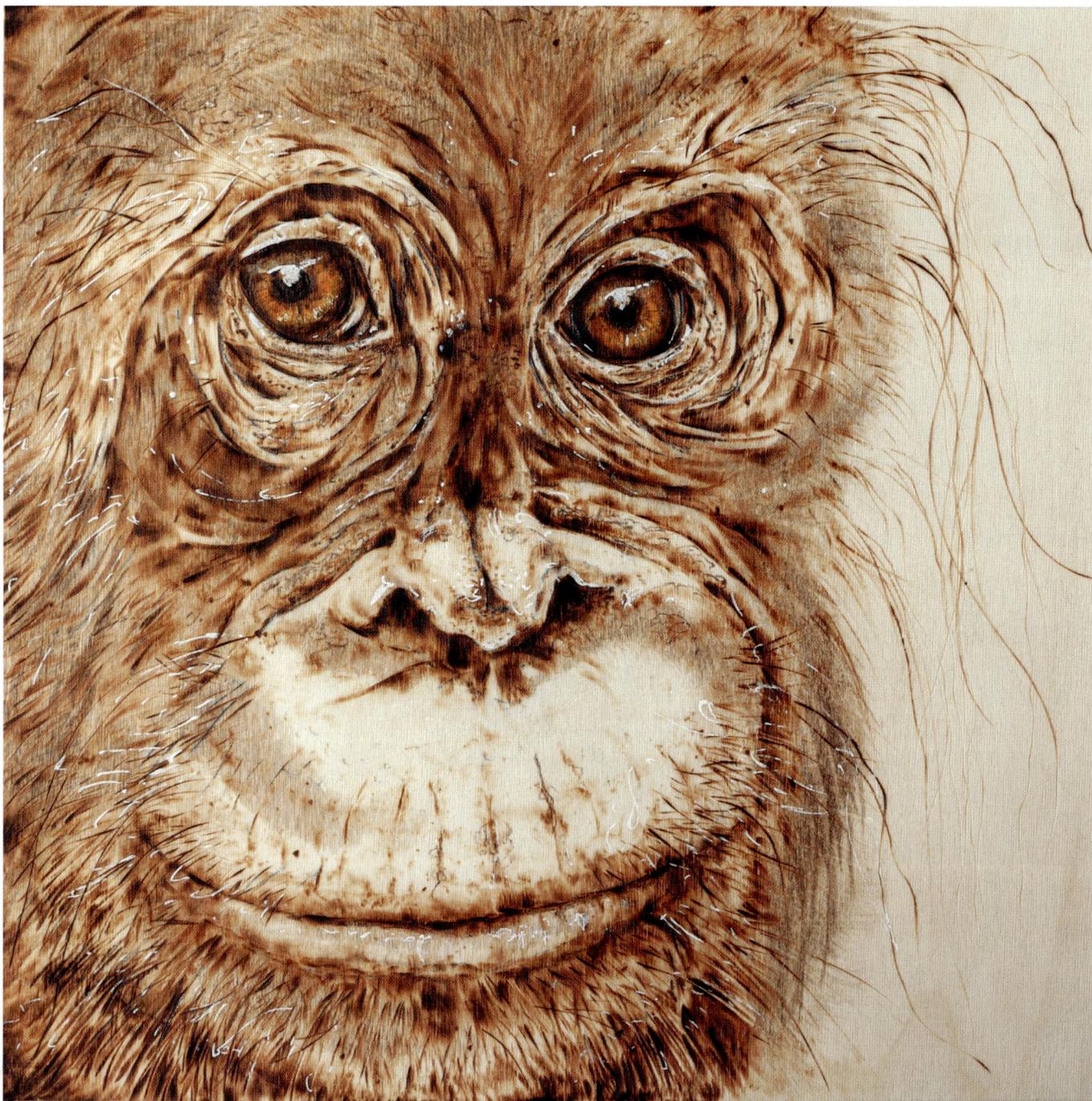

Old Man of the Woods 30 × 30cm (11¾ × 11¾in)

Pyrography, ink and pen on basswood panel.

'For in those eyes I see a dream of a time in a less selfish world.'

Colour can be as dynamic or as subtle as you choose. In this burning, walnut ink was used to enhance this orangutan's beautiful chocolatey eyes, fill them with emotion, and bring them to life. Once dry, a touch of tangerine Inktense pencil was added to warm them up. The ape was then finished with a white 0.7mm Posca pen to add contrast, texture and highlights.

COLOURED PENCILS

Coloured pencils work wonderfully with wood. Their subtle, gentle colours can be used to enhance contrast in your artwork, or add detail. They can be applied in layers to create depth and interest. As with paint, if you can stretch to artists' grade pencils, jump in with those. They contain more colour pigment and less binder than students' grades, resulting in a much brighter, more vibrant colour with better lightfastness. They require less effort to cover the surface and their pigments blend and interact better with each other.

Traditional coloured pencils Different pencil brands suit different woods. Waxier pencils work well on softer woods as their creamier consistency glides over the surface and the softer lead doesn't indent the surface. Harder pencils, such as PrismaColor's Premier Verithin range, and some of the oil-based pencils with a slightly hardened core, are good for harder woods or saved for details. If you want to use these on very soft woods, consider using them over a ground or gesso.

My go-to ranges for coloured pencils are Derwent Lightfast, Caran d'Ache Luminance and Faber-Castell Polychromos pencils. All these artists' pencils are great all-rounders, suitable for flat cover, detailed work and hatching. All come in huge ranges of strong pigmented colours and are intermixable and fully blendable. They also offer a great standard of lightfastness. Some brands, such as Derwent Lightfast, are even vegan friendly.

Inktense pencils Derwent Inktense pencils are a hybrid between acrylic ink and pencils. The range has been formulated so that the colours become waterproof once activated and dried. This allows you to work on multiple layers without affecting previous applications. Inktense colours are highly-pigmented and retain their vibrancy after drying, creating wonderful ink-like effects.

The pencils can be applied wet or dry to wood or paper, with the pigments coming alive when water is added. Inktense pencils can be applied to many porous surfaces including wood and fabrics. I'm happy to use them dry on untreated wood. If I'm planning on wetting them, I apply a suitable ground or gesso to the area first. Be mindful of how you varnish your piece – if you activate dry Inktense pencils with a wet varnish they will move. Consider switching to an aerosol varnish.

Boxes of pencils hold a beauty all of their own: beguiling rows of brightly-coloured soldiers, all lined up ready to serve. As beautiful as boxes are, they can take up a lot of space on your desk. Simplify by selecting the pencils you want to use for your project and place them together in an old mug or similar. You can see at a glance if your colours harmonize – and it stops them rolling off the table. You don't want those leads snapping!

APPLYING COLOURED PENCIL TO WOOD

When applying coloured pencils to wood, I work in gentle layers. It's really important not to apply too much pressure whilst shading with your pencils, particularly when working against the grain. Pressing too hard will damage the wood, causing unsightly gouges, indents and pockmarks in the surface, particularly on soft woods.

I start by blocking in the foundation colour to establish the tone. For general shading, apply small overlapping circles, a method used by tattooists to block in solid colour. Once an adequate amount of creamy pigment has been applied, dissolve the pigment with isopropyl alcohol using either a cotton bud (US q-tip), blending stump or paintbrush (depending on the size of the area) and blend before leaving to dry. This step acts to thin the pigment and diffuse it into the grain of the substrate, giving it a more painterly, watercolour-like appearance. It also allows more layers to be applied, further increasing the intensity and interest.

The second layer tends to be a more textured layer. It doesn't need to be the same colour as the base layer, but bear in mind that most coloured pencil pigments tend to be transparent or semi-transparent, so the colours will optically mix on the surface. Far from being a drawback, you can use this to your advantage, as the combinations allow for subtle colour shifts, ramping up shading and form – but can also produce vibrant colours that sing.

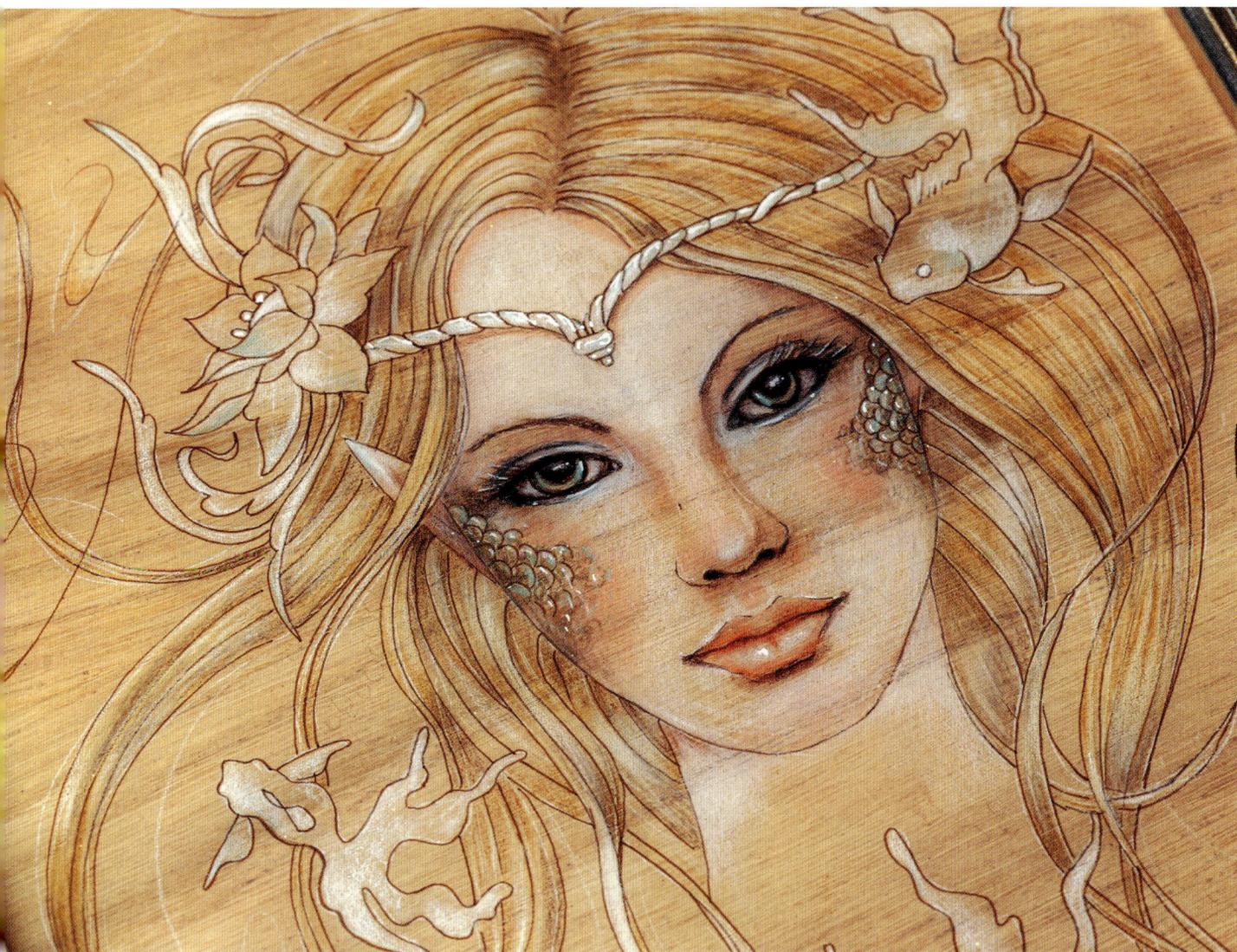

The Dream of the Mermaid 40 × 60cm (15¾ × 23½in)

Pyrography, coloured pencil, resin and glitter on oak panel.

'From the waves she span music, ethereal and sweet...
And from the stars the melody fell to the ocean as light as summer's rain.'

Created for a fun exhibition entitled 'Under the Sea' – for what could be more under the sea than a mermaid? – she was worked on a large oak panel using a fine writing tip in an illustrative pen and wash style. Soft shading was applied to her hair, nose and mouth using a flat shading tip.

Once the pyrography was completed, the rest of the image was further developed using a number of layers of coloured pencils. She was finished off with resin (see pages 158–160) to give her a magical underwater feel. To give the piece a little something special, tiny particles of art glitter were dropped into the resin while wet. Held in suspension, they now catch the light as the viewer moves around the image.

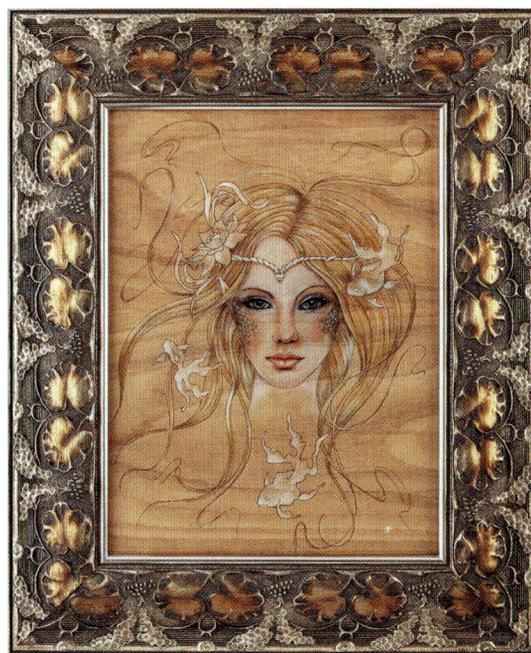

Who is the whitest of them all?

I'm continually on the search for the best white pens, acrylic markers and pencils to use with my mixed media projects. When using white pencils on wood I look for opacity, blendability and coverage. In the example opposite, I've used six different white pencils with one pass on a oak-veneered board – just look at the difference! For the 'Whitest One of All' award, there is one clear winner: the Derwent Drawing Chinese white 7200 – however, if you're after a different effect (perhaps something more ethereal, where the wood shows through) you might like to try one (or more) of the others.

1 Stabilo Write All 8052 An all-purpose marking pencil for glass, plastic, metal and wood. Easy to sharpen, it is highly pigmented, which gives strong lines. It is, however, water-soluble so will wipe off with a wet cloth.

2 Derwent Drawing Chinese White 7200 A soft, creamy-textured pencil with a unique waxy consistency. It produces a velvety smooth and opaque finish on wood without having to press too hard. It sharpens to a great point and has a very high lightfastness rating of 8. In this test it produced the brightest, most stable, saturated and opaque result and was the easiest pencil to use to lay down a strong white on sanded wood.

3 Faber-Castell Polychromos Weiss White 9201-101 Polychromos are my normal go-tos for coloured pencil work because they offer highly lightfast vivid colours as well as being smudgeproof and water-resistant. However, on wood their harder (and highly break-resistant) oil-based leads tend to skip across the grain, resulting in a patchy, weak colour.

4 Derwent Procolour Chinese White 72 When working on paper, Procolour Pencils are the perfect combination of a strong point and smooth laydown. The firm texture of the lead gives this pencil the strong covering power of a wax-based pencil, yet glides like an oil-based one. On wood, however, the firmer lead tends to skip, resulting in a patchy cover, even on a well sanded surface.

5 Prismacolor Premier White Blanc PC 938 Perfect for laying down blanket cover and bright highlights, this range is lightfast and offers richly saturated pigments. The soft, waxy, thick cores of this range require constant sharpening to maintain a sharp point, and the lead breaks very easily. Other than that, these proved a close second place in this test.

6 Derwent Lightfast White 2718 Derwent's Lightfast coloured pencils are their premium range and another of my absolute favourites (they layer wonderfully with Polychromos). They are oil-based artists'-quality pencils, completely lightfast. They can be sharpened to a lovely point for the most intricate of detail. I find them rich and beautifully pigmented and they cover well on sanded wood – though they don't perform as well here as the softer, more waxy pencils.

La Luna 10 × 10cm (4 × 4in)

Pyrography and coloured pencil on poplar wood.

Another experimental tattoo-style burn. The design was just outlined with a writing tip. The background was then stained with tea to give it an aged feel, and yellow pencil was used to add contrast around the moon. The luminosity of the moon was created using layers of white, pink and blue coloured pencils. Each layer was worked over with solvent (Zest-it Pencil Blend) and left to dry before the next was applied.

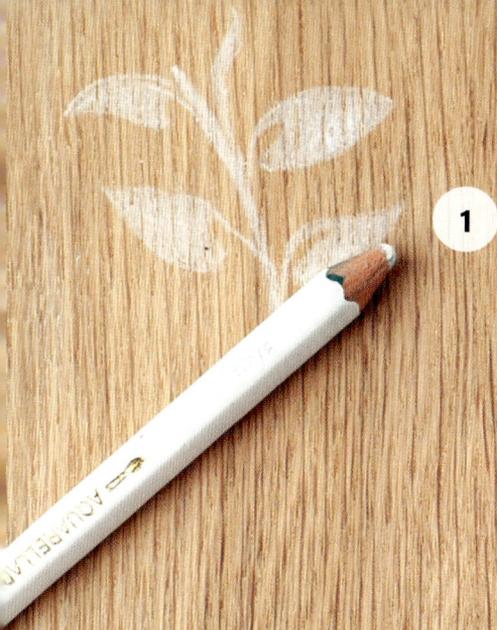

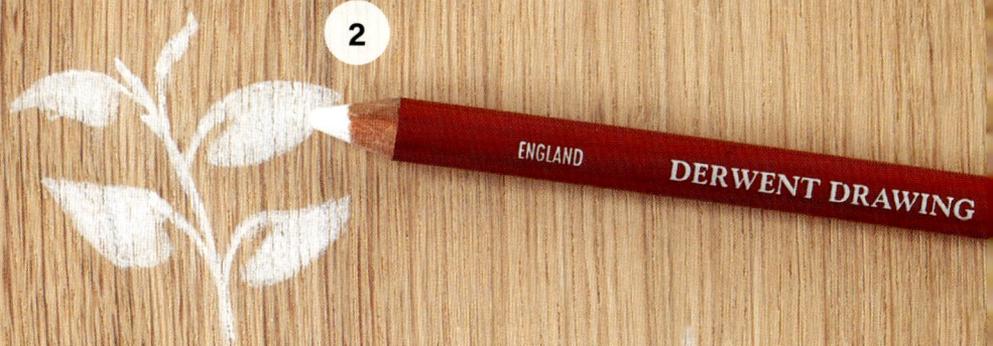

BRINGING COLOUR TO THE JUNGLE

Here's our friend, the tree frog, again. We left him on page 87, where we had built up the tone with stippling. Now we're going to add some exciting colour with Inktense pencils! For this project I wanted to show how to add an element of colour to the frog without detracting from the burn. In short, I wanted the pyrography to remain the hero of the piece. Inktense pencils are great for this as they are well-suited to layering so they can be as subtle or vibrant as you choose.

Neat applications of activated Inktense colour can sometimes look a little bright and intense for some pyrography images, so here I'll show you how to apply them indirectly, by using watercolour paper as a temporary palette before applying the colour to your work with a suitable paintbrush.

Surface: Existing frog piece from page 87

Materials: Inktense pencils: cadmium orange 0250, tangerine 0300, hot red 0410, sun yellow 0200, apple green 1400, bark 2000, Derwent Drawing Chinese white pencil (7200)

Tools: Scrap of watercolour paper, a soft, springy paintbrush that holds plenty of water and has a pointed tip

MATERIALS AND TOOLS

1 Scribble patches of cadmium orange and tangerine Inktense pencil onto a spare scrap of watercolour paper. Wet your paintbrush and gently wipe it over the patch of colour to create a dilute wash.

2 Apply dilute washes to the toes, legs and eyes, reserving the highlight areas. We are tinting rather than painting, so don't get the wood too wet: dry the paintbrush with a paper towel if you have too much water on the brush. Next, apply hot red in the same way to the base of the eyes. Leave to dry.

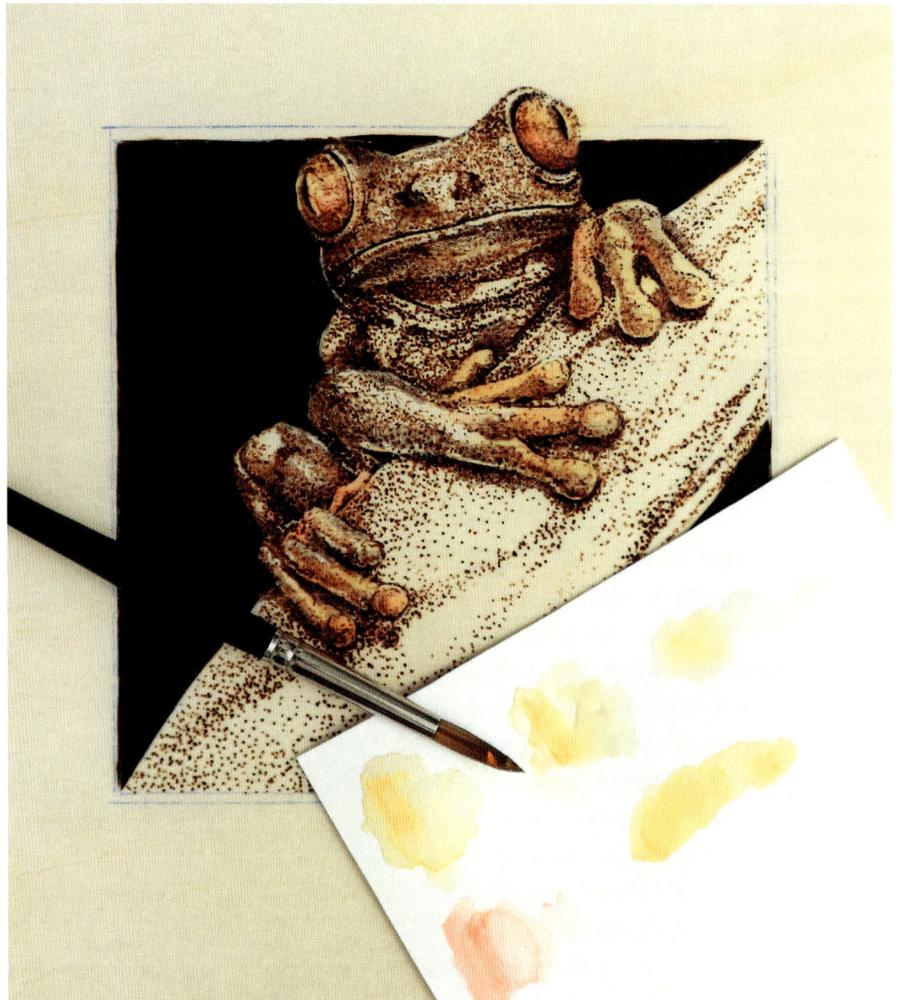

HOT TIP

Inktense is a water-based product and will sink into the grain of the wood. If you are considering laying an Inktense wash down on an area connected to a light background, first cover the area you wish to work upon with clear gesso. This will act as a barrier, stopping the added water-based colour bleeding into unwanted areas, and leaving the pryo work beneath visible.

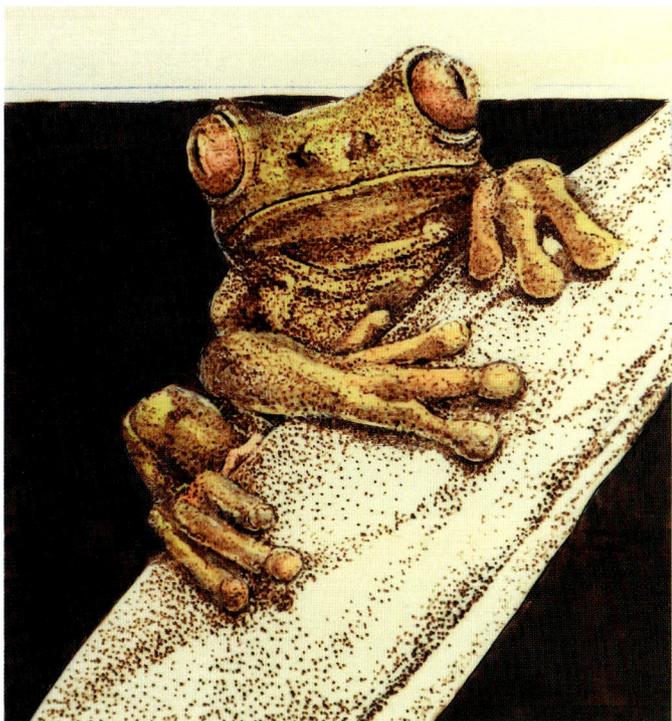

3 Using the same technique, apply a foundation wash of sun yellow to the body and face. Reserve the highlights and pay close attention to the top of the eye, where it breaks out from the dark background. Apply the paint with a dry brush in this area so that the wet wash won't diffuse and track along the grain of the wood. Leave to dry.

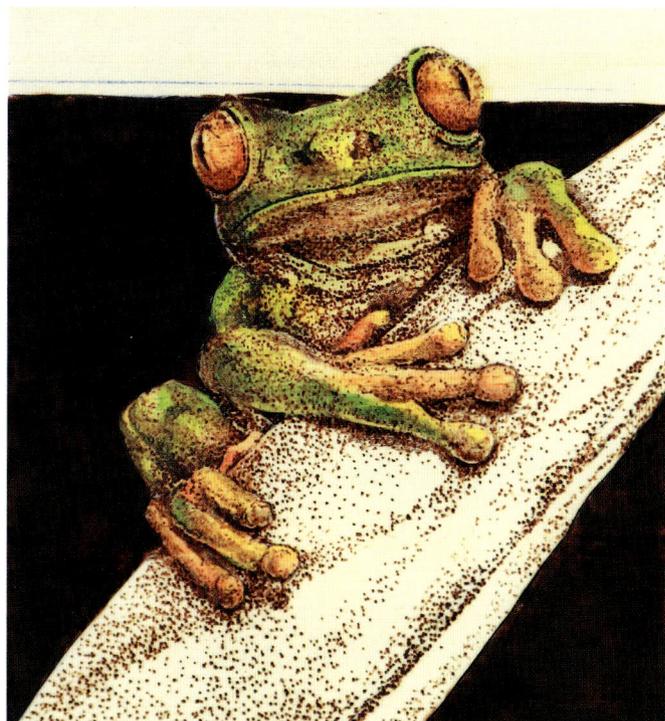

4 Apply various strengths of apple green Inktense washes to the face and body of the frog, strengthening the washes in areas of shadows and preserving areas of yellow where the light catches the frog. The stippled underpainting will show through the transparent washes to give the artwork form. Again, leave to dry.

5 Assess the artwork and add further layers to increase the vibrancy of paint in areas if needed. Leave to dry, then apply highlights with a soft white pencil. Finally, adjust the shadows if needed with a pale wash of Inktense bark.

HOT TIP

If you don't have Inktense pencils, you might try painting the frog with watercolour paint. Remember to add a couple of layers of transparent watercolour ground to the whole of the frog before you begin.

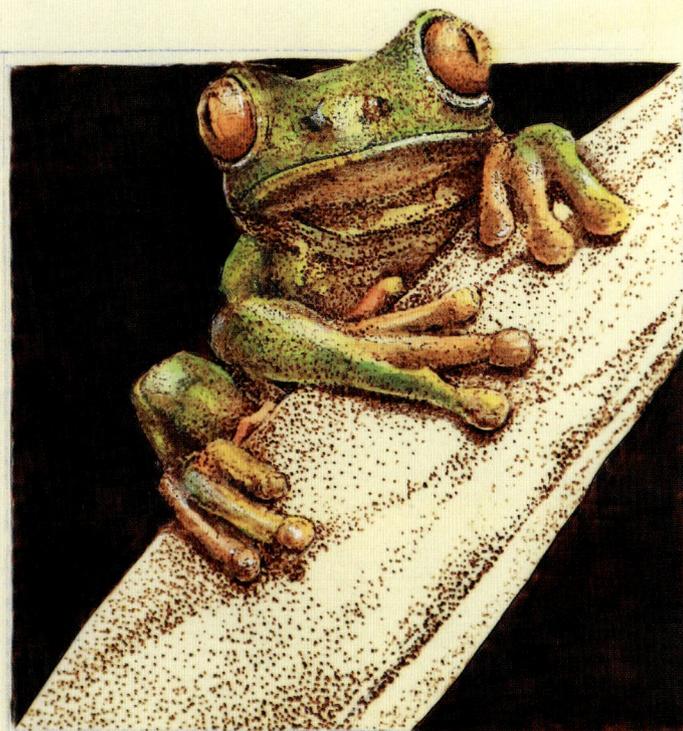

PEN AND WASH STYLE PYROGRAPHY

Pen and wash is a fun, direct and dynamic approach to pyrography. It allows you to create movement, freedom and expression with a liquid wash. It lends itself well as an extension to a more illustrative style, and is also a great way to add a splash of colour to your pyrography work. For safety reasons, do not reburn an area once a wash has been applied.

The essence of the pen and wash style encourages a loose, painterly approach. The strength of the drawing beneath will underpin your artwork, and the juxtaposition of the two creates interest and atmosphere. Some artists use a minimal approach for pen and wash, burning a few pyrography lines which hint at the subject's form and shape, then flooding the area with a wash to create interest. Others develop the pyrography sketch or drawing into a full study of lines, textures and patterns before adding just a few pale wash tones to counterbalance the pen work.

Part of the fun of this approach is to allow the paint or ink to run on the surface and breach the lines. With this in mind, avoid painting too carefully within your burn lines, or you'll end up with a laboured, tight-looking image. To help free you up, reach for larger paintbrushes when applying a wash to your work. I like using quill mop brushes for this style of work. If you don't have a mop, just look for any round brush that tapers down to a nice tip and has a large belly to hold plenty of paint. Sizes vary across brands – I have a size 4 that is bigger than my size 12 from another range, for example – so just use the largest brush that you are comfortable with for the size of your work piece.

I would suggest using a synthetic brush with a gentle 'spring and snap'. This will give you more control and help to combat the surface texture and grain. Painting on wood is more wearing on a brush than painting on paper, so keep your best watercolour brushes for working on paper.

My go-to washes for monochrome tonal work in the pen and wash style are Tom Nortons' walnut drawing ink or a diluted acrylic ink in sepia (Daler-Rowney's is fab). Both work well on wood and hot-pressed watercolour paper. I also enjoy using steeped tea (no milk!) combined with pyrography on HP paper. The two complement each other wonderfully and give the image a romantic, whimsical, 'olde worlde' feel.

MY CHOICE: BRUSHES

For brushes in general, I use the Jackson's Icon range which are amazing synthetic watercolour brushes at a great price point, even for the larger sizes. I initially bought the Quill from the range to try it out because I'd heard good things about the 'micro-synthetic' fibres, which are treated to act more like natural hairs than most synthetic brushes. It swiftly became one of my favourite brushes for the pen and wash style in particular, as it has the perfect amount of softness and spring for the way I work and is brilliant for washes... even in tight areas! As you can imagine, the pointed rounds soon followed, and I have not looked back since.

Da Vinci Cosmotop-Spins are great versatile paintbrushes, popular for their water-holding capacity. They are another good option.

The Fisher King 30 × 30cm (11¾ × 11¾in)

Pyrography and water-soluble ink on basswood

Using my Workhorse (the Razertip SS-D10) with a flat shader tip, I worked the pyrography first using bold, confident strokes and repeated marks to indicate feathers. Once complete, the whole panel was covered with two layers of transparent watercolour ground. Over the top of this I used a wet-in-wet technique and splatters to add colour, with quinacridone gold, orange, turquoise and metallic ink.

PYRO AND THE PEACOCK

Ths project is a great showcase piece to consolidate your pyrography and mixed media skills. It's an interesting fusion of styles and techniques that we've covered on our journey. The *mehndi*-style adornments and beads require confident mark-making skills, while other areas require soft shading and an understanding of tips and layering. We're also going to complement all those lovely sepia tones with a colour pop in the shape of a peacock butterfly.

If you are using wood with a live edge, seal the bark as described on page 88 before you begin.

If you are using wood with a live edge, seal the bark as described on page 88 before you begin.

MATERIALS AND TOOLS

Surface: Large basswood slice or similar softwood panel, 26 × 35cm (10¼ × 13¾in)

Materials: Transparent gesso, acrylics or gouache paints in the colours of your butterfly, white glue or matt medium, iridescent medium (optional)

Tools: SS-D10 machine with writing tip and shading tip, assorted paintbrushes, layout paper and tracing paper, blue transfer paper, burnishing tool to transfer the design, kneadable eraser

THE INSPIRATION

This piece was inspired by a nostaglic black and grey shaded tattoo that I did many years ago for a client. I liked the idea of incorporating earthy sepia tones for the main body of piece, but fancied giving the piece a pop of colour and using a more realistic, less stylized approach on the butterfly. I like it when two styles nestle together and bring something new.

Feel free to switch things up and experiment with different designs – perhaps change the time on the watch or substitute the butterfly for another insect, or a bird. If you choose to do this, always keep your composition in mind. The arrangement of your design elements is often more interesting, pleasing and dynamic when you use a simple rule-of-thirds approach. Using the rule of thirds involves dividing your composition into thirds, both vertically and horizontally, and then placing the key elements of your composition (the flower and the butterfly in this example), either along these imaginary lines or near the junctions of where they intersect.

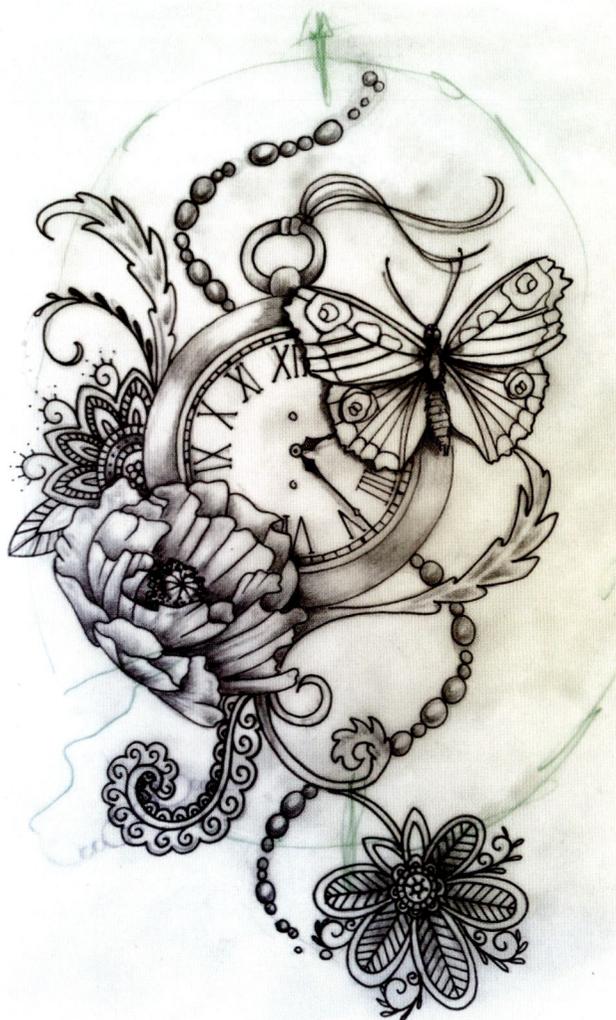

My initial sketch for this project.

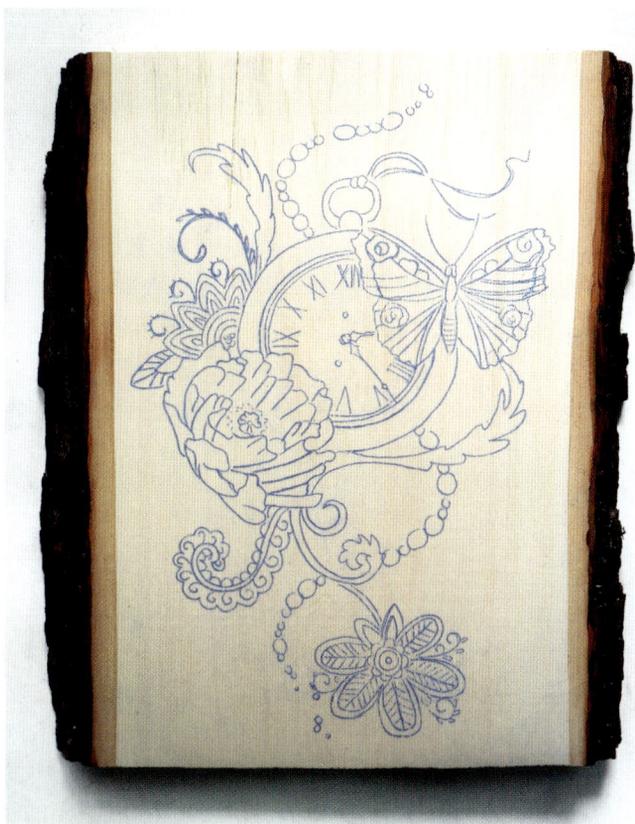

1 Select your wood and prepare the surface to a smooth finish. Transfer your design as described on page 29. If the lines are a little dark, soften and clean them up with a kneadable eraser.

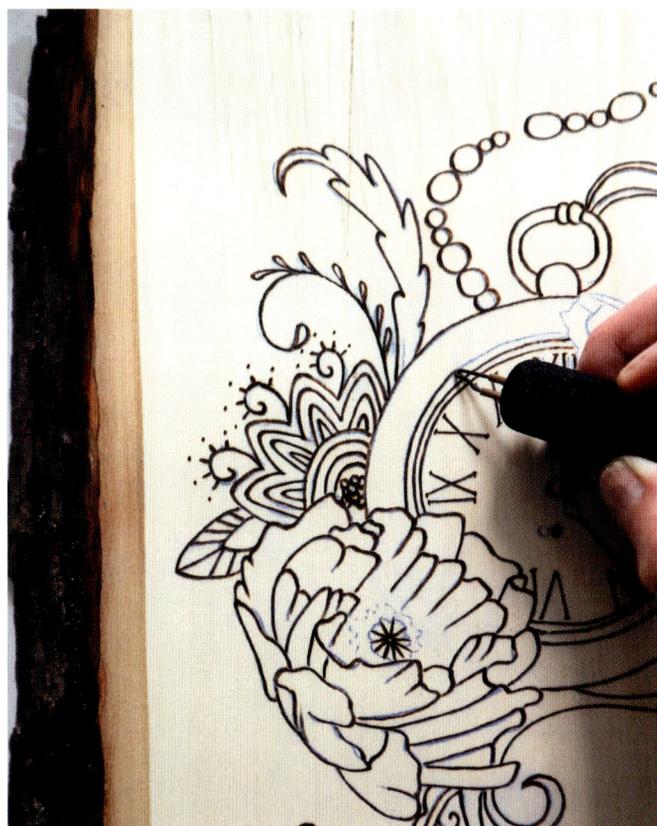

2 Begin burning a bold outline using a writing tip. Be confident and assured with your lines. If you are working on a smaller design than I am, consider swapping to a smaller ballpoint or stylus tip.

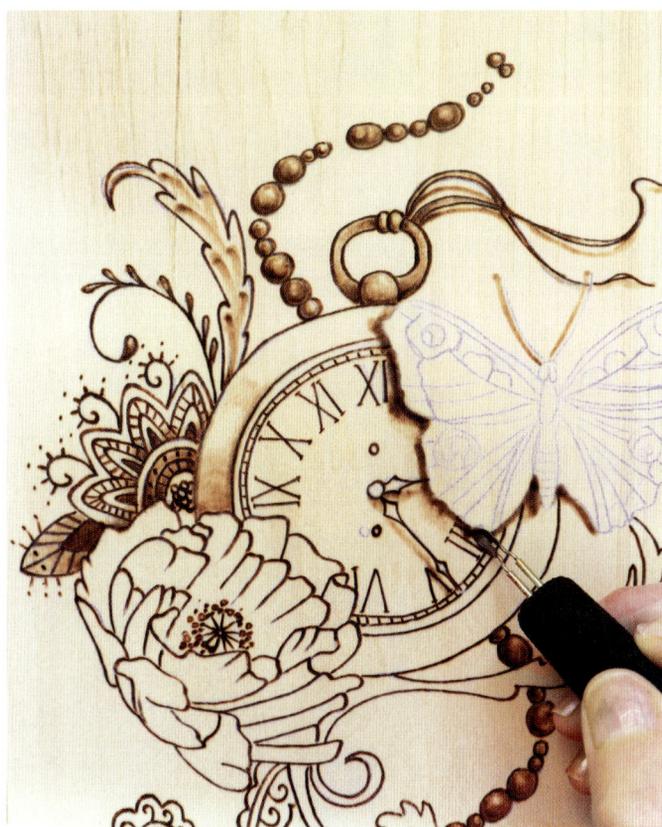

3 Once you are happy with your outlines, switch to a shader tip (here I'm using a spoon shader, but you could equally well use a flat shader) and begin to establish areas of shadow, paying particular attention to your light source and cast shadows.

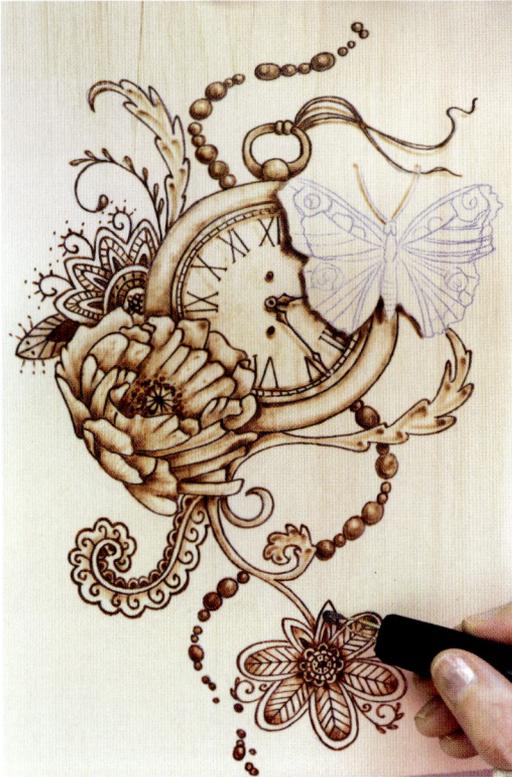

4 Resolve the midtones and begin to create smooth transitions and gradients of tone to link the elements of your design together. Leave clear any areas that you intend to paint or add colour to. Powerline (see below) some of your main outlines to add some drama and impact to your image.

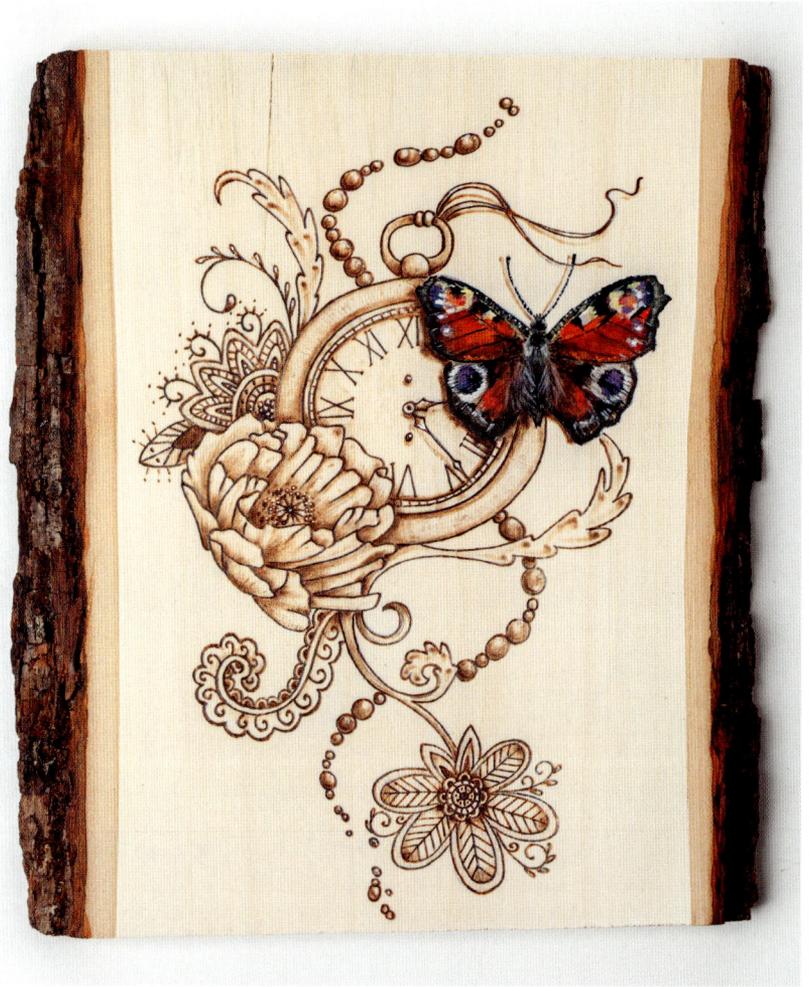

5 Carefully apply clear gesso to your colour pop area, keeping your brushstrokes following the form of your subject. Leave to dry, then paint in the normal way using acrylics or gouache. For this painting I used acrylics with an iridescent medium to add a little butterfly shimmer. For a more subtle look, consider using artists' coloured pencils. Notice how the strategically-placed pyrography shadow under the painted butterfly's wing gives a wonderful three-dimensional look to the image.

Powerlining

Powerlining is a technique of strengthening certain lines in a design to guide the eye and add emphasis to particular parts. It's simple, too – once the piece is outlined and shaded, use a writing tip to re-establish and thicken some of the outer lines, particularly on the bottom edge of a shape. Used by many tattooists, powerlining is a technique that translates well to pyrography. It adds drama, interest and depth to an illustrative piece which has a lot of line work.

Pyro and the Peacock 26 × 35cm (10¼ × 13¾in)
Pyrography and acrylics on basswood slice.

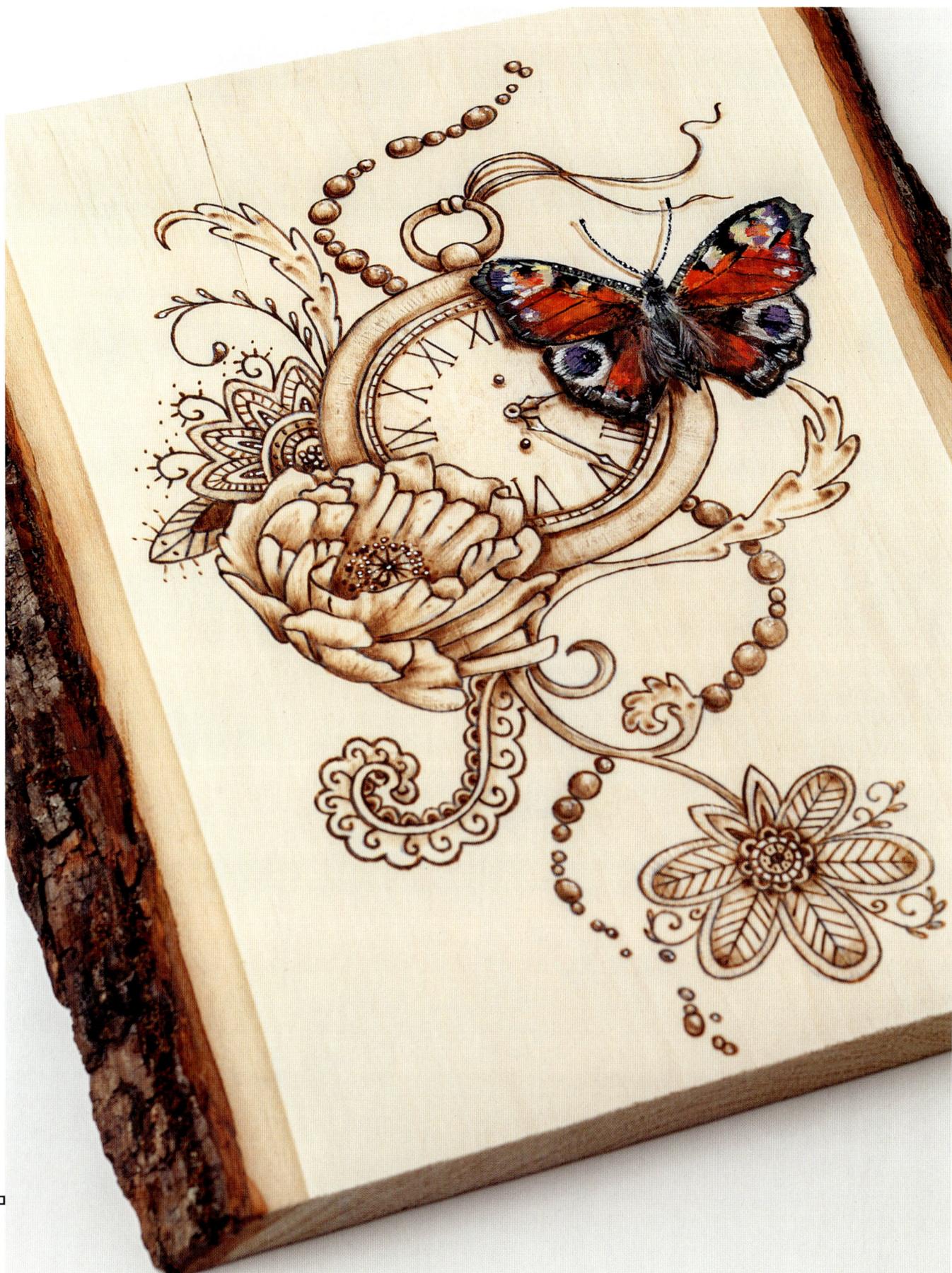

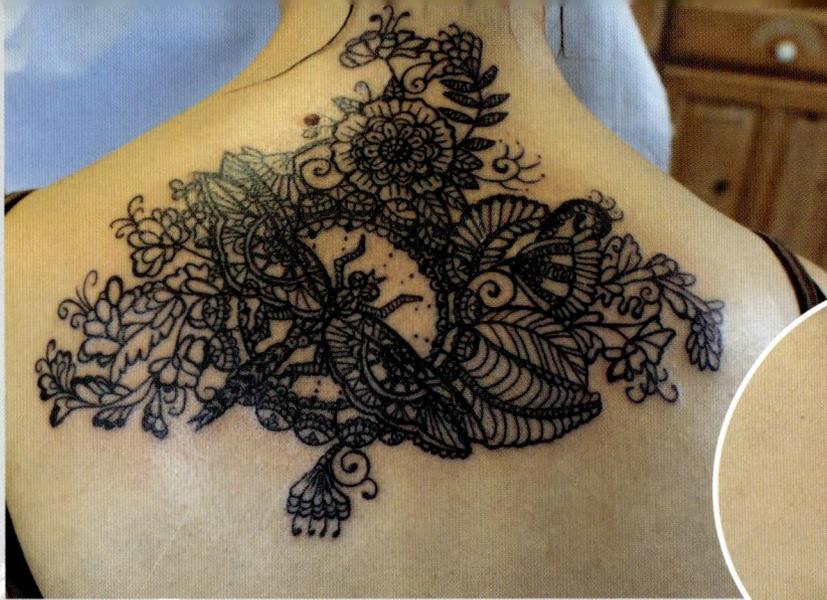

Some examples of my tattoo work – you can see how each style can be developed into pyrography through line, tone and creativity. As an exercise, consider how you would go about creating these on wood or paper – what techniques would you use?

TATTOO STYLE PYROGRAPHY

Tattoo style works offer a great way to experiment with line, shade and bold colour. As a tattoo artist, pyrography offers me an alternative canvas to skin; one on which I can experiment more freely to develop ideas, while using similar techniques. Since tattooing is principally pen and ink work on skin, the skills and techniques transfer to pyrography readily: it is a simple matter to swap the tattoo needle or piece of bone for a pyrography pen and tip.

Tattoo styles

There is not one single tattoo style but many, with amazing, talented artists creating their own spin on classic tattoo designs every day. Most modern designs are adapted from historical tattoo styles and references – some of which are decades or even centuries old. The great news is that most of these styles work amazingly well on wood and are fabulous ways to expand your artistic toolkit with new ideas and concepts. The ancient style of poke work (also called line and poke, or stick and poke) is demonstrated on pages 68–69, and there are many others to explore: new- and old-school, classic Americana, black and grey, geometric and blackwork tattoo styles for inspiration. Each of these styles has a distinctive and recognizable way in which line, tone and colour (or lack thereof) are used.

Most traditional tattoo styles are built around strong, confident, bold, crisp lines. These styles are best suited to burning on light woods or hot-pressed watercolour paper with some form of writing tip. When working with similar bold lines in pyrography, I often infill with layers of bright coloured pencils or soft, dreamy washes of watercolour.

Black and grey tattoo ink styles are softer, more expressive and moody. These call for your go-to shaders, and can make wonderful stand alone expressive pyrography pieces. Geometric tattoo styles and blackwork lend themselves well to a mix of writing tips, shaders and skews.

Throne of Beauty

This quirky example of a traditional tattoo-style pyrography on wood was a commission a few years ago for an amazing tattooist from Birmingham, Dawnii Fantana. She wanted her studio logo of a lady and butterflies immortalized on an oak toilet seat. It was a great fun project which later became known as the 'Throne of Beauty' – for obvious reasons!

Miakoda 30 × 40cm (11¾ × 15¾in)

Pyrography, tea, ink and coloured pencils on birchwood.

This is another old-school style tattoo that I reinvented on wood, using a writing tip for most of the linework. The luminous colours are multiple layers of coloured pencils, while the background was created using tea and walnut ink – an unlikely but effective combination! Miakoda now hangs in a women's refuge in Africa.

GAIA

In the spirit of experimentation, let's try this tattoo style burn on paper rather than wood. We'll complete the colour element using watercolours with a wet-on-dry approach to create glowing layers. Adding colour to your tattoo style pyro work can really take your work into a different dimension. We'll also have a sneak peek at gilding here, giving you a brief introduction before we look at it in more depth in the next chapter.

 This project shows how to use complementary colours for layering dark tones and shadows. By putting complementary tones side by side on the page you lend a vibrancy to the shadows which can appear quite flat if you use black and grey. Here, the skin tone is a yellow-red wash, for example.

By using blue-violet, which sits on the opposite side of the colour wheel, for the shadows, the colours optically mix on the page and appear much more vibrant and rich than in monochrome. The Artistic Isle paints have a lovely shimmer, but if you don't have any, you can improvise by adding mica particles or iridescent medium to your paint.

 If you want to work on a wood surface instead of the paper, that's okay – simply apply two or three thin coats of transparent watercolour ground to the whole surface after step 3. Leave overnight to dry before continuing. The design was created as part of a collaboration project by a super-talented tattooist called Dawnii Fantana, of Painted Lady Tattoo Parlour.

MATERIALS AND TOOLS

Surface: Arches Aquarelle 300gsm (140lb) hot-pressed (HP) watercolour paper, 30 x 40cm (11¾ x 15¾in)

Materials: 24ct gold leaf (use imitation if preferred); copper leaf, table salt, watercolour paints: hansa yellow light, scarlet lake, Indian yellow, ultramarine violet, cerulean blue, phthalo blue, burnt madder, burnt umber, sap green, viridian, quinacridone magenta, and dioxozine purple, plus optional aloe, saltwater and saffron paints from Artistic Isle; white Posca pen (0.7mm)

Tools: SS-D10 pyrography machine, with writing tip or ballpoint tip, tracedown carbon paper, sizes 8, 4 and 2 pointed round brushes, size 4 quill brush; putty eraser, wax paper

HOT TIP

Before you start, take time to practise on a spare piece of paper first to get your temperature right and become confident with your lines.

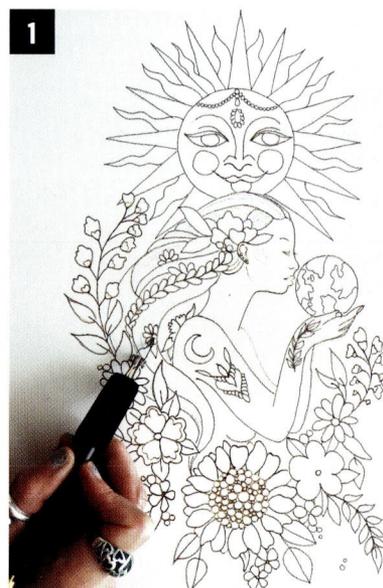

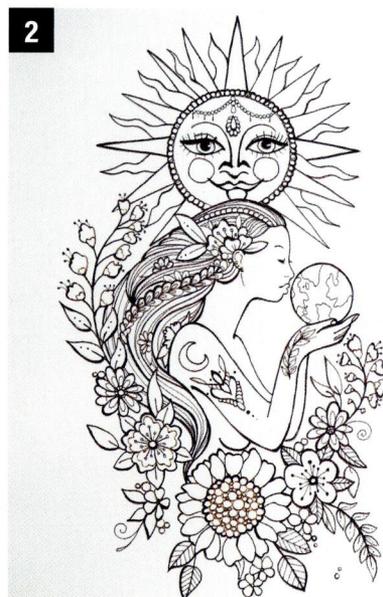

1 Transfer the design to the watercolour paper using tracedown carbon paper. Carbon can interfere with your burn, so before you start burning, remove as much carbon as possible by tamping the transferred lines with a putty eraser. Start to burn the outline and key features of the design using a writing or ballpoint tip. Keep your line confident and consistent.

2 Once all the key features are in place, reinforce some of the areas with bold powerlining (see page 116).

3

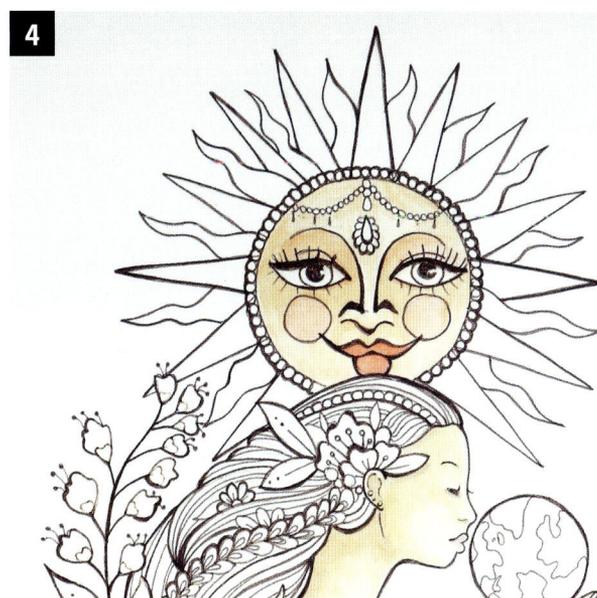

4

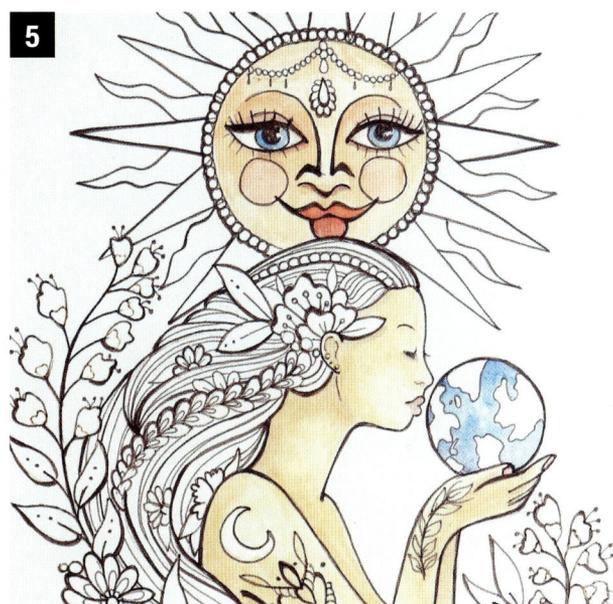

5

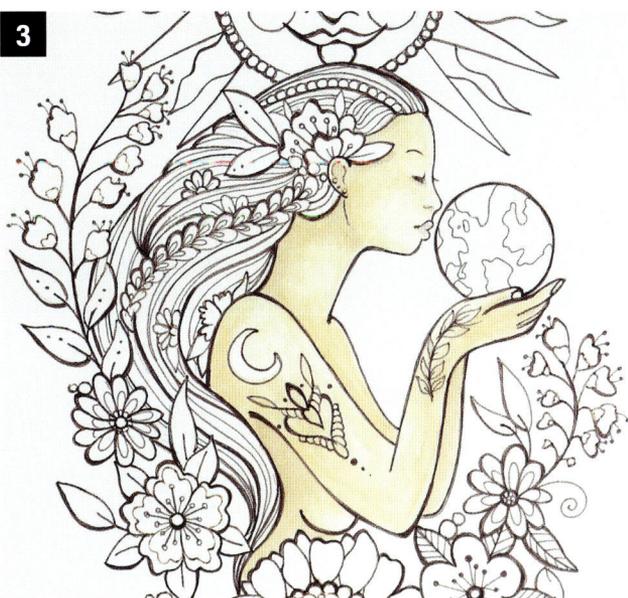

3 Working wet on dry, use a mixture of hansa yellow light and scarlet lake to create a skintone mix. Apply the first wash evenly over the whole of the figure. Once dry, glaze more washes over the figure to build up the colour, leaving the lighter areas exposed. Gradually this will build up to indicate form. You can alter the mixture as you go: the more red you pick up in the mix, the more peachy she will look. Create shadows using a light glaze of ultramarine violet and add to the lips.

4 Approach the sun in a similar way, laying down a light wash of hansa yellow with a touch of scarlet lake, avoiding the details and eyes. Once dry, add more scarlet lake to the mix and warm up the face and cheeks. Finally, add more scarlet lake to the lips and leave to dry.

5 Carefully apply clear water to the irises of the sun's eyes and the oceans on the world. While still nice and wet, apply a variegated wash to these areas by dropping in touches of cerulean blue, and adding ultramarine violet and salt water (paint) towards the edges to create shadows and contrast. You don't want this to look too flat and even! Once dry, add some ultramarine violet around the sun's eyes and lips to create shadow.

6 Mix burnt madder and burnt umber to create a warm mix and apply a flat wash wet on dry over all of the hair, carefully painting around the hair ornaments and flowers. Leave to dry. Use consecutive layers to build up the hair colour, varying the mix of the two paints. Use more red (burnt madder) in the lighter areas and more brown (burnt umber) in the shadows. Allow the base wash to show through in the lightest areas.

6

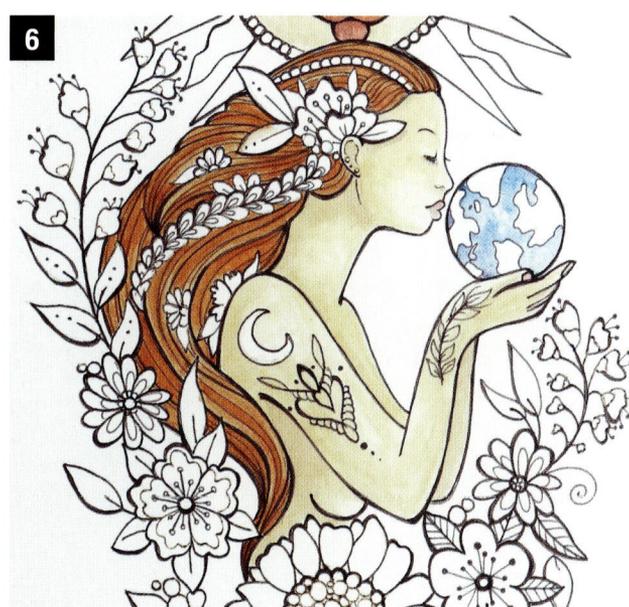

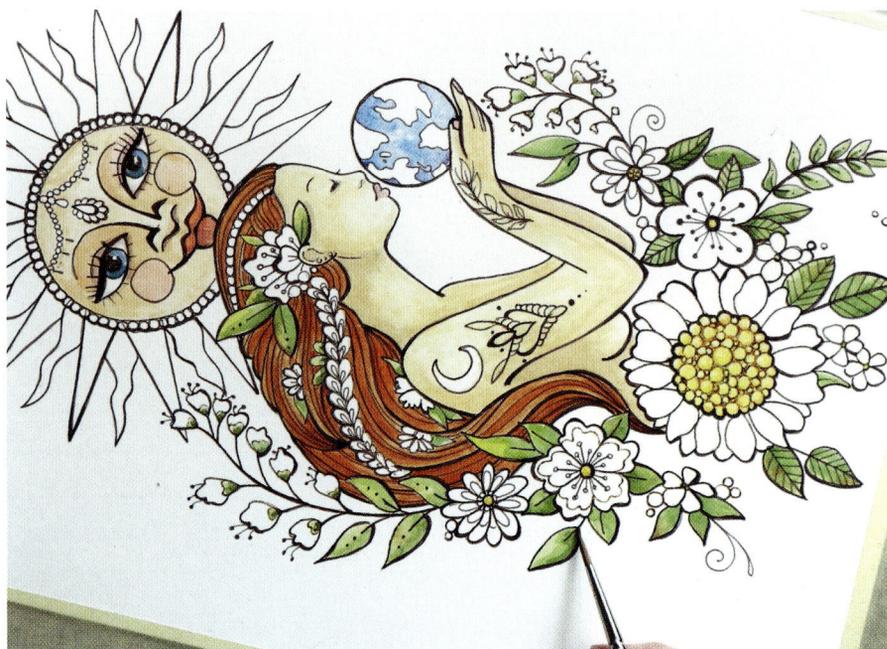

7 Apply a base wash of Indian yellow to the centres of all the flowers. Once dry, use a small round brush to apply further glazes of the same colour to the seed shapes in the centre of the large flower. For the leaves, carefully apply clear water to the shape of each leaf in turn and drop in diluted sap green, Indian yellow and viridian (or blue), varying the mix as you go. Let them mingle with each other. While the leaves are wet, drop in touches of the hair colour mix to some greens to unify the colours. Leave the paint to dry before moving on.

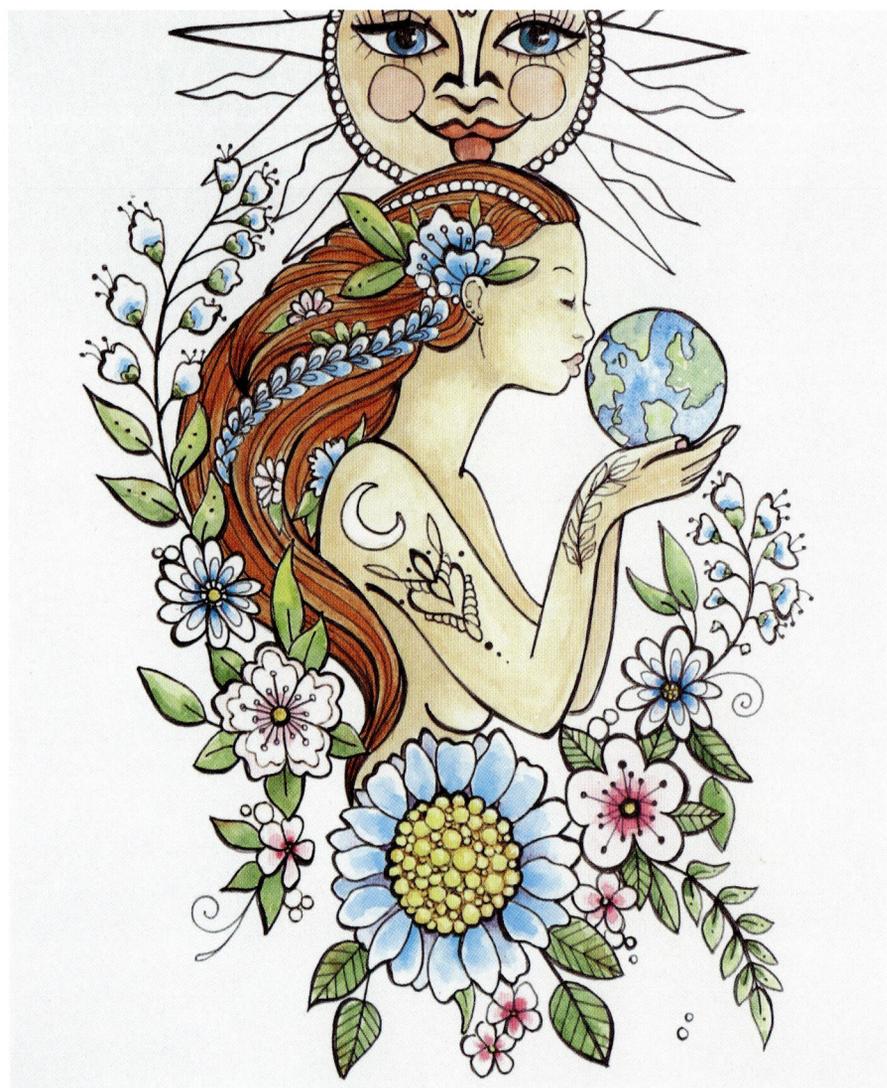

8 Turn your attention to the blue and pink flowers. Paint the blue flowers using a light wash of cerulean blue for the base then further glazes of cerulean blue, salt water and phthalo blue, varying the mix over the flowers. While you have the blue mix in your palette, apply it to the braid in her hair using a small round brush. Repeat the process for the pink flowers, using a dilute base of quinacridone magenta and layering up by intensifying the colour with the same paint, concentrating the colour around the base of the petals.

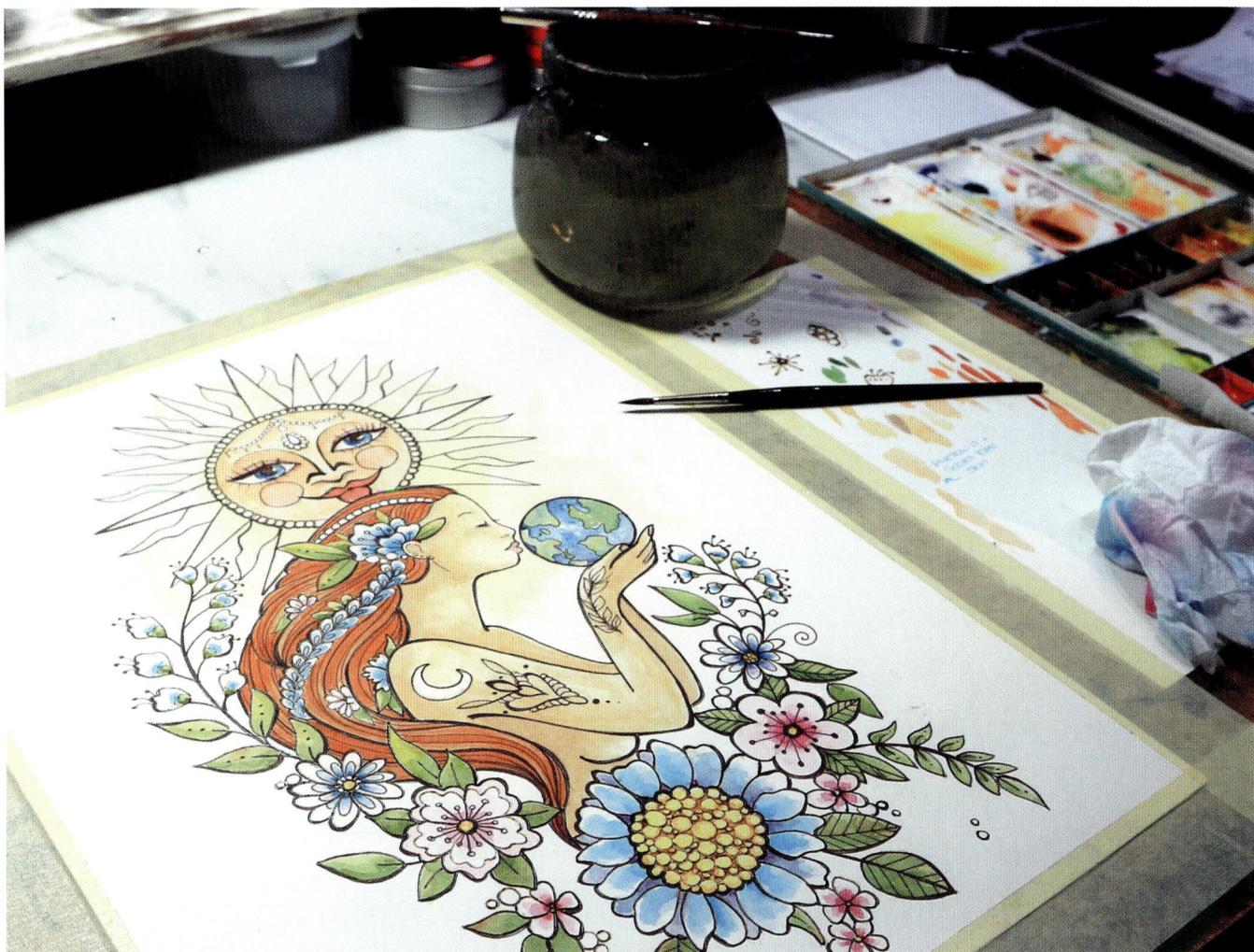

9 To add a golden glow, prepare a dilute wash of hansa yellow light with Indian yellow and a touch of scarlet lake to warm it up. With a loaded quill brush, apply the mix around the sun, over the sun's rays and also the immediate background. Work quickly so that it doesn't dry on the page and leave any hard edges. Bring the 'glow' under her chin and down towards the earth. Fade it out to nothing with clean water.

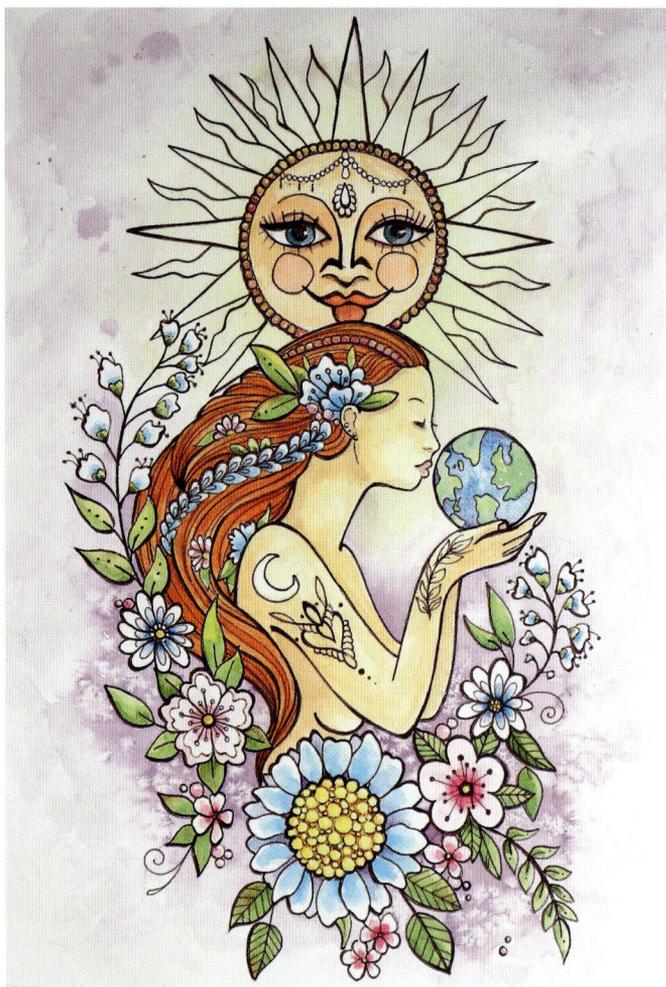

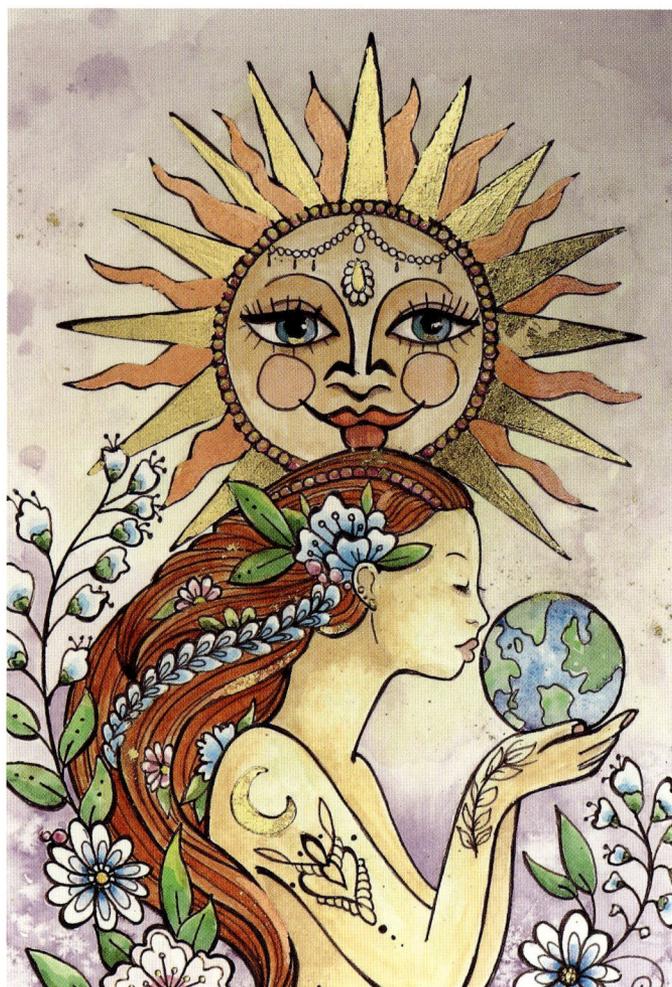

10 Paint the background with a dilute wash of dioxazine purple, using a flat wet-on-dry wash and plenty of water. Use a small brush to paint the tricky intricate areas, and switch to a size 8 round or size 4 quill as the areas get larger. Feather the colour out with water as the wash meets the yellow glow around the sun, and add a few splatters of diluted purple into the background if you so desire. As the shine leaves the surface of the wash, drop salt in the wet background. Leave to dry overnight, then gently remove the salt with a soft brush to reveal interesting blooms and patterns.

11 Use the techniques on pages 132–133 to apply gold and copper leaf to the sun and small shimmery highlights on her hair. Paint the beads surrounding the sun with a small round brush using quinacridone magenta. Once dry, check the overall lights, darks and contrast of the artwork and adjust if required.

APPROACHING THE BACKGROUND

Backgrounds are yours to play with, so use your intuition and whatever you have at hand. Play and experiment. If a paint doesn't granulate and you want it to, then try adding some granulation medium (though a little goes a long way!), throw on some salt to create patterns, or sprinkle mica powder to make it shimmer... there are no rules!

Gaia 30 × 40cm (11¾ × 15¾in)

Pyrography, watercolours and metal leaf on hot-pressed watercolour paper.

To finish, I used cerulean blue paint to add the decorative beads on the sun's forehead, then added white highlights to the beads and flowers with a Posca pen. To create further interest and a touch of magic, you might add some handmade saffron paint to a few of the seedheads and brush aloe along the upper sides of the leaves. If you don't have any iridescent paints, try mixing a small amount of Winsor & Newton's iridescent medium in to your normal paint – less is more. Massive thanks to Dawnii for the inspiration and design.

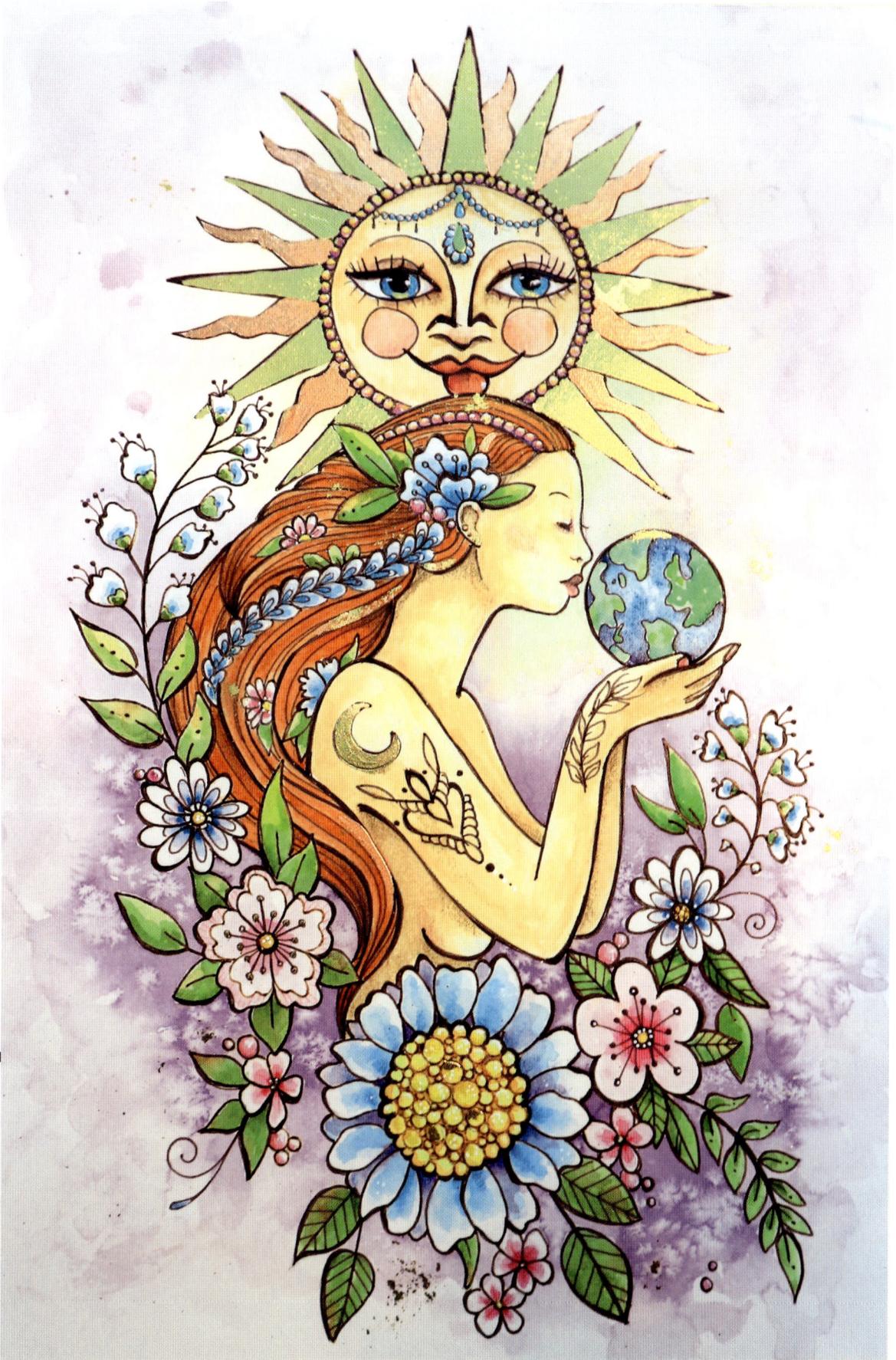

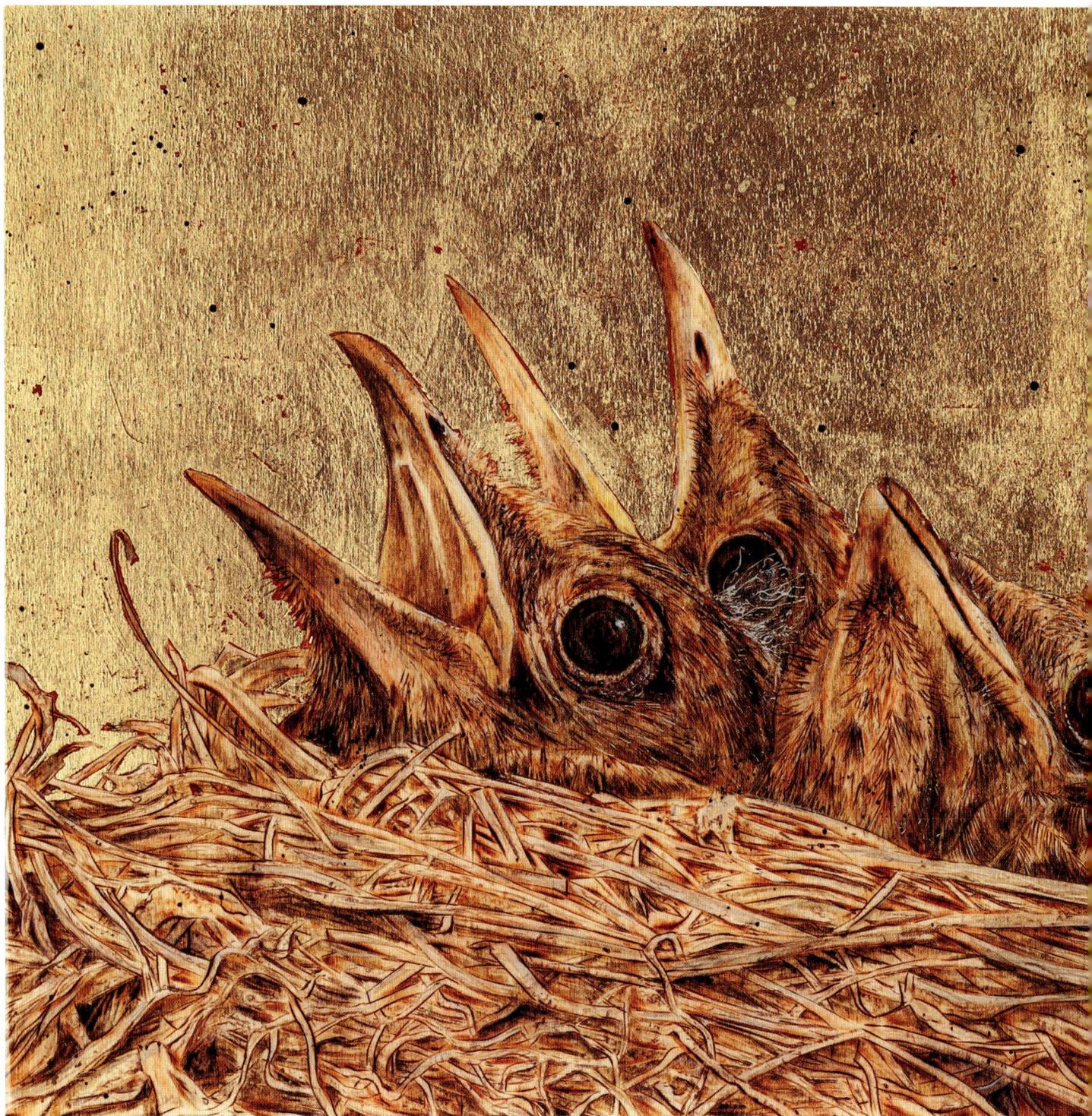

Service Please 40 × 30cm (15¾ × 11¾in)

Pyrography with gold leaf on birchwood panel.

These little chicks were created to offer a contemporary twist on pyrography as an art form. The focus was on texture and storytelling, and they were accepted in the SWA (Society of Women Artists) 159th Annual Exhibition.

THE MIDAS TOUCH

'Every artist dips a brush into his own soul, and paints his own nature into his pictures.' **Henry Ward Beecher**

I'm a bit of an art magpie: as you can probably tell, I love anything that glitters and shines. It's no surprise then, that I simply adore gold leaf and it plays a big part in my work. The wonderful warm sheen and reflective properties of gold leaf and metal paint complement the timeless burnished mahogany tones of pyrography perfectly. Gold (and other metallics) offer eye-catching and contemporary adornments to your work.

ADDING GOLD TO YOUR PYROGRAPHY

Gold leaf, just like pyrography itself, has been around for centuries. Both are steeped in ancient history, which also helps to make them an interesting and exciting pairing. You can find gold leaf used in old illuminated manuscripts, beautiful gilding on frames and even the great Michelangelo himself was partial to a bit of the Midas touch, so you're in good company! Let's unlock its secrets...

Pure gold (24ct)

Pure silver leaf (pink)

Variegated blue

Variegated black

Copper metal leaf

Gold metal leaf

Variegated copper

GOLD AND METALLIC LEAF

'Leaf' refers to squares of metal that have been hammered into very thin delicate sheets. Gold leaf is sold either in loose leaf booklets or bundles. Each leaf is typically separated by a sheet of tissue paper; in larger numbers the leaves are laid over themselves and separated every one hundred leaves or so to make each bundle more manageable.

Gold leaf is also available in transfer booklets, with each leaf carefully pressed into a specially treated tissue paper. The leaf will stay adhered to its backing paper until it is pressed face-down onto a sized surface (see page 131). The back of the paper is then rubbed (or burnished) to release the leaf and peeled away. Transfer booklets are typically more expensive than buying loose leaf bundles.

I am often asked, 'Is there any difference between gold leaf and metal leaf?' There certainly is – let me explain.

Metal leaf Sometimes referred to as a composite or imitation leaf, metal leaf contains no precious metals and so the squares are cheaper (and usually bigger) than those of genuine gold leaf. Available in a wide variety of colours, including gold, copper, silver and variegated, metal leaf is well suited to art applications. However, it will naturally tarnish over time and therefore needs to be protected within the artwork by some form of sealant. I often use an acrylic gloss medium.

Gold (silver or copper) leaf These are true precious metal leaves and are available in a wide variety of styles and shades. Gold leaf can be purchased in different weights of gold from 6ct (carat) white gold up to 24ct pure gold leaf. Its price fluctuates in accordance with the global market, and tends to come in much smaller squares (commonly 80 x 80mm/3¼ x 3¼in) and booklets containing fewer leaves than metal leaf, typically just five to twenty-five.

What to choose?

Gold leaf is beautiful. It will not tarnish and is more delicate than its metal leaf cousin. Comparing the two, pure gold leaf offers a more subtle rich glow, and has an inherent quality that grants more depth to its sheen than that of metal leaf.

Having said that, I rarely use gold leaf as a standalone finish. Because I often cover the leaf with layers of other media to enhance its textural effects, knock back the shine or create contrast, it's not worth using real gold leaf in your art unless you really want to. I recommend saving the real gold leaf for specific accents within certain special pieces of work. Imitation gold sheets still offer a wonderful luminous metallic finish to your work, but are cheaper, larger, and can be purchased in reams of up to five hundred sheets, making them much more versatile – it's a no brainer! Indeed, many people struggle to tell the difference when incorporated into a mixed media artwork.

Unless specified, I use 'gold leaf' to refer to both gold and metal leaf – both will serve just as well for the techniques in this book.

Metal leaf booklets
The small booklet at the top is pure gold leaf; the others are various metal leaves.

All that glitters

The beauty of gold/metal leaf is that, once burnished, the gossamer thickness of the leaf echoes the textures and treasures beneath, as you can see in the samples and finished kingfisher pyrography here.

GILDING

The process of covering a surface with gold leaf is referred to as gilding; not to be confused with traditional water gilding, which is a more complex and time-consuming process used by framers and is not covered in this book.

The type of gilding we are showcasing can be applied as a finish or background over any moulded or flat, firm surface; or used as an embellishment in selected areas. I use gilding on paper, artboard and many types of wood. There are lots of different effects you can achieve with gilding – we're going to explore some of them throughout this chapter.

Using gold leaf

Gilding is a one-way ticket with a pyrography piece, and should be used towards the end of a project. You will not be able to burn (or reburn) on any area covered in a metallic finish. Firstly, metals are inorganic, and secondly, the metal surface is underpinned with glue which would give off toxic vapours.

Before you begin gilding, consider the overall feel and look of the piece, and work out how best to use gold leaf to accentuate that. Do you want to mix the leaf types? Do you want to create a statement with the leaf? Do you want the surface to look aged and distressed? Do you want to apply the leaf over the whole background or selected areas? These decisions will affect how you approach your gilding and in what order you apply it.

Wee Wren 30 × 20cm (11¾ × 8in)

Pyrography, acrylic paint, coloured pencils, pen, gilding and found materials on birchwood panel.

If you plan to distress the gold surface, consider a complementary colour under the leaf to peep through. Here, I've used red oxide acrylic paint (see left). In the finished piece, the form of lost-and-found dried leaves can be seen behind the gilding: they're attached to the surface by the paint.

Little Jenny Wren 30 × 20cm (11¾ × 8in)

Pyrography, acrylic paint, coloured pencils, pen and gilding on birchwood panel.

The background to Little Jenny Wren *has been approached in a similar way to* Wee Wren, *above, but here I wanted it to look more serene. Before the gold leaf was applied, the background was painted with red oxide acrylic paint. The red oxide colour was chosen to complement the darker markings on the wren's feathers. Care was taken to blend away any brushmarks during the application. After gilding, the surface was lightly distressed by scudding (see page 142) to create interest and allow some of the red oxide paint to peep through.*

Gold leaf size

Size is an adhesive with an extended open time, used for bonding metal leaf and foils to a variety of surfaces. When this specialist glue is applied thinly, the surface will remain primed for up to twenty-four hours, allowing large projects to be handled with ease.

There are two types of size: water-based and solvent-based. Either will do the job. Solvent-based glues offer a smoother finish as they self level, but I'm not a fan of their inherent toxic properties, nor the smell. I always opt for a water-based product if I can – it makes cleaning your brushes easier, too.

Tint it!

Acrylic size dries clear, so I find it handy to add the smallest drop of a brightly-coloured acrylic ink or paint into size to give the adhesive a tint. This allows you to see where you are placing the size, and also where it is when you return to your work to apply the leaf.

Applying and using size

To use size, you simply apply a thin coat with a paintbrush, credit card or sponge brush then leave it to go tacky. This takes about fifteen to twenty minutes, depending on how much you have used, and the weather: it will take longer if it is cold and damp.

It is important to wait until the size is workable. Start too soon and the leaf will not adhere correctly and will slip and move. Test the size with the back of your hand. It should feel tacky to the touch but not transfer to your skin. Most modern sizes have a long 'open time' giving you plenty of time to gild your surface.

A word of caution: gold leaf will stick everywhere you have applied the size – and I mean everywhere! Be precise, be confident (wobbles will show) and take your time with your application. Less is often more!

1 Using an old, slightly damp brush, apply a really thin layer of size across the surface, covering everywhere you want the leaf to go. Remember that the leaf will stick wherever the size is – it's so easy to accidentally cover areas of your pyrography if you're not careful. Minimize visible brushstrokes by following the grain of the wood. Apply size to the edges of the board, too.
2 Wash the brush out throroughly, using warm soapy water and leave the size to dry for fifteen to twenty minutes. The size is ready to use when it is slightly tacky to the touch, but leaves no residue on your fingers.

MY CHOICE: SIZE

My go-to brand of size is Polyvine Metal Leaf Acrylic. It works well on both wood and paper, it's water-soluble so there are no nasty chemicals to clean the brushes with, and, as it has an acrylic polymer base, it also works well with all the other art supplies that I use.

Applying size
You can use any brush for this, but be sure to rinse it off afterwards. You might find it useful to save an old brush specifically for applying size.

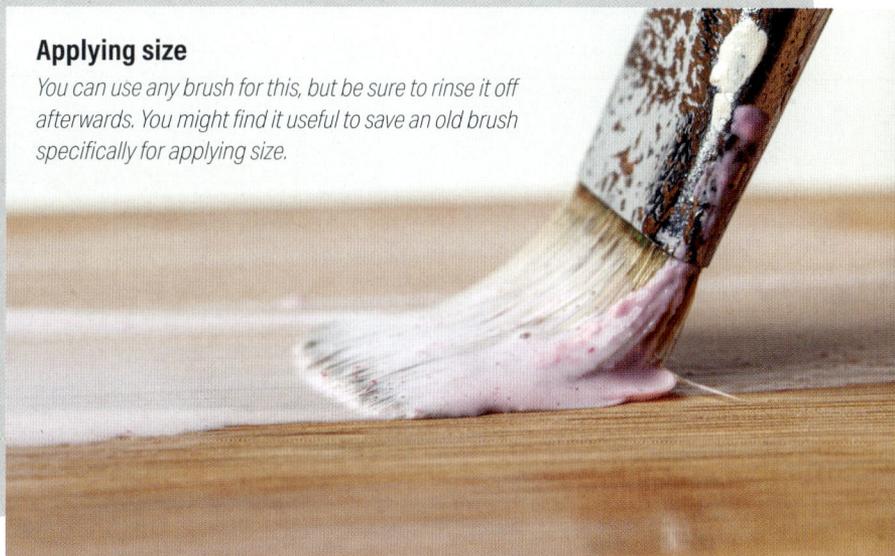

APPLYING GOLD LEAF

Once the surface has been primed, you need to get the leaf onto the size. As soon as you pick up one of those gossamer sheets of gold, however, you'll realize that it acts as though it has a mind of its own. It will fly away with the merest whisper of a breeze and will crumple, tear and fling itself off your desk in a heartbeat. Fear not, there are ways of taming this beguiling shiny enigma. Gold leaf's kryptonite is waxed paper, which tames it into submission and works like a magical gold leaf crane!

If you want to gild the edges of your work as well as the front, elevate your piece off the table by placing it onto a few flat pots or rolls of tape. This will allow you to work round the edges more easily.

1 Cut a piece of waxed paper larger than the square of leaf you're using, and with enough border to get a good grip on it. Lower it onto the exposed leaf.

2 Hold it in place and gently rub the palm or side of your hand all over the wax paper. This will create a static charge that will temporarily attach the leaf to the wax paper, allowing you to carefully lift it to your wood (or other surface).

3 Position the gold leaf over a sized area of your artwork then gently lower and transfer to the size.

4 Use an old cloth to gently rub on the back of the wax paper, working all over to ensure the gold is pressed down onto the sized surface.

5 Gently lift the wax paper away, revealing the leaf in place.

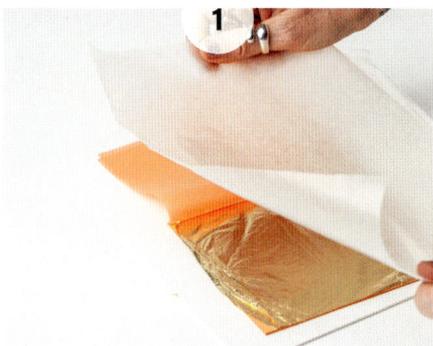

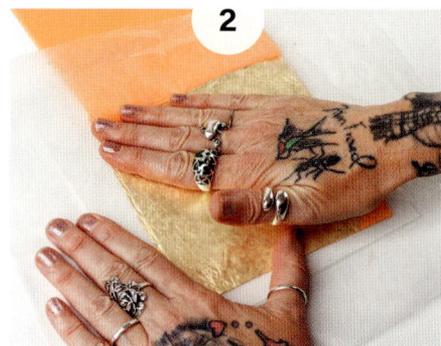

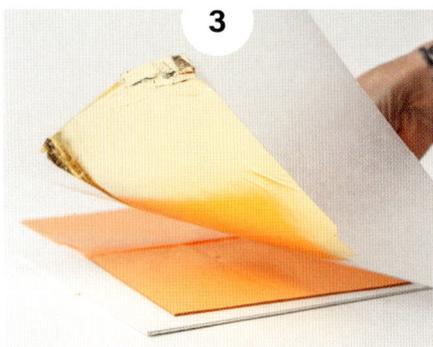

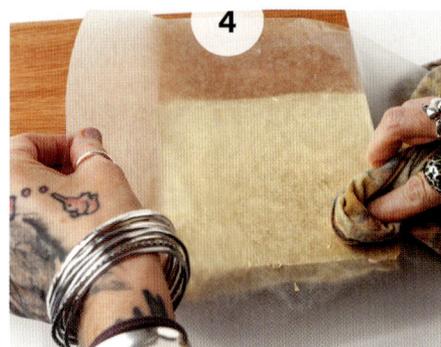

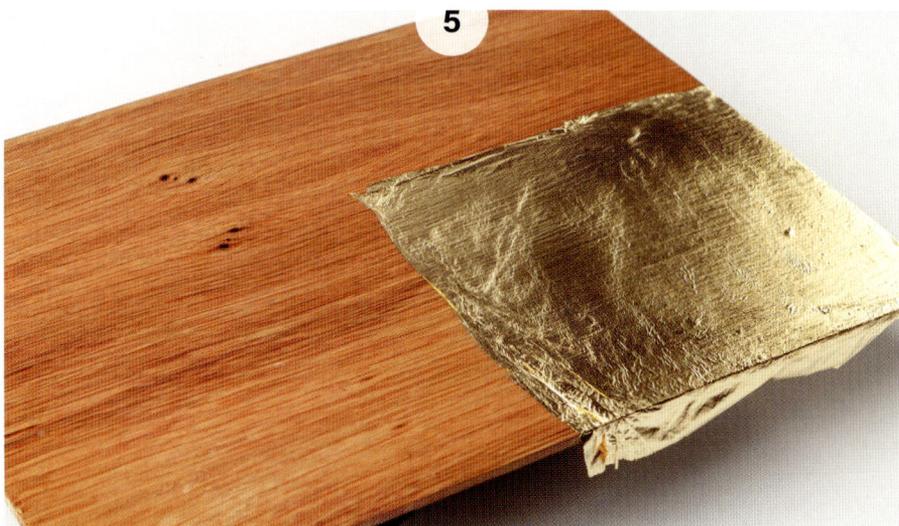

6 Apply the next leaf in the same way as the first. For a completely covered surface, it's important to overlap the leaves of gold – it's best to err on the side of caution and overlap by at least 1cm (½in).

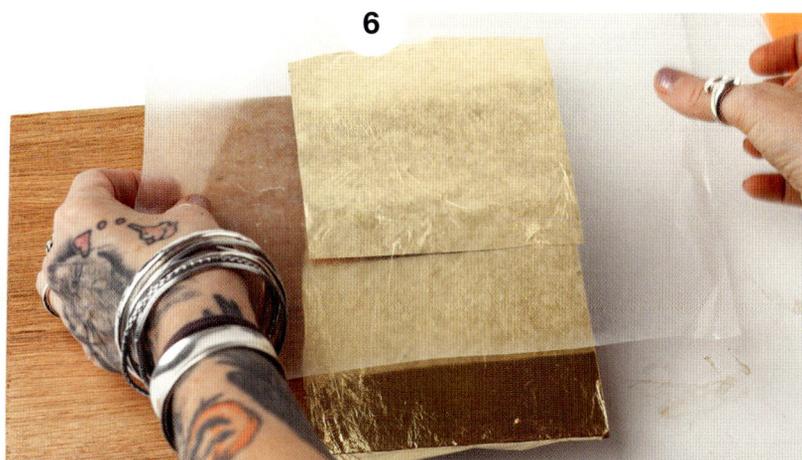

6

7 To avoid wastage, cover as much of the surface as possible with whole leaves, then cover any gaps with odd bits – you'll likely find you can use parts of a single leaf to cover most of the smaller gaps.

7a

7b

The covered surface, ready for burnishing.

HOT TIP

If you do find any gaps or holes after applying gold leaf, you can pick up excess pieces of gold leaf with your fingers and offer them to any small gaps as necessary. Replace the waxed paper and gently rub the area to ensure the additional gold is adhering. Once burnished (see overleaf), you won't spot the patch.

BURNISHING

With the gold leaf on the surface, the next thing you need to do is burnish it. Burnishing helps the fragile gold leaf to adhere and makes the gold surface smoother and more reflective, adding to that wonderful illuminative quality. As the gold is put under pressure, the surface will reproduce the form and texture of what is below – this gives a particularly beautiful effect on woodgrain.

It's best to burnish methodically and in sections. During the process, excess leaf and overlaps will naturally start to fall and sheer away, but the size will hold the rest in place. I always save and reuse any large flakes that are removed from overlaps in a small tub. These are great for patching up any golden gaps or use as metal flake sprinkles to add interest to other art pieces. Seal the leaf depending on the designated next step with your piece.

HOT TIP

I often take my work outside into the garden for burnishing and cleaning, as the gold leaf tends to go everywhere. I love watching the tiny golden flakes blowing away on the wind and dancing around the patio.

1 Make sure the surface is covered, and wrap any loose leaf around the edges of the wood.

2 With your work flat on the surface, place a clean sheet of wax paper over the gold leaf and begin to rub firmly with a soft cloth. Rub over the top of wax paper in small, circular movements.

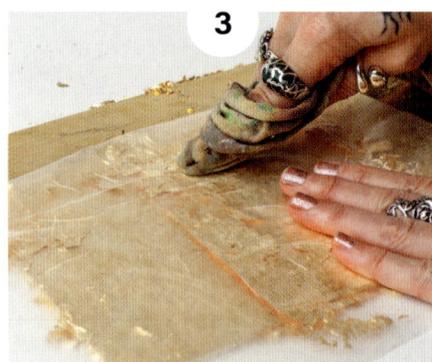

3 You're aiming to work the gold right into the grain of the wood with this movement, so use a firm pressure. Moving the waxed paper as you need to, continue until you have burnished the entire surface. Pay particular attention to the overlaps, joins in the leaf, and the edges of your work.

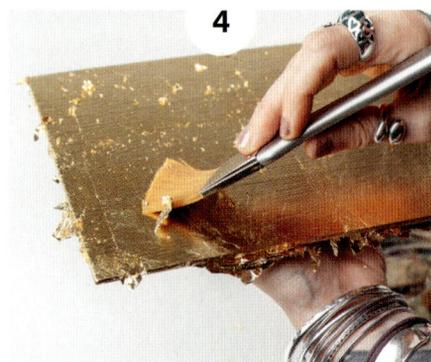

4 To finish, remove the waxed paper, then gently run a soft synthetic brush along the overlapped areas to tidy up the edges. Using a soft brush is paramount so that you do not scratch or mark the gold leaf surface. Leave the size to fully cure overnight.

The finished burnished surface. Note how the grain of the wood is visible as a texture.

Sealing gold leaf

Sealing a gold leaf background is crucial to the integrity of the piece and essential to keep imitation leaf from tarnishing. Further, due to its gossamer-thin nature, gold leaf is very fragile, so it will always benefit from some form of protection.

The materials and techniques you use to seal any metallic leaf are largely down to personal choice – there are many products out there. Fortunately, gilding suppliers often provide their own recommendations for specific sealants that are suitable for their products.

For my part, I seal depending on my next layer. If I am intending to continue building on the background (or metal leaf areas), I will brush the leaf with an acrylic gloss medium to seal it. This creates a new stable layer to work on and locks the leaf inside. This is perhaps a slightly controversial method, as acrylic paint contains traces of ammonia – but it works for me and I've never had a problem.

If I'm done with burning and painting and have finished my piece, then I will instead look to a varnish or spray to protect the artwork. Another technique I use and have experimented with a lot is resin. A coast of resin seals the inherent beauty and luminous glow of gold in a protective coat which gives the artwork a magical, crystal-clear, and highly reflective appearance. It's a fabulous way to create something with an added wow factor! You can read more about resin and varnish on pages 156 and 164, respectively.

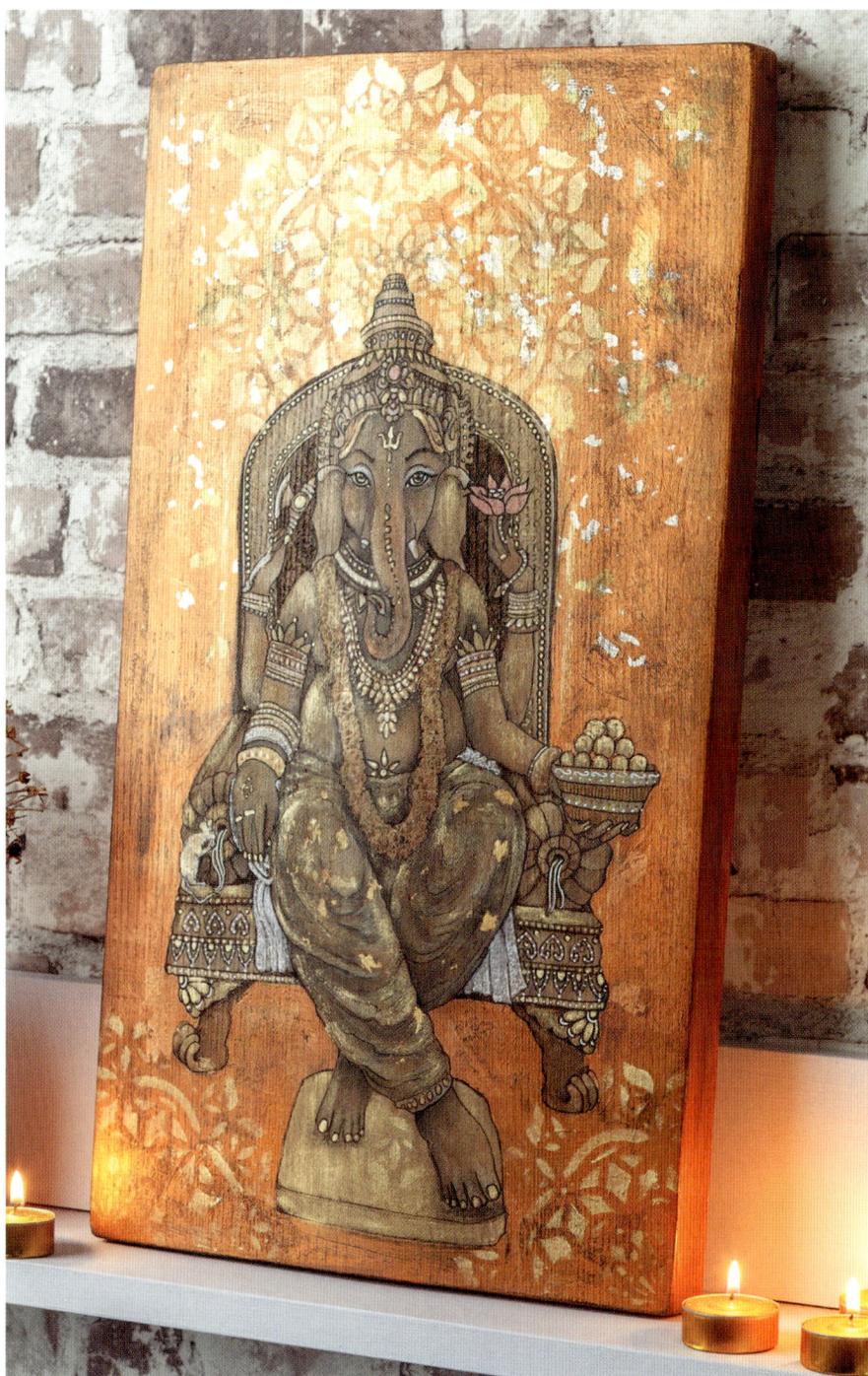

Ganesha 40 × 60cm (15¾ × 23½in)

Pyrography, gilding and shoe polish on an ash wood slice.

'Deep into my heart I roam, to find the wisdom of my soul.'

Ganesha was a really interesting piece, burnt on a rather large and very weighty piece of ash. The image was completed using both my Detailer (fine writing tip) and Workhorse (spear shader and ballpoint) machines. The original idea was to have a dark background, so once Ganesha was established I switched to my Grunt to dial up those darks – however, once I started I didn't like it! It was starting to look too heavy and masculine. Time to change tack and add some gilding. I needed to even out that part-burnt background, so I decided to cover all the negative space with liquid black shoe polish and gild it with copper, distressing the leaf to allow some of the black to show through in places to add interest. It worked a treat!

CREATING A GOLDEN GLOW

With the basics of gilding under our belts, let's look at some different options for using it. The first – and perhaps most obvious – use of gilding is to create a large, flat, clean background.

The seductive sheen and reflective properties of gold leaf are wonderful for giving backgrounds a soft glow on both wood panels and paper. When creating a large area of gold leaf on paper, ensure that the paper is stiff and remains flat. You might find it necessary to attach it to a board. Before applying the leaf to your artwork, consider the final outcome: how do you want it to look? Remember, the smoother the surface, the shinier and glossier the leaf will appear.

Underlying colour

As shown earlier, you can gild directly onto wood but I prefer to lay down a colour under the leaf. I believe it gives a better finish, adds interest and can change the mood of the background. It also creates a stable foundation for the size to adhere to and – as you can see in *Tree Pirate* here – prevents a light wood 'halo' in the transition between subject and background. It also gives you the option of gently sanding or scratching back areas of the gold leaf to expose the colour later.

The colour will be visible in the tiny gaps between the leaves or wherever the leaf doesn't stick. The paint colour I choose to go under the gold leaf often depends on my subject. The colours I frequently use are Golden's transparent iron oxide, or Liquitex's raw umber, carbon black or indigo. Invariably the colour is a strong dark tone to contrast the gold leaf and complement the artwork.

The paint can be applied as a smooth coat – as shown here – or as a texture (see pages 140–141). This method is not for the faint-hearted, as these backgrounds are applied after you have burnt and completed your subject, often after many hours of work. This is the point of no return, as once the paint (or a medium) is applied, you cannot re-burn that area.

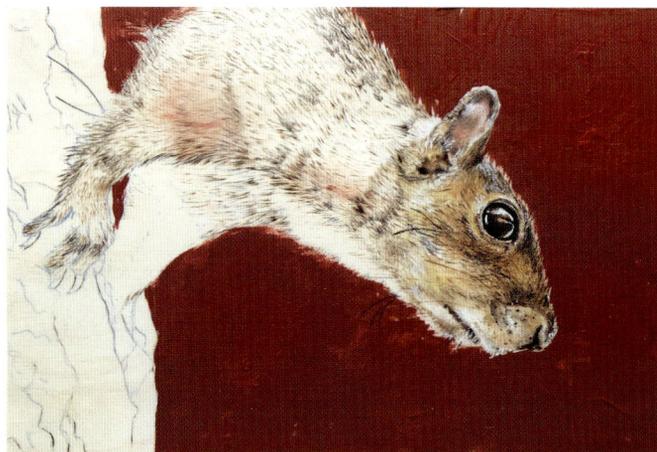

With the outside edges of my burn complete, the background colour was carefully added using a heavy-bodied red oxide acrylic. I paid close attention to cutting in around the squirrel to preserve the transition of his choppy fine fur, then smoothed out the brushstrokes to maintain a flat background. The background is used to define the squirrel and tree as a negative shape – notice how much lighter those unshaded areas look by comparison.

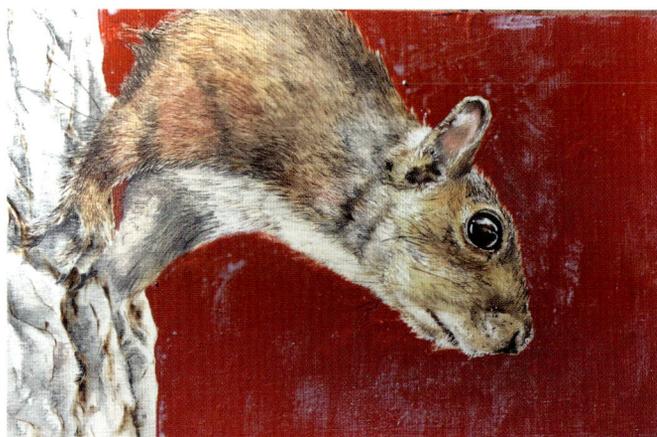

Once the paint had dried, I completed the body of the squirrel and added suggestions of texture, shadow and shade to the tree bark, being mindful not to burn up to the paint. Once the burning was complete, I used a neutral grey 'activated' Inktense pencil to create shadows and definition around the neck, back leg, feet and bark, before highlighting with a white pencil once dry. This gave me another opportunity to create texture, so I carefully followed the direction of form with those marks. Next, I applied size to the background and, with a dry brush, added some loose marks on the bark to link all the elements together.

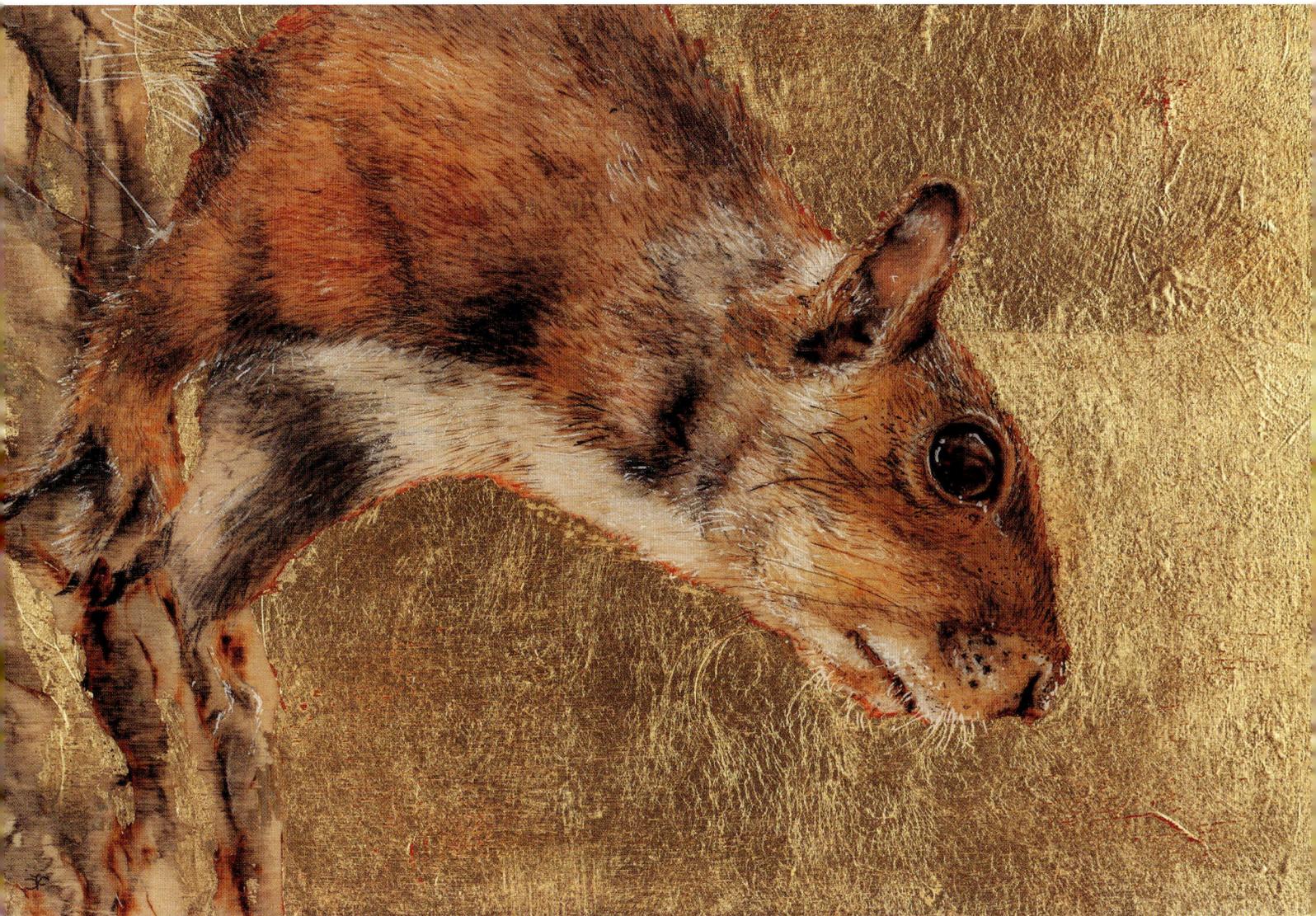

Tree Pirate 30 × 20cm (11¾ × 8in)

Pyrography, gilding, Inktense pencil and Posca pen (white) on birchwood panel.

The composition of this little chap intrigued me. Curiosity and mischief are written all over his face and his pose creates a strong diagonal. His eye is the focal point which underpins the piece – and it's where I started the burn.

I gilded and finished Tree Pirate *with a white Posca pen for the lightest lights and whiskers. Notice how the underpainting is used in the area under the chin to create contrast, and how the natural wood is used as the edge of the tree. It is also preserved as the lightest light on the texture of the bark.*

Harvest Moon 20 × 30cm (8 × 11¾in)

Pyrography, coloured pencils and gilding on poplar panel.

Created for a workshop and inspired by my favourite song, Harvest Moon, by Neil Young, the pyrography was done with a simple wire tip, before contrast mark-making was added with black and white pencils. Once complete, the full moon was gilded. The students decided where their moon was to be added, then drew a circle directly onto the panel using a mug or coaster. The rest of the background was then sized and excess bits of silver from the moon were dropped into glue before the copper leaf was applied.

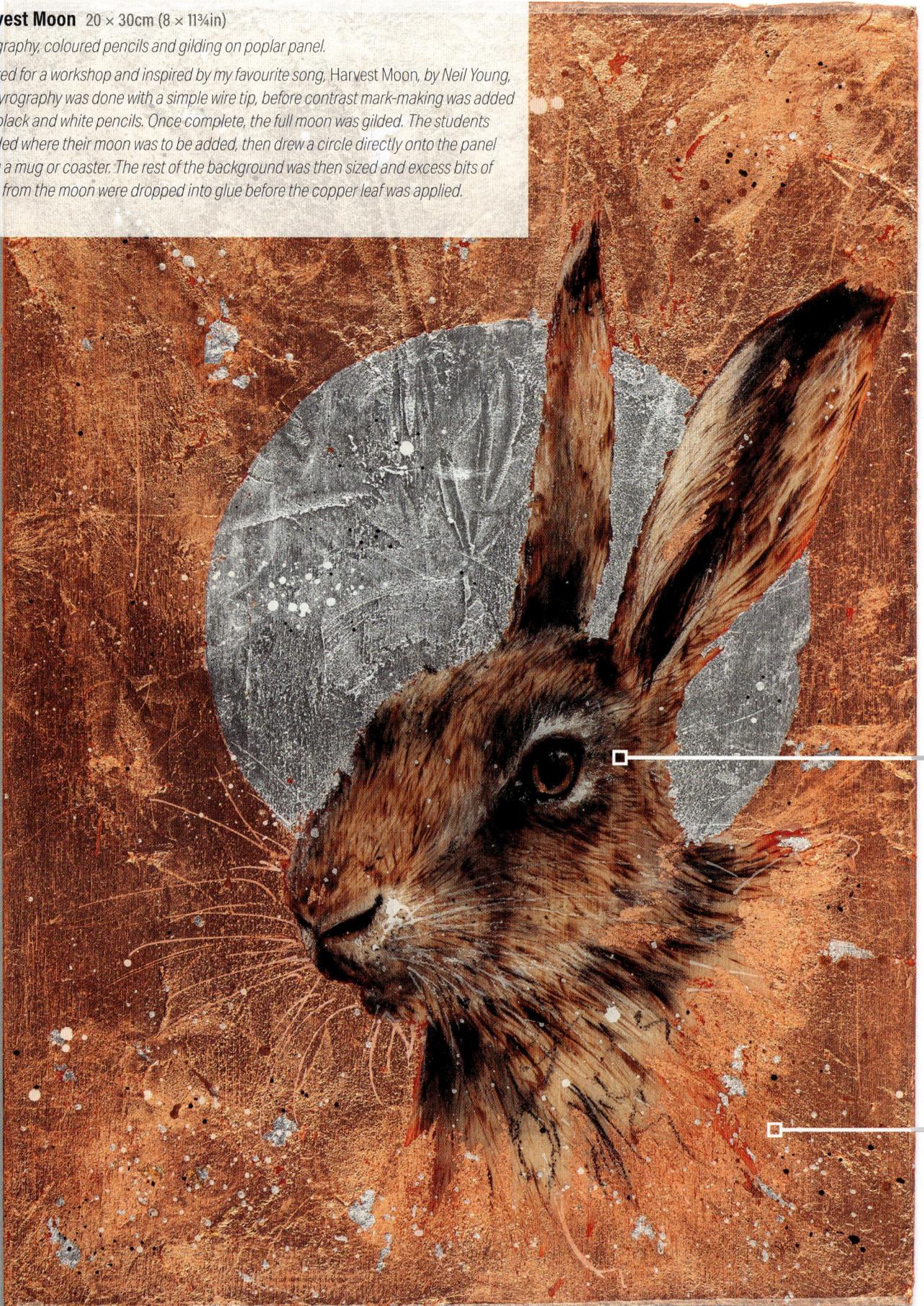

DOUBLE TROUBLE: MIXED LEAVES

When gilding you do not have to stick to one kind of leaf. Backgrounds can be enhanced by combining and mixing different varieties within the same piece, either in a planned way, or more randomly to create interest.

Textural effects can be achieved by dropping flakes of a different metal or colour into the size before gilding with the main gold leaf sheets. When you burnish those areas, the overlying area of the sheet will fall away (as it has nothing to adhere to), exposing the differently-coloured leaf fragment beneath. The result is a seamless transition between the two. It's a wonderful way to produce an element of motion, create diagonals or lead the eye to a specific area.

Planned features, utilizing contrasts between different metallic leaf elements, can also make for an arresting piece. In this example, *Harvest Moon*, both copper and silver metal leaf were utilized in the background. The beautiful warm copper was used to set the feel and tone of the artwork, whilst the silver leaf was used for the full-bellied moon casting its ethereal light over the hare.

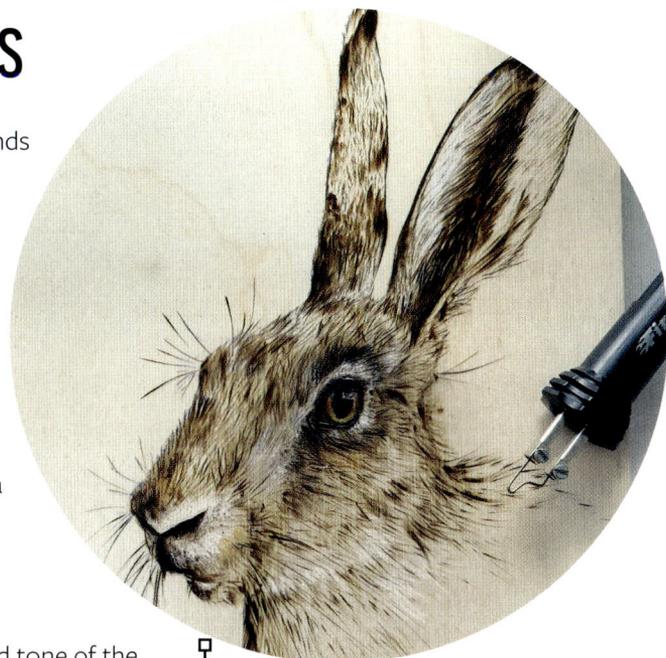

Pyrography

This detail shows Harvest Moon *prior to gilding. Remember, you can't go back afterwards, so make sure everything's how you want it before you begin.*

Hiding the joins

The copper leaf was carefully integrated into the subject by dragging size on an almost dry brush over the ear, around the throat and dropping it into the eye, to create a glint here.

Additional texture

Before the copper was applied, silver flakes were dropped into the size to break up the background. Once the copper and silver leaf was burnished, silver acrylic ink was splattered randomly onto the background to create further texture.

TEXTURED METALLIC BACKGROUNDS

Wood panels can be very flat and one-dimensional, as can pyrography. To add movement, impact and interest to my work, I often use textural elements within the background. As mentioned earlier, once burnished, gold leaf will echo the surface beneath – so why not use that to your advantage?

Acrylic medium and acrylic gels can be applied to wood panels and paper prior to gilding, creating texture to add impact and interesting effects. Even better, you can use found materials and tools from around the house to develop the texture. Consider using credit cards, the mesh bags that fruits come in, combs, bubblewrap, forks, butter knives, sticks, trowels and so forth to create different textures.

You can also embed a wide variety of materials into the medium while it is wet. The elements I use within a background will vary depending on the piece I'm working on (it's a great way to link your artwork with a particular place and time). No matter what you're going to add, most texture backgrounds start with the same basic technique, shown here on a practice panel.

1 Use a palette knife to apply a dollop of texture gel or gesso to the surface. This will need to cover the surface, so don't be shy with the amount you apply. If you end up with too much, you can easily remove the excess while it's wet.

2 Add a drop or two of acrylic paint in whatever colour you want to use.

3 Mix the paint with the texture gel on the surface (if you're concerned about accidentally covering part of your pyrography work, mix it on a separate palette).

HOT TIP

If you have a small, detailed piece and wish to create a textured background around it, try out your medium on a sample piece first to ensure the product does not relax down over the edges of your burning as it dries! Texture gel holds peaks much better than gesso.

4 Use the palette knife to spread the mix over the whole surface, creating whatever marks and shapes you wish. Leave to dry overnight.

5 Apply size over the dry textured surface, and leave for twenty minutes.

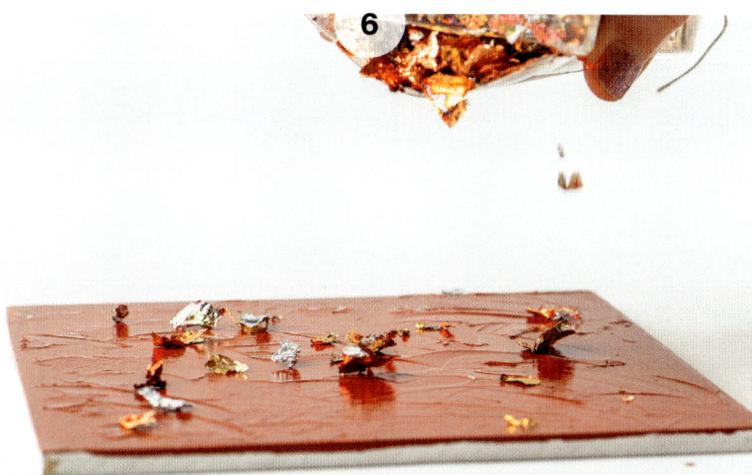

6 You can now gild the surface. Here, I'm sprinkling on a few loose flakes first.

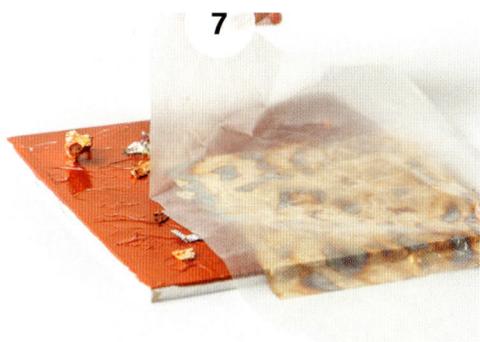

7 On top of the scattered loose flakes, I've added a variegated gold leaf – you can apply whatever you like, of course.

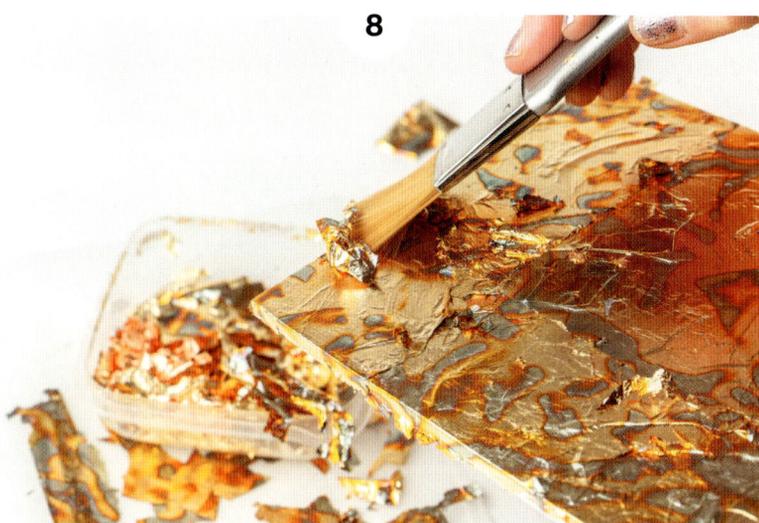

8 Burnish and remove the excess leaf as normal.

The finished textured metallic background – you can see the relief created by the texture gel medium.

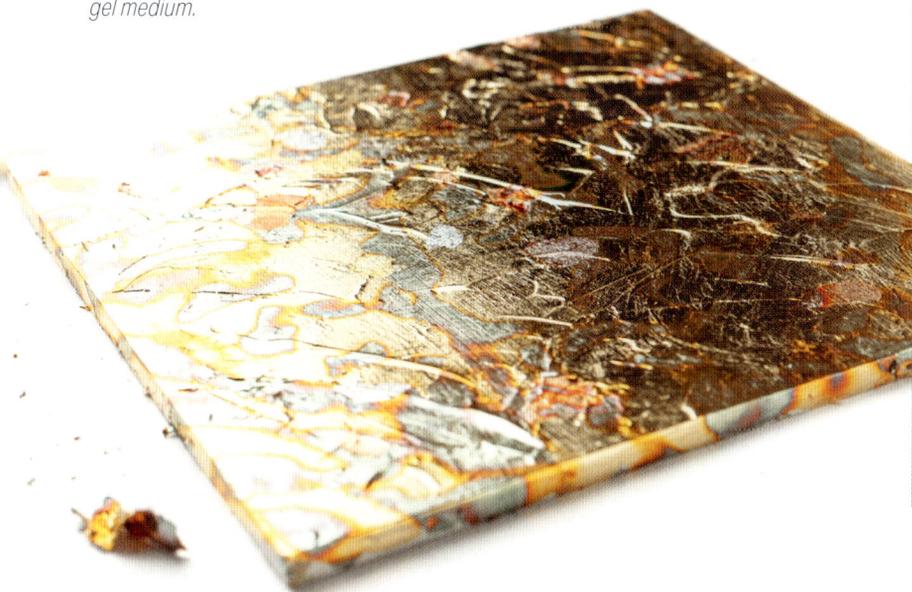

HOT TIP

There are dozens, if not hundreds of different acrylic texture mediums to experiment with, so have fun.

Applying an acrylic medium doesn't necessarily mean that you have to have a rough surface. They can also be used to give the leaf a softer, toned-down, reflective quality. To do this, simply apply the medium to fill in and mask the grain of the wood, and use a credit card to smooth it out. The smoother the surface the leaf is applied to, the shinier the leaf.

DISTRESSING THE SURFACE

' Learn the rules like a pro, so you can break them like an artist.'

Pablo Picasso

As we have seen, there are many ways to create unique and interesting effects using gold leaf. Once you get to grips with the application, the world's your oyster. However, as beautiful and illuminating as gold leaf is, sometimes you just want it to look a little more aged, grungy and weathered. All of the techniques (additional or subtractive) I use to distress or add interest to the metal leaf start with an acrylic coloured underpainted basecoat beneath the gilding.

Wet sanding

Wet sanding is a great way to expose fragments of the coloured paint from below to shine through and create a visual contrast to the metal leaf. To start, you need a fresh gilded surface, fine grit (180/220) sandpaper, water and acrylic gloss medium.

Wet sanding is a subtractive method of breaking down the layer of leaf, and is best applied after burnishing but before sealing. It will naturally remove some of the shine of the metallic surface. You can apply a coat of acrylic gloss medium to the distressed surface afterwards to restore the shine if you wish – just make sure it's dry before you do.

1 Dip the sandpaper in the water to get it really wet.
2 Rub it over the areas of gilding to expose the paint. There should always be water between the sandpaper and the surface.
3 Mop up the excess water with an old rag, taking care not to get water over your burning.

Scudding

For a similar but more subtle effect, I use an old wet bristly paintbrush for a technique I call 'scudding'. The paintbrush acts as an abrasive mop and will pick up the texture of the wood or acrylic medium below, by removing the leaf on the raised areas of the surface and leaving it in the recesses.

1 Dip an old clean paintbrush in water then push it onto the surface, right up to the heel of the ferrule.
2 Apply a little pressure and gently move it around using small circles or back-and-forth movements.
3 When you've achieved the desired effect, pat your work dry with a clean towel or rag.
4 Seal with a gloss medium if you wish to bring back the shine.

Wet sanding

Different grades of sandpaper will create different effects. The lower the grit number, the coarser the sandpaper, and the more abrasive it will be to the gilded surface. Experiment with different grades and types on a sampler. When working on a large background I apply extra water to the surface of the gold leaf using a pipette. As dry acrylic is waterproof, the water will not sink into the wood. You should, however, keep water away from your main burn.

Scudding

Less damaging to the surface than wet sanding, scudding is still tough on your brush – so do make sure to use an old one!

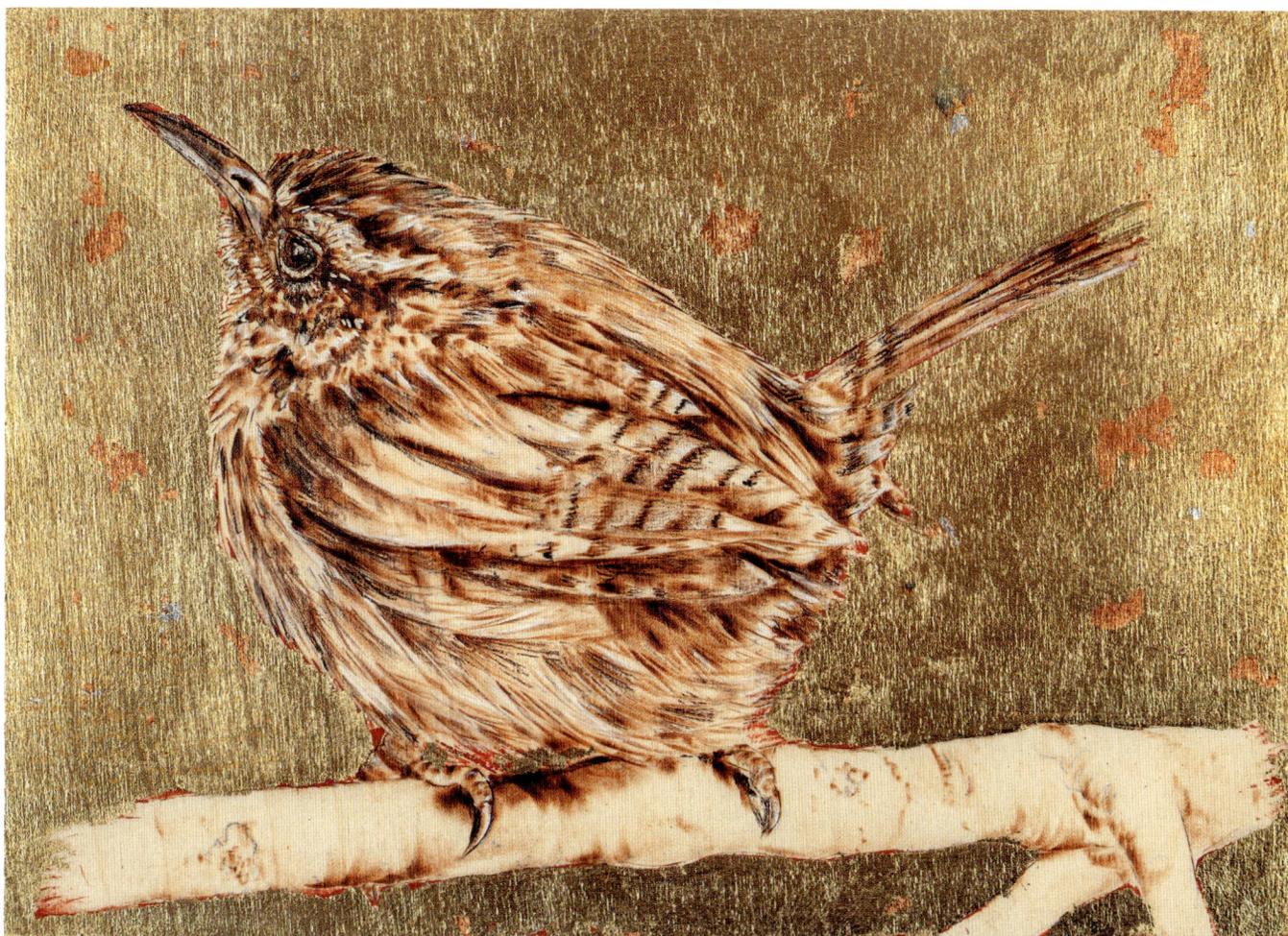

Fledgling 30 × 20cm (11¾ × 8in)

Pyrography and white pencil with gold and copper leaf on birchwood panel.

This little guy was a little experimental sketchbook-style piece playing with mark-making by working directly onto the wood (that is, with no initial drawing) using a flat shader as my pencil. I particularly like the smudgy marks on the branch. It's surprising how a few well-placed marks and shadows can give the appearance of volume, texture and form. Although initially he was just a fun sketch (see right), I felt he warranted completing and so he was gifted the Midas touch.

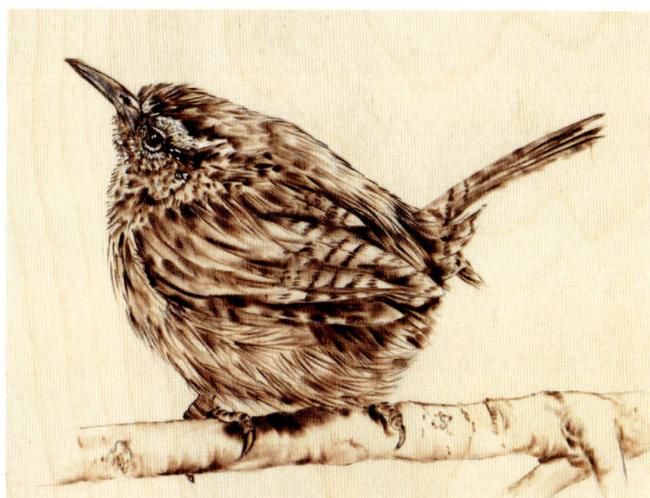

REED WARBLER: LADY OF THE MARSH

Here's a fun little project that shows you how to incorporate found objects into a textured background. We have looked at how to create a simple textured background on pages 140–141. Here we use a more layered approach. For a more controlled application we will paint the background first using a mix of acrylic medium and heavy-bodied acrylic paint (you can substitute the acrylic medium with gesso, and the paint with ink, if you prefer). Textural elements and found items are then applied to selected areas using the acrylic/gesso mix as a glue. I'm using an existing reed warbler piece to demonstrate upon, but the lessons can be applied to any artwork you choose.

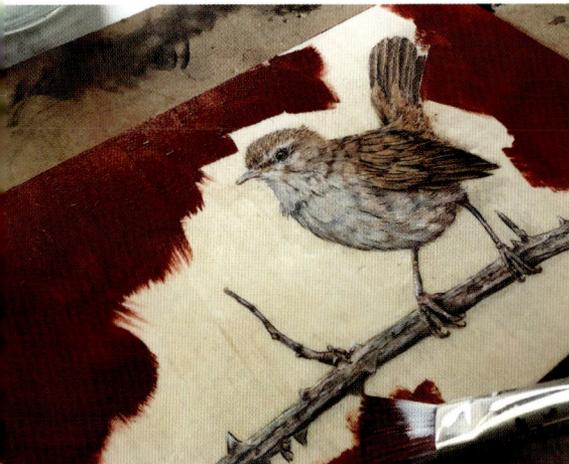

<table>
<tr><td>Surface: Existing completed pyrography</td></tr>
<tr><td>Materials: Acrylic paint (I'm using red iron oxide), acrylic matt medium or gesso, found materials, metal leaf and size</td></tr>
<tr><td>Tools: Old brushes, palette knife, old rag, fine grade sandpaper, wax paper</td></tr>
</table>

MATERIALS AND TOOLS

THE INSPIRATION

This little reed warbler was part of a series depicting native birds of the South West of England. Often heard, but rarely seen, this particular warbler is found (and sings in) reed beds. The bird was initially sketched out on layout paper to the size of the panel, then transferred to the wood. This was important as the collection pieces were all of a similar size and orientation.

A small spear shader tip and a skew tip were used to create the details in the bird and his perch with gentle layers. Once completed, coloured pencils (Prussian blue and Chinese white) were used to add subtle details on top of the pyrography.

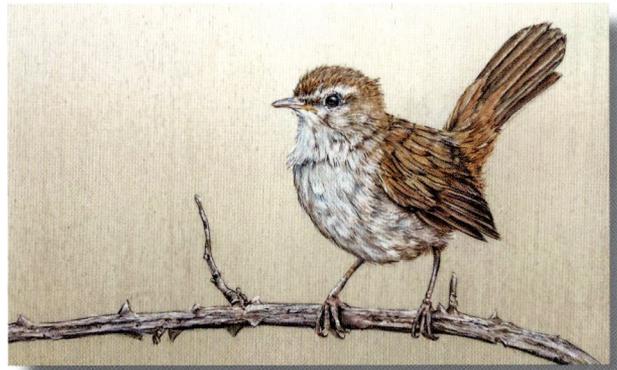

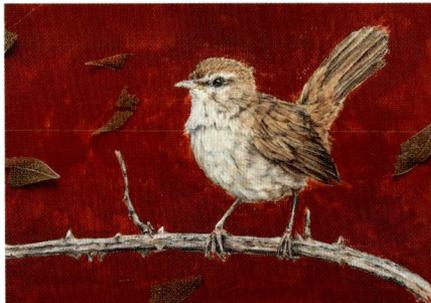

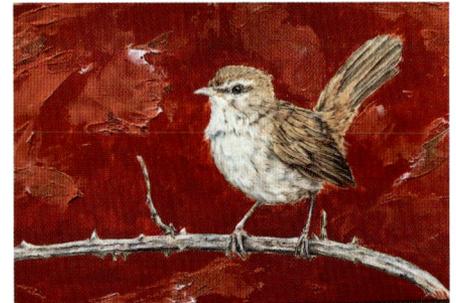

1 Combine your paint with acrylic medium, using a palette knife to mix them together. Add enough paint to the medium to produce a strong unified colour, then apply the mixture to the wood panel (or paper) background with a knife, sponge or brush, carefully avoiding any areas of pyrography that you want to reserve.

2 Start to mould and sculpt your desired patterns and movement within the coloured medium using textural tools. Acrylic medium makes a great glue too. While the mix is open (wet), experiment by adding found or other materials onto the surface. Here I've added dried skeleton leaves.

3 To ensure the found materials stay in place, work over them with the coloured medium. Don't go over them too thickly. You want to keep the structure of the objects intact. Leave to dry overnight, with your panel/paper flat so the medium won't drip or move.

HOT TIP

The medium (carrier) you use with the paint will affect the finished result. Gesso will give a more subtle low-relief textural effect compared with acrylic modelling pastes and gels. Experiment and find what works for you.

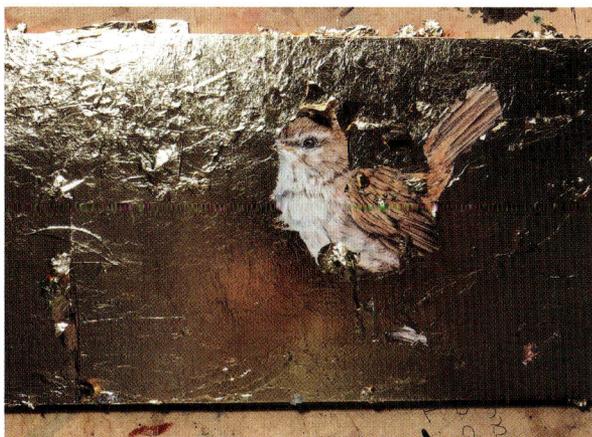

4 Gild as described on pages 132–133. Pay close attention to the folds and creases created by the textural medium to ensure you are working all the way into the nooks and crannies you have created.

5 Burnish the surface as described on page 134, and remove all excess leaf. Begin to work back into that surface, distressing the leaf using scudding or wet sanding techniques (see page 142). You can spatter the piece with metallic ink or paint to add an extra flourish, too.

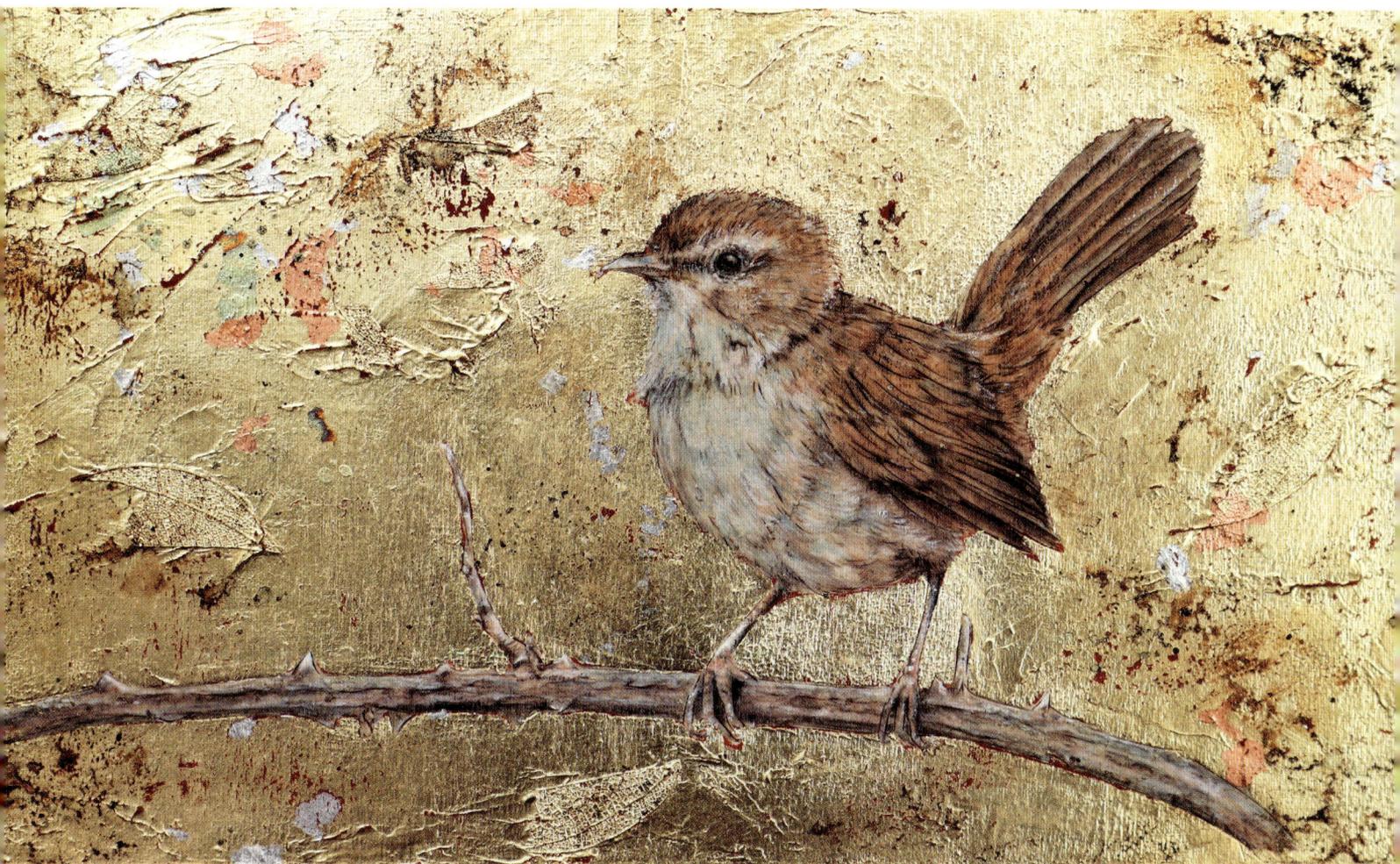

Golden Warbler (Lady of the Marsh) 30 × 20cm (11¾ × 8in)
Pyrography, gilding and coloured pencils on poplar panel.

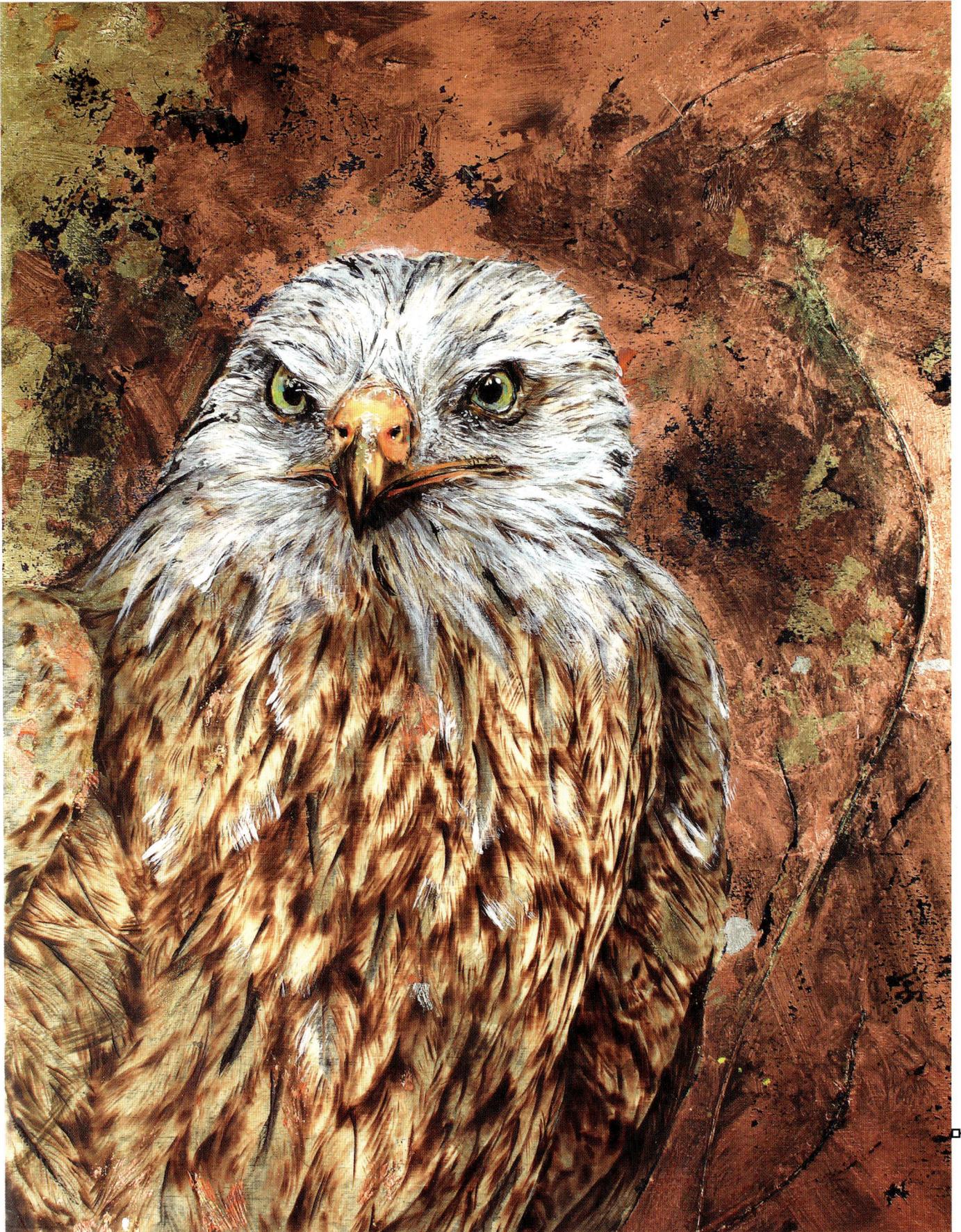

GETTING DOWN AND DIRTY

Adding different mediums, colours and chemicals to the gold leaf surface can be used to create interest and add drama to an underlying composition. Dramatic lights and luminous darks can be used as glazes, ammonia can be used to create a smelly, but beautiful, antique 'olde worlde' tarnish, and vinegar can be used to create the most amazing cobalt turquoise blooms on the leaf. It's like art alchemy happening before your very eyes! The best way to find what works is to play: so much depends on the particular brand you use, and when you use it.

Tarnishing

Exposure to air causes imitation gold leaf to tarnish over time, so we need to seal the leaf to stop the process. However, tarnished metallics offer an interesting texture and can give a piece of work a great antique, aged look. Such a look can be replicated using everyday products. As imitation leaf is made of zinc and copper, ammonia is an easy and inexpensive chemical to use to tarnish it: the ammonia reacts with the copper element in the leaf, accelerating the oxidization process. This will only work if applied following burnishing, and before the addition of any sealants, glazes or acrylic mediums.

If you're unsure about using household chemicals, another simple but effective way to create an aged look on the gold leaf surface is by directly applying a glaze (or multiple glazes) of black and raw umber acrylic paint to the surface with a rag. The effect looks even better with the addition of some texture beneath the gilding – this can be seen on *Red Kite*, opposite, and the technique is explored overleaf.

Red Kite 30 × 40cm (11¾ × 15¾in)
Pyrography, Inktense pencils, gouache, gilding and found objects on birchwood panel.

Drips and splats

Once I'm finished tarnishing/glazing the gold leaf, I often drip and splatter metallic inks over it to finish. You can see this effect on most of my gold work. It's a simple and effective way to add interest and texture to the gilt panel. Watercolour is incompatible with the metallic surface of the panels, but acrylic inks work well as they adhere to the surface and dry waterproof. I particularly like the Liquitex iridescent bright silver and gold inks. They have a great sheen, are relatively opaque and the pipettes in the lids make great ink splats from the droppers – just make sure that you shake them well before use.

HOT TIP

If you're wondering how to get hold of ammonia, look in your cleaning cupboard: ammonia is an additive to many household items, and countless cleaning products contain ammonia. Check the label and look for an ingredient called 'ammonia hydroxide'. Always experiment on a sampler first because if ammonia is left on the gilt for too long the leaf will disintegrate. Some artists use liquid ammonia to tarnish metal leaf but I'm averse to the awful stinky smell and fumes. When using any chemical, consider safety and personal protective equipment first. If in doubt, leave it out!

Glazing

Glazing is the application of a transparent layer of colour that shifts and changes the underlying colours in the layer beneath. The technique plays a key role in the way I work with gold leaf backgrounds.

Glazes can be used to optically change or subtly enhance the entire colour of the substrate layer. Complementary colours linked to the shifting metallic hues of the leaf can be used to enhance the leaf and add richness, intensity and depth to the background. For instance, the reflected hues of metallic gold leaf are red and green. By adding transparent glazes of those colours to the background, the colour shift will be amplified, creating magical veils of luminous dancing, shimmering colour.

To create a glaze, combine equal parts paint (the colour will depend on the artwork) and slow-drying acrylic medium and mix well. The slow-drying medium tones down the intensity of the paint and increases its open time, giving you more time to work. It also aids blending, which in turns helps to prevent the paint from drying streakily. Transparent or semi-transparent paints work best for a glaze.

HOT TIP

Always make the glaze by starting with the slow-drying medium before gradually adding small amounts of paint to the medium; it's a less wasteful way to work.

1 Prepare your artwork for glazing by painting the background with a large brush. A 25mm (1in) or 37mm (1½in) flat brush is ideal. Think about the brushstrokes, as they'll be visible through the gold leaf. I tend to use the brushstrokes to subtly direct the viewer's eye towards the subject's eye or other focal point. Here I've used Prussian blue acrylic paint.

2 To avoid a hard outline around your subject, paint near to it, then use the tip of the brush to 'worry' towards the edge. There's a natural tendency to be concerned about accidentally painting over your hard work with pyrography, so use this in a positive way, and edge the brush towards your subject gradually, letting the hairs of the brush do the work.

3 Leave the paint to dry.

4 In a small palette, mix a little texture gel with your paint (Prussian blue, in this example) and use the mix as an adhesive to attach a few found materials. I'm using some grass and seeds, and a small feather found on a walk.

5 Leave to dry thoroughly, then apply size as described on page 131. While you should avoid covering the subject; do feel free to add a few hints of size here and there – gilding can act as highlights and link the subject to the background.

6 Gild and burnish the surface following the instructions on pages 132–134.

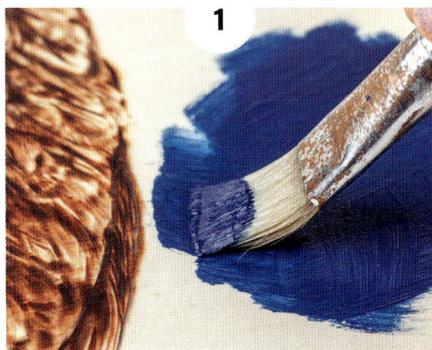
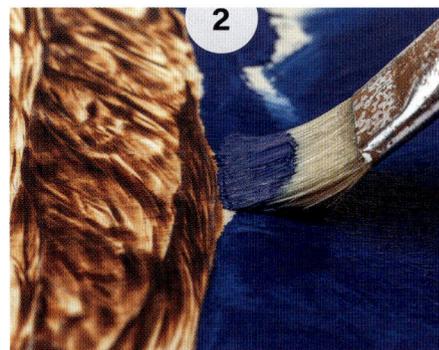
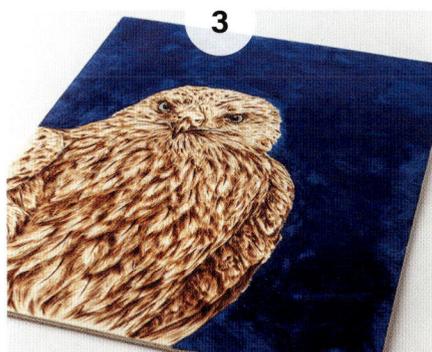

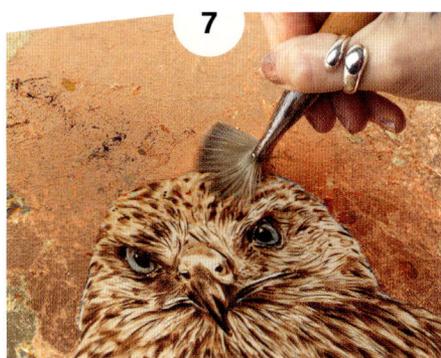
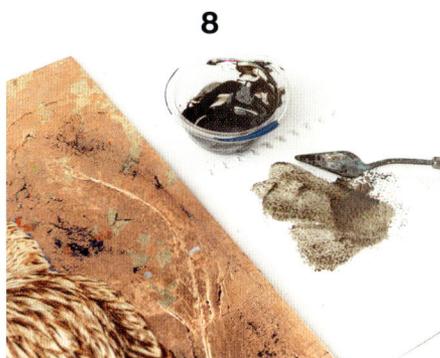
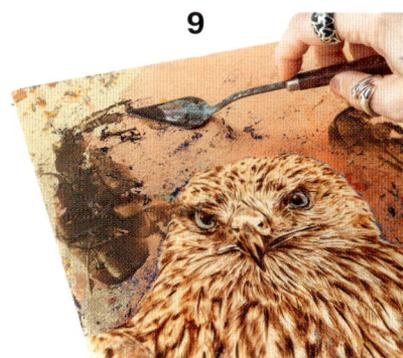
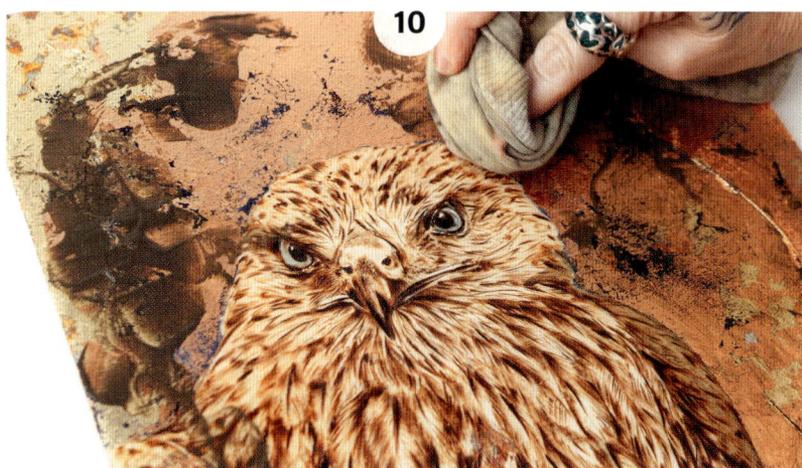
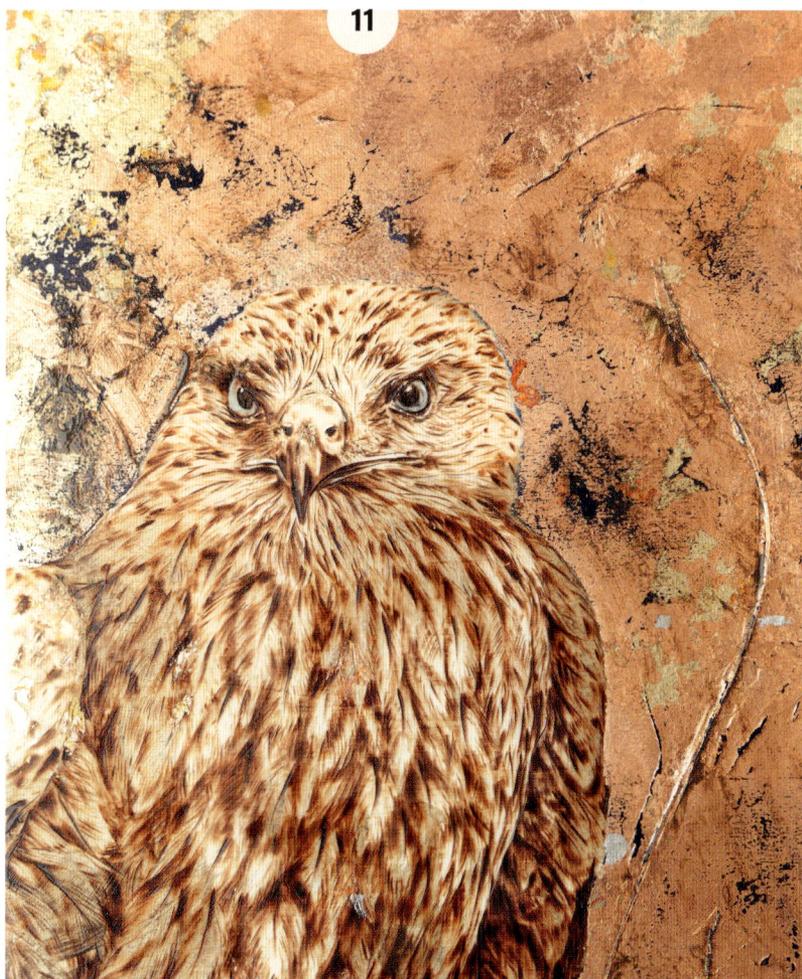

7 Use a damp brush to agitate and distress the surface (see 'Scudding' on page 142) and reveal some of the underlying colour.

8 Make a 1:1 mix of paint to slow-drying medium in a small pot, and test out the consistency on a spare piece of paper to check the depth of colour. Adjust by adding more medium or more paint as necessary.

9 Apply the mix to the surface – you can use anything to do this; a brush, palette knife or even an old rag. The slow-drying medium will give you more open time, but you still need to work quickly.

10 Working quickly (this is particularly important with large pieces), use an old rag to push the glaze around and selectively wipe it away from the surface. Have fun playing! Glazing is used to add a hint of colour and drama without obscuring what's underneath.

11 Work the glaze into the creases to enhance the texture and form. How much, and how little of the glaze you remove is down to personal preference. Once the glaze has dried, you can continue to develop the surface, and add further glazes, if you wish. The finished version of this piece is on page 146.

HOT TIP

A glaze can be used to create a subtle vignette on the background to subdue and block the bright corners and edges. This helps to keep the viewer's eyes within the artwork.

A FINAL FROGGY FLOURISH

We're now ready to finish our frog; and what better way than with gold? I decided to add a thin accent frame to the stippled frog to add a contrasting transition between the dark dramatic background and the pale wood. Adding a gold leaf accent or border within your artwork is also a great way to accentuate areas and create another point of interest or texture. It's also a sneaky way to tidy up dark edges, which can hide a multitude of sins! The technique works well on both wood and paper.

MATERIALS AND TOOLS

Surface: Existing frog piece from page 111

Materials: Polyvine metal leaf size (or similar), variegated metal leaf

Tools: Teaspoon, soft flat synthetic paintbrush, low-tack painter's tape (Frogtape®), wax paper

1 Begin to mask the area around the edges of your artwork with low-tack painter's tape, being careful not to stretch and pull the tape, as this will distort the profile of the line. Start from the outside as this will help you to judge the width of the frame (the gap from your work to the tape) against the work. Here I want to create a thin frame, but yours can be as wide as you like. Offer the tape to the line and gently smooth it in place. Continue around the other edges in the same way, creating a frame around the outside of your piece.

2 With the outer frame complete, add the inside section of the frame in the same way. Ensure the end of your tape is straight (at 90°) and offer it carefully to the corner of your design. Lay the tape along the length of the artwork and crease it back on itself at the next corner. Lift the tape and cut along the mark then smooth down and check the fit. Adjust if needed. Continue working around the artwork methodically, keeping an equal distance between the outer and inner tape.

HOT TIP

If the edges of your artwork are messy, move your border in. The gold leaf will create a fresh new edge. You can see this in step 3, where the excess burn along the upper edge of the frog is visible in the border.

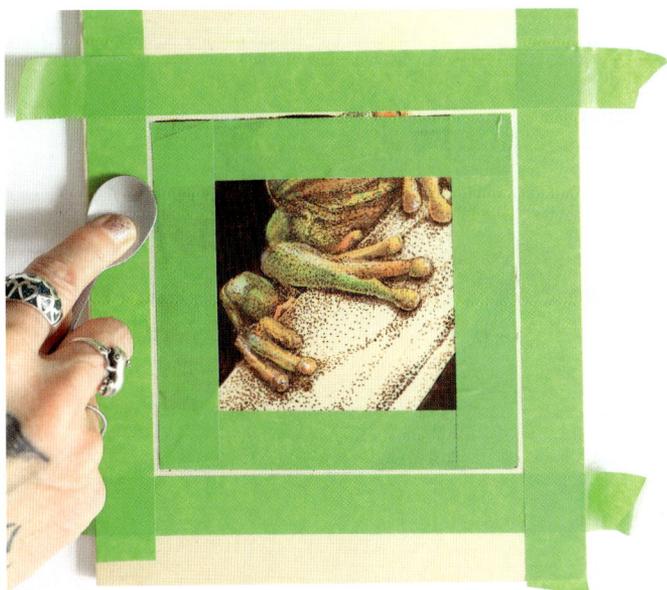

3 Once you're happy with the edges, gently run the bowl of the spoon over the painter's tape to adhere the tape to the surface, paying particular attention to the edges and corners. This will stop the size creeping under the tape. You don't need to press hard, you're just activating the adhesive on the underside of the tape. Be particularly gentle on soft woods as you don't want to indent the grain.

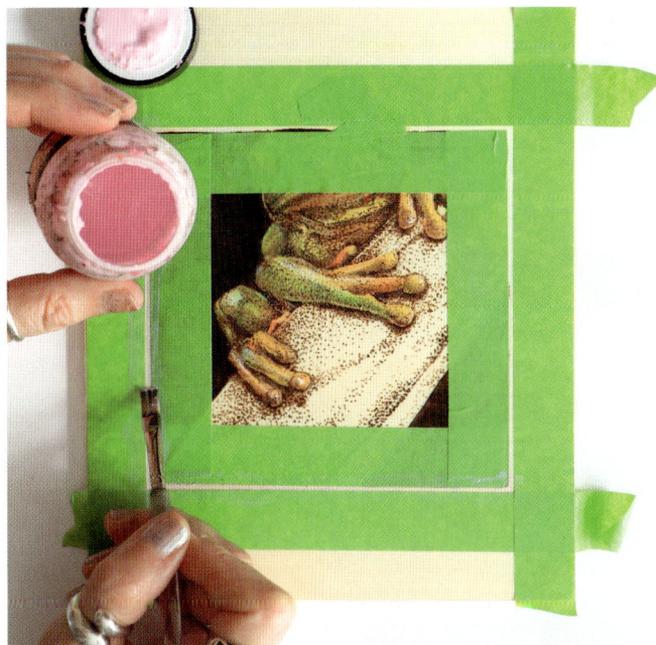

4 Take time to assess your piece and ensure that any small objects that you don't want to gild are masked (I added tape to cover the frog's eye, for example). Apply your size evenly and sparingly to the unmasked area, using a small damp synthetic flat brush. It's okay to go over the edges of the tape along the frame. Leave for fifteen to twenty minutes until tacky.

HOT TIP

Dampening your brush beforehand makes it easier both to apply the size and to wash the size out of the brush later.

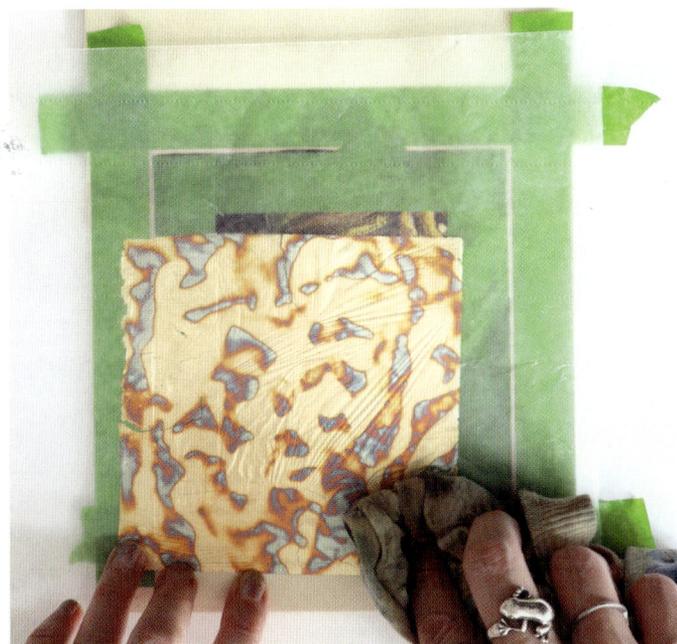

5 Apply the gold leaf to the artwork using transfer sheets or the wax paper method (see page 132–133). Offer the leaf to one section at a time, working around the frame. Feel free to place sheared pieces of gold leaf along the frame by hand if preferred. Secure in place by gently rubbing over with a rag through wax paper. Continue until the area is covered with the leaf and there are no gaps. It will look messy at this stage – but don't worry: that's totally normal.

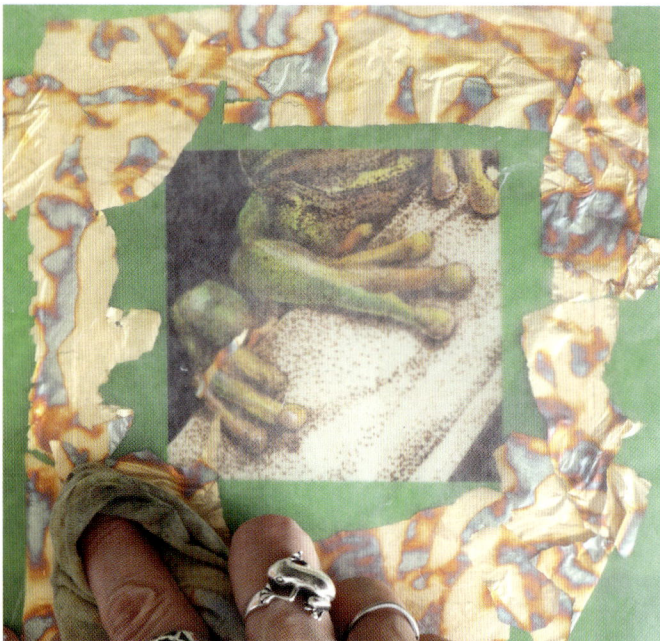

6 Place a clean piece of wax paper over the gilded area and burnish (see page 134) with a rag or soft cloth, by rubbing firmly in small circular movements through the paper. The wax paper will protect the surface of the gold leaf as you rub it. If you have a large area of gold leaf, work in sections. Remove the paper and save it for another gilding session.

7 Start cleaning off the excess leaf with a soft flat synthetic brush. Keep the brush angled flat and use gentle sweeping motions along the outer edges of the tape and the leaf in any areas of overlap. Leave overnight to cure. With the gilded area being so small and fine, it is important for the glue to have dried completely before you attempt to remove the tape.

8 Gently remove the framer's tape. Pull it away from the gilding and keep the tape at a low angle to the wood – almost pulling it back on itself, as shown. Work around the artwork slowly and methodically.

9 Once all the tape is removed, gently remove any excess gold leaf along the edges of the gilding with the brush.

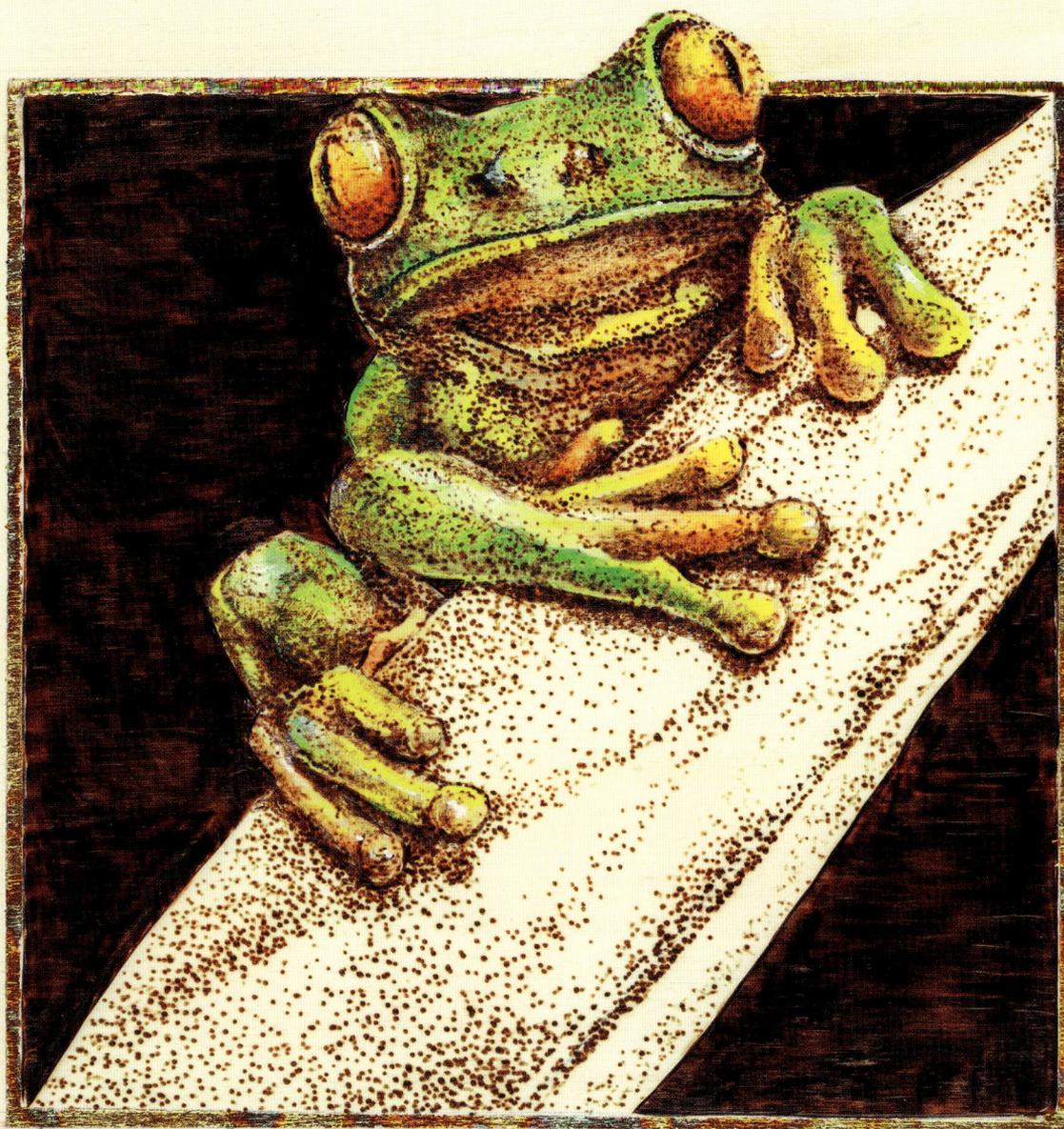

Tree Frog 30 × 30cm (11¾ × 11¾in)

Pyrography with mixed media and metal leaf on poplar panel.

Creating gold leaf backgrounds is a great way to get to grips with handling metallic leaf and learning how to integrate it with other media, but there are many other ways to add a glow. Accents of leaf and metallic paints can be used to create a warm glow, denote gentle reflections or suggest metallic glints.

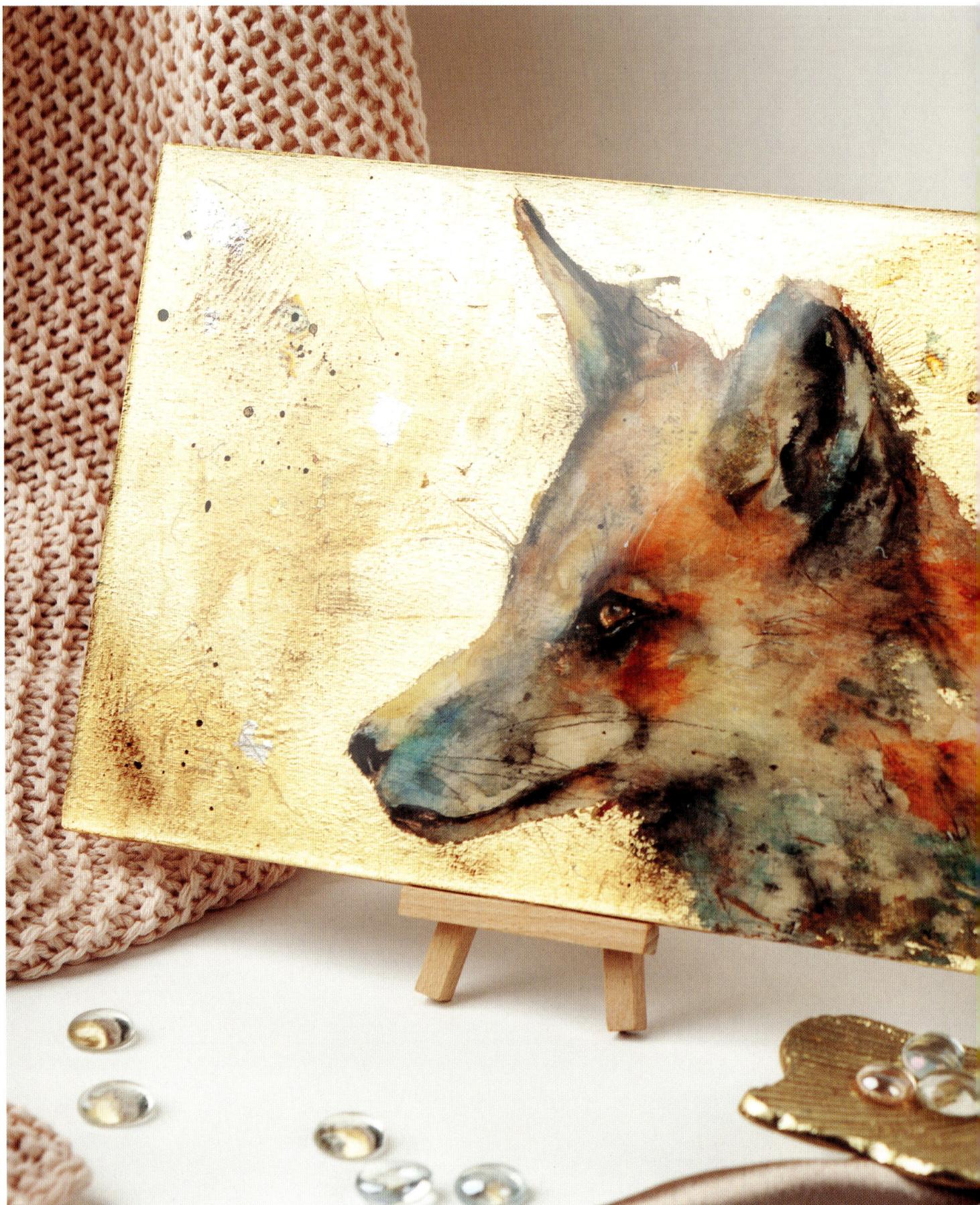

THROUGH THE LOOKING GLASS

'Art is the reflection of the imaginative mind.'

Debasish Mridha

I really enjoy using resin in my artwork. It appeals to my mixed media approach and offers a timeless functionality and simple aesthetic. I also find its glass-like lustre both versatile and beautifully attractive.

My fascination with resin began a number of years ago after going to see an exhibition where an artist encapsulated her artwork within a glistening cocoon of crystal-clear yumminess. The lustrous translucency of the glassy product amplified the colours of her painting and, on closer inspection, revealed that it held other tiny objects in eternal suspension, forever orbiting her work. You just wanted to touch it. I stood for a long while mesmerized and trying to work out what the product was, only to find out later it was resin! From that moment on I was beguiled.

PLAYING WITH RESIN

Many of my students and other artists I know are interested in using resin within their artwork (it doesn't have to be pyrography) but many have had a bad experience with the product or simply don't know where to start. Resin can be quite a costly mistake in more ways than one, as it's a relatively expensive product and doesn't have a long shelf life once opened. Secondly, resin is often used towards the end of your work – so it's accompanied by quite an understandable feeling of trepidation as you don't want to risk spoiling all that hard work!

I have experimented and tried many types of resin with varying degrees of success. Let me share my findings to take some of the guess work out of the equation for you. I'll let you into the secret of how I incorporate resin into my own artwork to create those beautiful mirror-like finishes that make people go 'wow!'

Sidmouth Fox 30 × 20cm (11½ × 8in)

Pyrography with watercolour and metal leaf on a birchwood panel, finished with resin.

'To run barefoot in starlight, to dream upon the dawn,
The promise of a brand new day, that's gifted on the morn.'

This piece shows the magic that happens when you fuse things together to create something exciting and new. The fox was created in a pen and wash style using a skew and spear shader. Wet-in-wet watercolour was flooded onto transparent watercolour ground once the burning was complete, and a metal leaf background was added with small patches dragged onto the fox. Copper leaf was added to the reflection in the eye. All of that mixed media loveliness was then encapsulated into a crystal coat of glistening resin.

THE BEAUTY OF RESIN

The type of resin used by artists is specifically designed to form a thick, slightly flexible, clear glossy coat over your artwork that helps to protect your image and amplify the colours. It should not be confused with casting resin which is a very different product. Art resin is sometimes referred to as epoxy coating resin.

Epoxy resins are typically sold in a set comprising two separate components: a bottle of hardener and a bottle of resin. To activate the product you mix equal amounts of hardener and resin measured by volume. (This 1:1 ratio is almost universal, but it doesn't hurt to check the manufacturer's recommendations.)

I always mix epoxy resin in a plastic mixing cup as it's easy to clean up and I'm conscious of waste. Epoxy resin will not stick to anything designed to repel water so leaving any extra resin in an inexpensive plastic container to set overnight allows me to peel it away the next day. The container can then either be recycled or saved for another session. Resin and water are not best of friends, so keep them apart!

Using epoxy resin is relatively straightforward, but for a smooth application it is really important to be well prepared before you start. Once you start you are on the timer!

The tools and equipment you need for working with epoxy resin: the bottles of resin and hardener, a flat waterproof surface (a spirit level is very handy to help with this), measuring jugs, plastic containers, stirrers, disposable gloves, wet wipes and – if you're using them – moulds. It is also handy to have a blowtorch or heat gun standing by.

MY CHOICE: RESIN

I have experimented with a number of different epoxy resins and by far my favourite is a product named ArtResin. It's easy to use and, unlike a few of the other makes I've used, it doesn't yellow over time. A number of other epoxy resins on the market contain toxic elements that I would rather avoid, whereas ArtResin does not and is safe to use indoors. It also boasts zero shrinkage whilst drying.

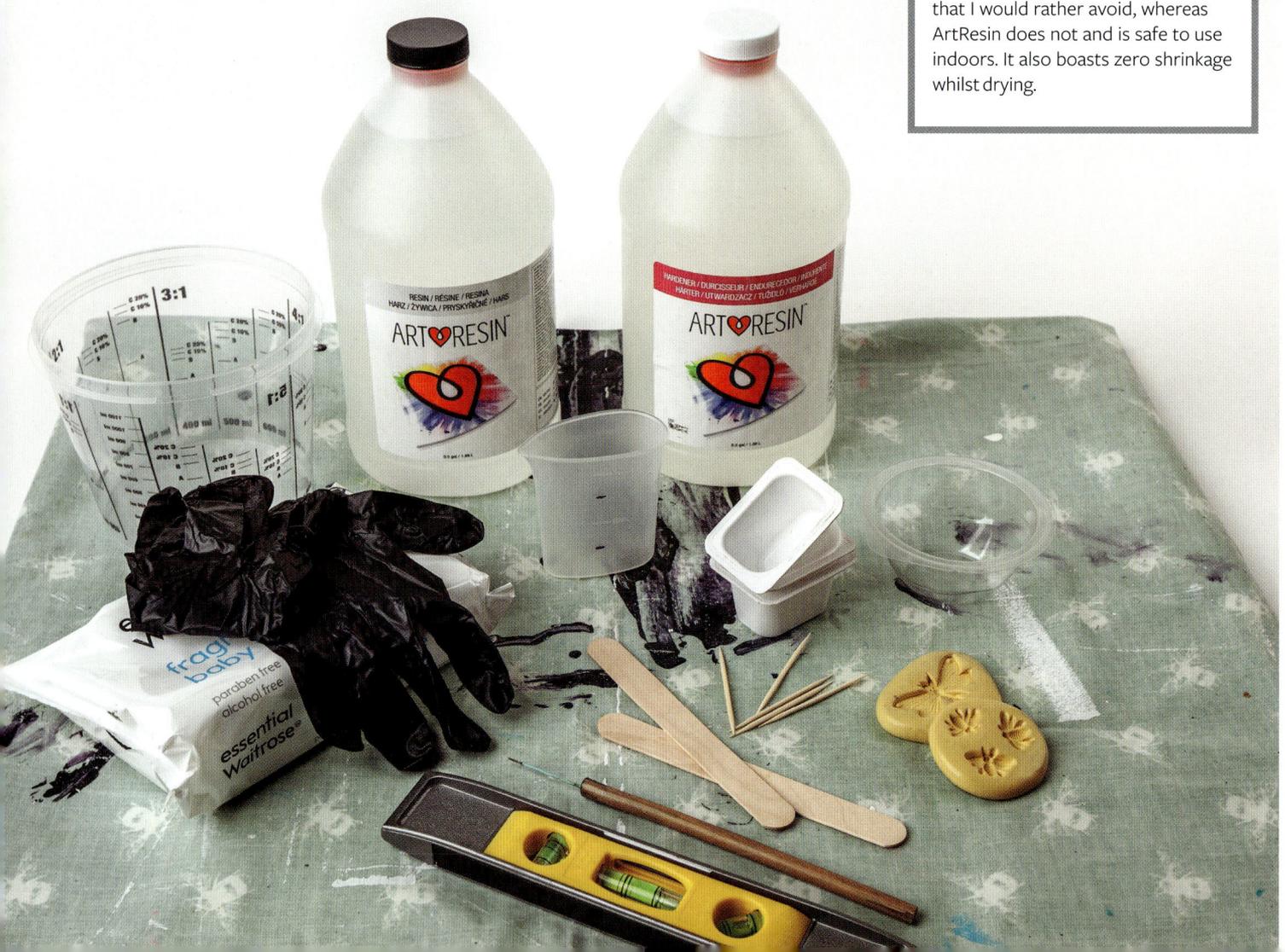

PREPARING YOUR AREA

Before working with resin, I make sure the area I'm working in is clean and as dust-free as possible, as resin seems to work like a magnet for every mote of dust, eyelash, dog fur and strand of hair in the area! I also make (or find) a box that is big enough to place over the artwork with plenty of clearance on all sides. Make sure this is clean too; there is nothing worse than lifting the box up in the morning to find remnants of cardboard fluff or a bit of last night's takeaway immortalized forever within your work.

Make sure you protect your work surface area, as resin flows and drips, and things can get messy. I have an old piece of oil cloth which I always use to cover my table, as cured (dried) resin will peel off oilcloth cleanly (it's a strangely therapeutic thing to do; a little like popping bubble wrap). This also means that you can use the same old bit of oilcloth for all your messy work, which is great for the planet.

To keep the bottom of your work clean, apply masking tape to the underside of your artwork, close to the edges. This will prevent drips of resin tracking underneath. The tape, along with all the drips, can be removed once the resin is part-cured, leaving crisp edges at the side and the underside clear.

It's important to find a way to support or raise your art piece off the work surface. Dried resin acts like glue and will quickly turn your masterpiece and work surface into the top and bottom parts of a very pretty arty sandwich, if you don't have clearance to allow drips to fall! I typically push large map pins a little way into each corner of the underside of my panel, which act like little feet. This technique also works well for canvases. If you don't have any map pins, try empty yogurt pots, old cotton reels or any similar household items that are stable, the same size and keep the artwork level. That nicely leads me to one of the most important things: to get the best results your work must be as flat as you can make it. Use a spirit level and check that bubble! This is one of the reasons why I like to use map pins as they are adjustable.

Resin works best on a firm surface. If you are applying resin to paper then attach the paper to some form of art board or panel to create a firm surface to work on. Make sure to seal the porous surface of the paper before applying the resin.

Raised from the surface

Always raise your work up off the surface to leave clearance for drips. Make sure your base is stable.

Levelling

Levelling is vital. Ensure that the surface of your artwork is as level as possible – or the resin will creep over the lowest side in a pretty (but useless) resin waterfall.

APPLYING THE RESIN

Once you're ready to go, applying resin is as easy as following the simple steps on these pages.

1 Measure With gloves on, use a plastic measuring jug to pour equal amounts of resin and hardener into a mixing cup. Mixing cups are freely available to buy in shops and online, but I save old plastic cartons for mixing. I have a pile of them in the shed! Just clean them out well and make sure they are dry and dust-free before you start.

2 Mix Stir gently but thoroughly for at least three minutes (the time will vary for different products, so check the manufacturer's advice). Be sure to scrape the bottom and the sides of your mixing vessel as you stir to thoroughly combine the product. Small bubbles will naturally start forming within the mix as the chemicals react and combine.

HOW MUCH RESIN?

You need to have enough resin to comfortably cover the surface of your artwork and allow extra for the drips over the side. Rather than trial and error, I always use a resin calculator. There are some great ones online which are free to use. You simply input the length and width of your work and – *voila!* – it determines the quantity of resin to mix. They save so much waste. Check out: www.artresin.co.uk/pages/calculator

HOT TIP

Tongue depressors or lollipop sticks make great stirrers and are often sold as such, but if you can, try using plastic or silicone to mix (and move) the resin as the epoxy will peel off them once cured. I don't even wipe them off when I've finished; I simply drop them on the oil cloth and peel off the next day.

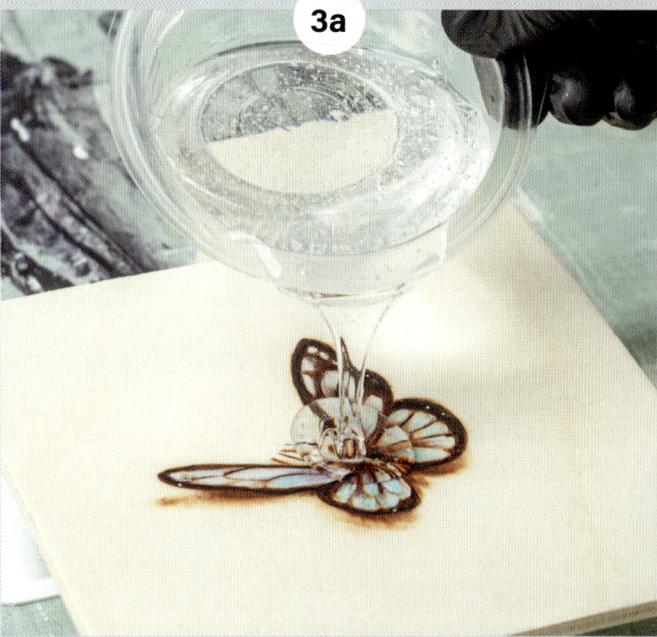

3a

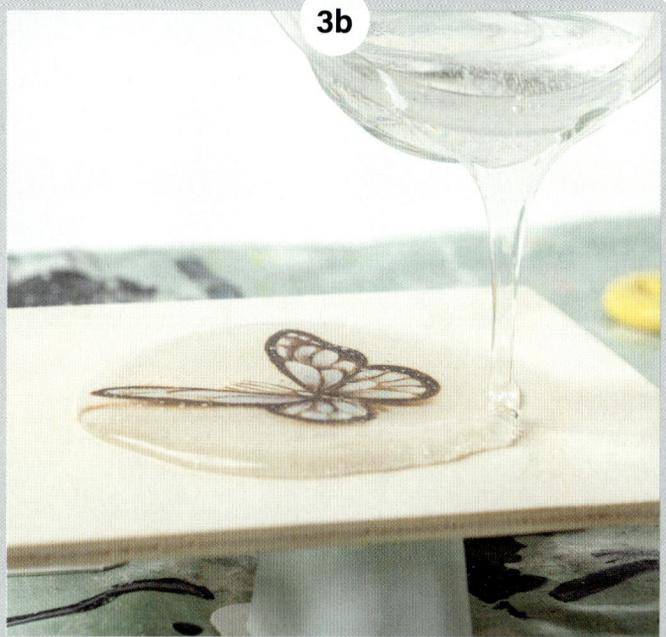

3b

3 Pour After making sure your piece is level, go ahead and pour the resin mix over your work. Start towards the middle of your piece (3a) and dispense smoothly in ever-increasing circles over your work (3b). Use a spreader to help move the resin around and evenly disperse the product over the surface of the art work. You have around ten to fifteen minutes open time at this point before the resin starts to change consistency. Encourage the resin over the edges (3c), and use a spreader to rub along the edges to ensure they are covered. Resin will self-level, so don't worry about moving it around too much in these early steps.

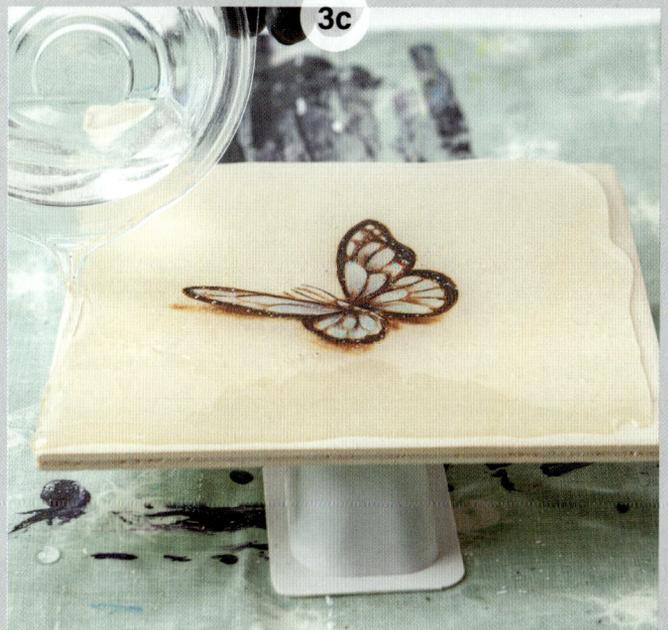

3c

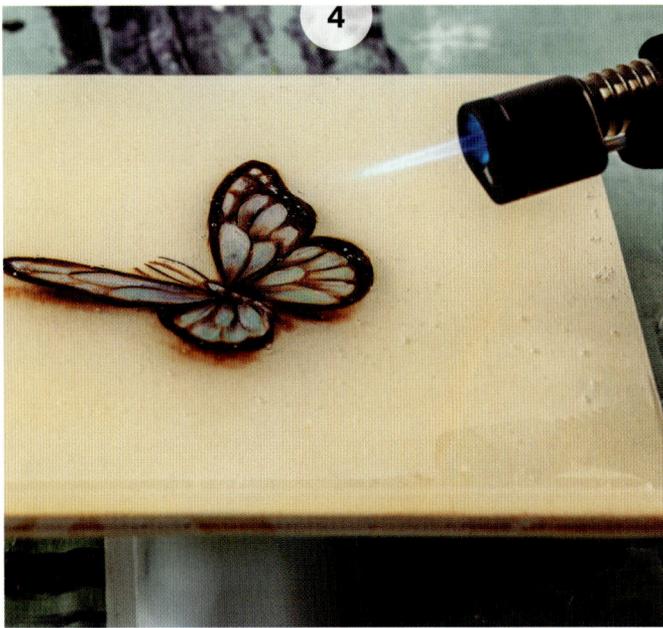

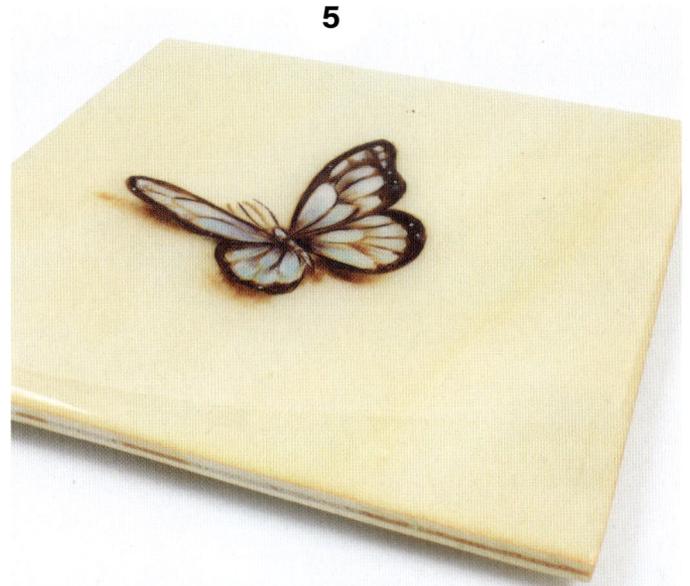

4 Bubble popping This bit's fun! Carefully play the flame of a blowtorch (see page 82) a little way above the top of the surface to encourage the bubbles trapped within the resin to rise and pop. When it comes to torching, less is always more: the bubbles should disappear right away. If they don't, move the flame a little closer. It is important, however, not to touch the surface of the resin with the flame directly: it is the heat that does the magic. Keep the torch moving back-and-forth across the entire surface, as though ironing clothes. If any foreign objects have nosedived into your lovely mix, take this opportunity to quickly fish them out with a cocktail stick. The resin will still self-level at this stage. Once satisfied with your looking-glass finish, very carefully place a large box over the top of the whole piece to protect it from dust while the resin cures.

5 Wait Resin needs to sit for several hours in its dust-free cocoon while it cures. It's really hard not to peek! I normally leave it overnight then dive down the stairs in the morning to behold its loveliness. You can remove the box after leaving the piece overnight, but be cautious: resin takes around twenty-four hours for it to be hard to the touch. After this, you can gently remove the tape (see page 157) from the underside of your artwork. It's good to remove the tape at this point as the resin has not totally cured, and the drips come away more easily on your tape. You should still be careful not to touch the surface directly. Most resins will take three days (seventy-two hours) to fully cure. It is easy to damage and mark it during this time.

No matter how careful you are when pouring, it's almost impossible to avoid trapping tiny bubbles. This stage helps to remove them.

Use a cocktail stick or similar fine object to remove foreign objects like hairs or dust with minimal disturbance.

MIXING IT UP – FOOD FOR THOUGHT

I mainly use resin as an interesting and different way to protect and present pyrography, particularly on panels. It amplifies and showcases the grain of the wood and draws the viewer in. Some resins have UV (ultraviolet) filters and stabilizers within them, which help to protect and preserve the pyrography. Resin works really well with gold leaf too. It amplifies the beauty of the gold leaf lustre and makes it look really special.

On occasion, I add tints to the resin at the mixing stage using tiny drops of acrylic ink. A little goes a long way. A drop of blue makes the resin look really water-like – fabulous for underwater scenes. I've also added fine art glitter (again, less is more) to the resin, which creates a wonderful subtle magical veil. It's almost translucent, and under the right lighting conditions or angle, the tiniest twinkles wink at the discerning viewer and draw them in to investigate. You can see an example on page 107.

If you feel inspired to have a go or would like to explore resin further, there is a plethora of exciting and innovative art resin videos and 'how tos' on the internet. One of my personal favourites and a one-stop shop for all things resin is the ArtResin website (www.artresin.com).

Golden Goose 40.5 × 30.5cm (16 × 12in)

Pyrography and metal leaf on birch panel.

This dramatic piece was created using both a shader and skew tip, and finished with gilding and mixed media techniques. It formed part of an exhibition by different artists exploring the migration of different species in various media. The exhibition was curated by the Royal Albert Memorial Museum in Exeter, UK.

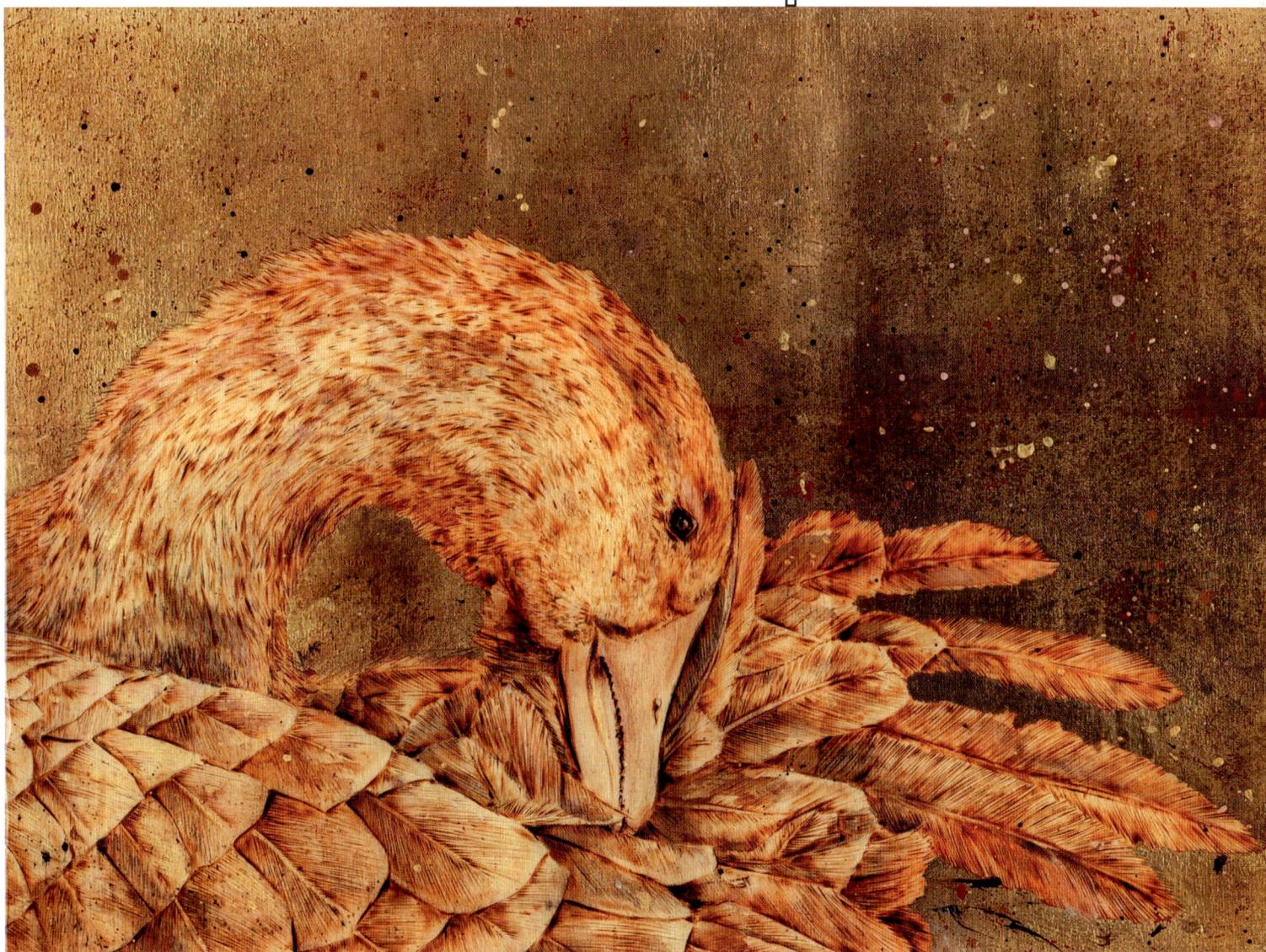

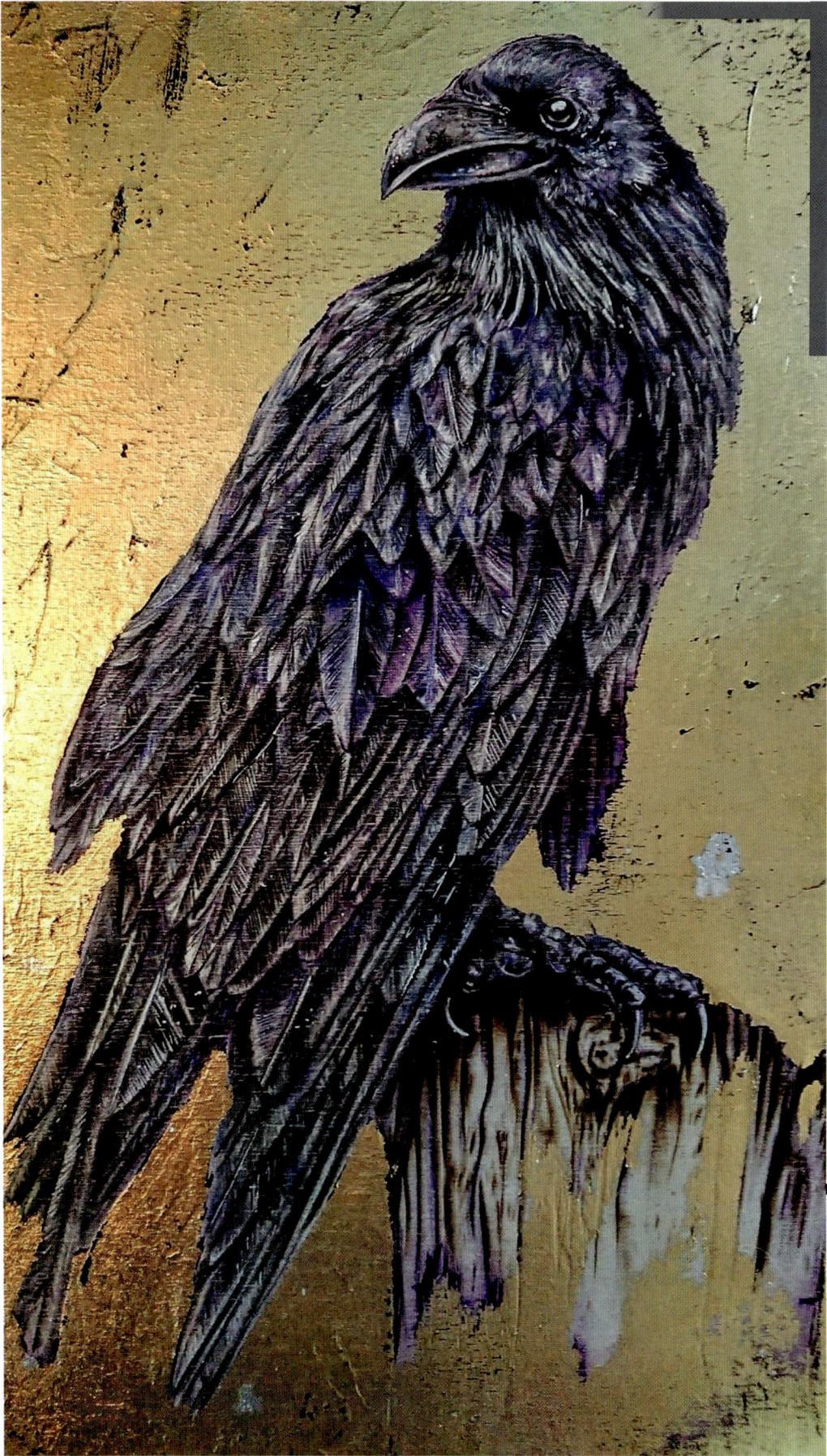

THE FINAL CURTAIN

Well done for making it this far. You've got to grips with pyrography, dabbled with mixed media, completed that latest masterpiece and now have that lovely warm inner glow of a job well done – brilliant! All that needs to be done now is to get your lovely artwork finished, framed, and ready for hanging in your home for you to enjoy – or to present to a relative or friend as a unique gift that they'll always cherish. Perhaps you're even thinking of selling it? Now comes the nervous excitement and the big decision of how to finish and display those wonderful pyro pieces.

FINISHING YOUR WORK

'Where should I go?' said Alice. 'That depends on where you want to end up,' replied the Cheshire Cat.

Alice's Adventures in Wonderland, Lewis Carroll

It is really important to protect and finish the surface to preserve your burned image. Pyrography uses an organic process to produce tones. As a result, your design will naturally appear to fade over time. This may take many years and will vary in degree, but direct sunlight will most definitely speed up the process. This effect is two-fold. As well as the tones of the burned design altering with age and time, most woods will also naturally darken. It is no surprise, then, that fading tends to be most evident on very pale tonal values.

You can't completely avoid pyrography fading or the patina of the wood darkening, but you can most certainly delay these effects. A traditional method of working is to seal the piece behind glass. This is a simple way to protect the piece against ultraviolet (UV) light and is an effective way to protect your work. You might also finish your work with a varnish or sealer. As with glass, this will create a physical barrier against atmospheric pollution. Varnishing or sealing are, however, non-reversible processes.

Different methods will give different results, and these will vary depending upon your wood type, too. It's therefore always a good idea to test out any product you are thinking of using on a sampler before covering your masterpiece. Be aware that the finish you choose can have a direct impact on the overall colouring of your wood.

HOT TIP

If you have opted to use resin as a finish on your artwork, then you've selected the 'advance to Go' card: your work is already safely sealed!

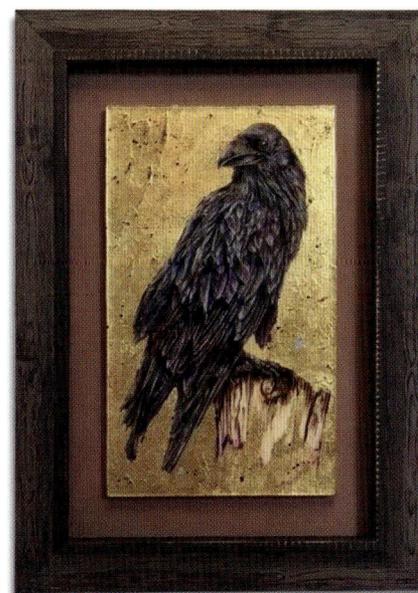

The Raven King 30 × 40cm (11¾ × 15¾in)

Pyrography, metal leaf and coloured pencil on birch panel.

Cornish legend has it that King Arthur didn't die, but turned into a raven and flew away. This piece was created for an exhibition at the Derwent Pencil Museum in the Lake District, which is why it is heavily based on coloured pencils. The pencils, however, hang on a strong tonal pyrography underpainting that underpins all the feathers, giving them depth and movement. Just because it's subtle, it doesn't mean it's not there! There's a nod to pure pyrography on the tree stump. He was finished with resin then float mounted using mirror plates (see page 167); and you can see the framed result to the right.

FINISHING TECHNIQUES

I use a number of different products to seal and protect my work, depending on what finish I think will showcase the piece best. All of the products below will protect your burnings, but each has a unique look.

Whatever you choose, don't hang or display your finished burnings in direct sunlight. No artwork, no matter the medium, likes sunlight – there's a reason most galleries use indirect artificial light rather than lots of big windows with strong natural light. If your work will be exposed to strong direct light of any kind, consider UV-filtering glass, or a varnish or sealer that contains UV inhibitors. A marine varnish or a heavy-duty varnish with UV filters is a good choice if the work is intended for outdoor display: just check it's suitable for your work. Some are very tinted and have a yellow bias.

Wood doesn't like to be hung directly near a heat source either, particularly over a radiator or under a high-wattage lamp. Wood is naturally porous and breathes and interacts with the environment. Extremes of (or regular changes in) temperature can cause damage through swelling and shrinkage. Over time, this can cause a change in the integrity of the wood which can ultimately lead to a breakdown in lamination, splitting and cracking.

Varnish

Varnish is a tough but flexible protective film that is applied over your artwork. There are plenty of options but check that the product is archival, and always try to use a sealer that has UV light protection. Yacht varnishes are often cited as the go-to varnish for wood products. Although they are great for protecting work from the elements, they are not necessarily developed with the artist in mind, and some will add a pale yellow cast to your work. Polyurethane and acrylic-based sealers tend to be much clearer, less pungent and better to use indoors.

Varnishes come in various finishes, namely gloss, satin and matt. Which you opt for is down to personal choice. I tend to favour a gloss or satin finish, as it retains the clarity of the wood burning and really livens up the woodgrain. In my experience, matt varnishes on pyrography look a little lacklustre, leaving the work dull and uninteresting.

If you enjoy using high-gloss finishes or epoxy resin to finish your work, it's good practice to photograph your work before you apply the product. Some finishes are so clear and lustrous that you will end up with reflections of yourself or glare from lights in the picture.

APPLYING VARNISH

Pour a little of your varnish into a palette or small pot, and apply it to the surface exactly like paint, following the wood grain. Use a large, slightly damp brush. Leave to dry for two or three hours, then apply a second thin coat.

MY CHOICE: VARNISH

My liquid varnish of choice is the Liquitex professional Acrylic Gloss Varnish. It's a lovely bright light varnish that is self-levelling and doesn't leave too many brushmarks. It also works well over gold leaf. I normally apply two thin coats with a soft brush, allowing the varnish to dry between layers. I work quickly and where I can, I work with the grain. Experiment and find what works for you.

Wax medium

Wax medium is another fabulous and permanent way to seal pyrography on any kind of wood. It can be applied directly from the tub with a lint-free rag or cloth. It enhances the grain wonderfully, and can either be left matt or buffed to a lovely soft sheen. It may sound strange, but wax medium can be used effectively on watercolours, mixed media and other surfaces too!

A very versatile product and super easy to apply, wax medium can be used as a stand-alone product or gently applied on top of an isolation coat (see overleaf). The product looks slightly milky on application but dries to a beautiful, clear, luminous and water-resistant finish.

APPLYING WAX MEDIUM

Waxing is an easy, tactile and direct way to finish your pyrography work with few time constraints. It is, however, non-reversible, so be sure that you've finished before applying the medium. Use it sparingly, as a little goes a long way. You will get a much better finish with a couple of thin coats as opposed to one thick coat!

1 Scoop out a small amount of wax on your cloth.

2 Apply the wax medium directly to the wood, rubbing it in with small circular movements. Be gentle and apply it thinly.

3 Methodically work across the surface of the wood, using just enough wax to allow it to go on smoothly. If your cloth catches or drags, scoop out a little more wax with your cloth and continue.

4 Allow the wax to dry overnight. Temperature, humidity and the amount of wax applied will affect the drying time. Apply a second coat if necessary. If you require a more lustrous finish then you can gently buff the surface with a dry soft cloth once it is completely dry.

HOT TIP

Pay close attention to the edges of the wooden panel or round. Be particularly gentle when applying wax medium over any areas of bark. It always pays to have sealed and strengthened the bark beforehand (see page 88).

MY CHOICE: WAX MEDIUM

Dorlands Wax Medium and Gamblin Cold Wax Medium are my two favourites and I happily use them interchangeably. With its evocative smell, wax medium feels like it has a hint of magic and a touch of nostalgia... I like to think it leaves the wood smiling!

Glass

Glass is a great way to protect pyrography on paper and can play a great role in preserving your artwork. Not only does it ward off finger smudges from prying hands, but it can also protect pieces from those harmful UV rays, which can cause all paintings to fade. If you're selling your work, it is always worth considering paying a little extra to upgrade your glass to include UV protection. Your friendly local framer will be able to offer further advice should you need it.

ISOLATION COATS

An isolation coat is a coating or sealant intended to stabilize or cover the layer below to create a new and homogenous foundation to begin to build on again.

If I'm considering varnishing a mixed-media piece, particularly on wood, I often use an isolation coat to seal all the absorbent areas. This creates a more stable foundation on which to apply the liquid varnish and it will bind any loose particles of pigment that I've been using to the surface without them bleeding or streaking.

Some artists recommend mineral spirit acrylic or its aerosol version, archival varnish gloss, for this, but I don't like the chemicals associated with them. Instead, I use a water-based spray varnish, such as Ghiant H2O. Water-based spray varnishes work in the same way as traditional alcohol-based spray varnishes but have ninety per cent less solvents than traditional aerosols. They're also UV resistant and will not yellow over time. Once applied, leave the isolation coat to dry fully before covering with a liquid varnish. One or two light spray coats are sufficient, drying well in between. To date, this approach has never resulted in a problem, and I find it works with my ethos and process. As always, do experiment and find what works for you.

When working with imitation gold leaf, It remains important not to touch the imitation leaf with bare fingers, as areas with finger grease could tarnish the surface drastically and will continue tarnishing, even underneath a varnish or isolation coat.

If you have a number of layers still to do on your work, consider using an acrylic medium as an isolation layer. Once that has dried, you can continue painting with acrylics or similar products on a stable new surface.

It's important to find ways of working that you enjoy and which fit well into the things you like to use. Don't be afraid to question why, try new things and push those boundaries. There are new products coming out all the while, so be curious! This self-knowledge will help you make better decisions in your creative life.

Be Still My Heart 50 × 70cm (19¾ × 27½in)
This was an experimental pyrography piece based on a tattoo I did many years ago. It was one of the first mixed-media pieces I ever created on wood, and she still remains very special to me. She's created in much the same ways as Gaia (see page 125) and finished with resin. It was a fun learning curve – one shaped much like a rainbow!

MOUNTING AND FRAMING

Framing is such a personal choice and has the power to make or break an artwork. Wood panels are the most versatile surface to frame. Treat them as you would a canvas panel, using small flexible brass plates to secure the wood panel to the frame (these can be bent if necessary to aid fixing). If you don't want to go to the expense of a custom frame for your piece, consider cutting your panel to a standard frame size before you begin and using an off-the-shelf product. They are so much cheaper and there are some fabulous pre-made frames around.

Be sure to attach the D-rings (for hanging cord) to the frame, not the panel. For optimal hanging, they need to be placed about a third of the way down from the top of the frame. It's equally important to ensure that the string is strong enough to support the weight of the wood. If the panel and frame are very heavy, consider using mirror plates instead of picture/hanging string and D-rings.

The use of glass is purely down to personal preference. Most pyrography artists don't want to hide the beautiful grain and surface of the wood under glass and choose to treat the art surface instead of using glass. I do use glass for most of my pyrography on paper/artboard, as it helps to protect and preserve the integrity of the paper. Such pieces are mounted and framed as I would a typical watercolour.

Tray frames Clean and contemporary, tray frames, (sometimes referred to as St Ives frames) are very popular and work well for all types of panelled pyrography work on wood. However, they can be quite limited in choice and colours, and the depth of the frame needs to be considered against the thickness of your wood for a well-balanced look. Deeper frames work better: it looks odd if the depth of the wood protrudes above the line of the frame – a little like wearing Sunday best that's a size too small!

Float mounting A float mount raises your image above a blank, uncut backing mat so all four sides of the artwork are visible (rather than being tucked under the frame edge – see *The Raven King* on page 163, for an example). This option is useful for framing freeform pieces of wood (with or without bark) or work that doesn't lie flat. I use this for panels too, and it is fabulous for showcasing resin. It creates a professional and unique presentation, but you must be sure to mount the work centrally or it will look odd. The colour of the backing board is also key to the success of the overall look of the piece.

When float mounting, artwork is typically attached directly to the mat board with T-hinges. Since wood can be weighty, secure your work with two small grub screws through the back of the frame and just into the back of the wood, to clamp it firmly in place.

To float mount pyrography on paper, first attach the artwork to an acid-free foam core by using a PVA glue, strong mount adhesive or framer's double-sided adhesive tape. This offers the paper artwork an element of rigidity and allows it to sit higher in the frame, creating a dramatic shadow.

If you choose to use glass, make sure the raised artwork isn't pressing against the glass surface. Over time the artwork will stick to the glass, condensation will set in, and the paper fibres will break down and ruin your burning.

FRAMING TIPS

Here are a few more tips that may help you make a choice. If in doubt, your local framer can give your lots of pointers and advice.

- Lighter frame colours suit more casual pieces and work well with the lighter woods. Darker frames add a feeling of formality and drama.

- To help your artwork stand out, choose a frame colour that harmonizes with your work, holds its own and invites inspection.

- Select something that not only enhances your work, but also looks good where it is going to be hung.

- Wood is a robust surface and doesn't necessarily require a mount. It often benefits from a wider frame to balance it out.

- Pyrography on rounds and live wood slices don't necessarily require framing. They can be varnished and a picture hanger attached (or inset) into the back of the artwork. Match your hanger to the weight of your work.

- If you are selling your work, it is important to relay any aftercare instructions to your client. Do advise your client against hanging your wonderful artwork in direct sunlight or near a heat source.

- Some artists choose not to hang at all, and opt for a small display table easel or a plate display stand to place the artwork on.

TROUBLESHOOTING

Sometimes a piece of work just doesn't go to plan... but that's okay! Mistakes are all part of the learning, adapting and evolving process, and they can often become great problem-solving exercises. Indeed, the unexpected can often lead you in a completely different direction, resulting in a far more exciting and rewarding artistic journey.

Happy accidents: when things go wrong

I had ordered a wonderful slice of spalted willow, a wood which I had never previously burned upon. Spalting is a natural type of wood coloration caused by fungi or insects within the wood, and can result in some beautiful and interesting patterning. Although primarily found in dead trees, spalting can also occur in living trees that are under stress. The unique coloration and ornamentation within the wood can be breathtakingly beautiful and I wondered if such patterning could be incorporated in a piece of work to give it an added interest and texture.

I was super excited when it arrived. The wood was a lot lighter (in weight) and thinner than I had anticipated but the coloration was really nice and I liked the shape of the waney edge. I knew that I wanted to burn something a bit different, and also to make the most of the fabulous spalting. I had recently enjoyed a wonderful day drumming and dancing at Fingle Bridge in Devon, UK, close to some magnificent extensive woodlands with amazing waymarked trails and an abundance of wildlife. Looking at the patterns in the wood I could envisage three super cute little owlets peeping out of the wood, and so an idea was born.

I got to work prepping the wood, sorting out my design and working out how I was going to integrate the spalted patterning with the owls. I really liked the idea of making the patterning of the wood a bit of a feature and somehow enhance the 'woodiness' of the grain. I settled on a detailed focal point (the owlets), contrasted by lovely strong darks to give the illusion of depth around the owls, which would also help to anchor them in the wood. In addition, I wanted to play and explore the organic abstraction of shapes that would fuse into the patterns of the spalted wood to suggest the tree bark.

However, once I started burning the wood the fumes released didn't smell too good at all. It smelt off! I persevered for a few minutes longer but then began to feel unsettled. I switched the machine off and took stock of what was going on with this beautiful piece of wood – why did it smell so bad, and what was I going to do about it? A little research revealed that, while there have been a few cases of people having allergic reactions to the inactive fungus spores contained within spalted wood, spalted wood is no more dangerous to woodworkers or those who have the wood in their homes than any other variety of wood pieces. Therefore, I figured that either the wood had been treated or something was going on with the spalted element. Whatever the case, I felt it better to err on the side of caution, and limit my time burning.

What to do? The owls were the focal point and would therefore involve the most layers and detail. I decided to use the pyrography that had already been completed, and that underpinned the owls, as the foundation layer. Rather than building them up with more burning, I opted for a more mixed media approach. I decided to limit further pyrography to defining the wood grain and adding some organic patterning. I also donned some personal protective equipment and opened the windows when burning.

I'm a strong believer that fear of failure, 'shoulds and shouldn'ts', and preconceived ideas can really hold you back. To avoid this, I practise a simple lesson: if things aren't working, simply take a deep breath and change them. This may involve altering your approach, your techniques, or your design – and may involve starting over. Rest assured that this is no sign of failure; but of growth – and the results (like *The Owls of Fingle Woods*), may surprise you – in a good way.

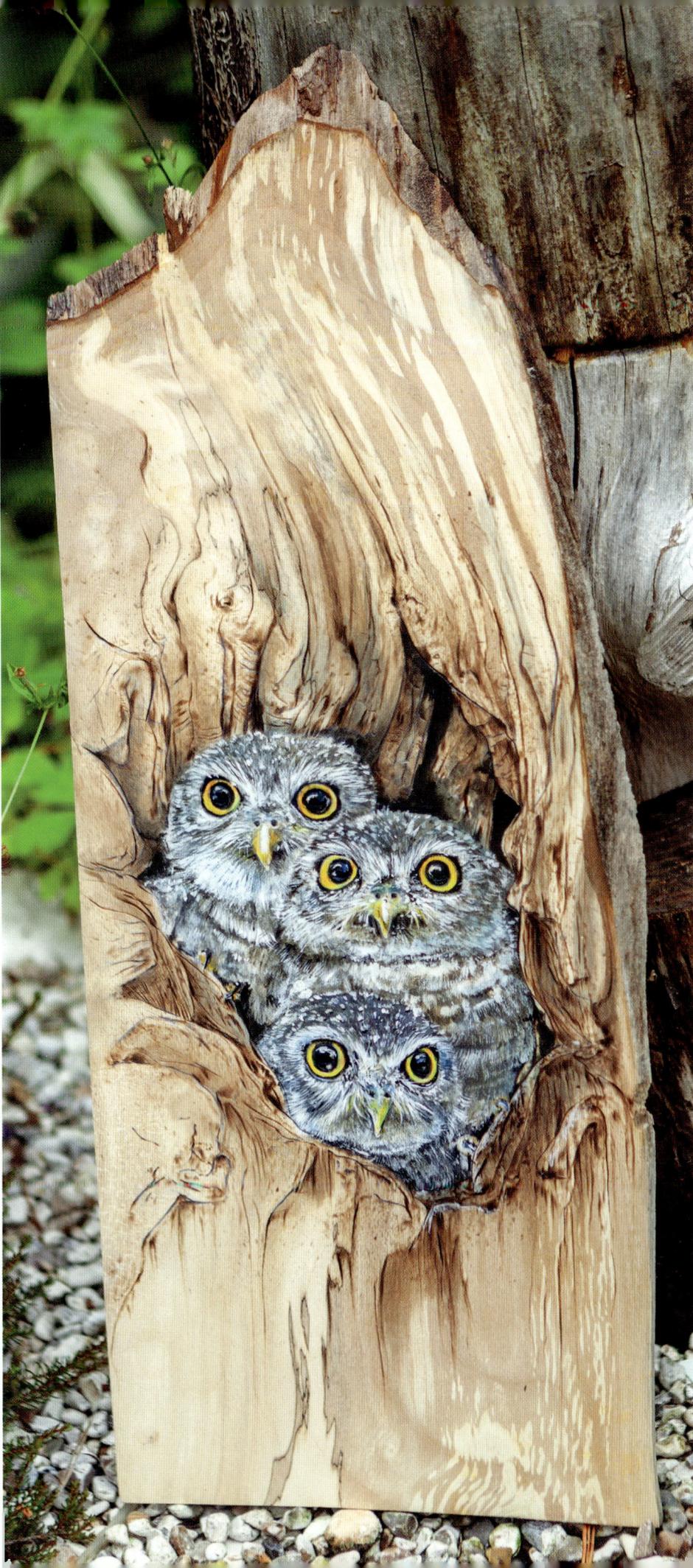

The Owls of Fingle Woods 22 × 58cm
(8¾ × 23in)
*Pyrography with mixed media on a spalted willow
slice. In the collection of
Mrs J. MacLean-Linton.*

'There's magic in the glowing moon,
And in the stars that shine;
Enchantment in the eyes that look
Beyond the twisted vine.'

THE DREADED WHOOPS!

No matter how much you practise or how careful you are with your mark-making, mistakes will inevitably happen. Correcting errors can be tricky, but with a little creative thinking and a pinch of know-how they can usually be rectified – or at least disguised. The methods that you can use to change or correct an area that has gone wrong depend on the wood or surface that you are working upon.

Sanding back If you want to remove or lighten a mark or line, you may be able to gently rub back the darkened area with a fine grain sandpaper. This will lighten the burn effectively. However, it has a limited success rate and can make the surrounding area look 'smudgy'. If you are working on thin plywood board and you haven't burned too deeply, this might be your only viable option. Be mindful not to expose the glue laminate layer beneath the surface.

Cutting away Thicker pieces of solid wood give you the option of using small wood carving chisels to cut away the error. Work at a shallow gentle angle to do so, and re-sand the exposed wood afterwards in preparation for burning again.

Scratching out For smaller mistakes, or to correct surface shading on plywood that has been taken too dark, try gently scratching the burn away using a craft knife or slice tool. Where possible, follow the grain of the wood to preserve the integrity of the surface. This same technique can be used to etch in fine finishing details like whiskers, as it removes the burn and exposes the wood as a highlight.

 Note that paper is less forgiving than wood. You may be able to gently scratch out if you are working on a suitable heavyweight rag paper. The only option is generally to repurpose that line!

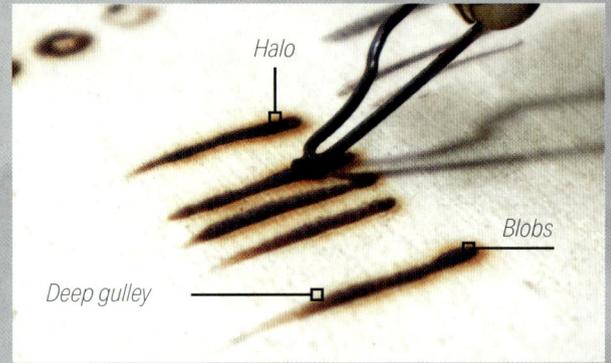

Common problems
Too hot a tip, pressing too hard, or working too slowly, is a common cause of overburned wood and unsightly lines. You can try to fix them with the advice on this page, but it's better still to avoid them entirely with the advice opposite.

Disguising mistakes

If none of the removal techniques above work, consider hiding the line or mark in plain sight. It's a technique that I used extensively when covering up old unwanted tattoos or reworking other people's tattoo mishaps (you would be amazed how many of those there are!) To hide a mistake in plain sight takes confidence, a deep breath and a bit of lateral thinking. There are principally two ways to approach it – burying it or repurposing it!

Burying You can disguise the mark or line by reburning over that area with a higher temperature, darker layers or a more densely packed texture. To hide the mistake successfully, you may need to extend the new lines/textures beyond that of the initial mistake. This may also force you to re-evaluate the surrounding areas to balance the new richer, darker tones and integrate them into the piece. Depending upon where the mistake is and what piece you are working on, you could consider using darker 'negative shading' to extend beyond the area in question and establish a new boundary.

Repurposing This involves turning that pesky line or shape into something new. When you work as a tattooist you soon learn to get creative. I was regularly requested to refashion spur-of-the-moment and drunken tattoos into something new, sophisticated and beautiful. Ex-boyfriend and girlfriend names were turned into all sorts of flowers and foliage, cheeky red devils became beautiful roses and their regrettable dolphin cousins were hidden under all manner of paraphernalia! You just need to think outside the box and integrate and extend those lines. Could you use some of the patterns and textures that you've created on your samplers or doodle pieces? Can you create different lines to flow through the mistake and organically allow something new and different to evolve from it? It can be a really fun challenge to try!

Dark spots – and avoiding them

One of the biggest pitfalls for beginners is dark spots appearing at the start, finish and intersection of lines. These frustrating dark spots are created when:

- The tip is too hot when it initially meets the wood (the tip cools as it is dragged across or through the surface).
- Hesitation during a line: changing direction and deciding to lift off can create a tiny pause.
- The tip meeting resistance or different density on the surface of the wood, such as ring marks or air holes.
- Burning against the grain of soft woods.

Strong heavy grains and soft spots in the texture of the wood you're working on can really affect the way the tip moves in, on and over the wood – when the pen is held perpendicular to the surface, the tip has a tendency to sink into the wood fibres and, at a microscopic scale, bumps along in the direction of the line.

If you notice dark pockets appearing when burning on a soft wood, or skipping, wonky lines or dark marks as you catch the grain, try adjusting the angle at which you hold your pen, particularly with writing style tips.

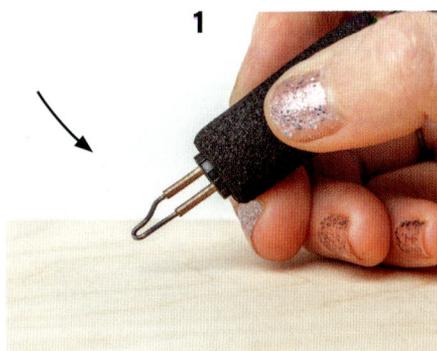

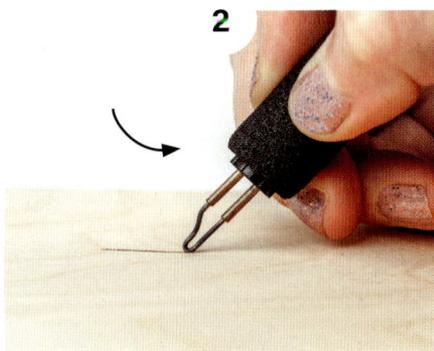

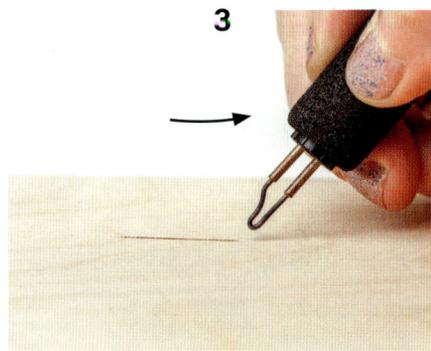

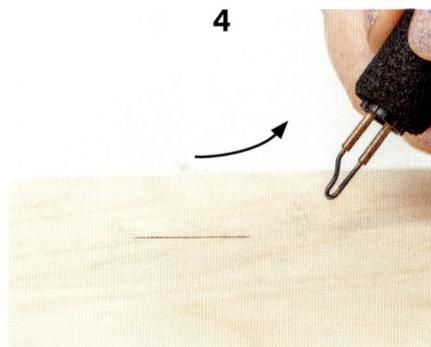

GETTING CLEAN MARKS: THE AEROPLANE OF HAPPINESS

To help avoid these unsightly brown heat blobs, imagine each line you make as a 'runway' and your pen as an aeroplane which is coming in to land, taxiing along the runway and taking off again in one smooth movement. The point at which the tip touches and leaves the surface of the wood should be gradual and controlled, so keep your fingers relaxed and your wrist soft. Practise this transition until it becomes habit; it will change the way your work looks.

1 Sweep the tool down in an arc towards where you want the line to start.
2 Land the tip – the aeroplane – and keep it moving to avoid an unsightly blob at the start.
3 Continue the sweep, gradually tapering the line away as you let the tip lift off again.
4 Lift the tool away completely in a controlled motion.

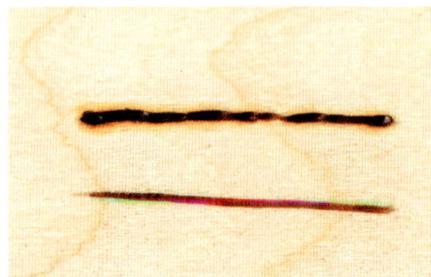

At the top you can see a bad line, with dark spots and a 'halo'. At the bottom is a good line made with a smooth sweep.

Help!

If you've turned the temperature down but your line still looks like you're drawing on the back seat of a car going down a country lane, then the problem likely lies with the surface you're working on.

- **Is it sanded enough?** Writing tips will pick up any tiny bump or change in the surface, so sand, sand and then sand some more. Try the tip on some hot-pressed paper and compare the results.
- **Are you using pine?** Pine is one of my least favourite woods. It's gappy, bumpy and creates an inconsistent burn – not beginner-friendly at all. Switch to something like basswood, poplar or birch.

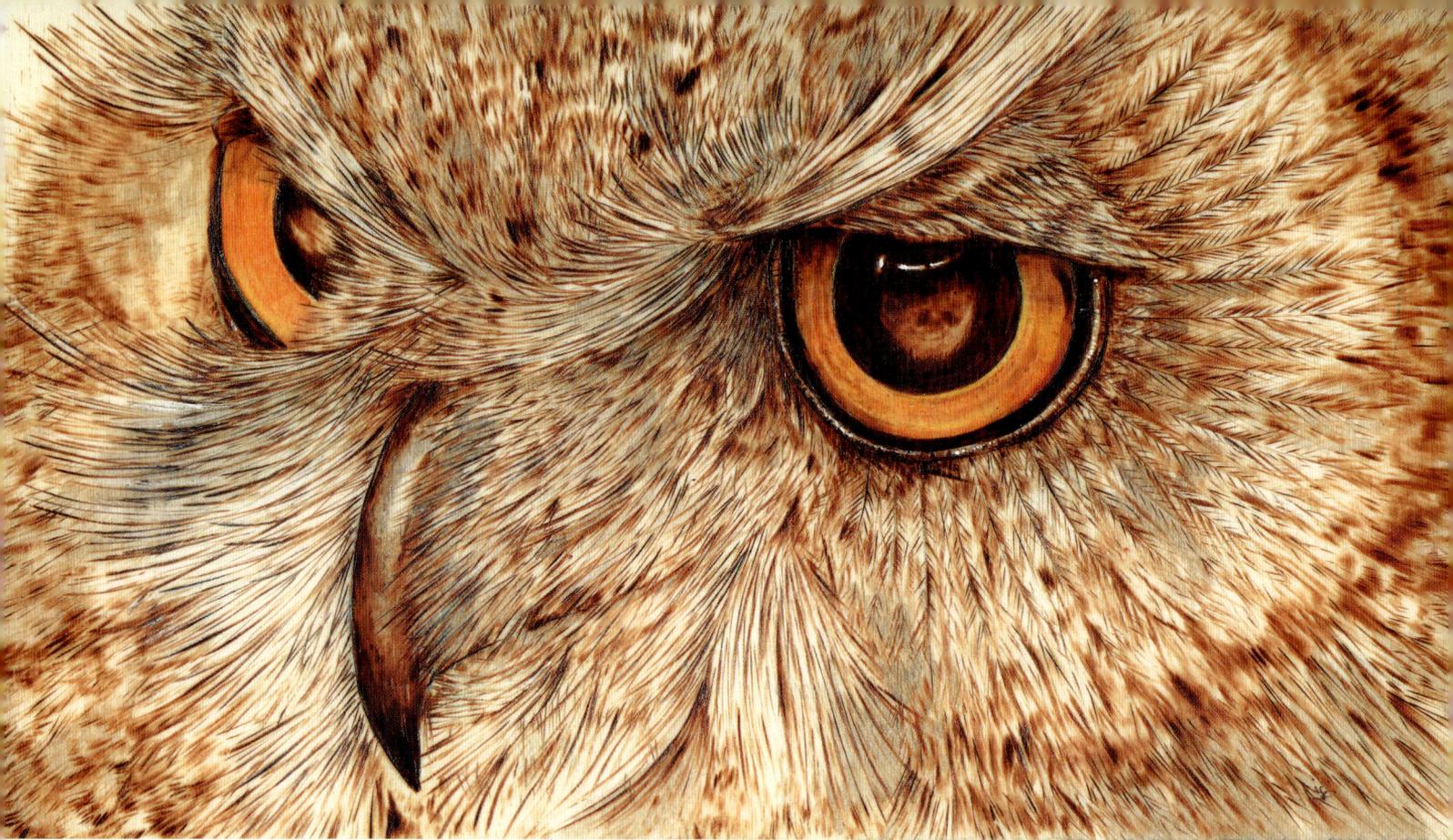

SAFETY

Pyrography is an engaging physical process which uses the direct transfer of heat to mark a surface and therefore by its very nature comes with its own risks. Common sense, awareness and attention to detail will keep you safe as you learn to burn. Most common safety concerns can be easily overcome by always being mindful of heat, health, smoke and dust. These notes are intended as a starting point for safety – you will need to assess the particular materials and specific techniques you intend to use. Have fun but stay safe!

Heat

The word 'pyrography' itself should tell you that the tips of the pens are going to get hot – how would you burn otherwise? Know your machine. Be mindful of where you place your pen when you are not using it and avoid getting the tip anywhere close to the electrical power cords or cables. Turn the unit off when it is not in use. Here are a few more pointers:

- Protect yourself and your surroundings.
- Don't burn near water (for obvious reasons).
- Always rest your hot pen in the holder provided and turn the unit off when changing tips.
- Never leave children unattended near a hot pyrography machine. Solid point pen tips can take a while to cool down.

- If the cables to your pen or machine become unusually hot and your tip remains cool, check the connections are pushed, plugged or screwed in securely. If the problem persists, turn off the machine and contact the manufacturer for advice.
- After a prolonged period of burning some pens become quite hot to hold (this varies between units). If it is uncomfortable, switch the unit off and have a rest. No matter how tempting, don't wrap combustible material around your pen in the hope of insulating it and burning for longer.
- In some solid point pens the heating element in the pen can get extremely hot (don't worry, this is quite normal). Keep your hands away from this area.

Sentinel 70 × 30cm (27½ × 11¾in)

Pyrography, white pencil and Inktense on a birch panel.

'Observation is the greatest source of wisdom.'

This wise old owl watching out over 'Safety' is all about mark-marking and is a great forgiving beginner's piece, particularly done at a smaller size. He was completed solely using a flat shader on the foot, toe and side, starting at the eyes and working outwards. Colour was added to the eyes using tangerine, chilli red and Sicilian yellow Inktense pencils.

Health

Pyrography is a great way to create art and express yourself, but you need to make sure that your support or surface is safe to burn. If in doubt, go online and check out the material safety data sheet (MSDS) for that product. It may take a little finding but it will give you information regarding your 'canvas' and will list all the potential hazards and risks associated with it. For example, the MSDS for medium density fibreboard (MDF) identifies a number of risks to human health regarding its manufacturing process, as it incorporates a urea-formaldehyde resin within the product. The formaldehyde is safely locked within the MDF but can be potentially dangerous when released as particles into the atmosphere as a result of being sawn, sanded or burnt.

Burning inappropriate surfaces can potentially release toxic fumes and vapour into the air and can cause both serious and long-term health problems to both you and the environment. Surfaces that are dangerous to burn include:

- Plastics, including acrylic
- Treated lumber
- Pre-finished or sealed wood
- Medium density fibreboard (MDF)
- Manufactured cork sheeting
- Dyed or chromium-tanned leather
- Treated or dyed fabrics
- Glossy paper or card stock.

Typically, if treated, don't heat it! Most of these products can be substituted if you look around. Consider substituting chromium-tanned leather with vegetable-tanned leather, for example.

Smoke

Regardless of whether a surface is 'safe' to burn, the smoke created from scorching and burning wood and other surfaces, no matter how small and insignificant, can pose an irritant to some artists, particularly those with asthma. Correct use of personal protective equipment (PPE), such as an extractor fan and mask, along with consideration of how you work will go a long way towards avoiding or ameliorating the majority of the effects.

Dust

Sanding is a key task in the preparation of most woods prior to burning. The process of sanding will create dust which can irritate the respiratory system and eyes. Always wear a dust mask, eye shield or goggles when sanding. Opt for a sander that is equipped with a dust collection box and use a micro-filter system to collect particles. Although they tend to be a little pricey, they are a great investment, cutting down on both time and mess.

AFTERWORD

'We shall not cease from exploration,
And the end of all our exploring,
Will be to arrive where we started,
[...] And truly know that place for the first time.'

T. S. Eliot

Books might be square, but I've always seen them as circular, too – we start at the end and end in the beginning... and this end is now your beginning!

I've enjoyed showing you around my happy mixed media world and journeying with you down the pyrography rabbit hole. I hope you've found plenty of tips, tricks and inspiration along your journey and you've enjoyed having a go at the projects. Admiring and imitating other artists is all part of the learning process, but that's just the start! How you choose to infuse your individuality and creativity into what you learn is what counts.

It just leaves me to say this: remember to surround yourself with supplies that you love; experiment, play and approach everything with wonder. Try out new techniques and find ways that you like to work, but above all, be fearless and be your bold beautiful self – those rules were made for breaking!

Acknowledgements

My thanks go to Katie French who first saw a glimmer of a book in the darkness and gave me a map to find it, and to Edward Ralph – I'm so fortunate that it fluttered onto your desk. Thanks also go to Mark Davison, the photographer, and the rest of the Search Press team for your wonderful support, your belief, and for making the magic happen.

To my lovely husband who helped to quieten the doubts and gave me wings.

To Ruby and Ryan, my life companions and children; who I see so little, but who mean so much, and are always in my heart as I write, create and dream... you are my spark.

To the Ferris family, who took me in as one of their own and unconditionally offer me strength, support and belonging. Particularly Brian, Sue and Dinah – my fabulous sister from another mister.

Massive thanks and much love to all my friends who fill my days with joy and laughter, and a special shout out to the HPG crew... you know who you are! Thank you for the late night messages, patience, warm friendly advice and endless cups of tea.

And finally to Luna, my sidekick and partner in crime, who kept me company (and my toes warm under the desk) when I was burning the midnight oil.

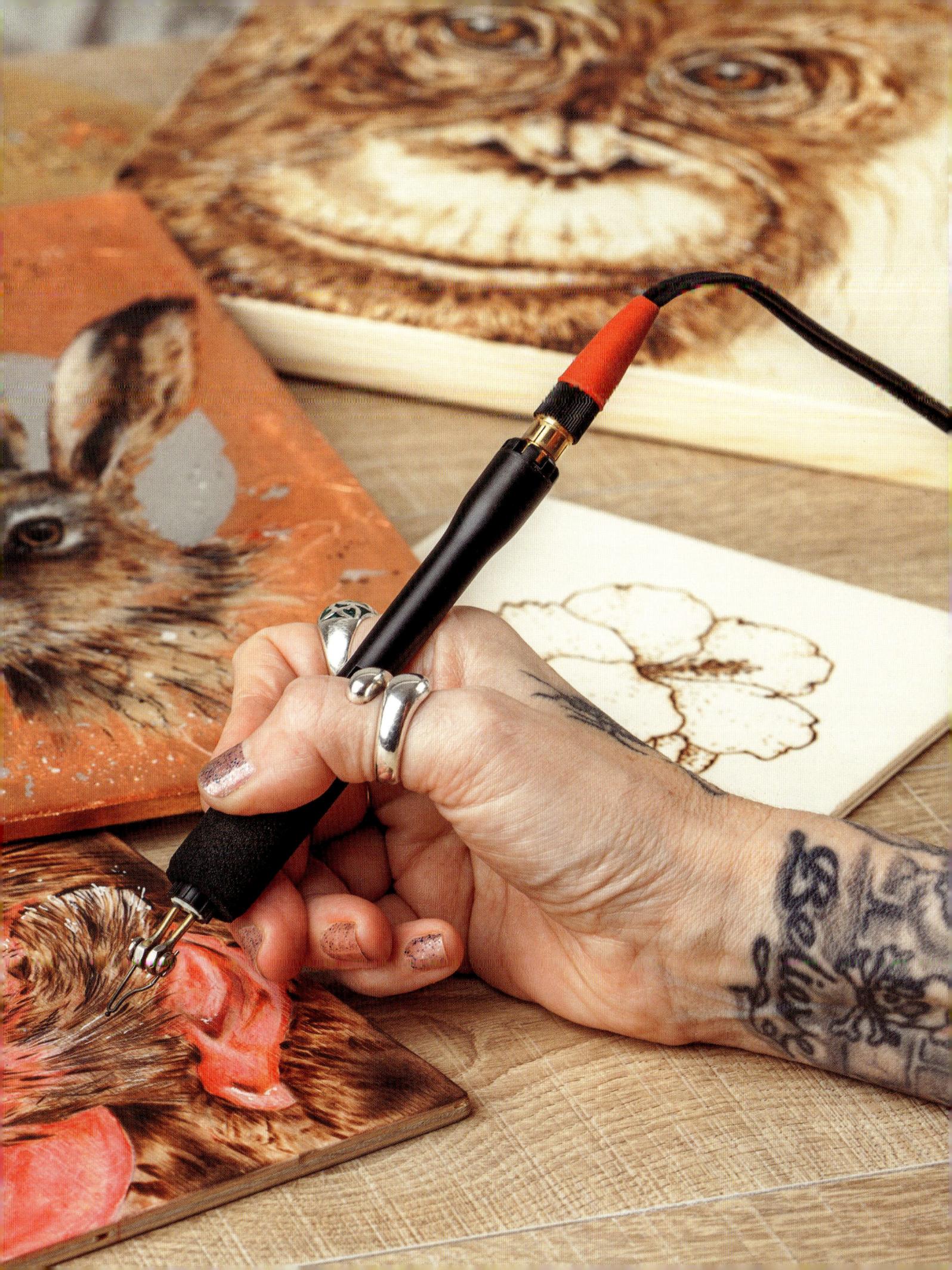

INDEX

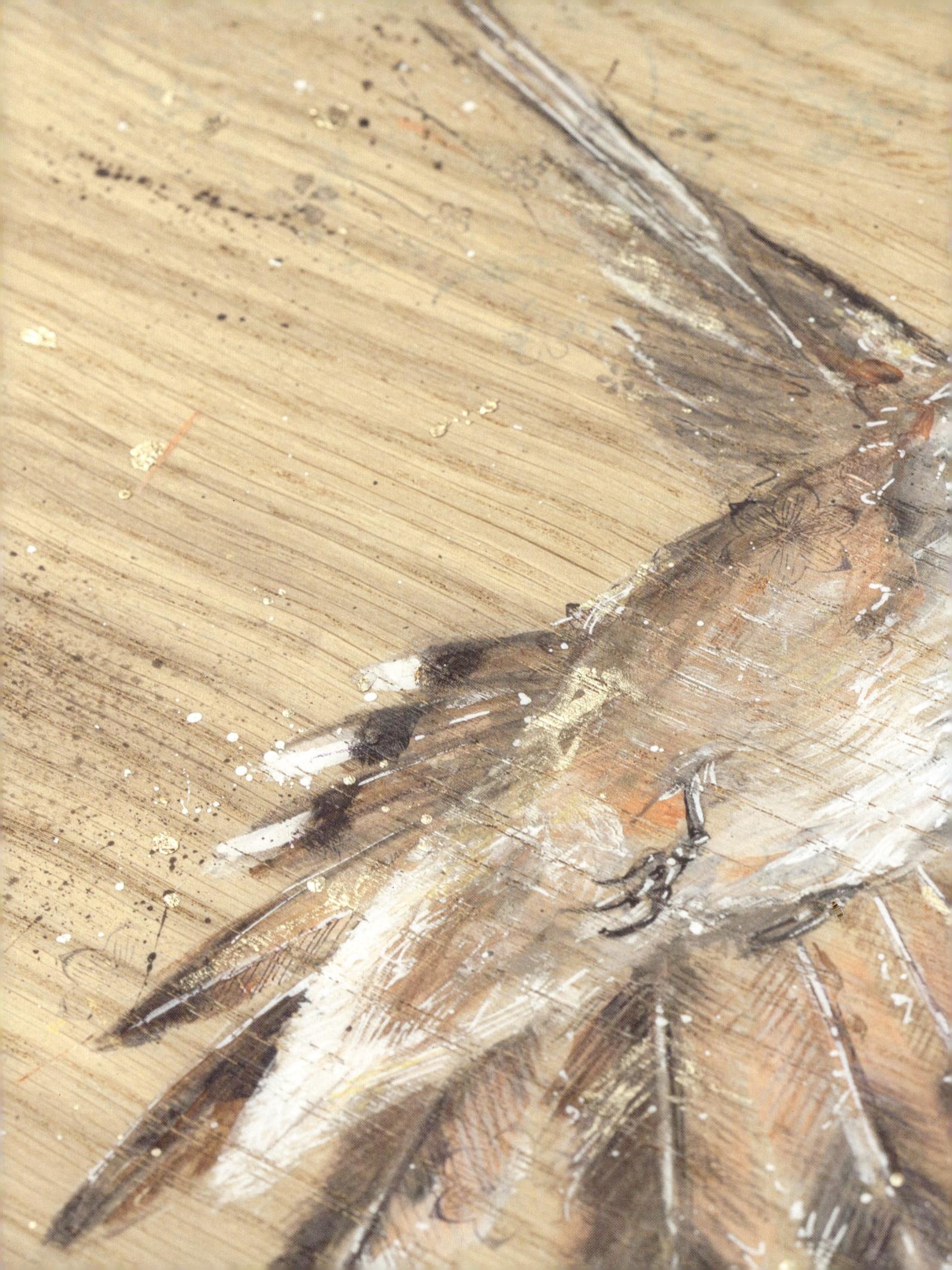